Oleg Cassini

The pleasure of your company

is requested in honor of

the Wedding Dress

RIZZOLI
NEW YORK

New York · Paris · London · Milan

"*Imagine, just imagine*"

OLEG CASSINI

The Grace Kelly Suite, Hotel Bel Air, California

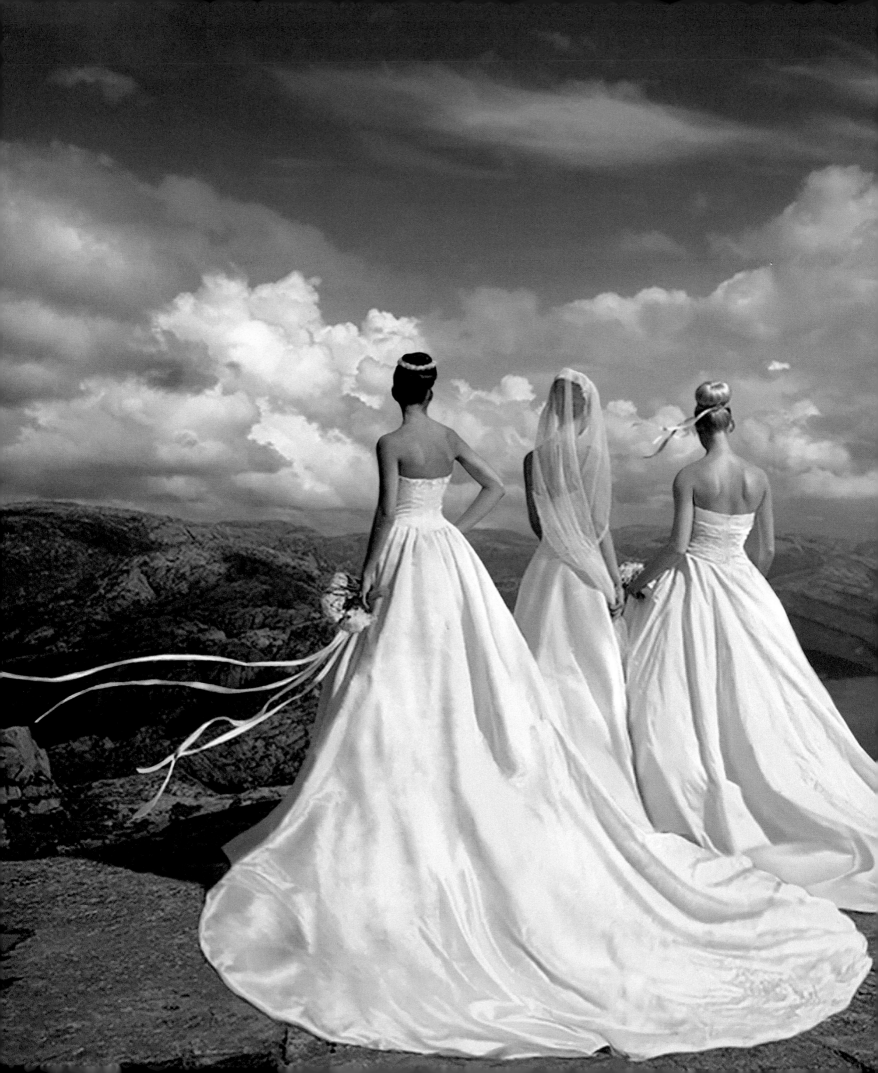

"Secretly in her heart she yearns for romance."

OLEG CASSINI

Preikestolen, Norway

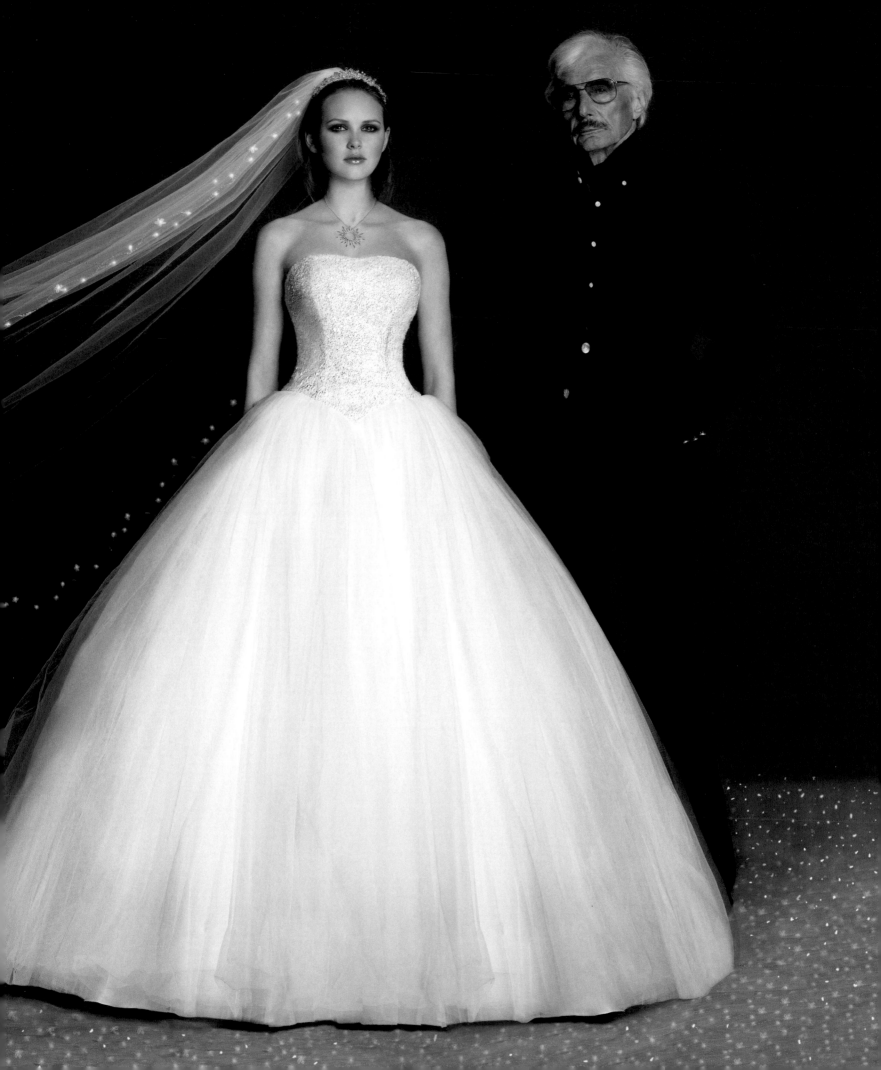

OLEG CASSINI
the Wedding Dress

The Silhouette

The Dress is an Envelope for the Body

The Hemline

The Neckline

The Bold & The Beautiful

a
thousand
days
of
magic

by Oleg Cassini

"To be well dressed is a little like being in love."... Oleg Cassini

Oleg Cassini, Decades of Design in The Art of Fashion

Foreword

I see Oleg Cassini in my mind's eye on the dance floor of the glamorous El Morocco doing the Kozachok, a Russian dance where participants kick out their legs while bent down at the knee. An almost impossible feat, but Oleg and his brother Igor were experts at anything athletic or, for that matter, romantic. They were Russian Counts, born in Paris, emigrating to the U.S. serving in World War II, and earning their success. Like many White Russians driven from their native land, they had a great heritage to live up to.

My friend, Oleg Cassini was making bridal gowns for the fashionable women of the world—film stars, ladies headed for the Social Register: the crème de la crème of beautiful brides on the Riviera, in Paris and Beverly Hills and elsewhere.

I always thought, Oleg has a certain extra sense about dressing women, and to be frank, I think it may have been because he was also expert on undressing many of the beauties of our time. This, in his spare time.

A lot of men think everything to do with bridal gowns is silly, just women's business. But because Oleg was thrown into dressmaking for survival, he turned his hand to it all in a unique way. He never forgot the woman who would wear the dress. If he had to make her beautiful for just one day, her wedding day, he preferred to give her a classic touch for life.

But he has always been a hero to me; any man in black tie who can dance athletically while crouched on the floor or leap over a flaming sword with a champagne glass in hand is the man for me.

Liz Smith

"Oleg, you are, and will be in fashion history, the designer who created the indelible and stylish image for the First Lady. You should be proud of your achievement, you are the designer who inaugurated her style."

SUZY MENKES
Fashion Editor,
International Herald Tribune

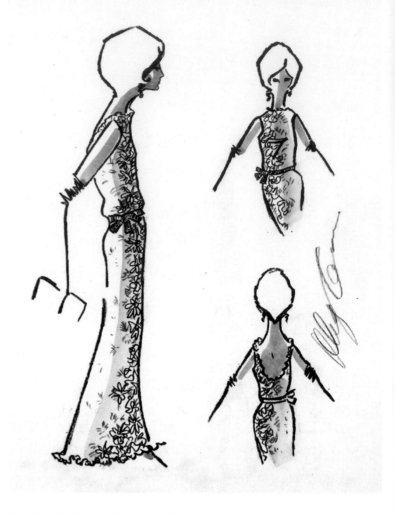

Sketch of the pink straw lace gown worn at the reception. The back of the gown was dramatic, the scalloped effect of the simple bateau neckline in front set off bot Jackie's neck and profile. A matching stole completed the outfi

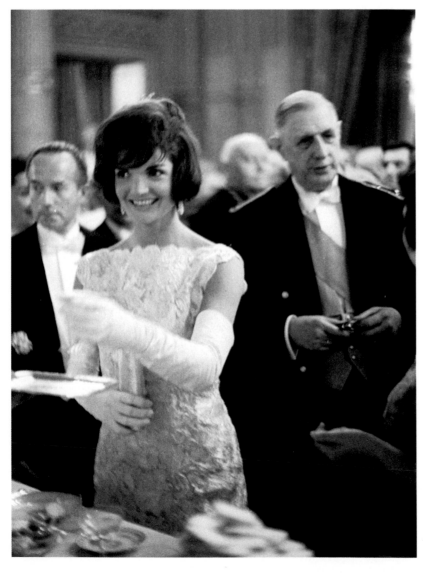

Jacqueline Kennedy & French President Charles de Gaulle at the Elysée Palace reception, Paris, France, May 31, 1961. President de Gaulle famously stated, "She knows more about France than most French women." He was effusive in his comments about, "the gracious and charmante Jacqueline."

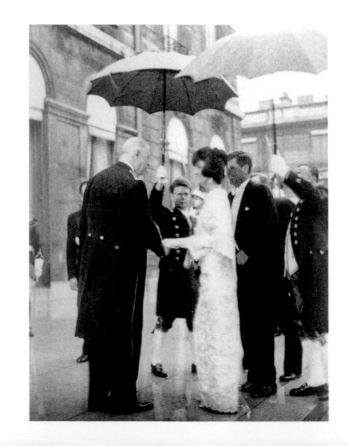

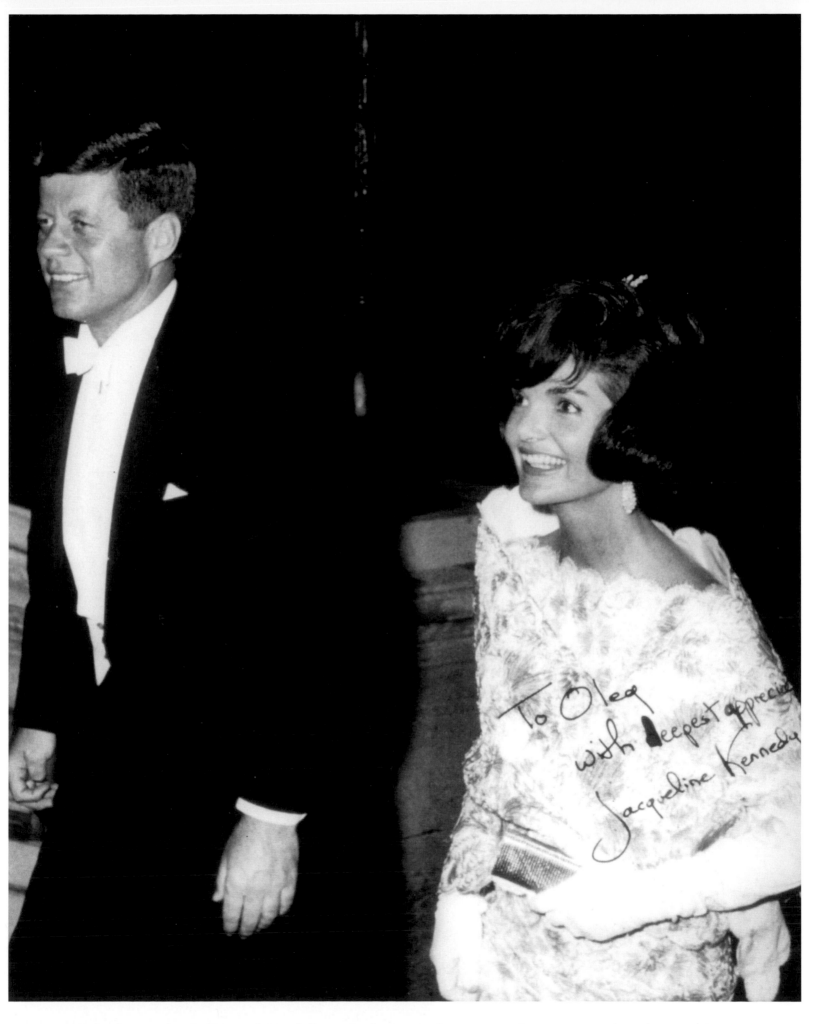

To Oleg with deepest appreciation Jacqueline Kennedy

President John F. Kennedy and First Lady Jacqueline Kennedy arrive at the Elysée Palace.

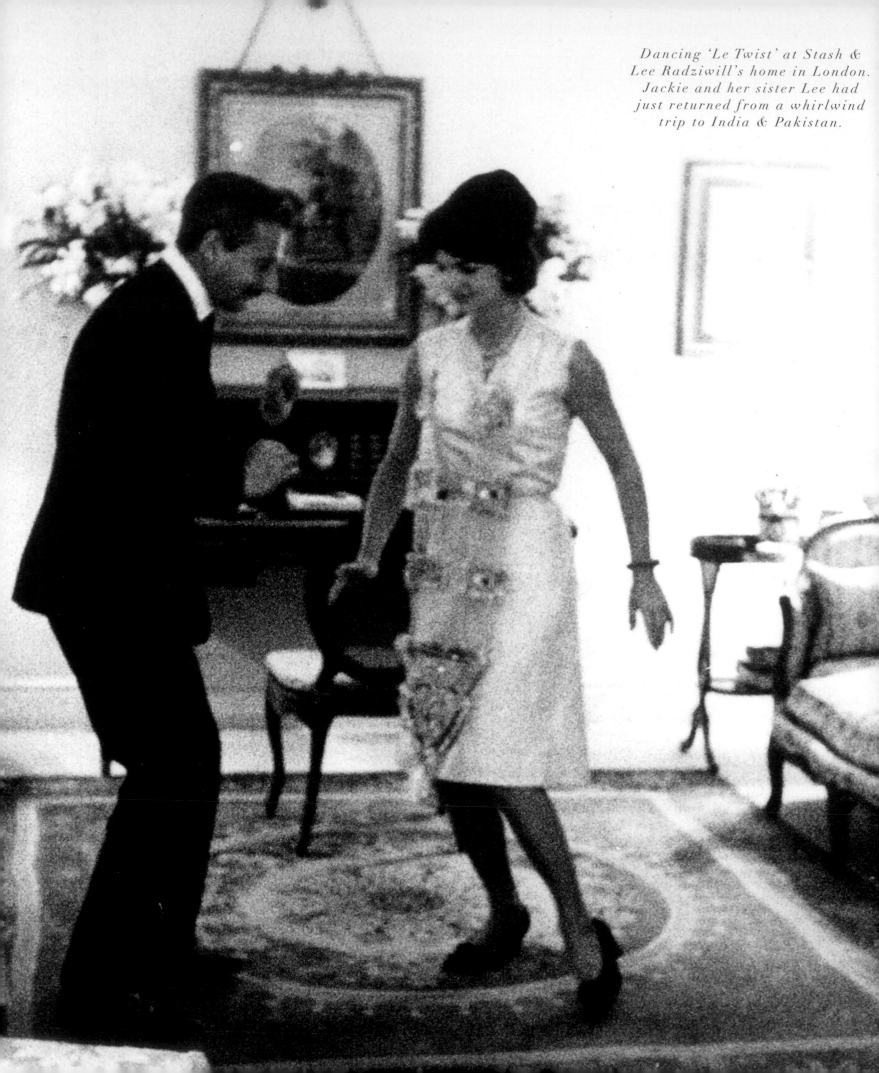

*Dancing 'Le Twist' at Stash &
Lee Radziwill's home in London.
Jackie and her sister Lee had
just returned from a whirlwind
trip to India & Pakistan.*

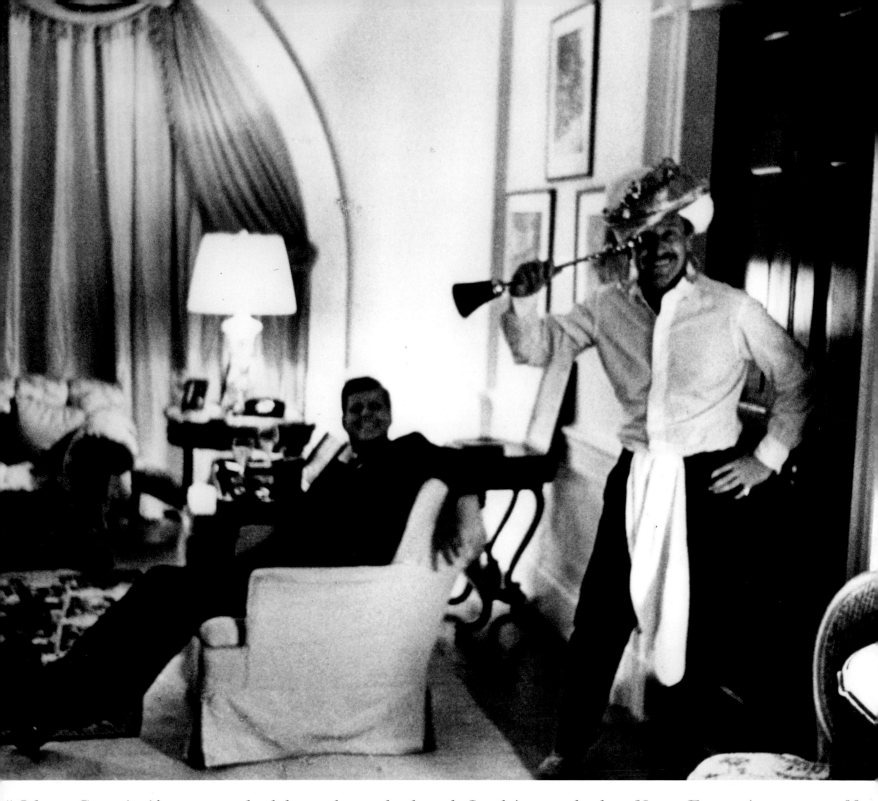

"Oleg Cassini's remarkable talent helped Jackie and the New Frontier get off to a magnificent start. This historic collaboration gave us memorable changes in fashion, and style classics that remain timeless to this day. Oleg's innovation and creativity have earned him worldwide recognition and admiration. His great warmth, twinkling humor; and enduring loyalty have earned him the respect and friendship of all the members of the Kennedy family."

EDWARD M. KENNEDY
Senator

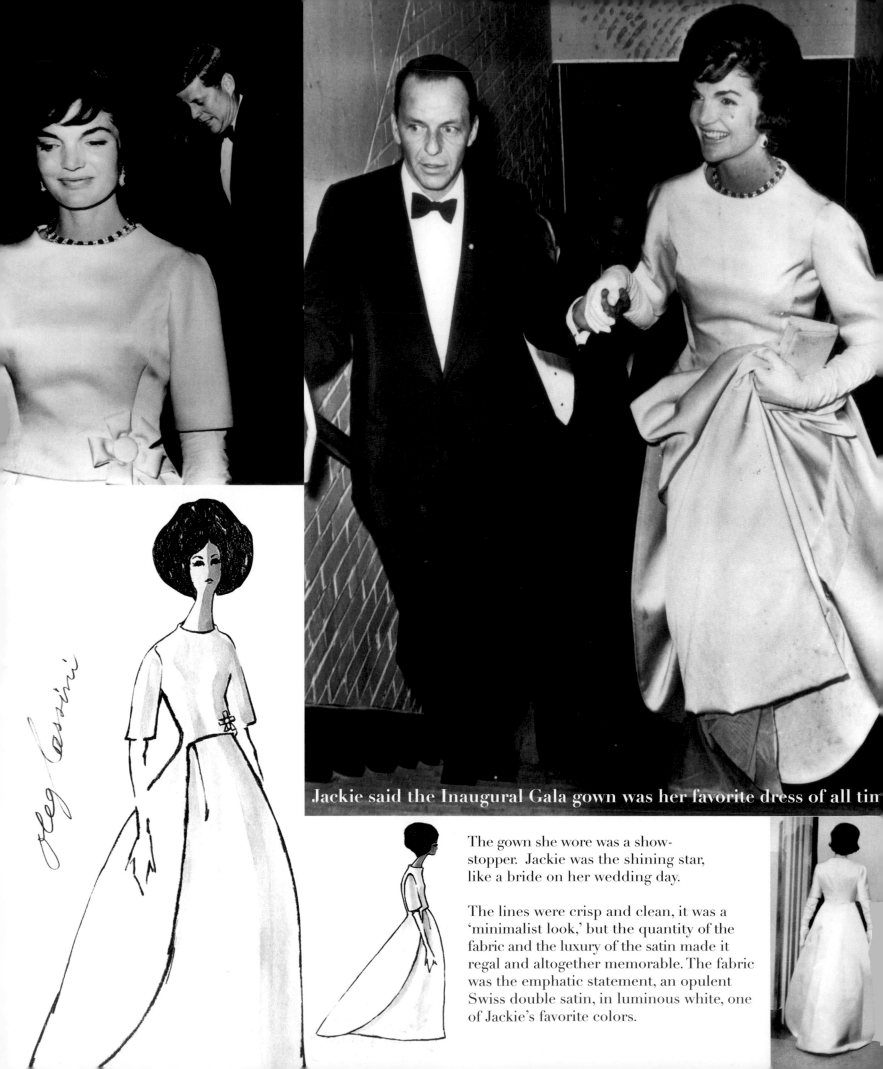

Jackie said the Inaugural Gala gown was her favorite dress of all time

The gown she wore was a show-stopper. Jackie was the shining star, like a bride on her wedding day.

The lines were crisp and clean, it was a 'minimalist look,' but the quantity of the fabric and the luxury of the satin made it regal and altogether memorable. The fabric was the emphatic statement, an opulent Swiss double satin, in luminous white, one of Jackie's favorite colors.

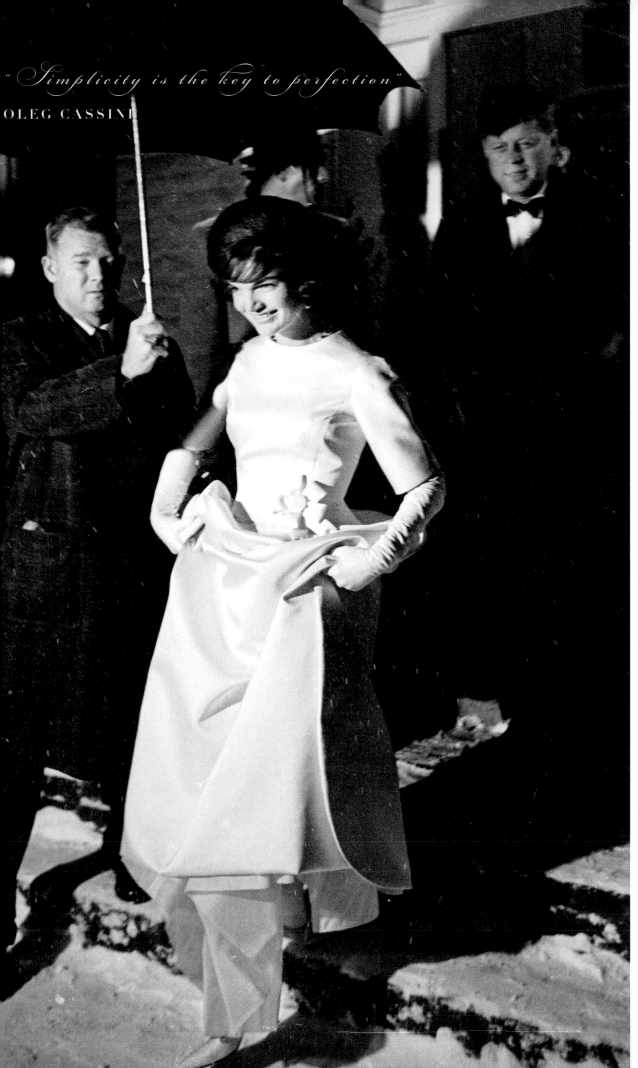

The Inaugural Gala Gown

On January 19, 1961, the Inaugural Gala was the first official event of the new Kennedy administration, the night before the swearing-in ceremony.

It was a star-studded evening; a black tie affair organized by Peter Lawford and Frank Sinatra who sang, "That Old Jack Magic," a parody of Frank's hit song, "That Old Black Magic." It would be Jackie's first major appearance as the glamorous new First Lady Elect.

Jack was very proud of Jackie and how she looked. He asked for the lights in the limousine to be turned on so the crowds could see Jackie enroute to the Gala. The gown was full length, of graphic simplicity, unadorned except for a French 'cocarde' at the waist. It was a tee shirt dress, but, what a tee shirt!

I told Jackie how it would set the tone for the new administration. We talked about history and the message her clothes would send, a simple, youthful, but magisterial elegance, and how she would reinforce the message of her husband's administration through her appearance.

For her, I envisioned a look of exquisite simplicity using the finest materials. I said, "You have an opportunity here for an American Versailles."

I also created gowns for the President's mother, Rose, who ordered a black lace ensemble, and his sisters, Eunice, Pat, Jean and Ted's wife, Joan.

This gown was included in the book, "Fifty Dresses That Changed the World" by the Design Museum, England.

Oleg's belief is that life should be celebrated every day. After skiing the black diamonds for hours on end with the Kennedys, he could entertain them with stories as he whipped up dinner for forty, laughter was always in order. Known for his Intercontinental style, Oleg liked to say, "To be well dressed is a little like being in love." He arrived in the U.S. with a tennis racquet, a title, and a dinner jacket and made the most of all three. "I am a great believer in luck," he once said. He never eased up on the charm.

Oleg was at one point engaged to Grace Kelly who eventually sailed off to Monaco (wearing an Oleg Cassini dress) to marry Prince Rainier. She kept a telegram Cassini had sent her that read, "Imagine, just imagine." Romance and elegance were not lost on Oleg. As the American designer tapped to dress First Lady Jacqueline Kennedy, Oleg elevated American style at a time when his European counterparts ruled the fashion world. Many of his designs for her were variations of a T-shirt, one-shoulder styles or strapless silhouettes. Interestingly, the 'Jackie Look' is one of the most influential looks for today's wedding dresses. When a photographer praised one of his gown's intricate embroidery, Oleg replied, "The idea is to enhance the beauty of the bride."

Senator Edward M. Kennedy said, "Oleg is a true original, with an eye for beauty, a love of life and an infectious laughter that enriches all our lives." Although he lived in France, Russia, Denmark and Switzerland before the age of nine, as an adult he took great pride in being an American and the achievements he accomplished in the U.S. A tireless competitor, Oleg remarked, "In this materialistic world we live in, surviving is an important thing. That's what Americans love—the winners."

ROSEMARY FEITELBERG *Women's Wear Daily*

Oleg Cassini is the rarest of rare species: a man who genuinely loves women. And for all his talk, it is he who had served them for most of his years. He has devoted his life to making women look and feel beautiful with his classically designed clothes most famously creating "The Look" for Jacqueline Kennedy when she was the First Lady. As the first designer to license in 1951, he has been creating everything from evening dresses to sunglasses in more than 60 countries ever since. His name has always suggested glamour— champagne, polo ponies, a box at the opera, he was married to a movie star, and engaged to Grace Kelly before she became a princess. The son of Russian aristocrats banished to Europe after the revolution . . . he designs clothes that betray a lifelong ache for lost grandeur, there is about him in every gesture from knocking ash from his cigar to straightening his tie an echo of old world distinction.

ALEX WITCHEL *The New York Times*

In January, 1963 when Jacqueline Kennedy was named America's best-dressed woman for the third year in a row, her official fashion designer, Oleg Cassini, was cited as a symbol of fashion leadership to the average woman everywhere. The First Lady had chosen Cassini shortly after her husband's election to the presidency because the Parisian-born designer was uniquely qualified for the role. Not only could Jacqueline Kennedy converse with Cassini in French, but he was steeped in the history, literature, and art of 18th and 19th century Europe that she adored. When she asked for a dress in "Veronese green" or "Nattier blue," he would instantly understand. He, in turn, could feel comfortable creating what he called "fashion scripts" to evoke "a dramatic version of a look" that projected Jackie's goal of "sophisticated simplicity."

SALLY BEDELL SMITH

The timeless elegance of Oleg Cassini—the combination of European elegance and New World energy is a rare combination but they have formed a dynamic synthesis in one notable man, Oleg Cassini. Oleg Cassini is the great American success story and the triumph of the cultivated European aristocratic ideal. Surprisingly, the first impression is one of delightful finesse, humour and genuine good manners of a man of great personal dignity. His great charm is that he likes people, especially beautiful women, and with this advantage, he has been able to create the fashion, the luxury, the ideas to enhance women everywhere.

JENNIFER SHARP *Harpers & Queen, London*

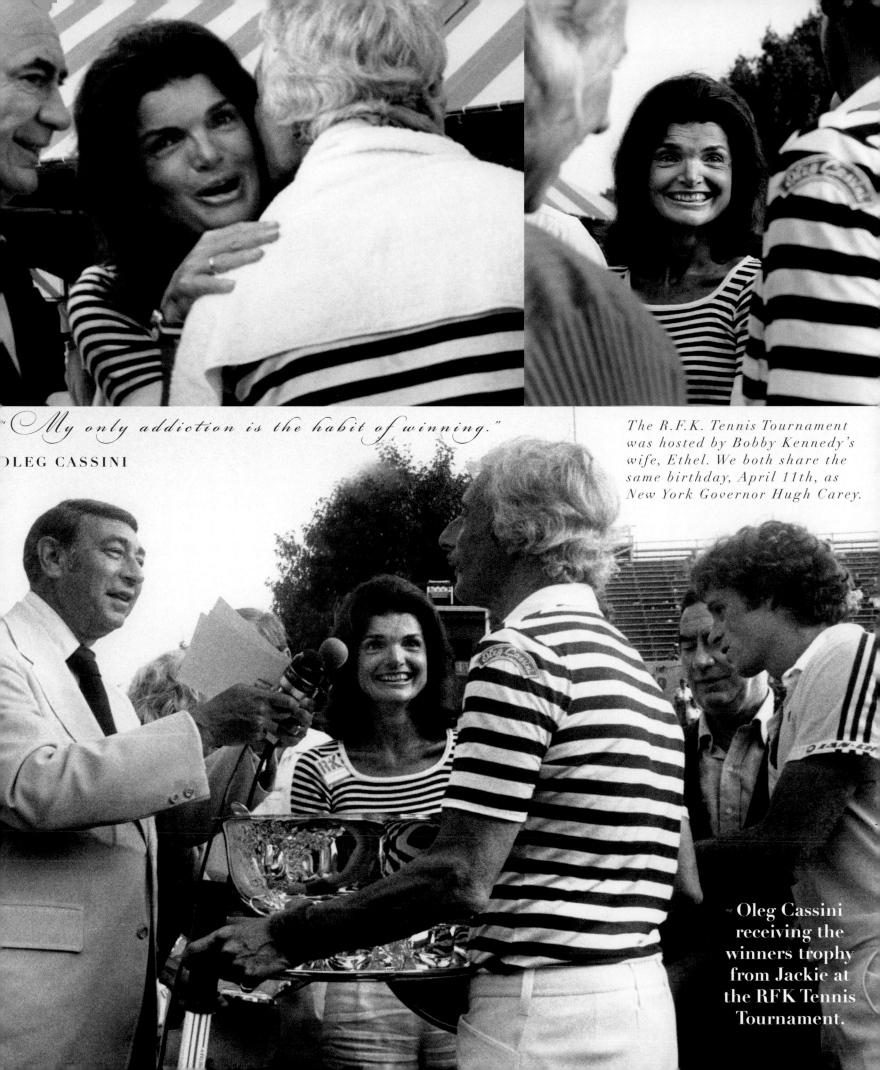

"My only addiction is the habit of winning."

OLEG CASSINI

The R.F.K. Tennis Tournament was hosted by Bobby Kennedy's wife, Ethel. We both share the same birthday, April 11th, as New York Governor Hugh Carey.

Oleg Cassini receiving the winners trophy from Jackie at the RFK Tennis Tournament.

"TO BE WELL DRESSED IS A
LITTLE LIKE BEING IN LOVE..."

OLEG CASSINI

"Simplicity is the ultimate sophistication."
LEONARDO DA VINCI

Introduction

Born in Paris to Count and Countess Cassini, Oleg's family ancestry dates back to the First Crusade. Oleg Cassini's grandfather was the influential Imperial Russian Ambassador to Peking, as well as Washington, under Presidents Theodore Roosevelt and William McKinley. Oleg wanted to be a soldier or diplomat, however, due to the collapse of the Russian Empire, the family moved to Florence, where Oleg studied art with the famous painter Giorgio de Chirico and after apprenticed with Patou in Paris.

Always intrigued by movies, Oleg went to Hollywood where he married a movie star and created magic for countless others. He arrived with a tennis racquet, tuxedo, a title and talent and turned it all into an empire.

In Hollywood, as a ranked tennis player, Oleg won a doubles tournament. His partner was the head of Paramount Pictures. Oleg was looking for a job and Paramount a designer, so it was serendipity. His first film was *I Wanted Wings* starring Veronica Lake.

Oleg designed for most of the major studios. The list of stars he dressed and undressed is impressive.

After serving in the U.S. Cavalry during World War II, with Ronald Reagan, First Lieutenant Cassini returned to New York to open his own fashion business. He went on to become the Secretary of Style to the White House and America's most famous First Lady, Jacqueline Kennedy. His reputation developed as a result of his genius for original spontaneous design. He created the look for his fiancée, Grace Kelly, and is known as a prominent figure in fashion, Hollywood, and international society, designing for the legendary beauties of the 20th and 21st century.

With great style and *joie de vivre*, Oleg Cassini epitomizes the American Dream in all its hope and glory, and does so always with style and timeless elegance.

An important influence in men's fashion, Oleg broke traditions with innovations impossible to be ignored. Revitalizing men's fashion by bringing color to shirts that had only been white, Oleg is the first celebrity designer, becoming as well known as his famous clients. He has dressed film stars, business leaders, TV stars and sports personalities including Johnny Carson, Burt Reynolds, Regis Philbin, Ted Turner and Michael Jordan.

'The Jackie Look' by Oleg Cassini resonated worldwide, and is credited with being the single most important influence in today's bridal wear. Edith Head, a significant designer in Hollywood, said that, "The Jackie Look is the single biggest fashion influence in history."

Oleg's trendsetting looks for Jackie, including the empire strapless, have had a major impact on wedding dress silhouettes. His strapless look is the predominant choice of today's bride.

Oleg Cassini, a taste setter, a trend setter, and an icon of style, is known for creating some of the most memorable moments in fashion history, from Hollywood to the White House, to being named the 'King of Bridal,' the number one best selling designer name in bridal today.

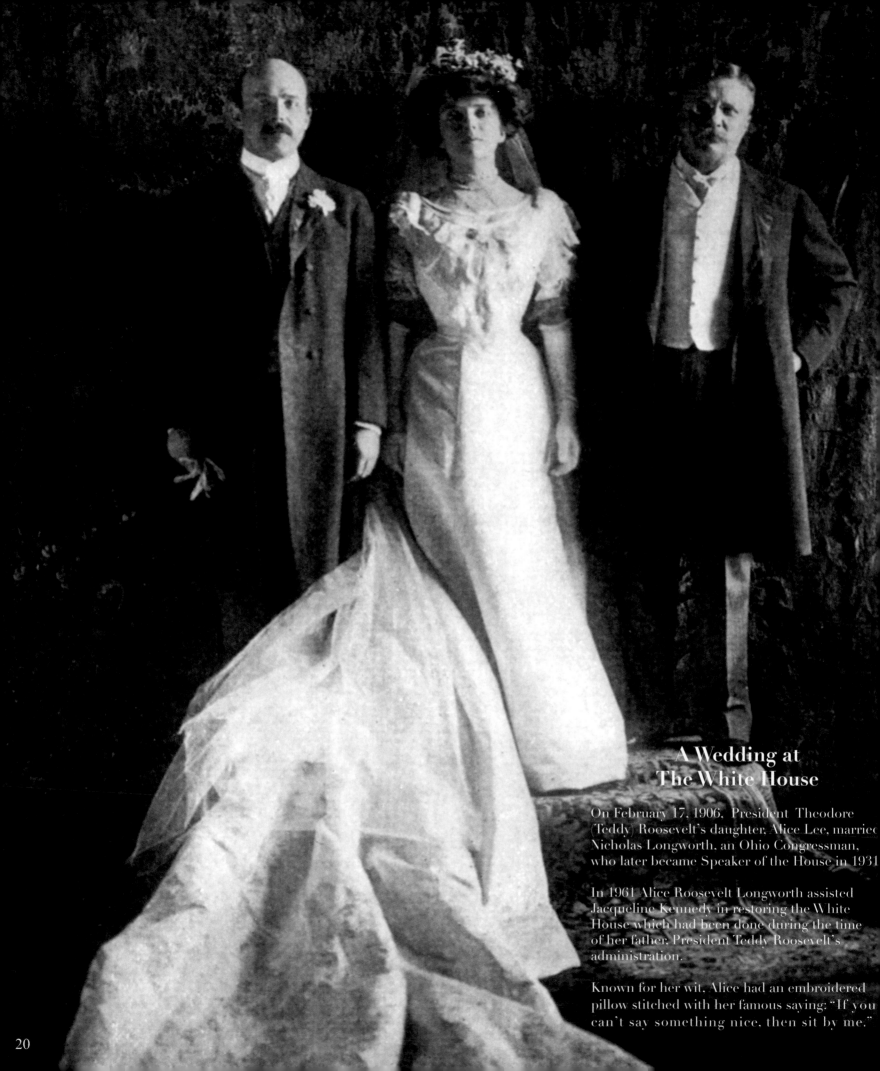

A Wedding at The White House

On February 17, 1906, President Theodore (Teddy) Roosevelt's daughter, Alice Lee, married Nicholas Longworth, an Ohio Congressman, who later became Speaker of the House in 1931.

In 1961 Alice Roosevelt Longworth assisted Jacqueline Kennedy in restoring the White House which had been done during the time of her father, President Teddy Roosevelt's administration.

Known for her wit, Alice had an embroidered pillow stitched with her famous saying: "If you can't say something nice, then sit by me."

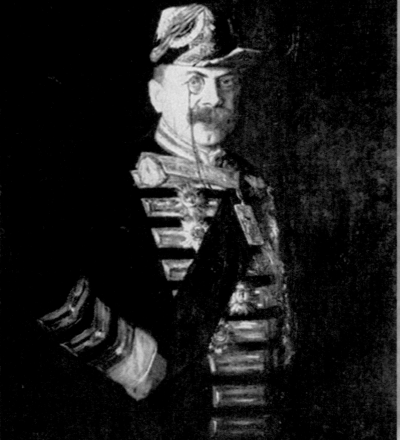

My maternal grandfather Arthur Paul Nicholas, Marquis de Capizzucchi de Bologna, Count de Cassini, was a famous Russian diplomat, the Czar's minister to China, and then Russian Ambassador to the United States during the administrations of Presidents William McKinley and Theodore Roosevelt. Arthur Cassini signed the Treaty of Portsmouth, ending the Sino-Japanese War and was honored by having both Port Arthur in Asia and Port Arthur, Texas named after him.

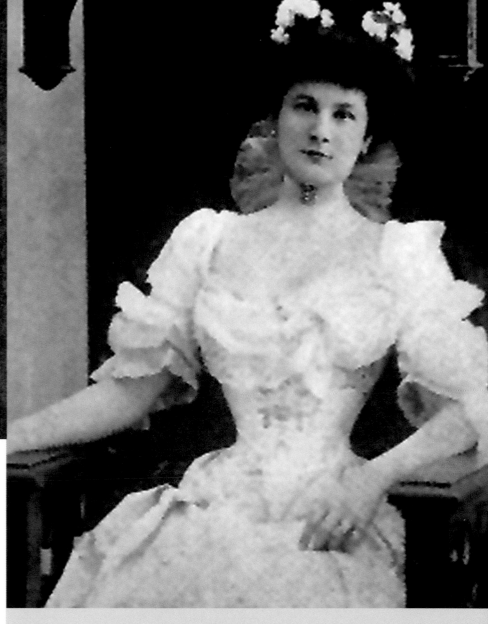

Countess Marguerite Cassini

My mother Countess Marguerite, daughter of the Russian Ambassador to the United States, the official hostess in Washington D.C. at the Russian Embassy was a trendsetter in fashion and society. She designed her own clothes and had them executed by numerous dedicated seamstresses. Her strategy was to focus on her tiny waist. She introduced many fashion trends including the sash cummerbund look and tulle bow that became quite the thing in turn of the century Washington D.C. Marguerite enjoyed audacity and was a glorious flirt. Along with her best friends,'Princess' Alice Roosevelt, and Cissy Patterson (who were known as the 'three graces' by the press), she was one of the first women to smoke cigarettes in public and to win an automobile race from Washington, D.C. to Chevy Chase at breathtaking speeds up to fifteen miles an hour. One of Marguerite's suitors was Franklin Delano Roosevelt the thirty second President of the United States.

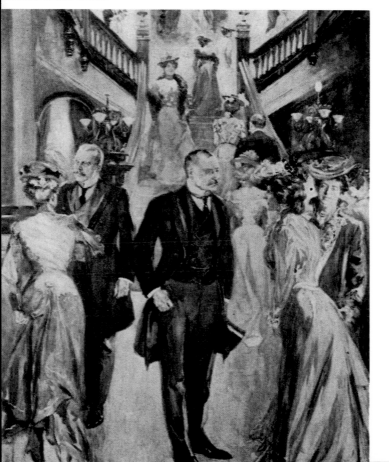

LEFT Lord Pauncefote, the British Ambassador, hosted a reception at the British Embassy in Washington. Baron von Hengelmuller, the Austro Hungarian Ambassador, is speaking with Countess Marguerite, and Count Arthur Cassini is speaking to Baroness Speck von Stenberg wife of the German Ambassador.

Dressed in a sailor suit like many other young children in Imperial Russia.

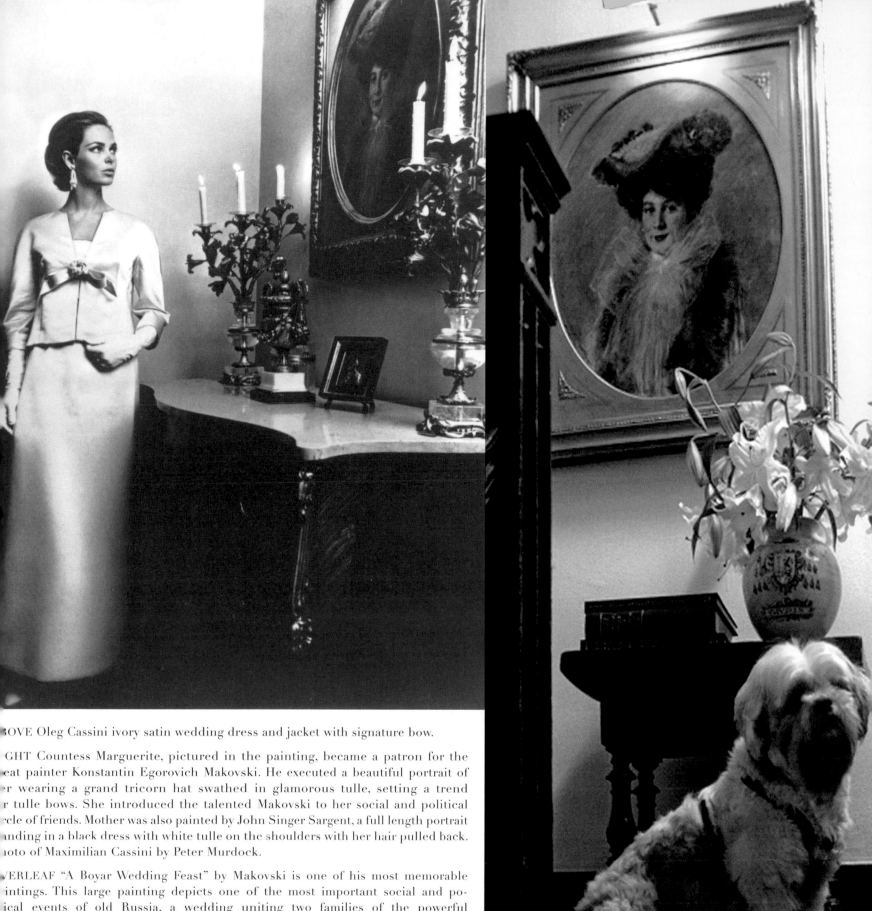

ABOVE Oleg Cassini ivory satin wedding dress and jacket with signature bow.

RIGHT Countess Marguerite, pictured in the painting, became a patron for the great painter Konstantin Egorovich Makovski. He executed a beautiful portrait of her wearing a grand tricorn hat swathed in glamorous tulle, setting a trend for tulle bows. She introduced the talented Makovski to her social and political circle of friends. Mother was also painted by John Singer Sargent, a full length portrait standing in a black dress with white tulle on the shoulders with her hair pulled back. Photo of Maximilian Cassini by Peter Murdock.

OVERLEAF "A Boyar Wedding Feast" by Makovski is one of his most memorable paintings. This large painting depicts one of the most important social and political events of old Russia, a wedding uniting two families of the powerful boyar class that dominated Muscovite politics in the 16th and 17th centuries. The artist has singled out that moment during the wedding feast when the guests toast the bridal couple with the traditional chant of "gor'ko, gor'ko," meaning "bitter, bitter," a reference to the wine, which has supposedly turned bitter. The newlywed couple must kiss to make the wine sweet again. The toast occurs towards the end of the feast when a roasted swan is brought in, the last dish presented before the couple retires. The painting is at the Hillwood Museum, Washington, DC, the former home of Marjorie Merriweather Post.

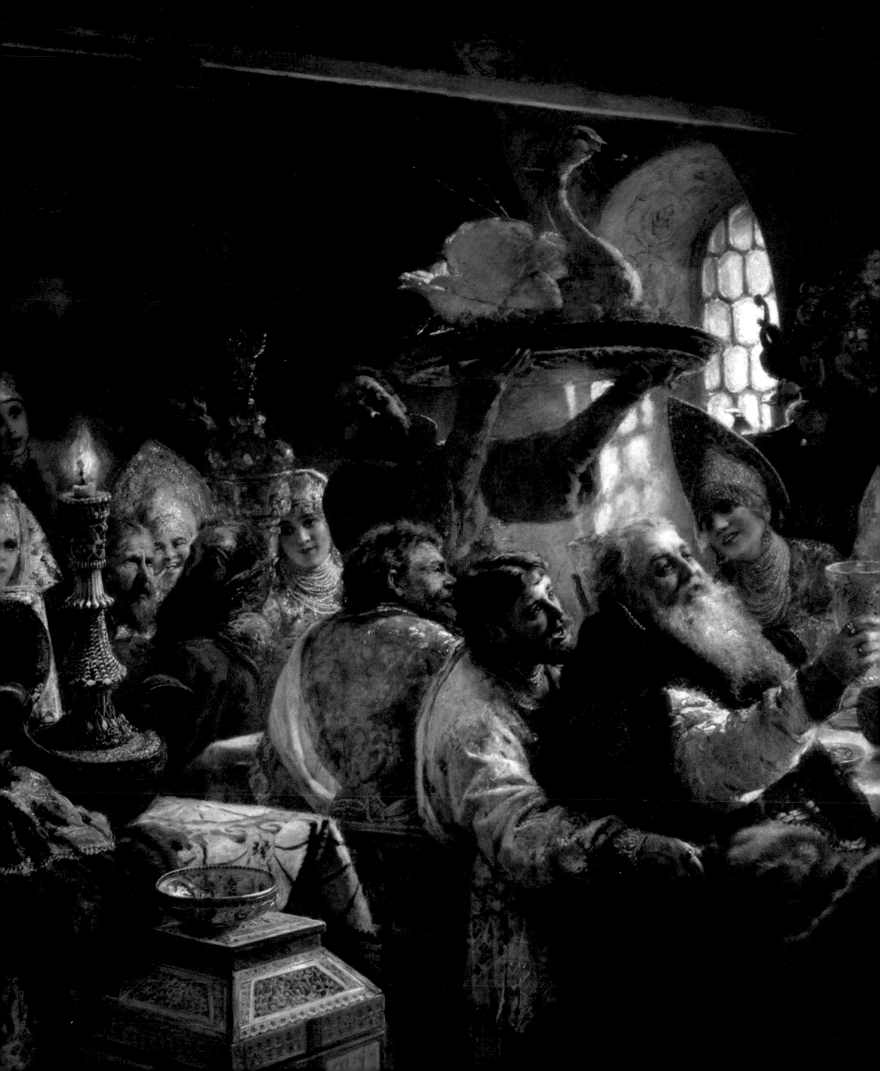

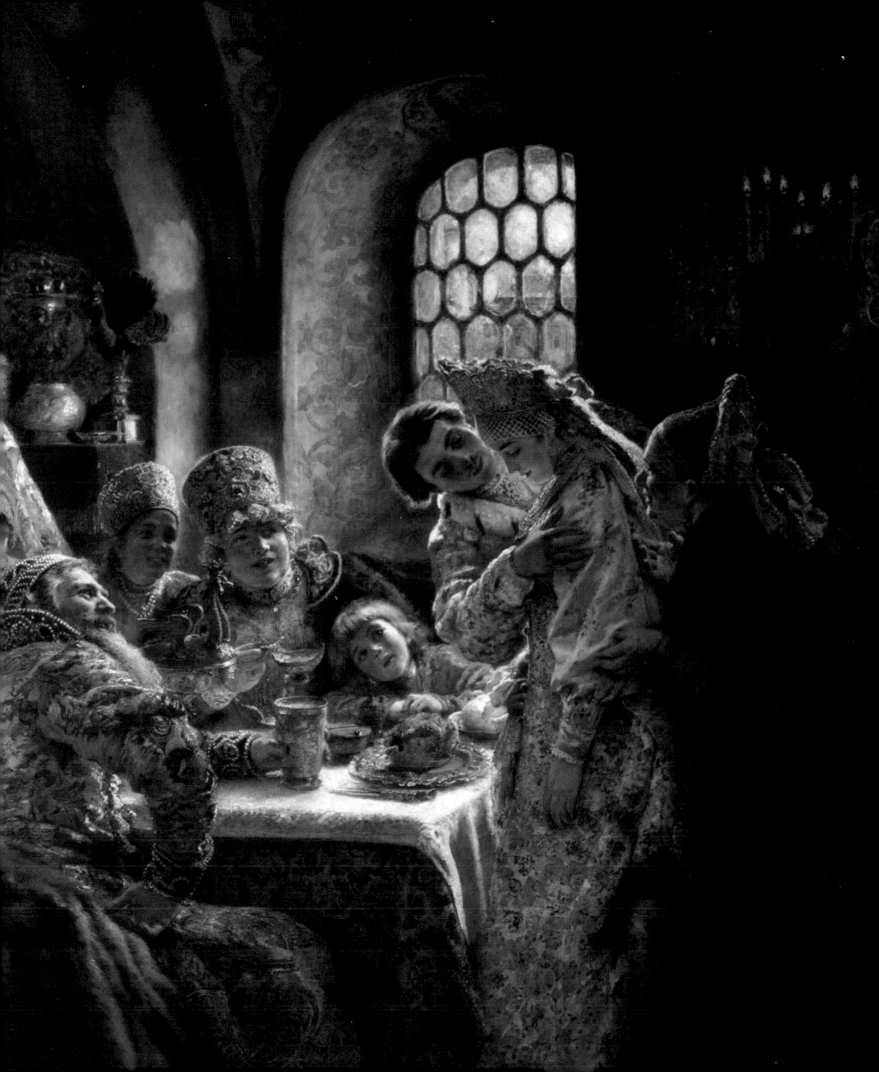

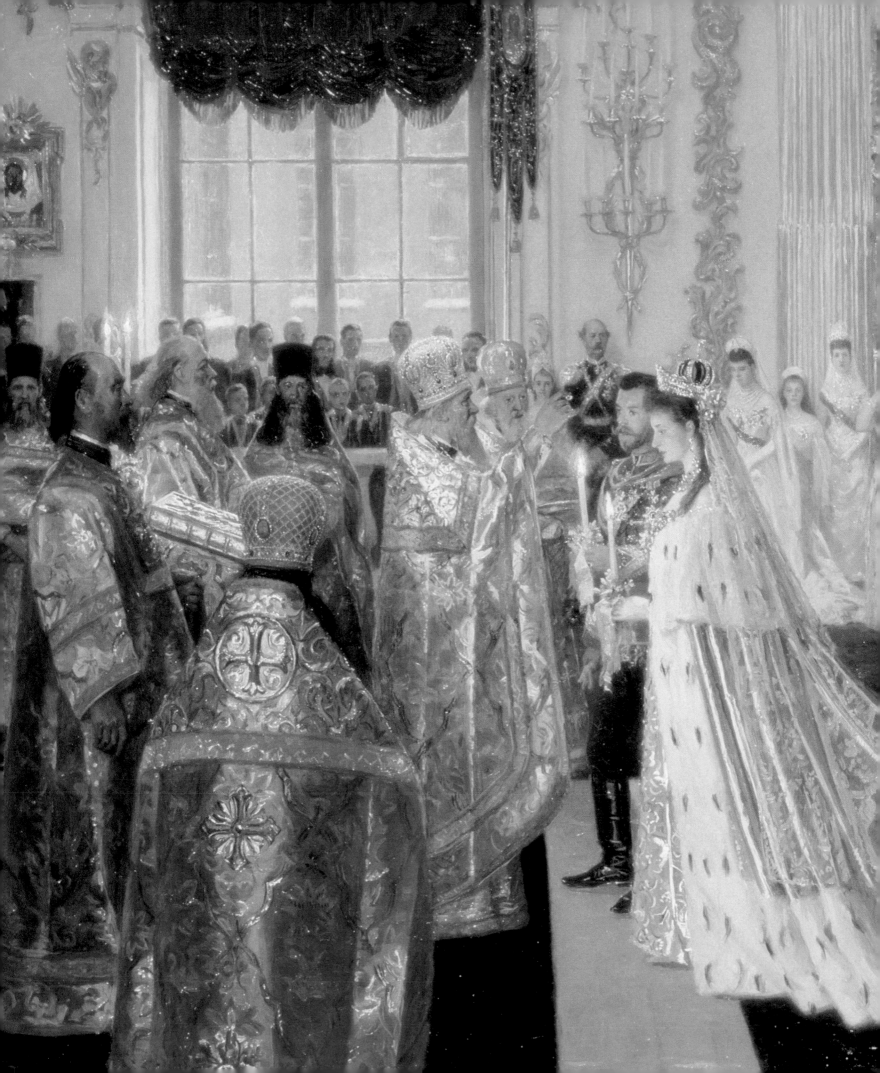

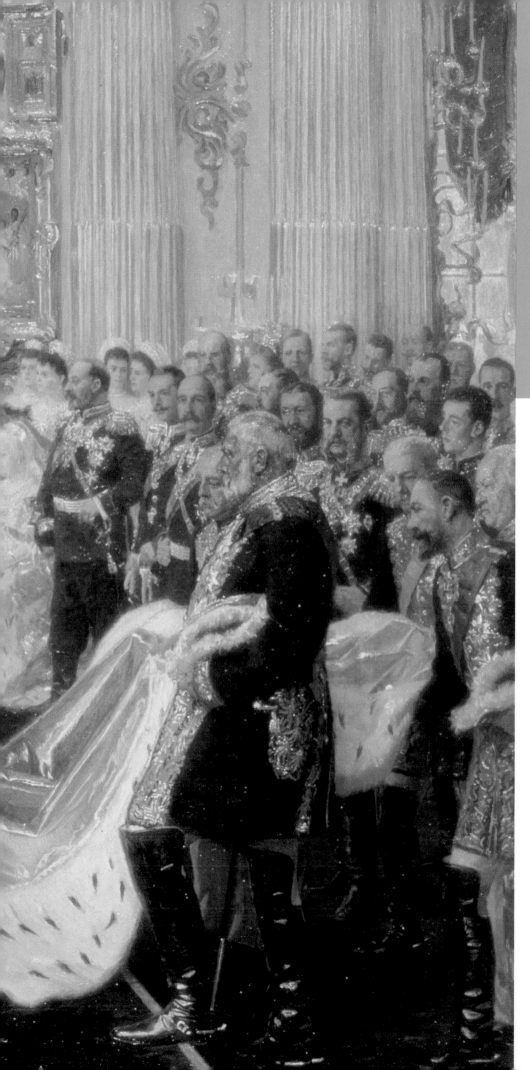

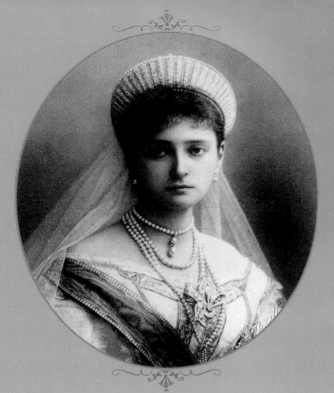

Nicholas & Alexandra
November 26, 1894

The Wedding of his Majesty, Emperor Nicholas II Emperor of Russia, and her Imperial Highness, the Grand Duchess Alexandra Feodorovna, Princess Alix of Hesse, took place in the Great Chapel of the Winter Palace, St. Petersburg, Russia. Princess Alix was dressed for her wedding in the Malachite drawing room of the Winter Palace. Her hair was done in traditional long side curls in front of the famous gold mirror of the Empress Anna Ioannovna, before which every Russian Grand Duchess dressed on her wedding day. She wore a diamond nuptial crown and magnificent diamonds on her Russian Court Dress of silver 'tissu.' Her long train was lined and edged with ermine and over her shoulders was placed the Imperial Mantle of gold cloth.

Princess Alexandra was the granddaughter of Queen Victoria. Among the guests were Alix's brother, the Grand Duke of Hesse, and her uncle, the Prince of Wales, Edward VII, son of Queen Victoria & Prince Albert of England.

LEFT The large painting of the Wedding Ceremony of Emperor Nicholas II & Empress Alexandra Feodorovna by Laurits Regner Tuxen hangs in Buckingham Palace, London. Courtesy of the Royal Collection H.M. Queen Elizabeth II. Reproduced by permission of The State Hermitage Museum, St. Petersburg, Russia.

"I think the Cowboy is the best dressed man in America."

"*We were in Hollywood: a magical place, filled with perfect-looking people.*"

Inspired by American films, particularly Westerns, I went to Hollywood. Los Angeles was still a small town then; the air was fresh and clean, and smelled of gardenias and orange blossoms, the weather remarkable, the traffic minimal, the flowers lush and fragrant . . . the girls beyond belief. They ambled along Sunset Boulevard as if it were a fashion runway, displaying their wares with a somewhat studied abandon, hoping against hope to be discovered by some errant producer.

This was the era of Lana Turner getting 'noticed' while sitting at the counter at Schwab's Drugstore, and the town was just awash with stunning specimens. They came from all over the country, all over the world. I had expected beautiful girls in Hollywood, but the number, there always seemed to be three for every man, and the sheer beauty was enough to make any red blooded fellow lightheaded. I felt a real sense of accomplishment when I could read in the gossip columns, "Betty Grable and Oleg Cassini tripping the light fantastic at Ciro's" . . . It was music to my ears. She loved to dance, and so did I, Betty was one of the best dancers I've ever met.

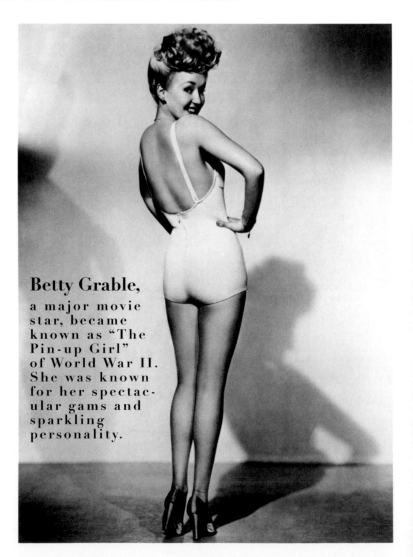

Betty Grable, a major movie star, became known as "The Pin-up Girl" of World War II. She was known for her spectacular gams and sparkling personality.

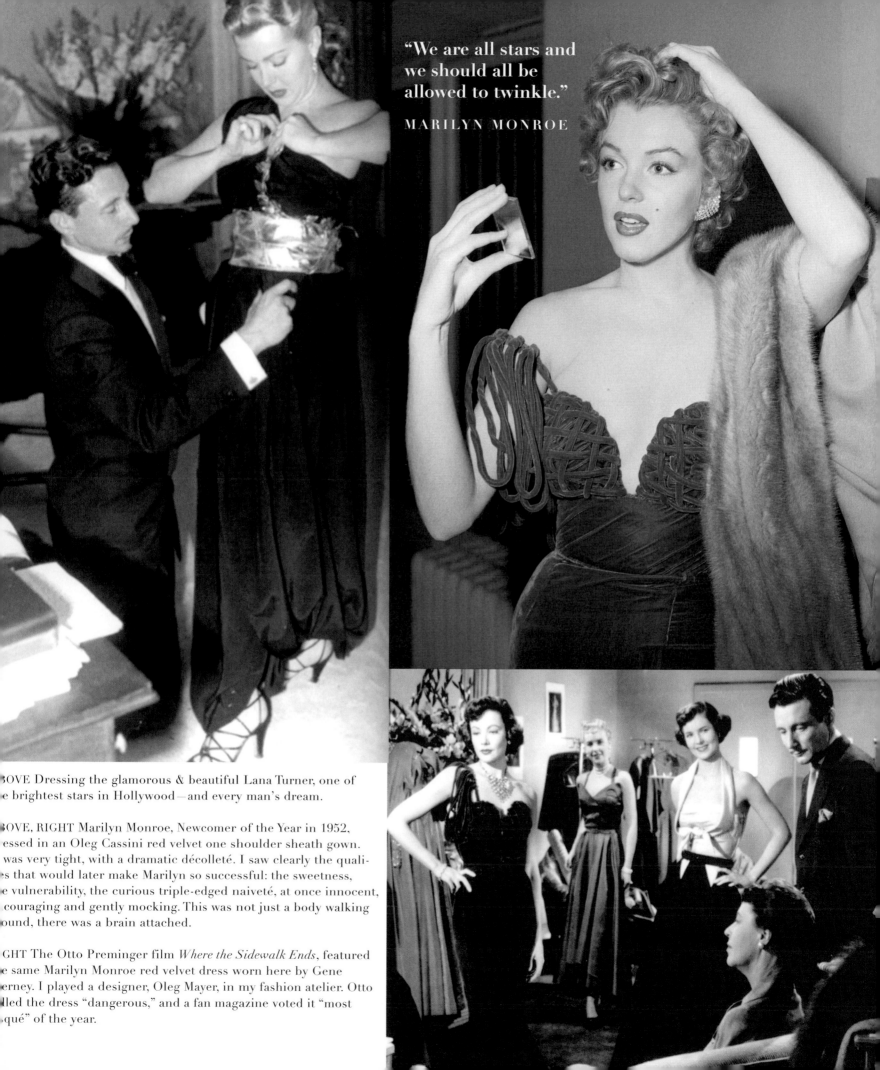

> "We are all stars and we should all be allowed to twinkle."
>
> MARILYN MONROE

ABOVE Dressing the glamorous & beautiful Lana Turner, one of the brightest stars in Hollywood—and every man's dream.

ABOVE, RIGHT Marilyn Monroe, Newcomer of the Year in 1952, dressed in an Oleg Cassini red velvet one shoulder sheath gown. It was very tight, with a dramatic décolleté. I saw clearly the qualities that would later make Marilyn so successful: the sweetness, the vulnerability, the curious triple-edged naiveté, at once innocent, encouraging and gently mocking. This was not just a body walking around, there was a brain attached.

RIGHT The Otto Preminger film *Where the Sidewalk Ends*, featured the same Marilyn Monroe red velvet dress worn here by Gene Tierney. I played a designer, Oleg Mayer, in my fashion atelier. Otto called the dress "dangerous," and a fan magazine voted it "most risqué" of the year.

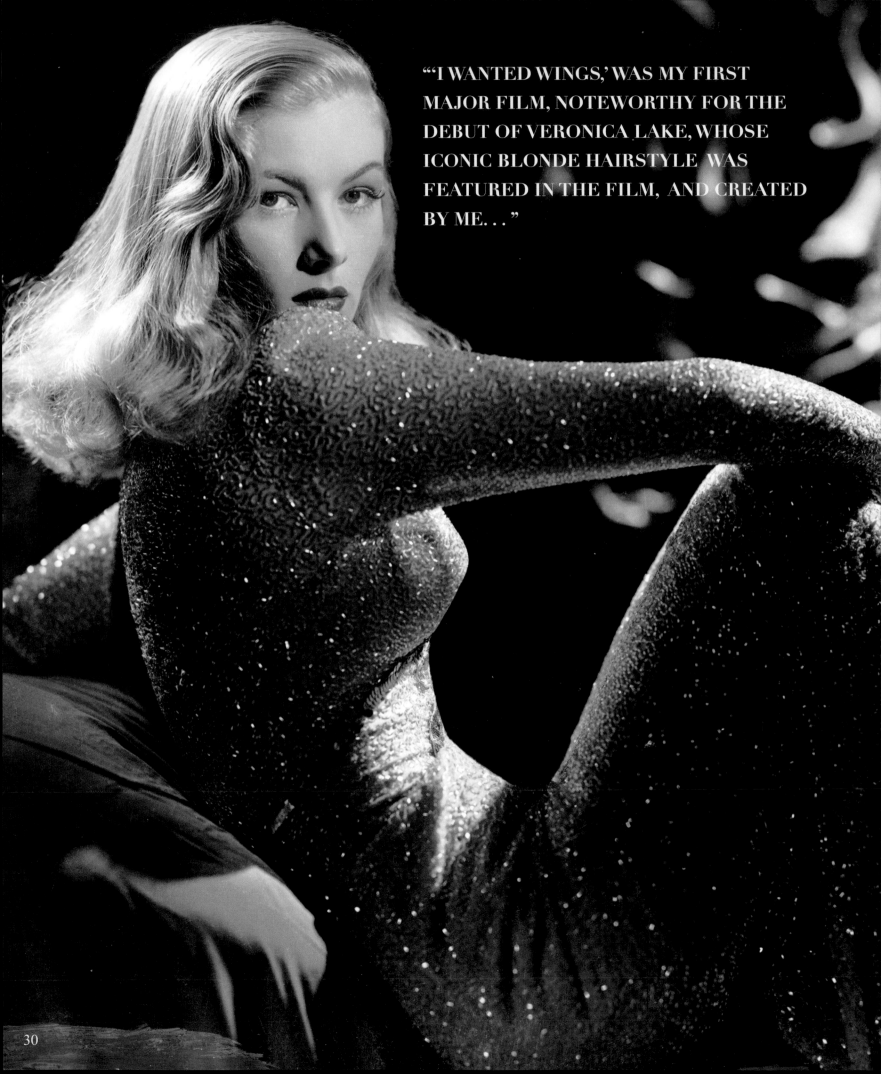

"'I WANTED WINGS,' WAS MY FIRST MAJOR FILM, NOTEWORTHY FOR THE DEBUT OF VERONICA LAKE, WHOSE ICONIC BLONDE HAIRSTYLE WAS FEATURED IN THE FILM, AND CREATED BY ME. . ."

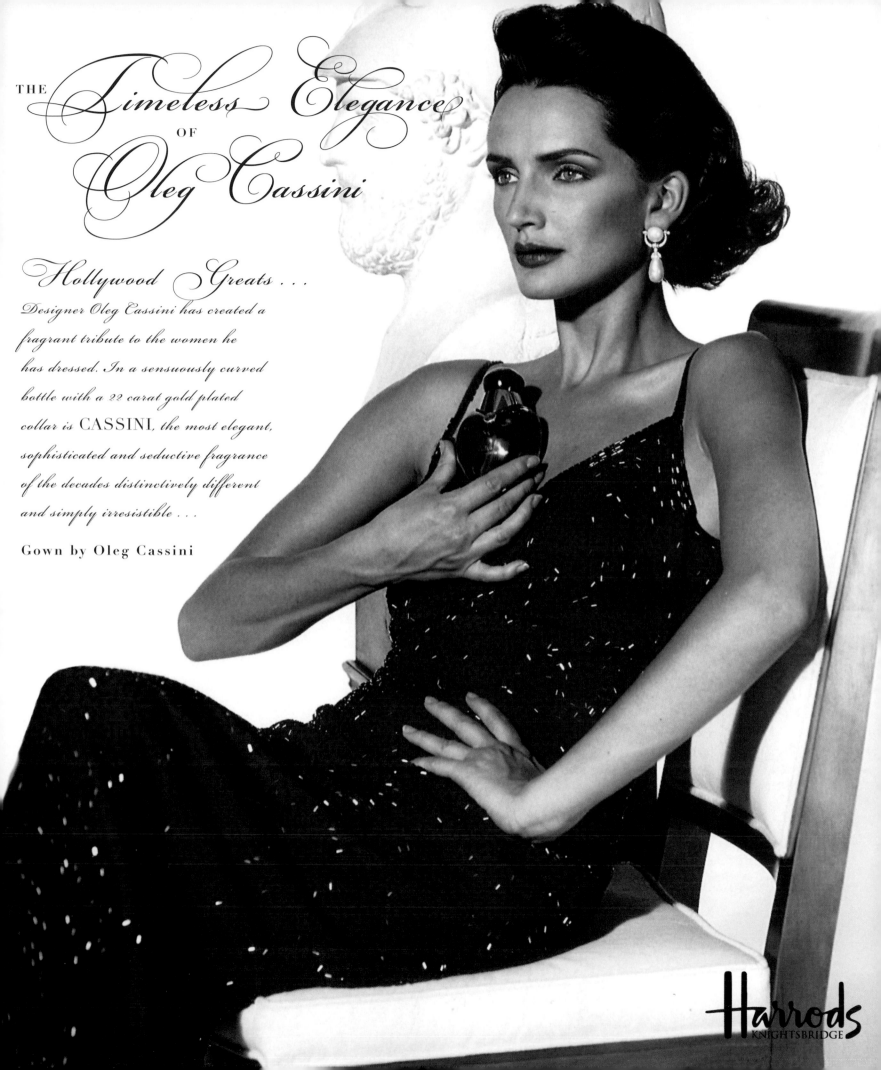

THE *Timeless Elegance* OF *Oleg Cassini*

Hollywood Greats . . .
Designer Oleg Cassini has created a
fragrant tribute to the women he
has dressed. In a sensuously curved
bottle with a 22 carat gold plated
collar is CASSINI, the most elegant,
sophisticated and seductive fragrance
of the decades distinctively different
and simply irresistible . . .

Gown by Oleg Cassini

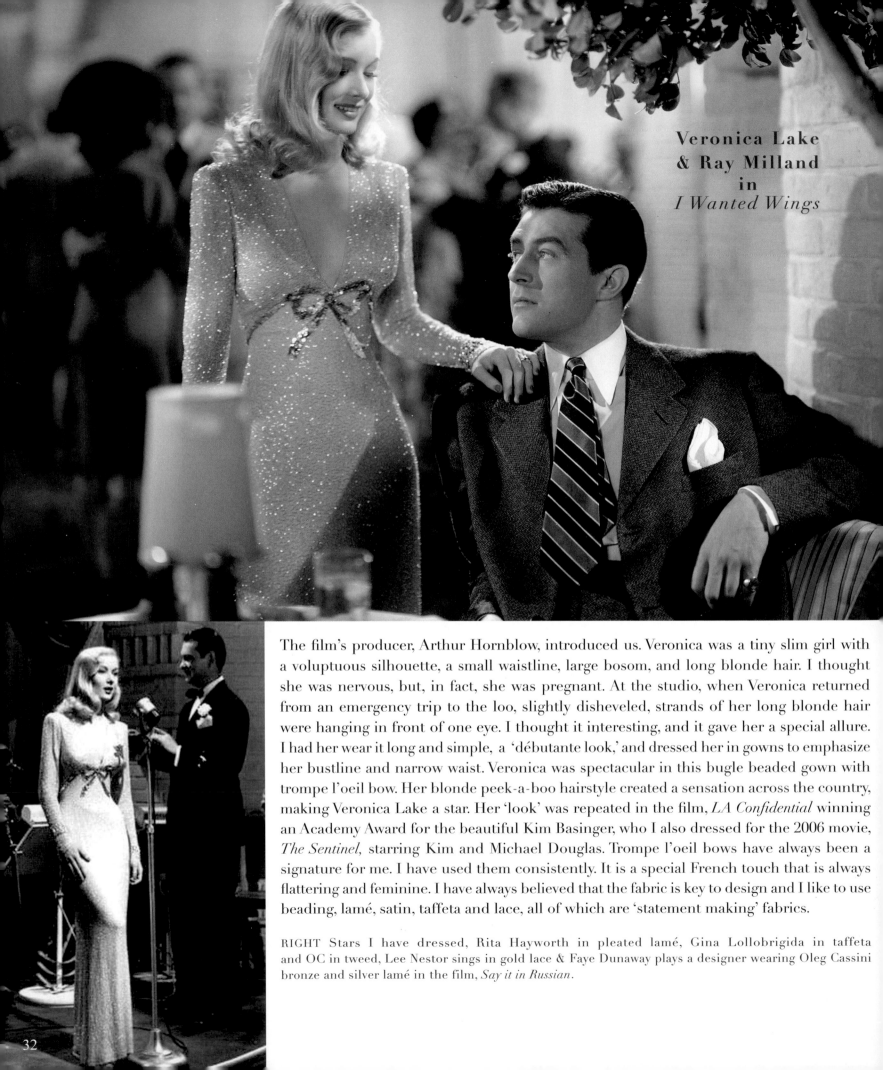

Veronica Lake
& Ray Milland
in
I Wanted Wings

The film's producer, Arthur Hornblow, introduced us. Veronica was a tiny slim girl with a voluptuous silhouette, a small waistline, large bosom, and long blonde hair. I thought she was nervous, but, in fact, she was pregnant. At the studio, when Veronica returned from an emergency trip to the loo, slightly disheveled, strands of her long blonde hair were hanging in front of one eye. I thought it interesting, and it gave her a special allure. I had her wear it long and simple, a 'débutante look,' and dressed her in gowns to emphasize her bustline and narrow waist. Veronica was spectacular in this bugle beaded gown with trompe l'oeil bow. Her blonde peek-a-boo hairstyle created a sensation across the country, making Veronica Lake a star. Her 'look' was repeated in the film, *LA Confidential* winning an Academy Award for the beautiful Kim Basinger, who I also dressed for the 2006 movie, *The Sentinel*, starring Kim and Michael Douglas. Trompe l'oeil bows have always been a signature for me. I have used them consistently. It is a special French touch that is always flattering and feminine. I have always believed that the fabric is key to design and I like to use beading, lamé, satin, taffeta and lace, all of which are 'statement making' fabrics.

RIGHT Stars I have dressed, Rita Hayworth in pleated lamé, Gina Lollobrigida in taffeta and OC in tweed, Lee Nestor sings in gold lace & Faye Dunaway plays a designer wearing Oleg Cassini bronze and silver lamé in the film, *Say it in Russian*.

To Oleg

With Love & many thanks always

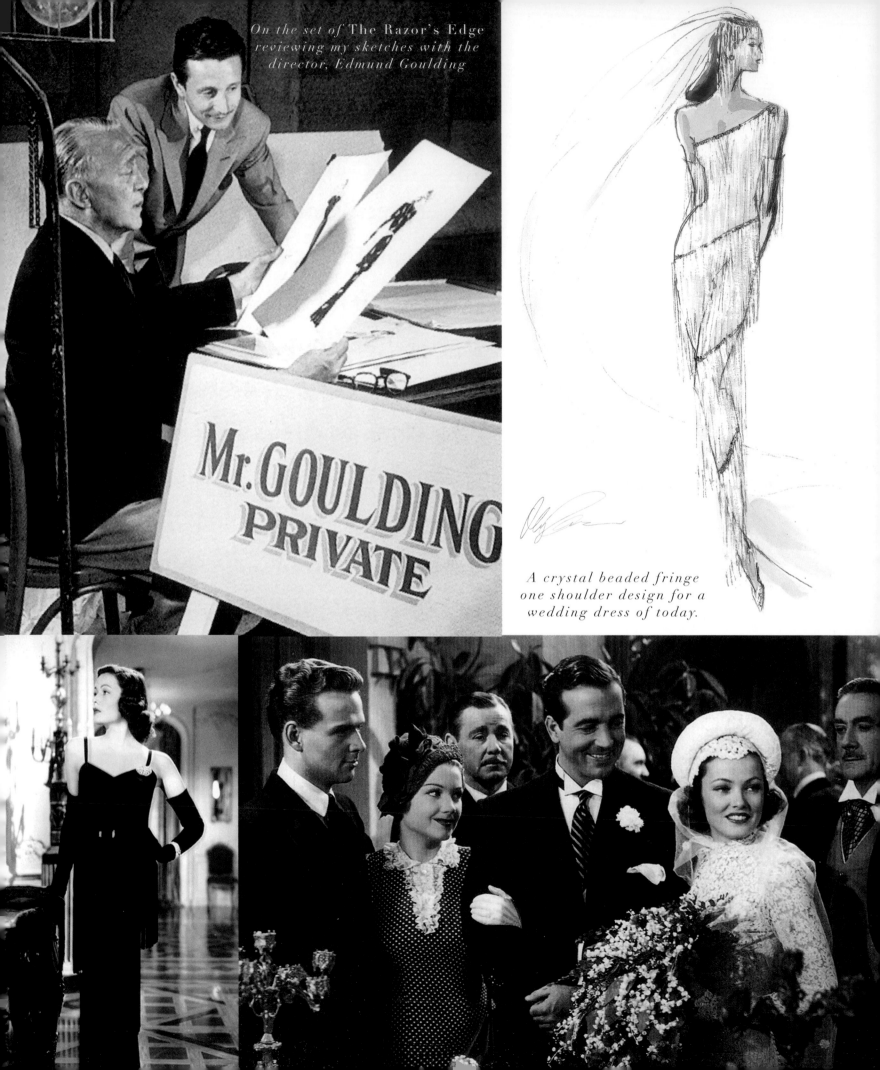

On the set of The Razor's Edge reviewing my sketches with the director, Edmund Goulding

Mr. GOULDING PRIVATE

A crystal beaded fringe one shoulder design for a wedding dress of today.

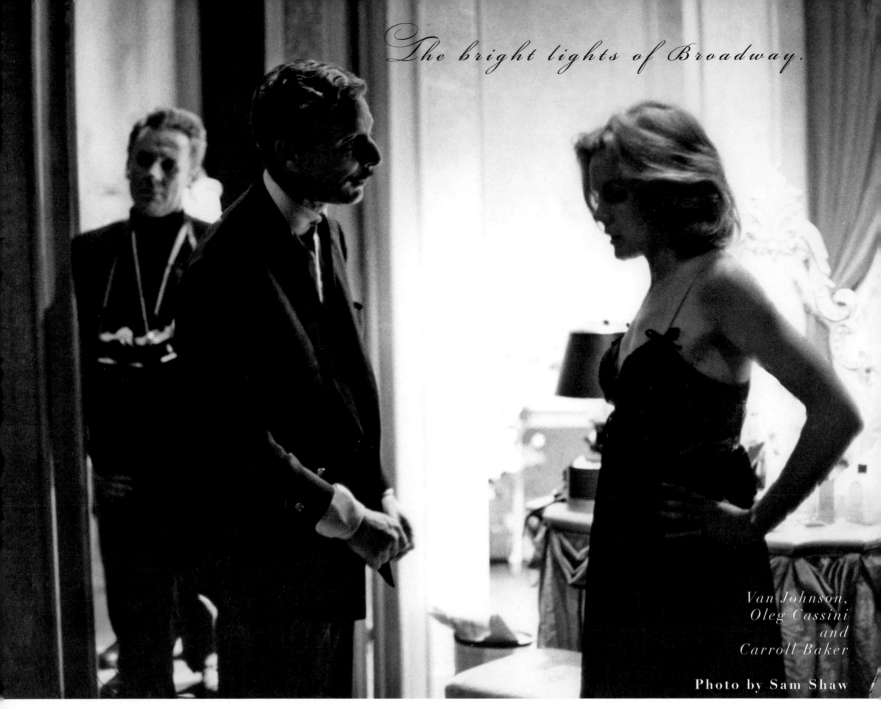

Van Johnson,
Oleg Cassini
and
Carroll Baker

Photo by Sam Shaw

enjoyed designing for the Broadway theater, the excitement of the live performance had a different dimension and design tech-
que than film. On the Broadway stage set of *Come On Strong* at the Morosco Theatre I am discussing wardrobe with Carroll Baker
d Van Johnson. Among other Broadway plays that I designed for were Mike Todd's *As The Girls Go*, Otto Preminger's *Critic's
oice* with Henry Fonda, and *His and Hers*, for Celeste Holm.

he *Razor's Edge* was a major film of 1946, and starred Tyrone Power, Gene Tierney, Anne Baxter, Clifton Webb and John Payne.
was directed by Edmund Goulding, produced by Darryl Zanuck for 20th Century Fox, and was adapted from the best selling
vel by Somerset Maugham. It would be my first important film after serving in the U.S. Cavalry during WWII along with a future
esident, Ronald Reagan. My assignment was to design the costumes for the two female leads, Gene and Anne. I did an innovative
dding dress for Gene, and took a chance on the dramatic sheath design. But in the end, the gown, like the film, was a great suc-
ss. Lace from head to toe, a mermaid sheath gown with a long flowing train and a special Renaissance-inspired headpiece. Anne
xter, who I dressed for her role in the film, won the Academy Award for Best Supporting Actress for *The Razor's Edge*. Anne
nt on to play the iconic Eve in *All About Eve* and along with Bette Davis was nominated for Best Actress. Marilyn Monroe, also
ayed an unforgettable cameo role in that film.

hen *The Razor's Edge* was completed, Darryl Zanuck sent me a note saying that I had done "a superb job." Although the film
as set in the 1920s, I wanted the actors' costumes to look modern, timeless and relevant. There was one dress in particular, a slim
ack gown with fringes, suggesting the flapper style of the 1920s, which was the time period of the film, but appropriate for any
a. It was very décolleté, with ribbon straps and a matching cape. I always include a fringe dress in my collections and they are
ways well received.

I liked Tyrone Power quite a bit. He was handsome as a god, and enormously charming, in a naive way. Everything came easily for him and he assumed it was the same for the rest of the world. He, Errol Flynn and Cary Grant were similar in that way. Each had an overwhelming charm that enabled them to live by their own rules.

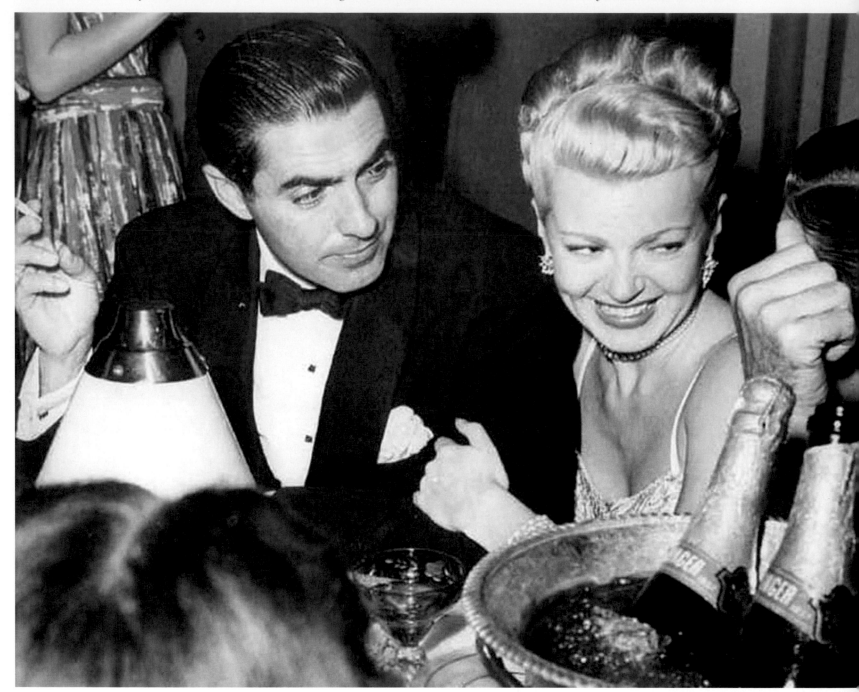

Lana Turner & Tyrone Power

A stunning combination, the blonde beauty of Lana Turner and the dark, classically handsome, matinee idol Tyrone Power. They were the romantic couple of their time. Pursued by photographers, they set the press world on fire. The 'one that got away,' they both went on to marry others.

Lana is quoted as saying, *"But more important to me than money was as always the love I longed for and finally I found it, if only for a moment. The man was Tyrone Power. I had always been attracted to him, but I kept my distance because he was married. Then he and his wife Anabella, separated, and one night he invited me over for drinks. What an evening, all we did was talk and listen to music, but for hours on end. We discovered we had similar thoughts and feelings, much the same values and tastes. Before he took me home, he held me in his arms and kissed me, and my heart started beating faster. This was a man I could love."*

"I planned on having one husband and seven children, but it turned out the other way round." LANA TURNER

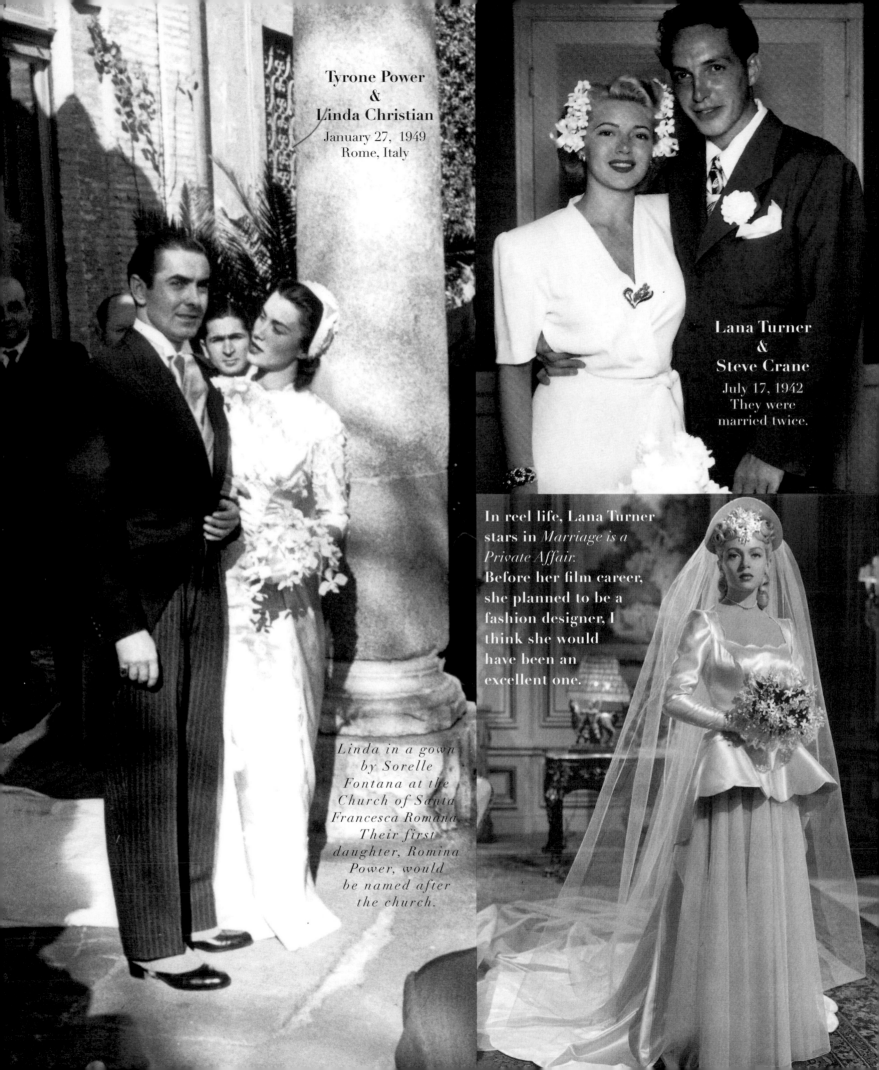

Tyrone Power & Linda Christian
January 27, 1949
Rome, Italy

Linda in a gown by Sorelle Fontana at the Church of Santa Francesca Romana. Their first daughter, Romina Power, would be named after the church.

Lana Turner & Steve Crane
July 17, 1942
They were married twice.

In reel life, Lana Turner stars in *Marriage is a Private Affair.* Before her film career, she planned to be a fashion designer, I think she would have been an excellent one.

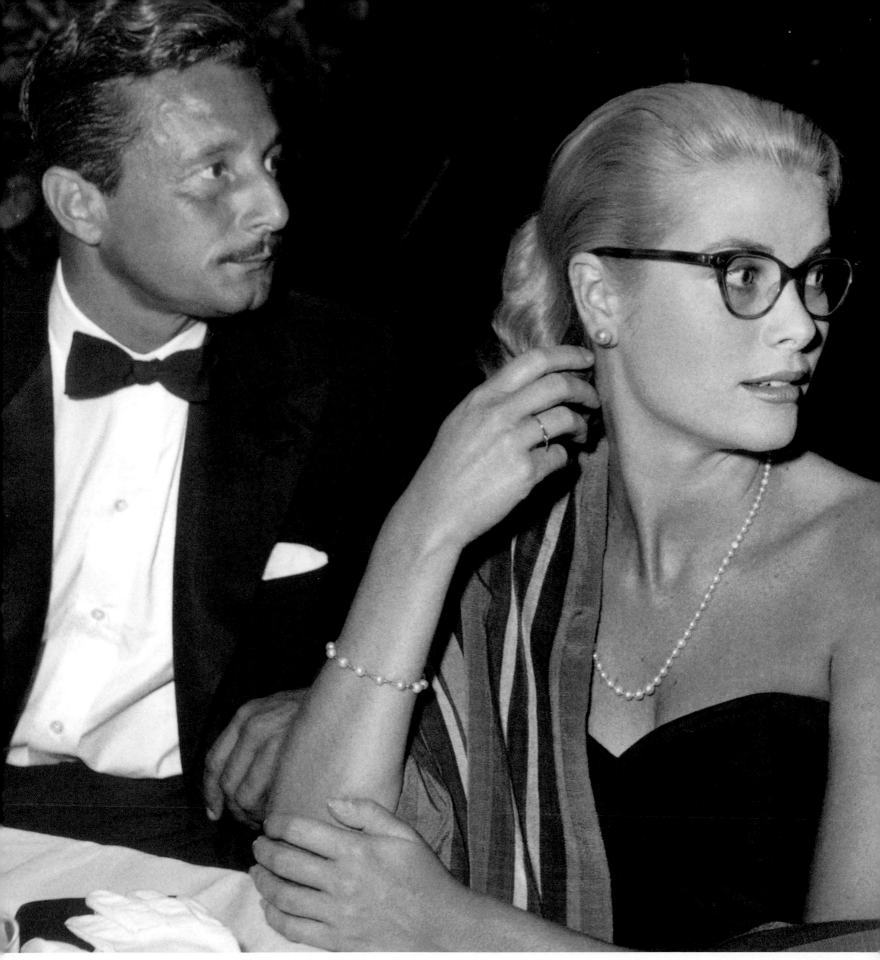

Grace wanted to be taken seriously; "producers won't if they think I'm just some glamour girl." "On the contrary," I said, "If you want to be considered a serious actress, show your range, and show them that you can be glamorous and sexy too. You don't have to dress like a school teacher. You are becoming a major star, and should be a leader in fashion as well." Grace seemed to see the wisdom of this and we began to discuss and work on ways she could look more glamorous. I selected a wardrobe for Grace from my collection, and designed dresses with her specifically in mind.

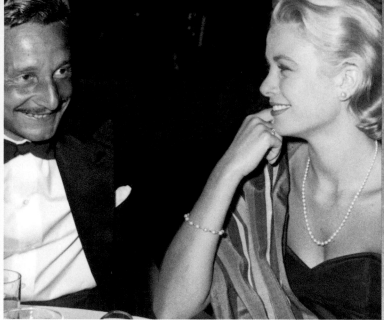

I asked Milton Greene, the famous photographer, "What do you think of her?" He said, "You must design a dress that conveys your sense of her." I thought of her as a pale, delicate English rose: the gown had a simple rounded halter top and a complicated, petal-like skirt. It was made of heavy taffeta, in an almost antique soft pink, carefully selected to compliment her skin tones. Milton photographed her in the dress, and some other informal photos of Grace in my oversized sweaters; which was Grace's favorite attire. *Look* magazine put Grace on the cover, in the sweater, and the photo of Grace in my pink dress was used inside. Within a matter of months, *Dial M for Murder* would be released, and she would no longer have to worry about her contract being renewed. She would also make the Best Dressed list for the first time, thanks to her new wardrobe. I created 'The Grace Kelly Look': I put her in subdued, elegant dresses that set off her patrician good looks. I told her that her beauty should be set off like a great diamond, in very simple settings. The focus was always to be on her . . .

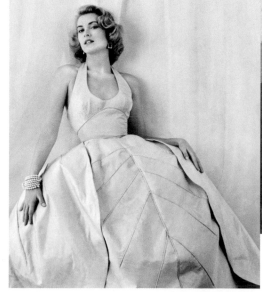

Grace at 23, in the Oleg Cassini flower petal dress from a Milton Greene photo shoot for Look magazine.

Dressed as Paris & Helen of Troy at a Bal Masqué

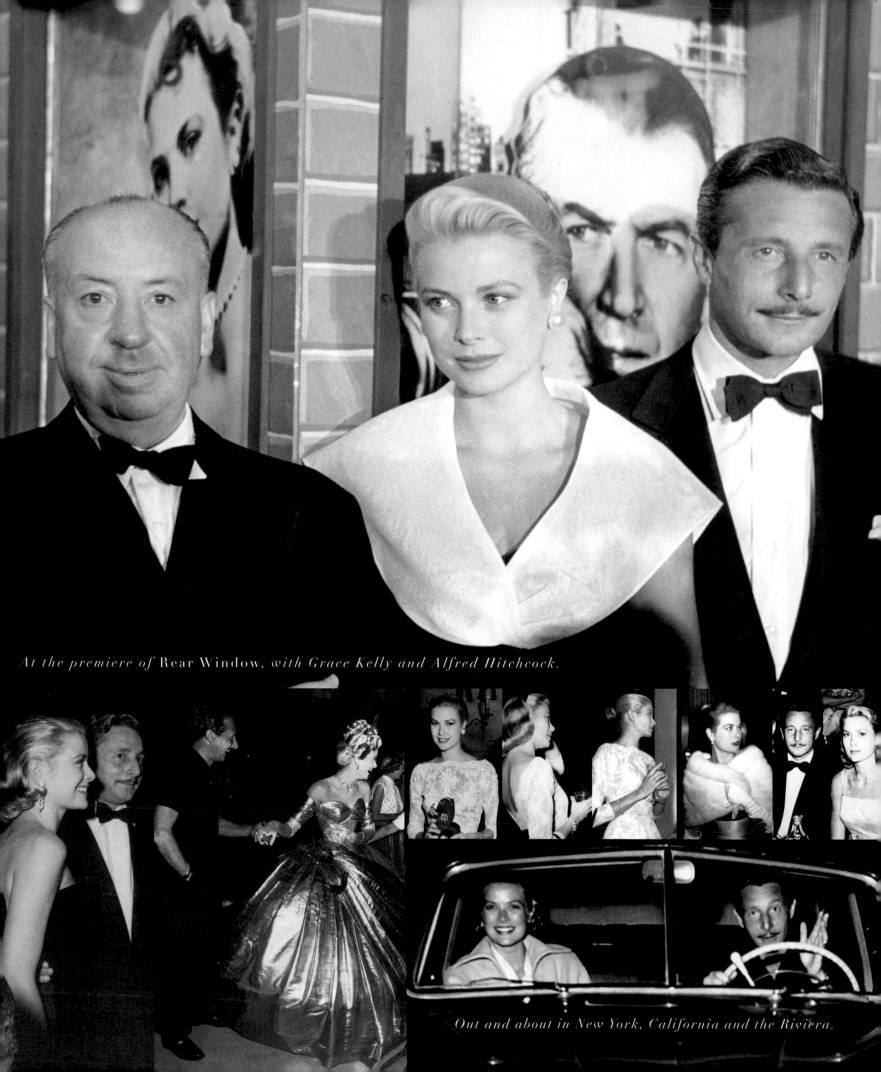

At the premiere of Rear Window, *with Grace Kelly and Alfred Hitchcock.*

Out and about in New York, California and the Riviera.

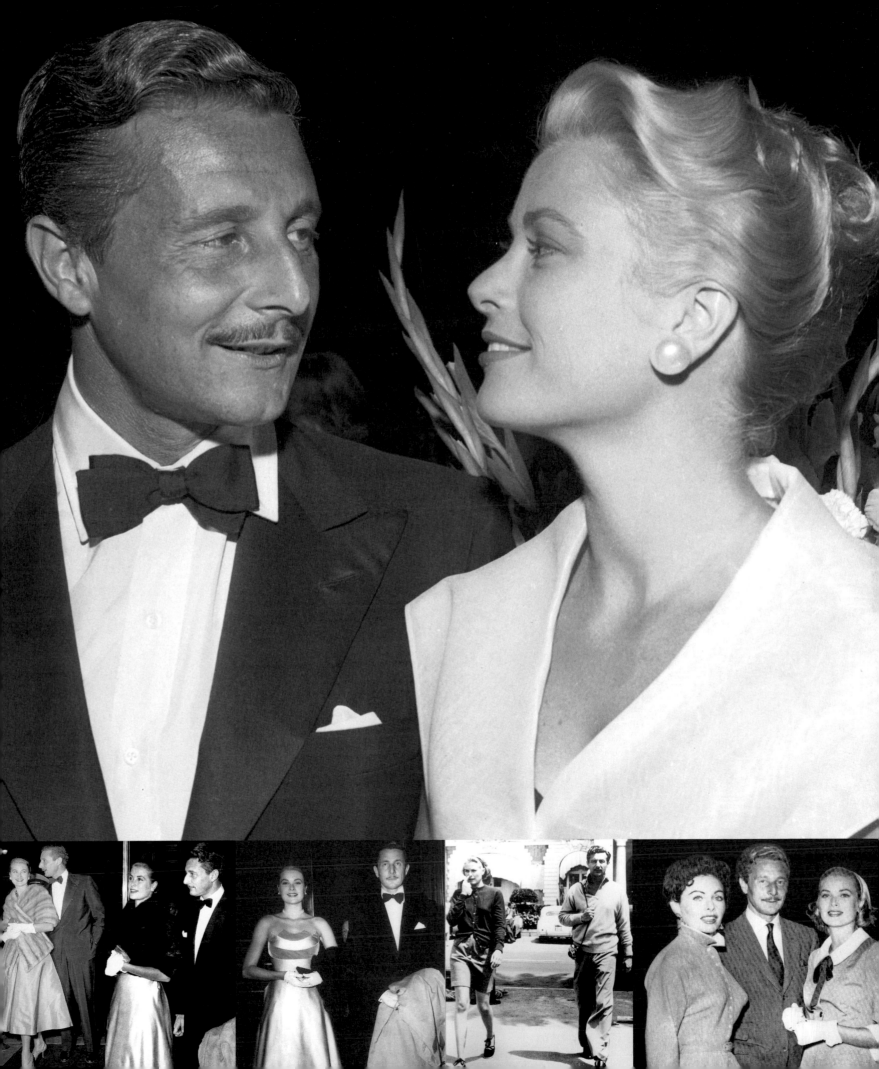

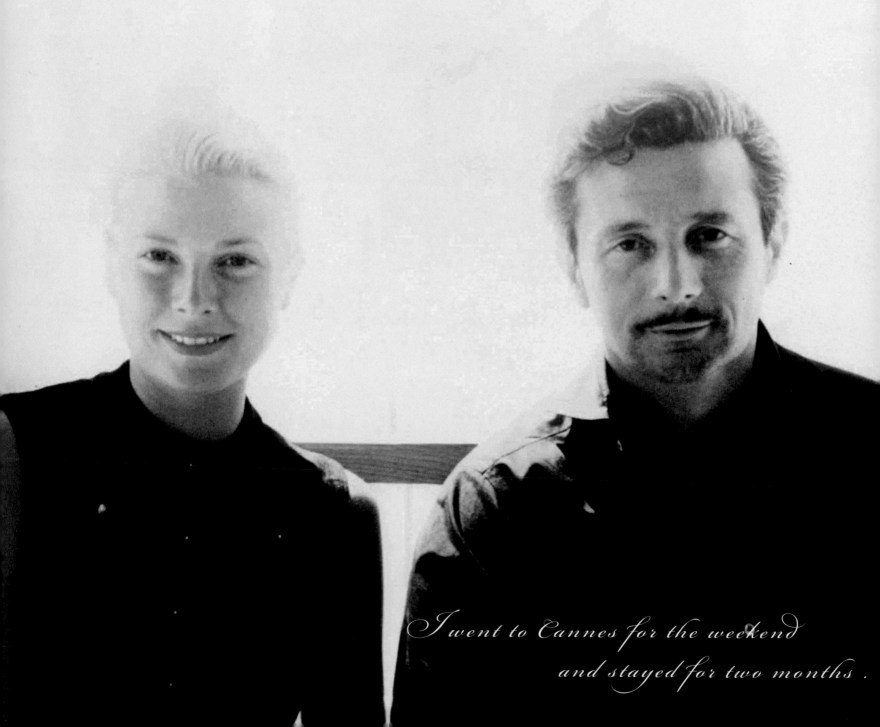

"*Those who love me shall follow me.*"
GRACE KELLY

I went to Cannes for the weekend
and stayed for two months .

We ordered champagne to celebrate our engagement, it was an altogether magical evening. We danced and gambled a bit, and Grace won. She never gambled much, or out of control, but she always won. She was one of the lucky ones, one of those people to whom everything is given; all too often, in my experience, these are the people from whom the Gods also take everything, in a single blow.

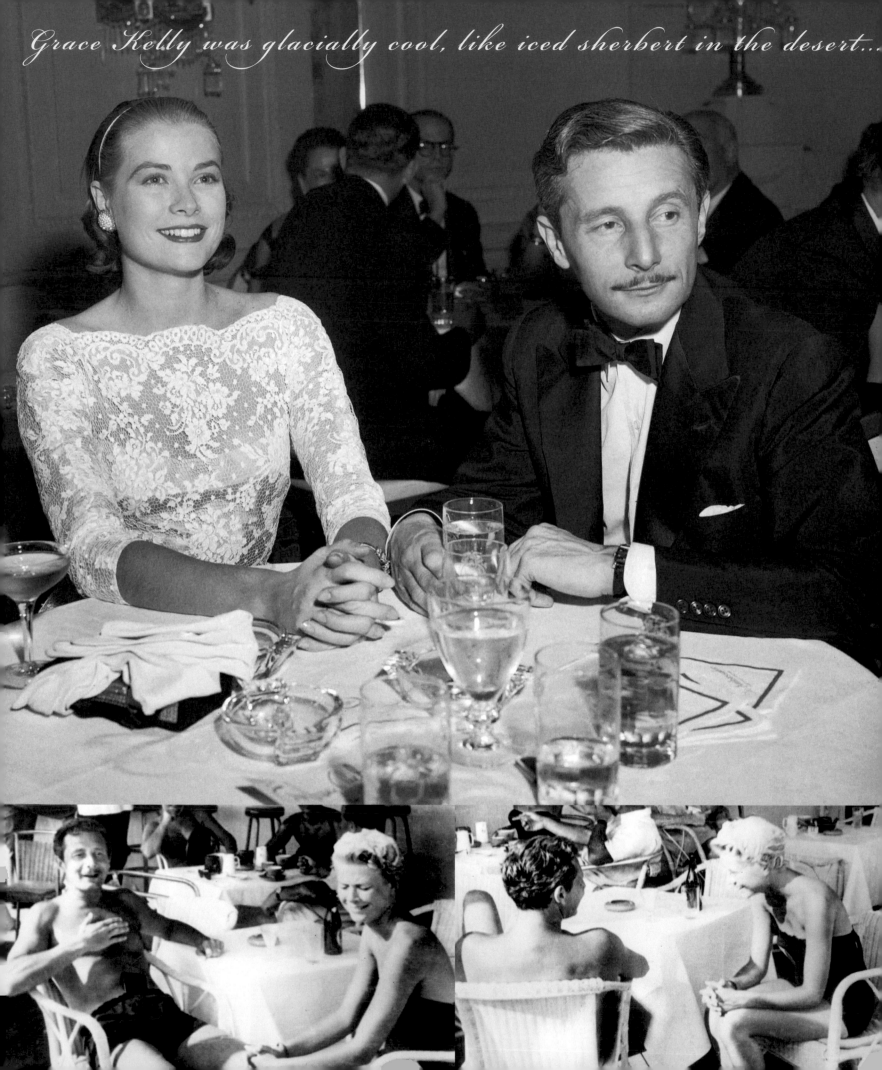

Grace Kelly was glacially cool, like iced sherbert in the desert...

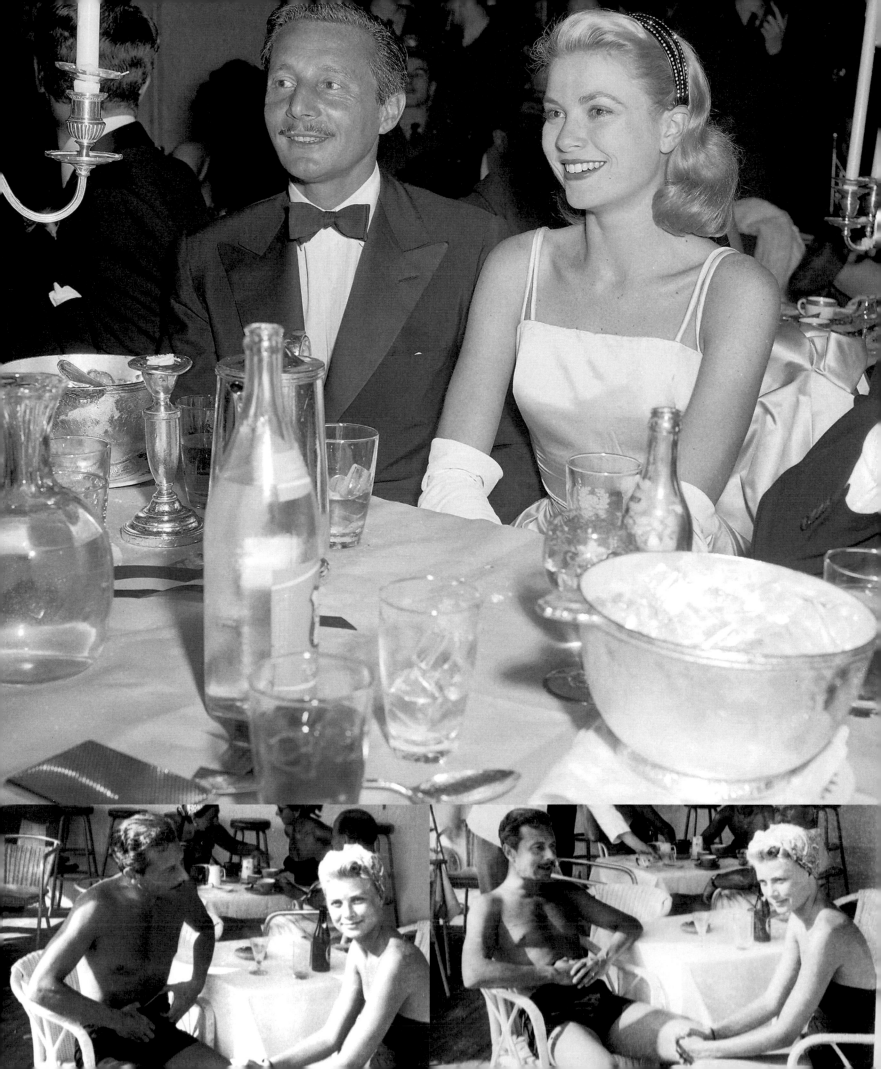

I love you and want
to be your wife —
— Grace —

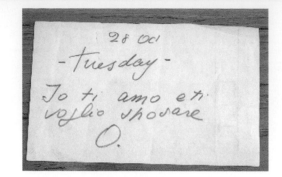

28 Oct
– Tuesday –
Jo ti amo et
voglio sposare
O.

Hotel Bel-Air
701 STONE CANYON ROAD
LOS ANGELES 24
 Friday

Darling —
 I really can't wait to
see you — now that I know
I want to marry you — we
have so much to learn
about each other — there
are so many things I want
you to know about me —
we must be patience with
each other and go slowly —
without wanting results too
quickly — but we need
each other and we must be
completely honest — at all
times —
 I feel for the first time
ready to approach love &
marriage in an adult way —

 Last november I hit
rock bottom and never thought
I could be capable of thinking
and feeling this way —
Thank God — I had my work

Hotel Bel-Air
701 STONE CANYON ROAD
LOS ANGELES 24

to help me through that period —
and Thank God for you —
But in this last year six
pictures have taken so much
from me physically and
emotionally that it will take
a while to recover — Please
darling — try to understand and
please help me — I love you
more every day and I hope
you feel that way too —
the time you said to me
that you couldn't love me
any more than you did
then — That upset me
terribly — Because I so
hope that we shall never
stop growing and developing
in minds and souls and
love for God and each
other — and that each
day will bring us closer —
 I love you and want
to be your wife —
 — Grace —

"When I was working on these pictures, she and
Oleg Cassini were in love. Oleg dropped in on
the shooting session, I said, 'Oh Oleg, please find
something romantic for Grace.' He went to the
wardrobe and came out with the gauzy organza
that perfectly framed the Madonna-like pose Grace
struck so naturally."

JEAN HOWARD

ABOVE Personal letters and notes between Grace and Oleg.

OPPOSITE Grace Kelly in a photo by the glamorous Jean, a superb
hostess and wife of Agent and Producer, Charles K. Feldman, was a
talented photographer, who covered the private world of Hollywood.
Photo: J. Howard / Vogue ©Condé Nast Publications

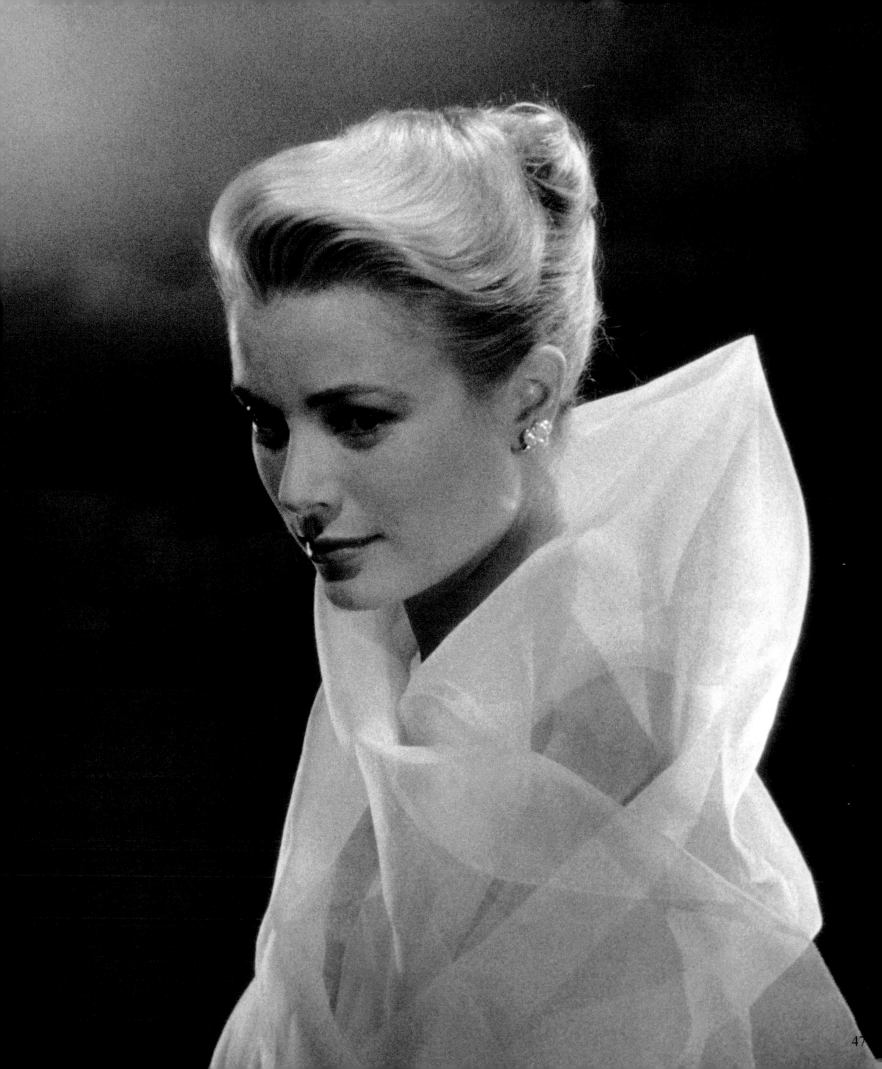

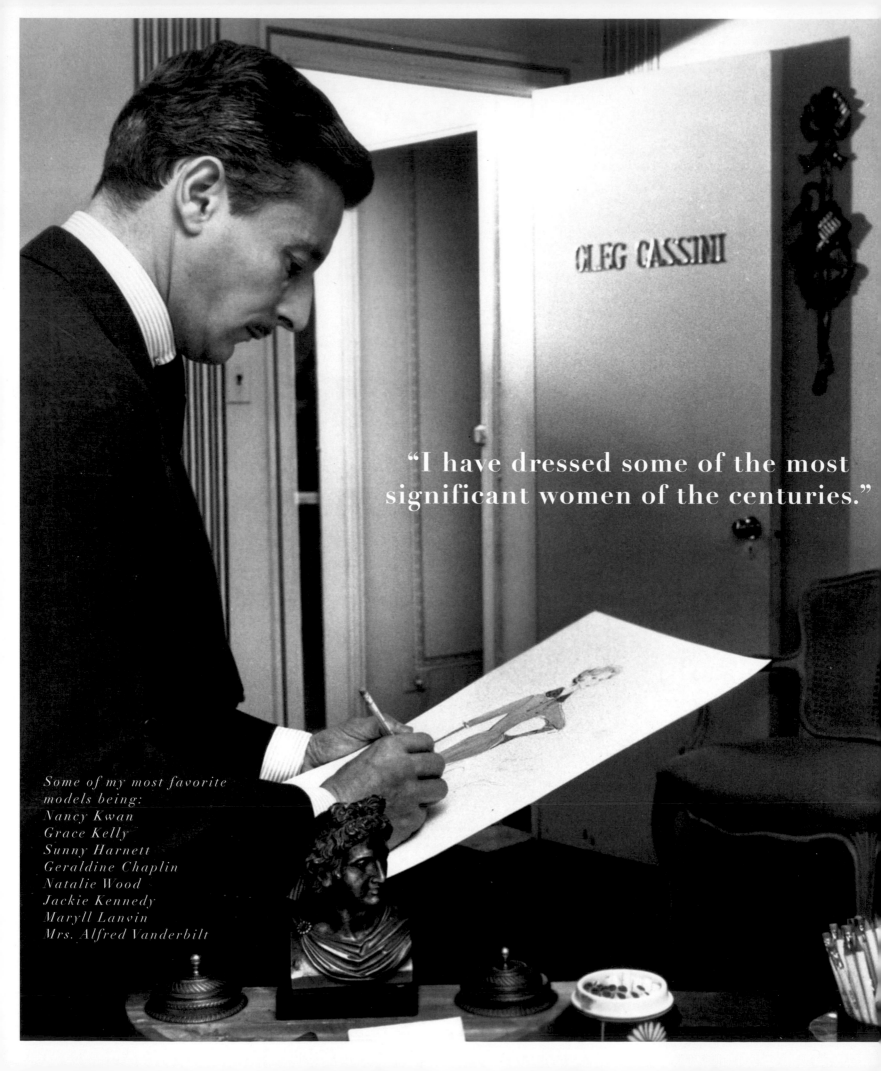

OLEG CASSINI

"I have dressed some of the most significant women of the centuries."

Some of my most favorite models being:
Nancy Kwan
Grace Kelly
Sunny Harnett
Geraldine Chaplin
Natalie Wood
Jackie Kennedy
Maryll Lanvin
Mrs. Alfred Vanderbilt

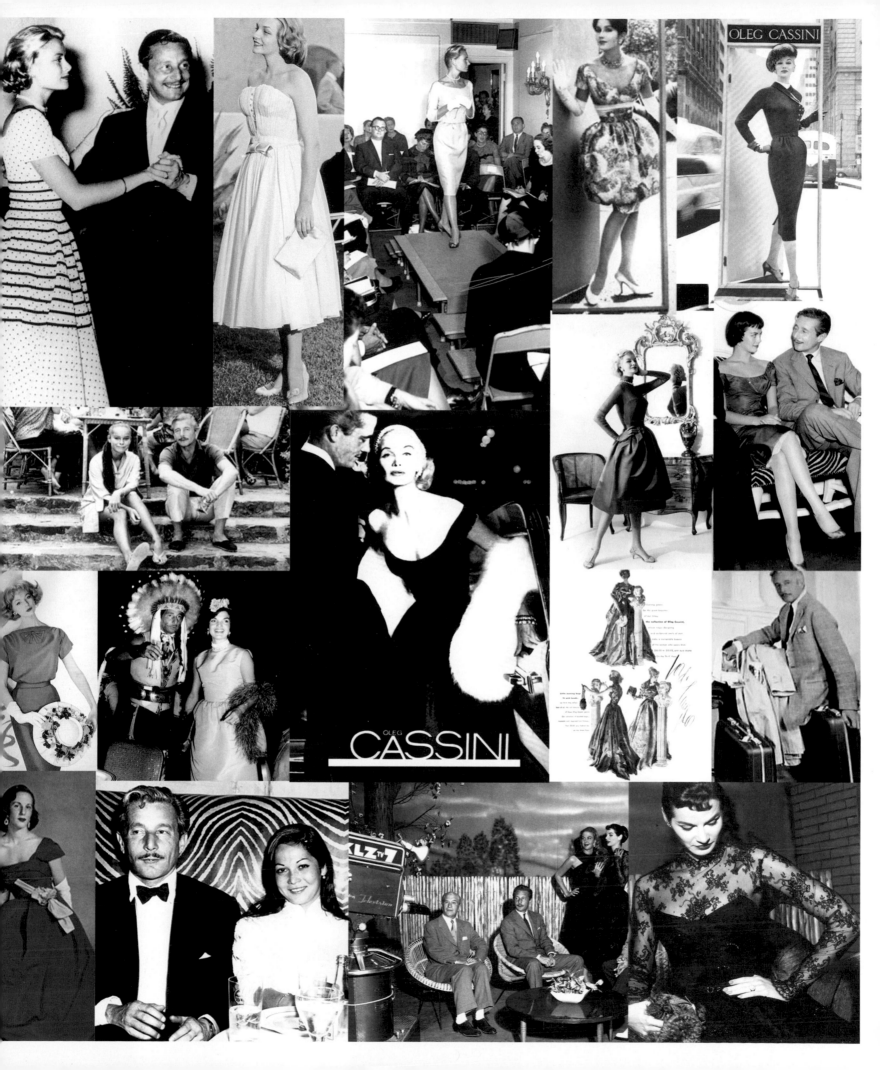

OLEG CASSINI

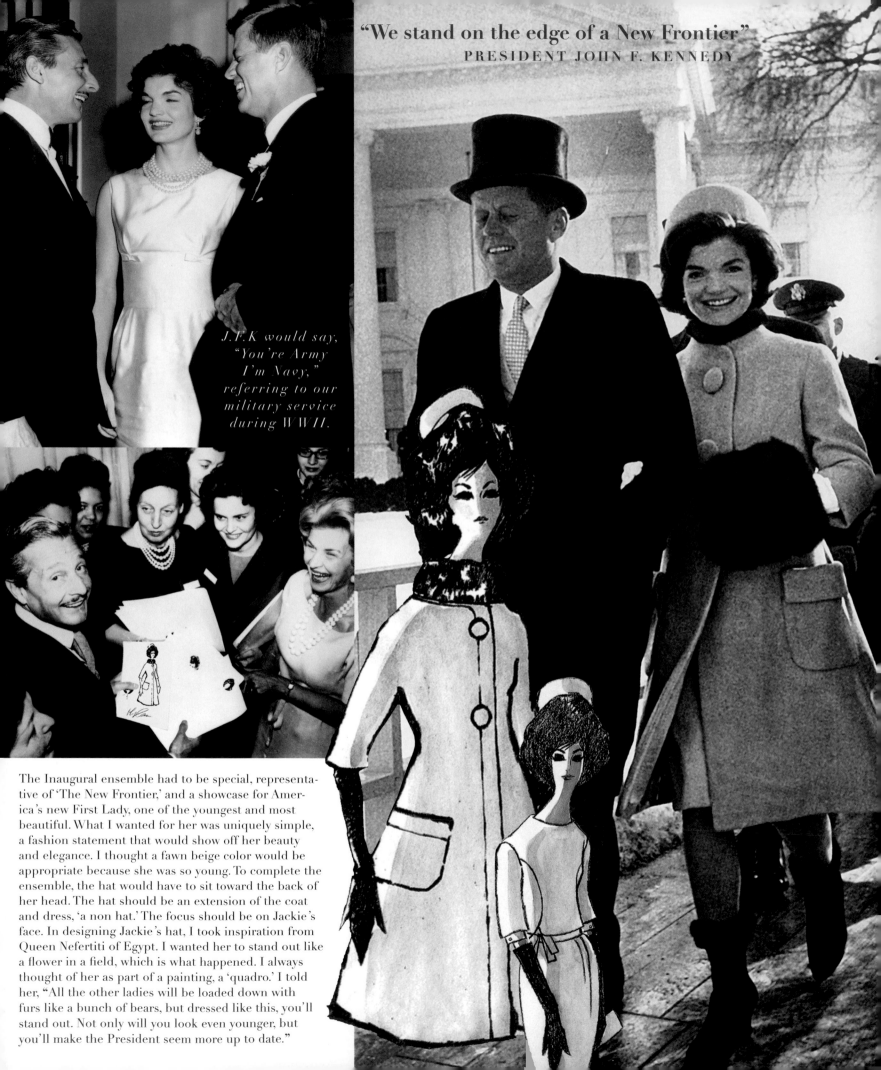

"We stand on the edge of a New Frontier"
PRESIDENT JOHN F. KENNEDY

J.F.K would say, "You're Army I'm Navy," referring to our military service during WWII.

The Inaugural ensemble had to be special, representative of 'The New Frontier,' and a showcase for America's new First Lady, one of the youngest and most beautiful. What I wanted for her was uniquely simple, a fashion statement that would show off her beauty and elegance. I thought a fawn beige color would be appropriate because she was so young. To complete the ensemble, the hat would have to sit toward the back of her head. The hat should be an extension of the coat and dress, 'a non hat.' The focus should be on Jackie's face. In designing Jackie's hat, I took inspiration from Queen Nefertiti of Egypt. I wanted her to stand out like a flower in a field, which is what happened. I always thought of her as part of a painting, a 'quadro.' I told her, "All the other ladies will be loaded down with furs like a bunch of bears, but dressed like this, you'll stand out. Not only will you look even younger, but you'll make the President seem more up to date."

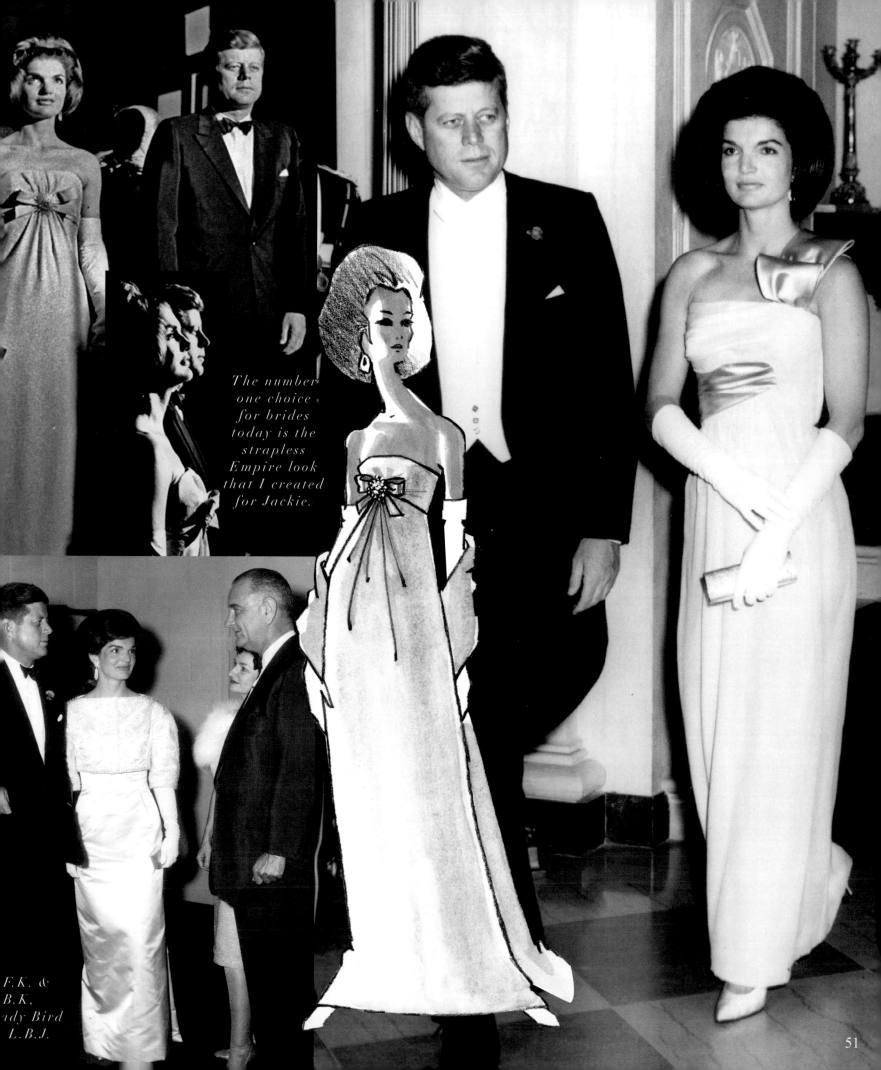

The number one choice for brides today is the strapless Empire look that I created for Jackie.

J.F.K. &
J.B.K.,
Lady Bird
L.B.J.

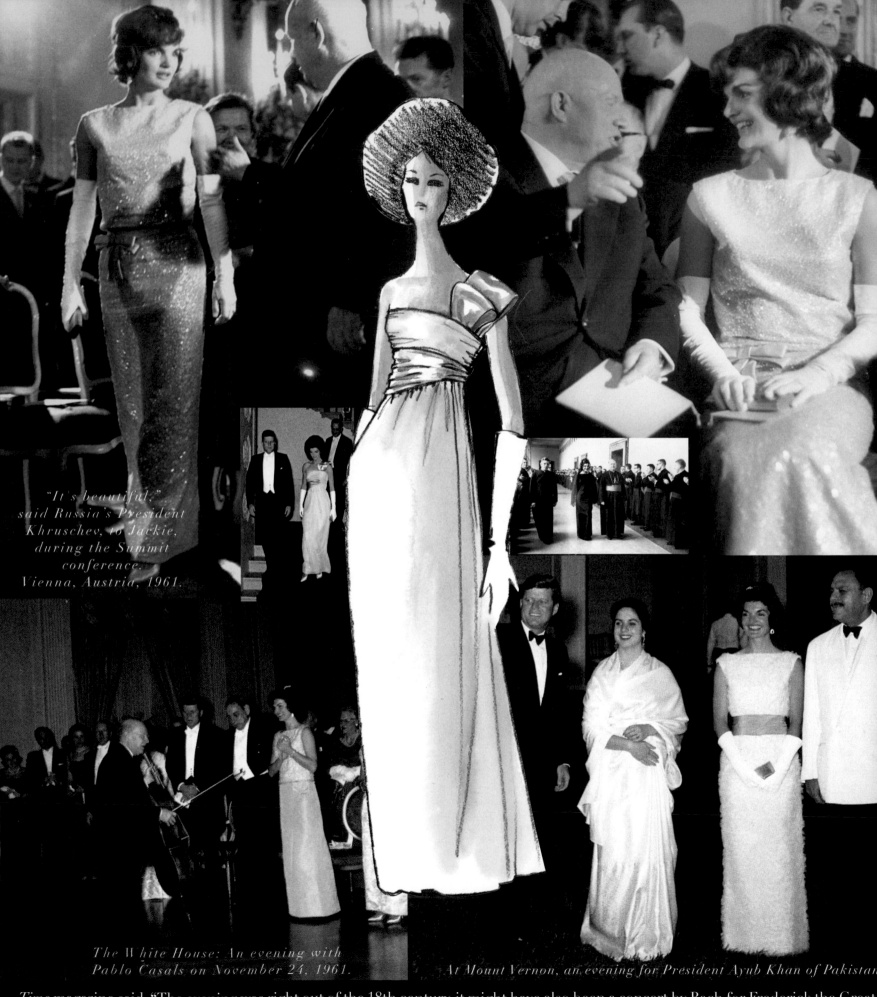

*"It's beautiful,"
said Russia's President
Khruschev, to Jackie,
during the Summit
conference.
Vienna, Austria, 1961.*

*The White House: An evening with
Pablo Casals on November 24, 1961.*

At Mount Vernon, an evening for President Ayub Khan of Pakistan

Time magazine said, "The evening was right out of the 18th century, it might have also been a concert by Bach for Frederick the Great.
The President summoned Alice Longworth to the front of the room for a bow. She had heard the great cellist, 57 years before, when
he played for her father, President Teddy Roosevelt at the White House.

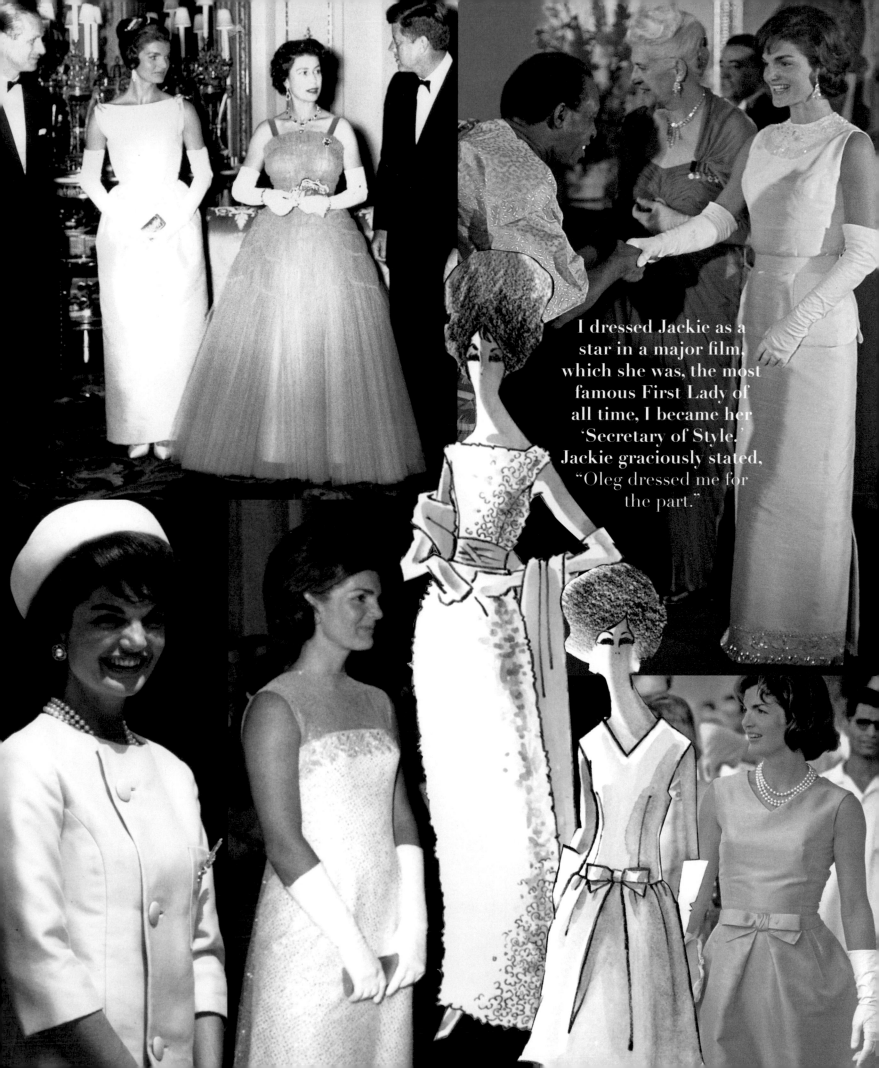

I dressed Jackie as a star in a major film, which she was, the most famous First Lady of all time, I became her 'Secretary of Style.' Jackie graciously stated, "Oleg dressed me for the part."

"If men only knew how great they looked in their white tie and tails, they would wear them every night of their lives."

JACQUELINE KENNEDY

"The Shah and I have one thing in common: we both went to Paris with our wives and ended up wondering why we had bothered. We thought we might as well have stayed home," said President John F. Kennedy in his toast to the Royal couple of Iran during their state visit to Washington, D.C. The young and beautiful Shahbanou Farah Diba was attired in a golden dress and wore several million dollars' worth of jewelry, including the famous peacock crown which was part of the state treasury. Shah Mohammad Reza Pahlavi's evening jacket was covered in glittering medals. Jackie wore my pink and white dupioni silk gown. The shimmering white bateau neck bodice was fitted to the waist with a center bow and sparkling crystal lace peplum over its petal pink softly gathered floor length skirt.

"A state dinner at the White House, planned like a wedding..."

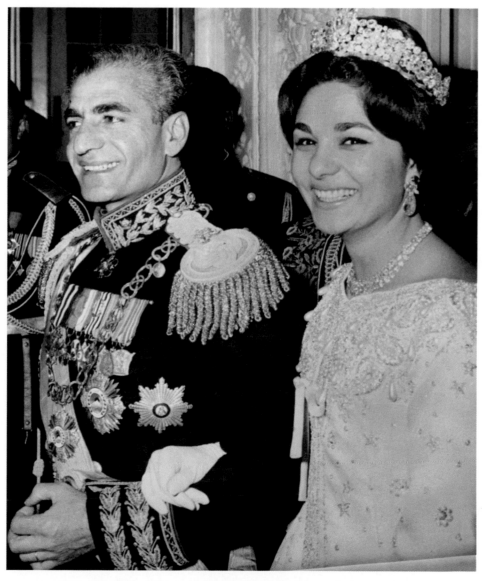

The Wedding Day of Shah Reza Pahlavi & Farah Diba

The Shah of Iran Mohammad Reza Pahlavi and his wife, 21 year old, Farah Diba during their wedding ceremony in Tehran, December 21st 1959. Queen Farah was crowned Shahbanou-Empress in 1967.

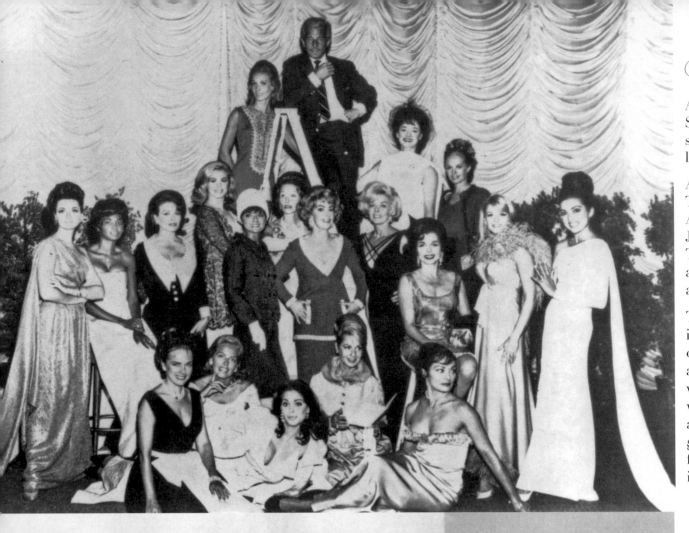

At a Cassini Charity Fashion Show, in Beverly Hills, I'm surrounded by stars on the ladder of success.

At the top of the ladder, with Tippi Hedren, Shirley Jones, Ann Miller, Gisele MacKenzie, Jeanne Crain, Paula Pritchett, Terry Moore, Jayne Meadows, and other models, socialites and actresses.

The wedding dresses featured in the collection: a white silk one shoulder sheath gown with an attached train lined in a vivid ruby color, accessorized with rubies and diamonds; and, a Grecian one-shoulder gown of a sheer gold lamé fabric that draped and flowed into a swirling train.

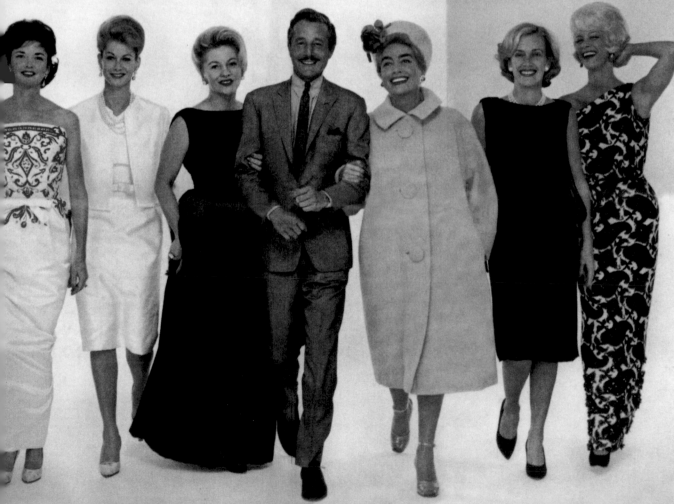

Magnificent 7
Dressed by Cassini

The wedding dress of rich ivory silk satin, accented with bold scarlet embroidery is worn by Charlene Wrightsman Cassini. Robin Butler wears the white silk suit ensemble. Joan Fontaine is wearing my bateau neck black velvet with silk taffeta ball gown.

Joan Crawford, in a bright Veronese green wool coat with trademark bold buttons wears a matching hat. Alice Topping is wearing a Cassini black silk crepe sheath with pearls. Missy Weston wears the one-shoulder paisley floor length sheath. I am attired in tonal shades of stone and copper, with a 'Bermuda Sand' colored shirt and sienna suede laced shoes.

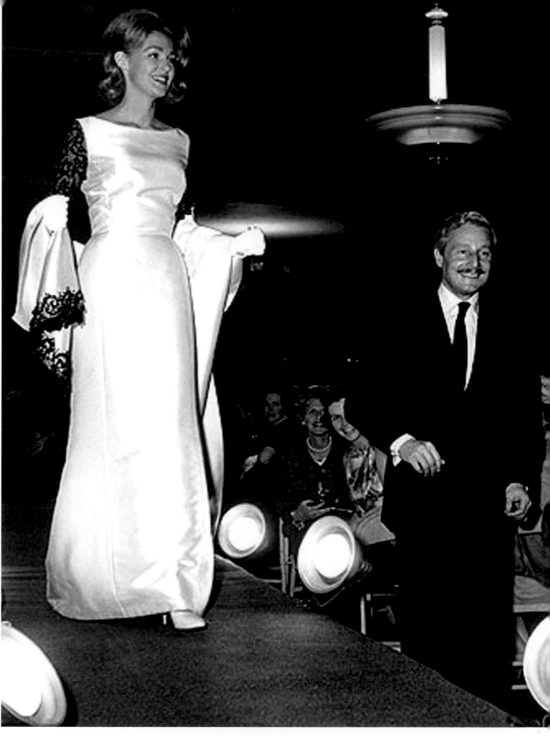

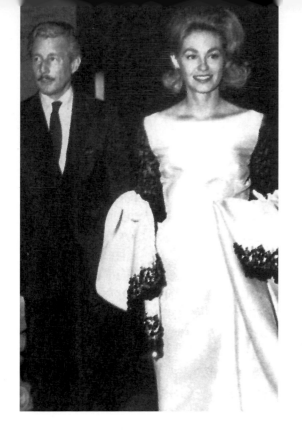

The wedding dress is traditionally the fanfare finale of fashion shows.

In Boston, a fashion show for Caritas, a favorite Kennedy charity, hosted by Cardinal Cushing. The beautiful blonde and glamorous Joan Kennedy, wife of Senator Teddy, was featured as my finale in a Princess gown of lustrous white satin trimmed with black lace and jet beads worn with a dramatic floor length stole.

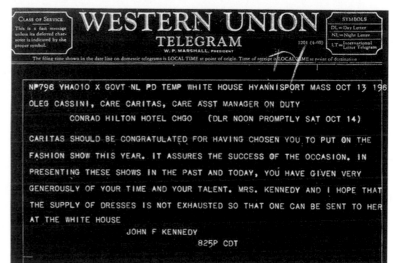

WESTERN UNION
TELEGRAM
W. P. MARSHALL, PRESIDENT

CLASS OF SERVICE	SYMBOLS
This is a fast message unless its deferred character is indicated by the proper symbol.	DL=Day Letter
	NL=Night Letter
	LT=International Letter Telegram

The filing time shown in the date line on domestic telegrams is LOCAL TIME at point of origin. Time of receipt is LOCAL TIME at point of destination

NP796 YHA010 X GOVT·NL PD TEMP WHITE HOUSE HYANNISPORT MASS OCT 13 196

OLEG CASSINI, CARE CARITAS, CARE ASST MANAGER ON DUTY

CONRAD HILTON HOTEL CHGO (DLR NOON PROMPTLY SAT OCT 14)

CARITAS SHOULD BE CONGRATULATED FOR HAVING CHOSEN YOU TO PUT ON THE

FASHION SHOW THIS YEAR. IT ASSURES THE SUCCESS OF THE OCCASION. IN

PRESENTING THESE SHOWS IN THE PAST AND TODAY, YOU HAVE GIVEN VERY

GENEROUSLY OF YOUR TIME AND YOUR TALENT. MRS. KENNEDY AND I HOPE THAT

THE SUPPLY OF DRESSES IS NOT EXHAUSTED SO THAT ONE CAN BE SENT TO HER

AT THE WHITE HOUSE

JOHN F KENNEDY

825P CDT

"I believe in sumptuous fabrics and simple lines, what I like to call timeless elegance."

OLEG CASSINI

Oleg Cassini had to make his own shirts . Nothing around was good enough for him.

Fashion is a representation of the times in which we live. -Oleg Cassini

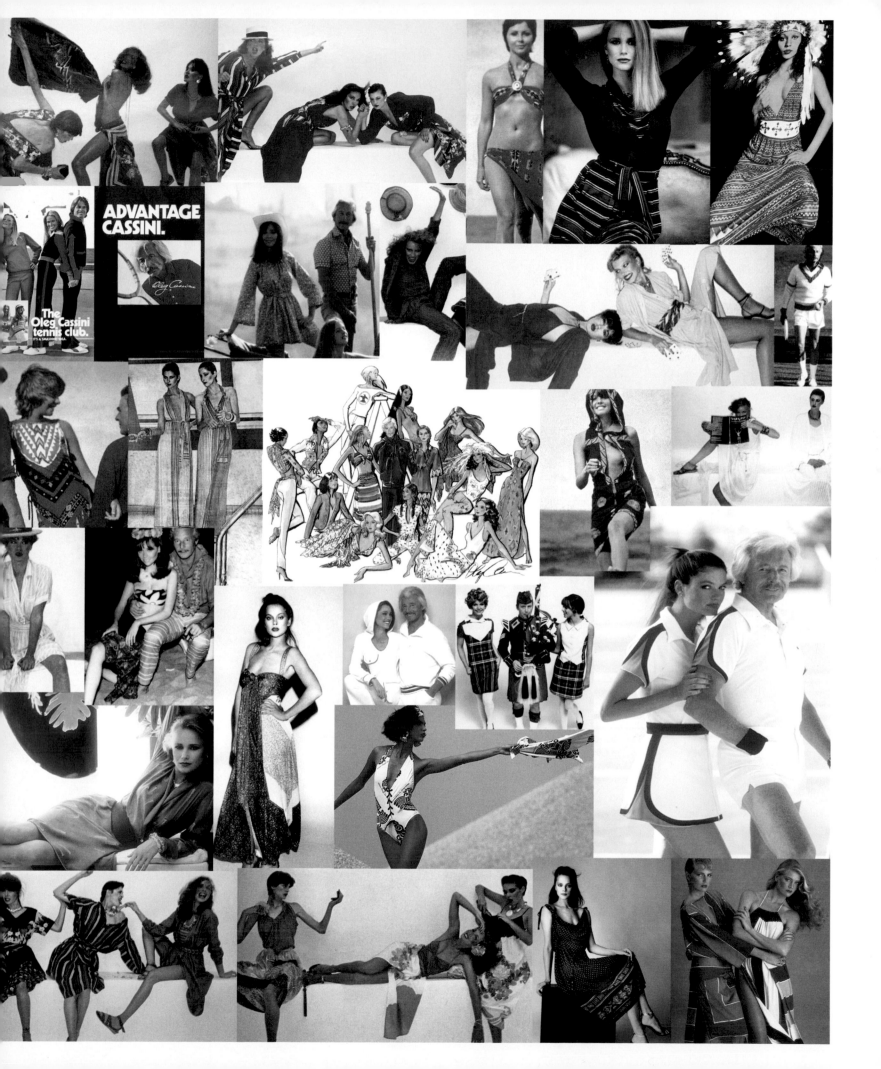

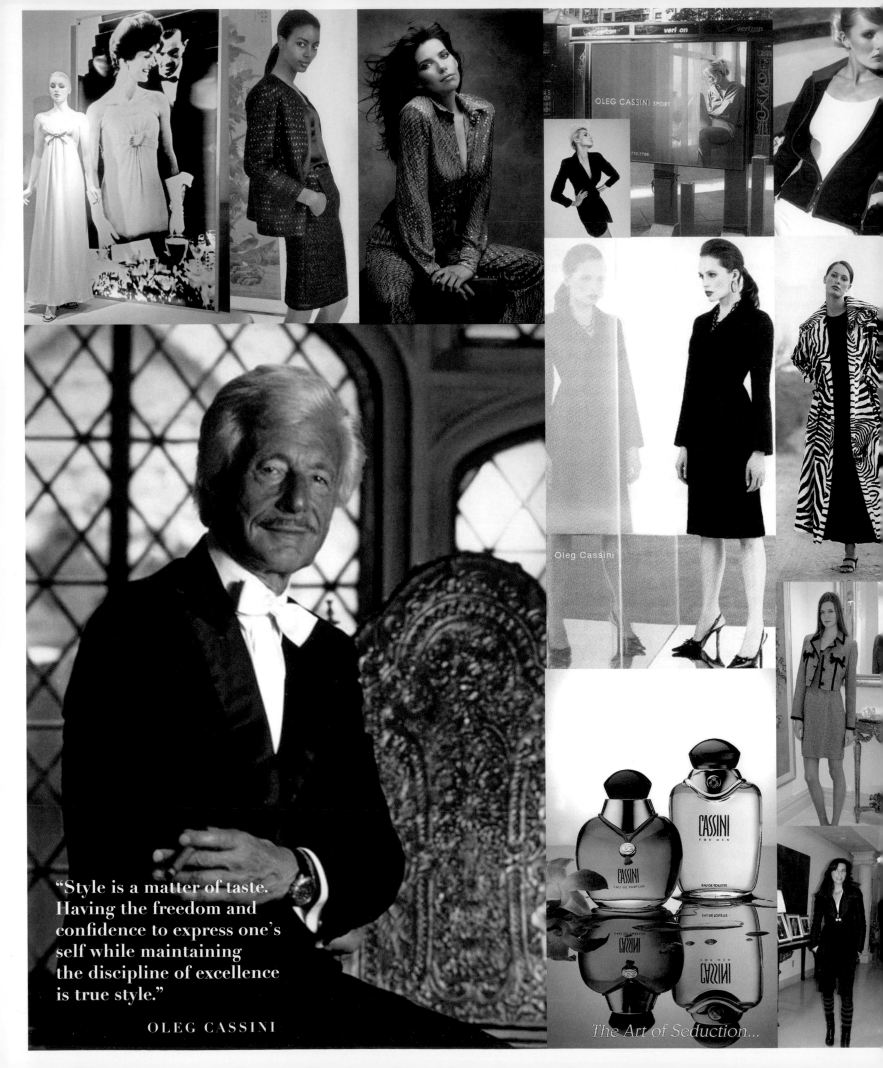

"Style is a matter of taste. Having the freedom and confidence to express one's self while maintaining the discipline of excellence is true style."

OLEG CASSINI

The Art of Seduction...

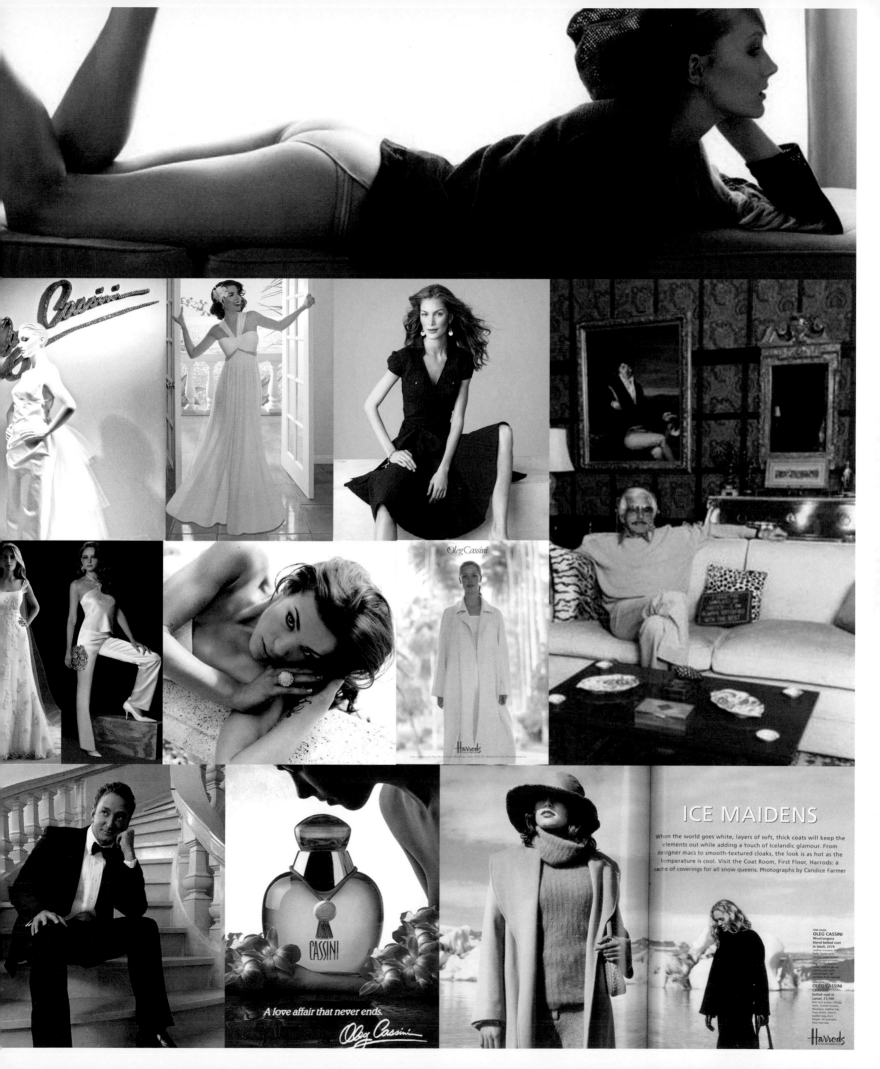

ICE MAIDENS

When the world goes white, layers of soft, thick coats will keep the elements out while adding a touch of Icelandic glamour. From designer macs to smooth-textured cloaks, the look is as hot as the temperature is cool. Visit the Coat Room, First Floor, Harrods: a cache of coverings for all snow queens. Photographs by Candice Farmer

A love affair that never ends.

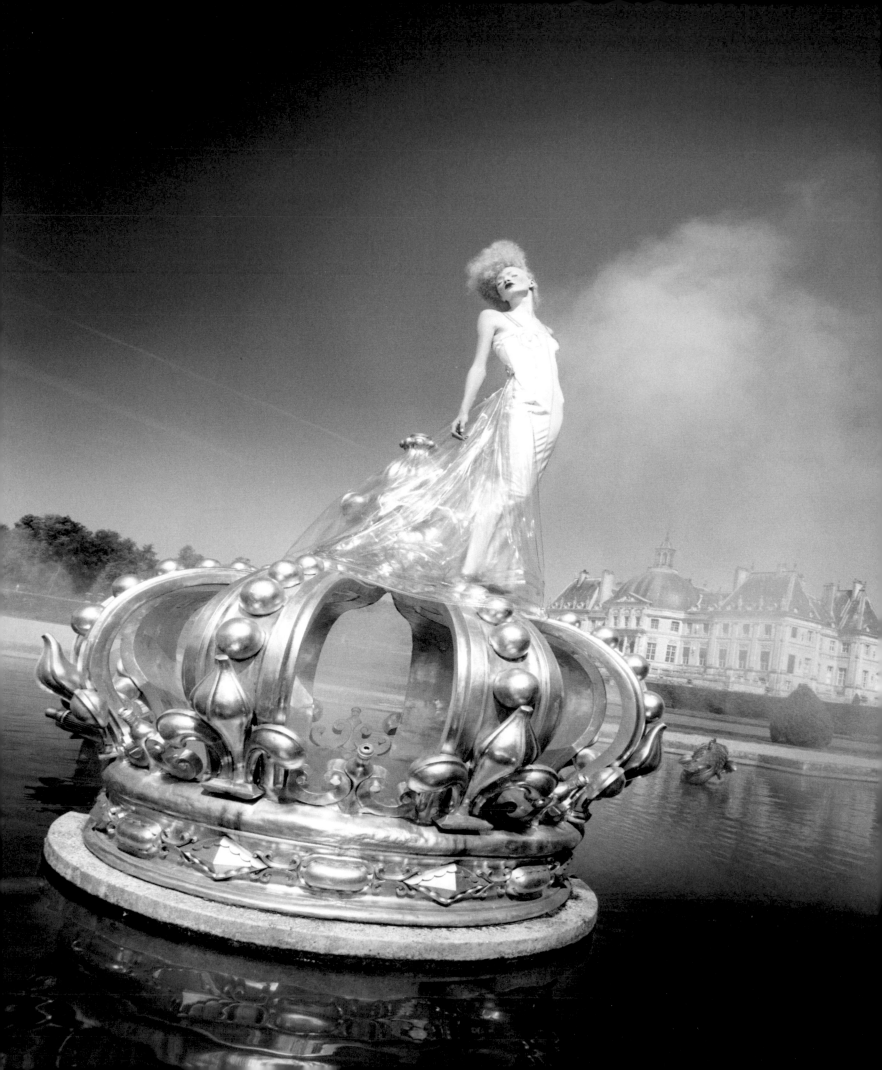

Royal Weddings

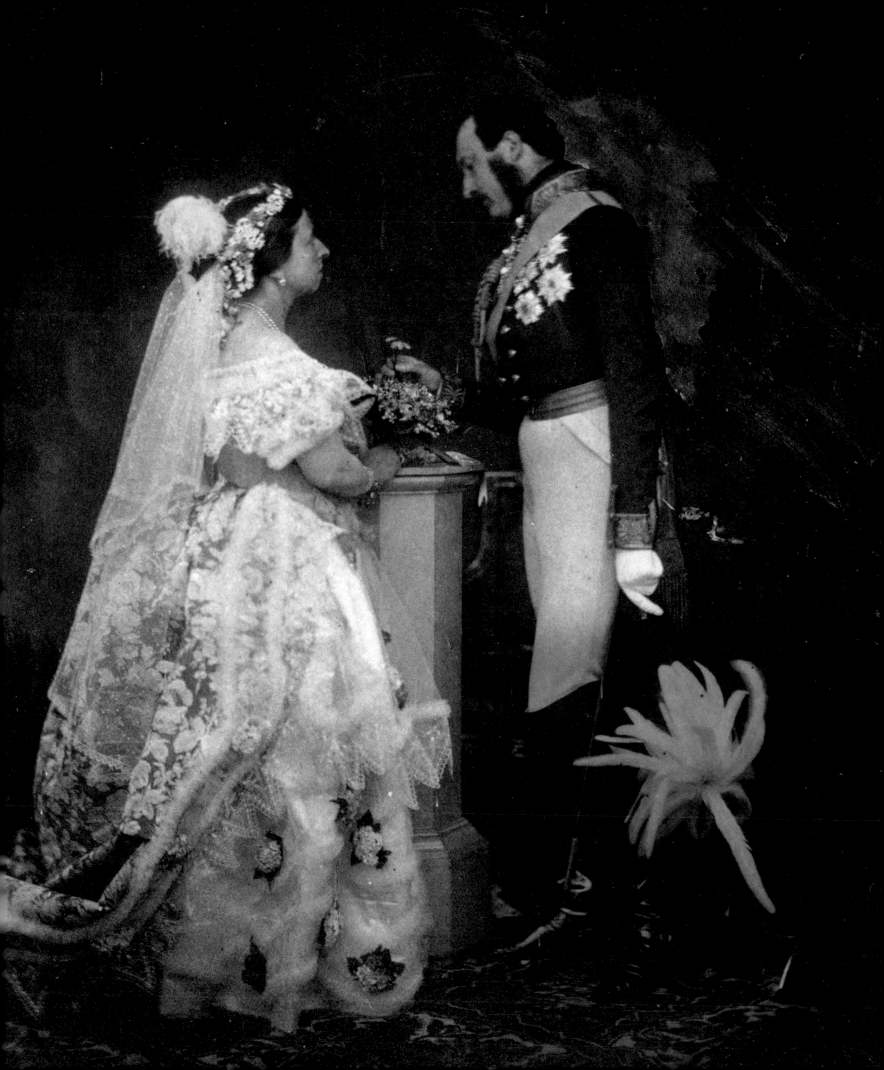

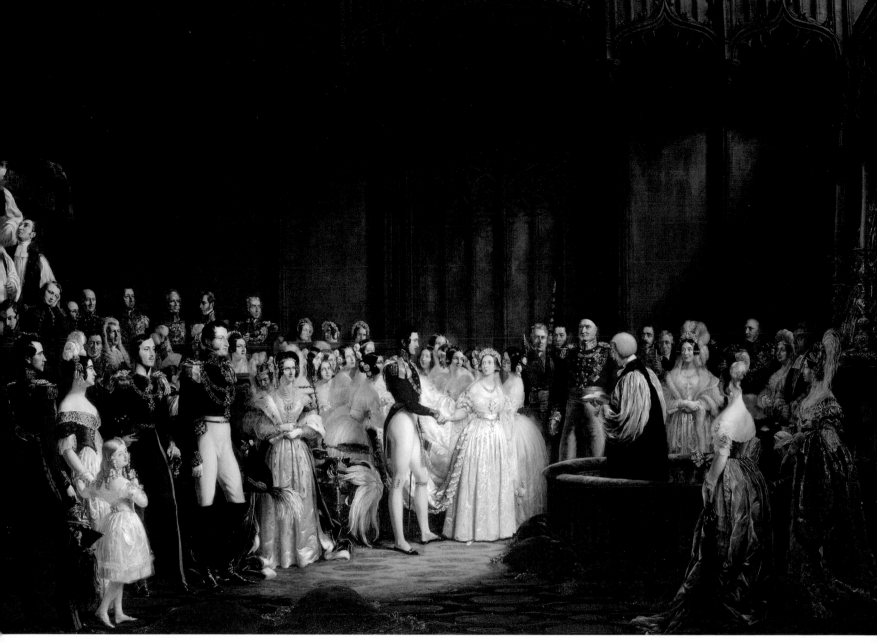

The Wedding of Queen Victoria & Prince Albert
February 10, 1840
The Chapel Royal, St. James Palace

Queen Victoria's gown is referenced as the royal wedding dress that popularized the color white. The choice of white goes back to Roman and Grecian times, representing purity. Victoria wore white for her wedding to her first cousin, Albert, Duke of Saxe-Coburg & Gotha in 1840. Her white satin ball gown with lace overlay skirt and 18 foot train was adorned with fresh, fragrant orange blossoms, which she also wore in her hair. The very happy union of Victoria and Albert produced nine children, and almost every European Monarch is a direct descendant of this marriage. Like Louis XIV, of France, 'The Sun King,' Victoria reigned for over six decades.

In the mid 19th century, white wedding dresses, veils and orange blossoms became the style. The significance of wearing white was an extravagant gesture, and created the need for a special, one time only, symbolic and treasured keepsake that the wedding dress has become. It is said that the Moors first introduced the orange tree into Spain, and passed to France, then to England, and from there to America, where orange blossoms were worn at a White House wedding by Mary Hellen, who married the son of President John Quincy Adams in 1828. Anne of Brittany and Empress Eugénie, wife of Napoleon III, also are credited with enhancing the popularity of the white wedding dress tradition.

LEFT In 1854, photography had just come in as a new art form and Victoria and Albert recreated their wedding in a photograph made 14 years after their actual ceremony. Courtesy of The Royal Collection H.M. Queen Elizabeth II.

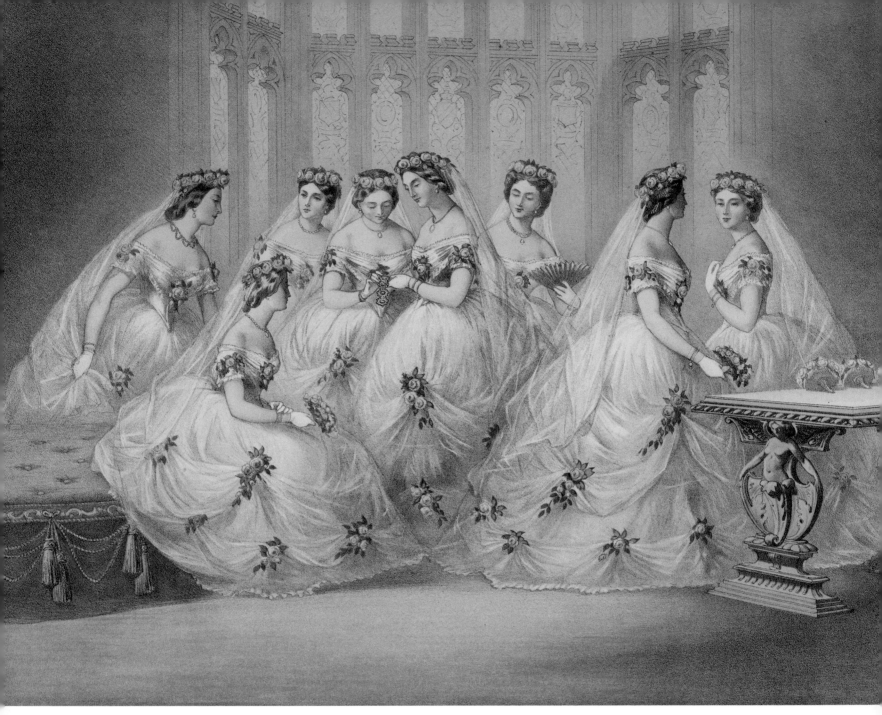

RIGHT Princess Alexandra of Denmark, 18, marries Queen Victoria's eldest son, Edward, Prince of Wales (King Edward VII).
ABOVE AND RIGHT Bridesmaids gathered at the wedding, wearing fresh flowers in their hair, and on their gowns.

The NY Times reported: "All were in dresses of great splendor, but without trains. The display of jewels was prodigious. Diamonds blazed on every fair bosom and hand. The corsage of the wife of the Right Hon. Benjamin Disraeli was liberally spotted with jewels. The dress of Disraeli was also literally plastered with gold embroidery and lace. The dress of the Princess was of ample but ordinary dimensions. The material was white tulle over white silk richly decked with orange blossoms. A wreath of orange blossoms encircled her head. Her coiffure was arranged à la Chinoise. For her ornament she wore a superb parure of pearls and diamonds presented by the Prince bridegroom. The train was of great length and was of white silk. As the Princess passed the Queen she made a deep obeisance. To the Prince she dropped a curtsy of exquisite grace, to which the Prince responded by a deep inclination of his head."

The Edwardian Age followed the Victorian Age, and was named for the charming and fun loving Prince Edward. He came to the throne in 1901, at the age of 60, after Victoria's six decade reign. Linked with the French 'Belle Epoque' period, his time is often referred to as a romantic golden age of long sunlit afternoons, garden parties and big hats. Remembered with nostalgia as an "explosion of intellectual and artistic energy," a time of elegance and beauty, it was a prelude to the dark days of the Great War that followed, WWI. Later in life, Prince Edward also socialized with actress Lillie Langtry; Lady Randolph Churchill (Mother of Winston Churchill); actress Sarah Bernhardt; and Alice Keppel, great-grandmother of Camilla Shand Parker Bowles, the Duchess of Cornwall. In 1995, an image of Alice Keppel and her daughter, Violet was placed on a British postage stamp.

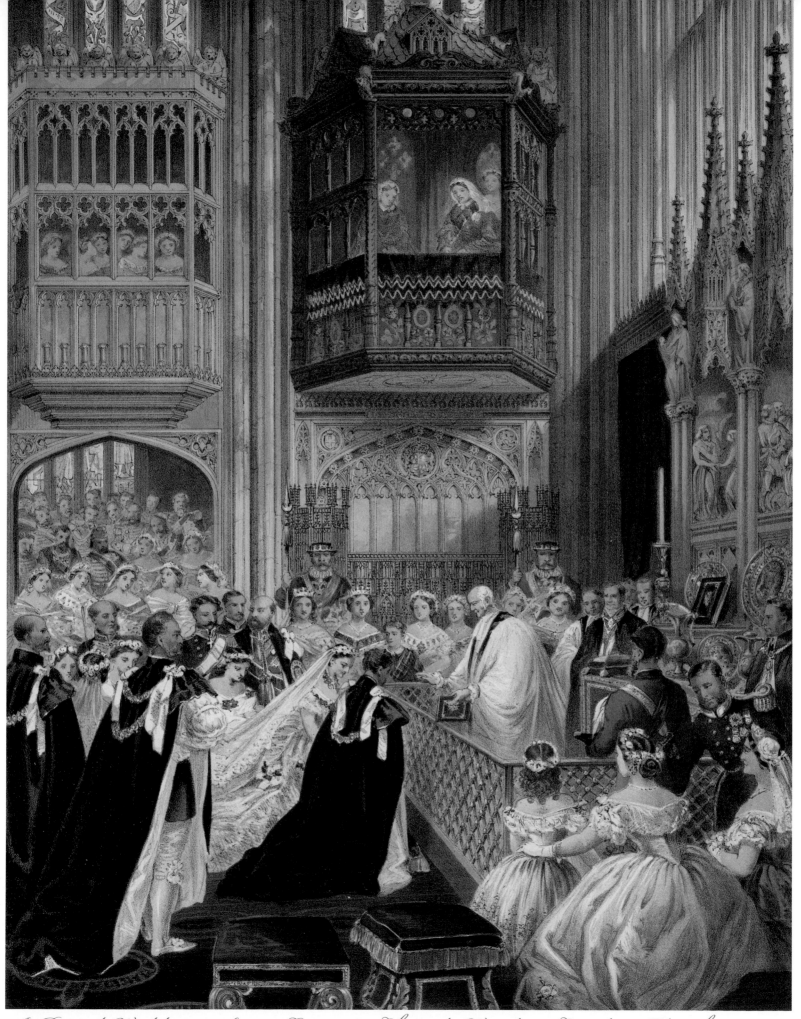

A Royal Wedding, Saint George's Chapel, Windsor Castle—March 10, 1863

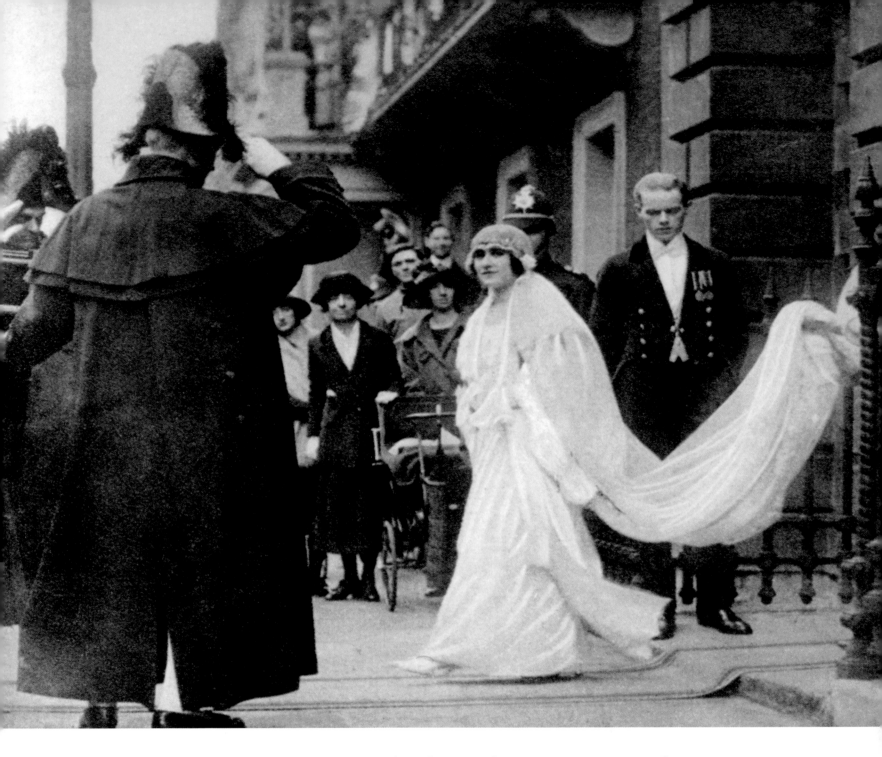

Queen Elizabeth—The Queen Mother

In 1923, Lady Elizabeth Bowes-Lyon married HRH the Duke of York in Westminster Abbey. Her wedding dress was the traditional full length gown with a court train. The dress featured the trendy dropped waist, and she wore a cloche style lace headdress. The look was described as medieval at the time.

Following the abdication of King Edward VIII in 1936, The Duke and Duchess of York succeeded to the throne as King George VI and Queen Elizabeth. The Duchess of York became known as Elizabeth the Queen, and later the Queen Mother, when her daughter, also named Elizabeth was crowned Queen Elizabeth II.

Queen Elizabeth II has reigned for over five decades with Prince Philip by her side.

The Duke & Duchess of Windsor

December 10, 1936

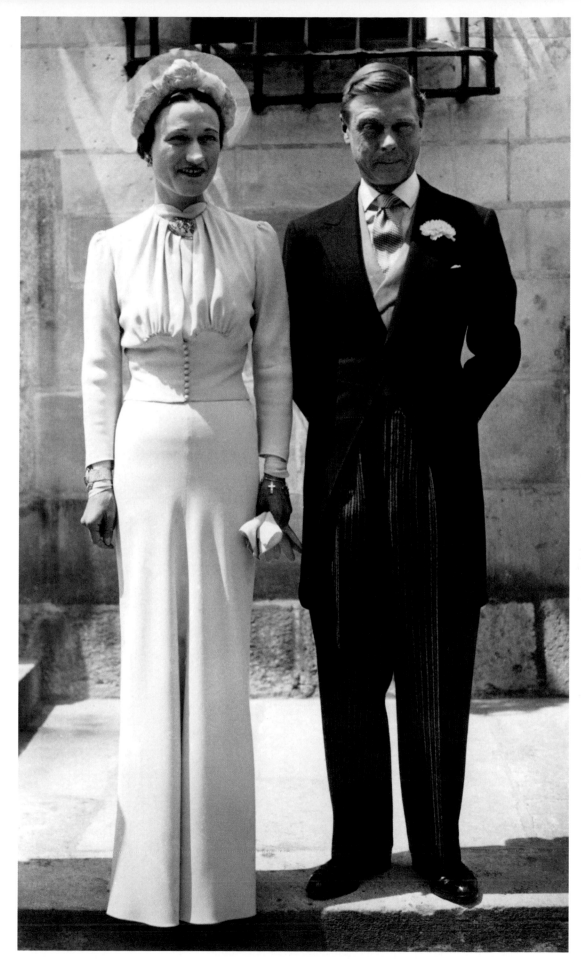

Theirs was known as the poignant star-crossed love story of their time.

Over the crackling radio waves, into the chilled air, the King announced the decision to his astonished people in a heartfelt message, saying: "I have now found it impossible to carry the heavy burden of responsibility and to discharge my duties as King as I would wish to do without the help and support of the woman I love."

On December 10, 1936, the King of England, Edward VIII, abdicated his throne, and his brother, the Duke of York, father of Princess Elizabeth, became King in his place.

On June 3. 1937, they married in France, his first marriage, her third. They traveled the world together known to all as the Duke and the Duchess of Windsor.

Wallis chose the memorable blue gown by Mainbocher, a long sleeved, bias cut gown that hugged her lean silhouette. It was complemented by an interesting crown headdress. In her 'Wallis blue gown' she made an exceedingly chic companion to the 'best dressed' of men. Both at their wedding and during their stylish life together, they were the epitome of elegance.

Renowned individually for their sartorial style, the glamorous and alluring Duchess was quoted as having said: "I am not much to look at so I may as well be the best dressed."

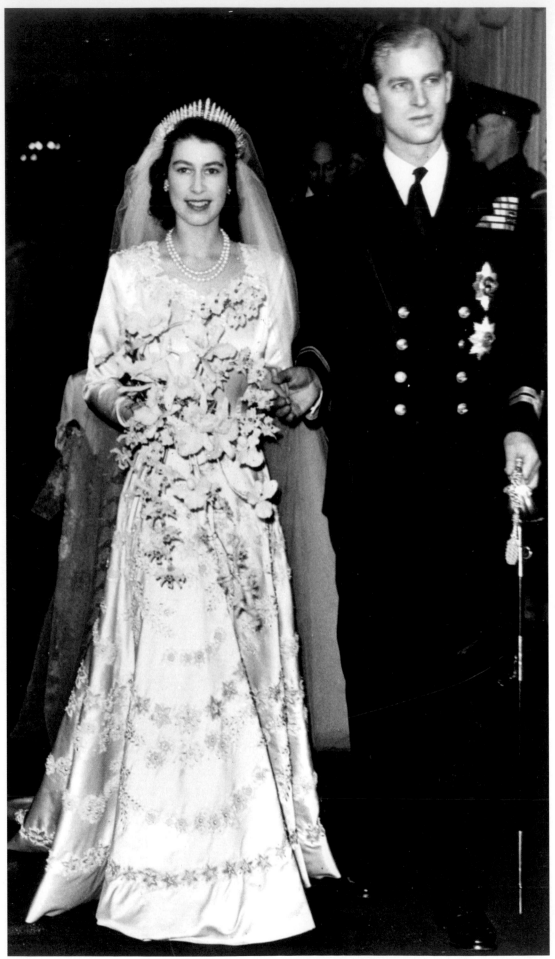

Six years later, Princess Elizabeth would be crowned Queen Elizabeth II.

Princess Elizabeth & Prince Philip

November 20, 1947

The Royal couple exchanged vows at Westminster Abbey before the Archbishop of Canterbury on November 20, 1947, and the wedding heralded the end of the dark days of WWII and gave way to the positive thoughts of peacetime. Winston Churchill, England's wartime Prime Minister, famously captured the feelings of the time about the wedding of Crown Princess Elizabeth to Prince Philip Mountbatten, nephew of the deposed King of Greece, as: "A bright ray of colour on the hard road we have to travel."

Being post war, frugality was pervasive, Elizabeth financed her wedding gown with 200 extra clothing stamps, and the main course of the wedding breakfast at Buckingham Palace featured partridge, a meat not subject to rationing.

Princess Elizabeth's long sleeved gown was ivory duchesse satin, with a sweetheart neckline trimmed with lace, and created by Norman Hartnell. The gown was embellished with 10,000 pearls, and had a record setting train of 15 feet of silk tulle, and was said to have been inspired by a Botticelli painting.

The pearl earrings were a present from Queen Mary (something old). Elizabeth's double strand pearl necklace, a gift from her parents (something new) and the diamond tiara, a loan from her mother, the Queen (something borrowed).

The bridal bouquet of orchids and myrtle was cut from the bushes used for the bouquets of all Royal Brides since 1850.

Winston Churchill, a wedding guest, stated: "If they had scoured the globe, they could not have found anyone so suited to the part."

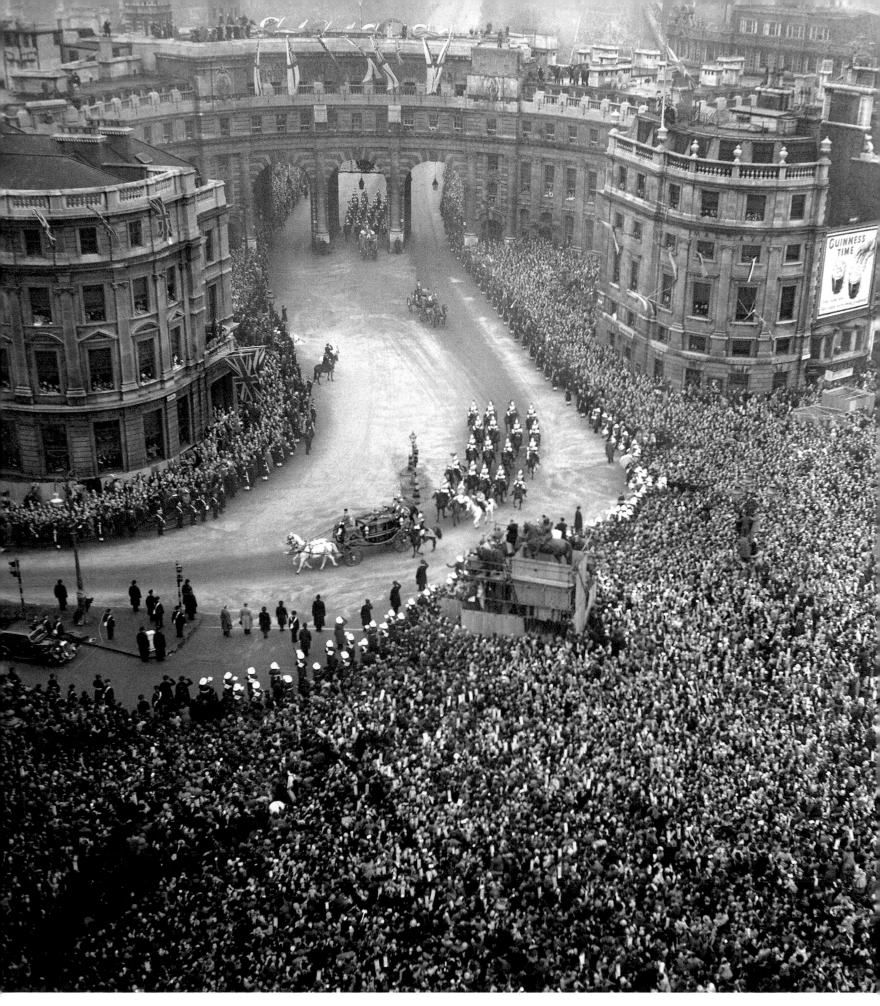

London, November 20, 1947: The Royal Wedding of Princess Elizabeth and Prince Philip.
The Irish State Coach making the turn at Trafalgar Square towards Whitehall.

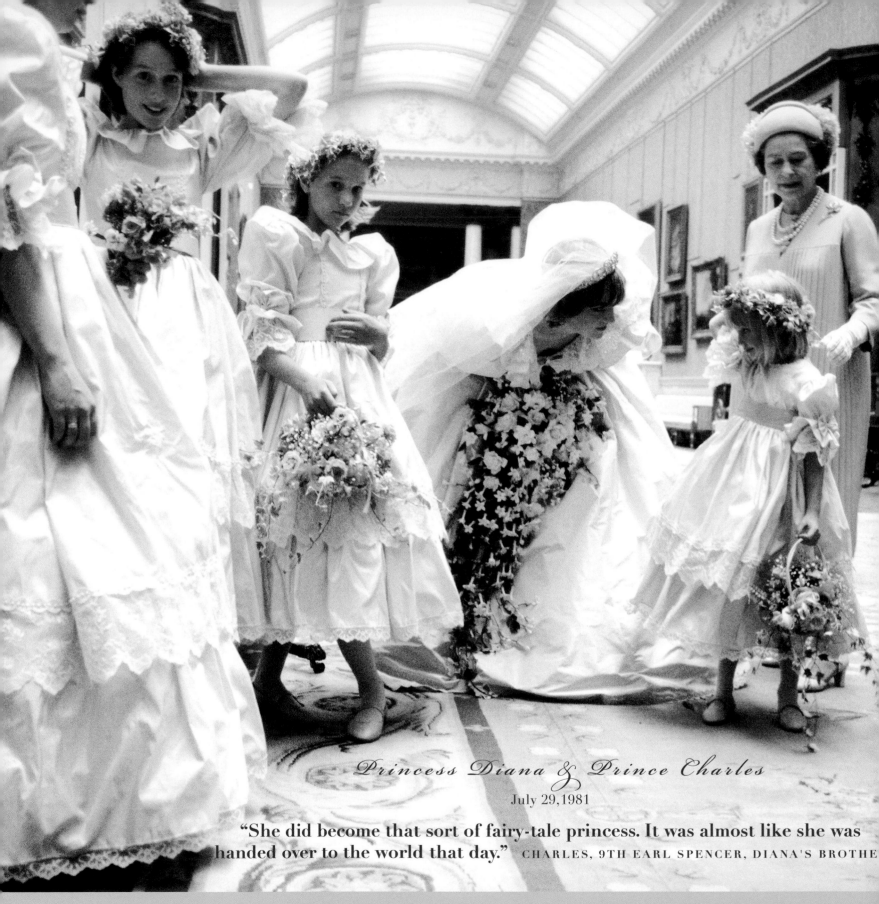

Princess Diana & Prince Charles

July 29, 1981

"She did become that sort of fairy-tale princess. It was almost like she was handed over to the world that day." CHARLES, 9TH EARL SPENCER, DIANA'S BROTHER

The world watched and became enchanted with the statuesque and aristocratic 'Princess Di,' who had just turned 20. Lady Diana Spencer, chose the team of David and Elizabeth Emanuel to design her memorable wedding gown. The extravagant sleeves, tied with bows and the fantastic 25 ft. long train, combined to give a truly majestic feeling to the gown. The beautiful young and coltish, long legged Princess Diana, with her model height of 5'10", the Royal Wedding trappings, the television moment by moment coverage all made the Wedding Day spectacular and iconic. Silk taffeta, opulent sleeve treatments, bows, lace and embellishments became a major fashion impression and widely encouraged the romantic 'Princess Bride' look. Mariah Carey, pop star, famously stated that she was inspired by Diana's gown for her own wedding to music impresario, Tommy Mottola. **Photo: Lord Patrick Litchfield**

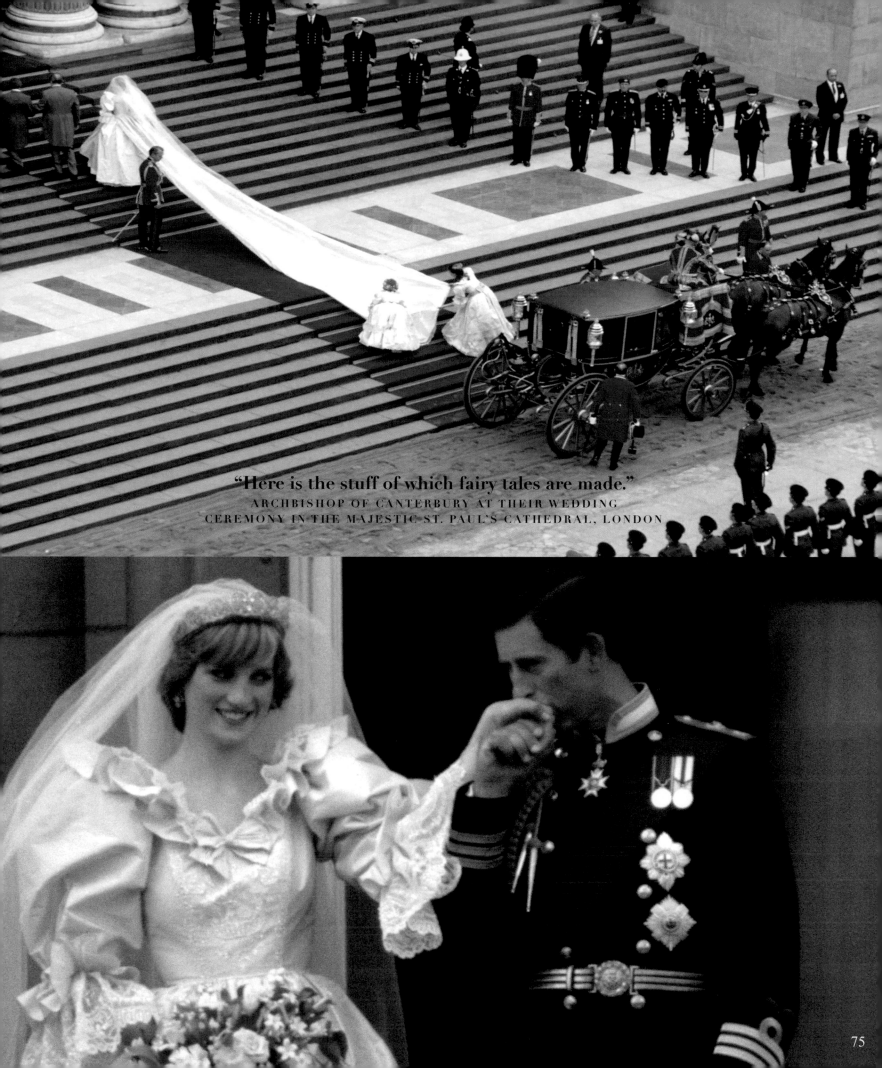

"Here is the stuff of which fairy tales are made."
ARCHBISHOP OF CANTERBURY AT THEIR WEDDING
CEREMONY IN THE MAJESTIC ST. PAUL'S CATHEDRAL, LONDON

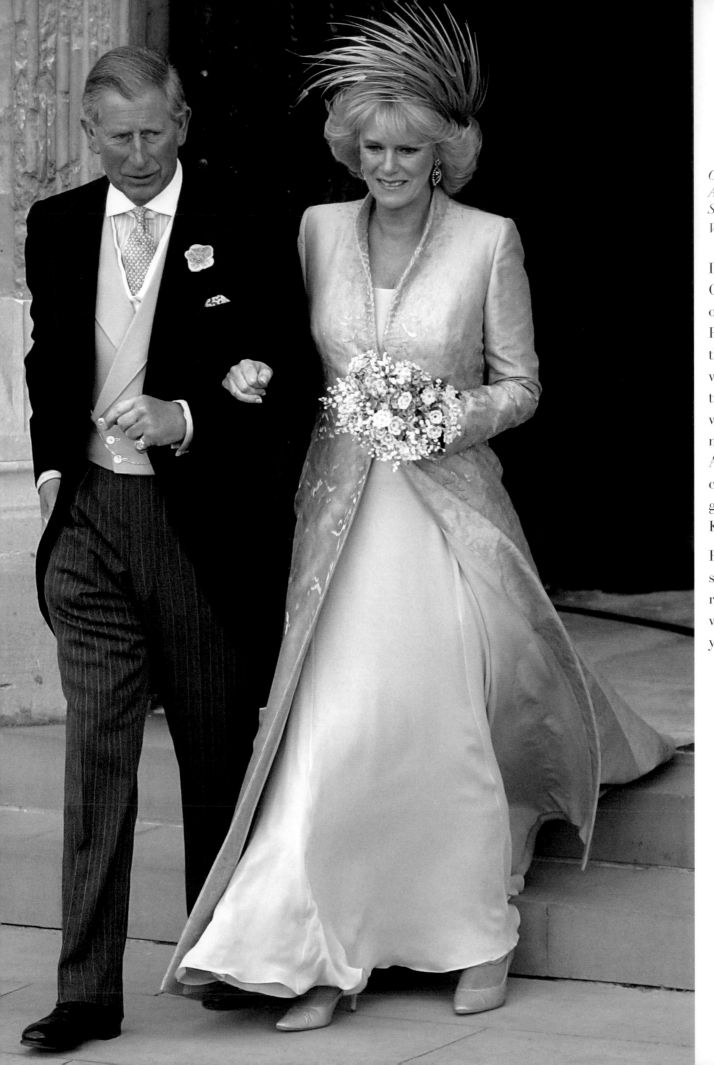

Charles & Camilla
April 9, 2005
St. George's Chapel
Windsor Castle

It has been said that Camilla Shand's opening comment to Prince Charles when they met while both were in their early twenties, Summer 1971, was: "You know Sir, my great grandmother, Alice Keppel, was a close friend of your great, great, grandfather, King Edward VII."

However, it has also been said that her comment, referring to his polo pony, was: "That's a fine animal you have there, Sir."

For the civil marriage service to Prince Charles, Camilla, the Duchess of Cornwall, wore an ivory dress and coat by Robinson Valentine with matching Philip Treacy hat.

For the prayer service at the St. George's Chapel, Windsor Castle, and the reception that followed, Camilla wore a porcelain blue floor length coat embroidered with gold over a matching blue gown with a stunning gold leaf spray, worn like a crown in her hair.

Color as a keynote has had great symbolism for wedding dresses. The various shadings of white are a favorite choice, and white has traditionally symbolized innocence, as well as blue, which has also symbolized fidelity and love.

"If the bride wears blue, the husband will be true."

RIGHT A proposed sketch for the Duchess appearing in People magazine prior to the wedding as a design concept, featuring a pearl embroidered illusion bodice.

Princess Caroline
&
Philippe Junot

June 28, 1978
Monte Carlo, Monaco

*Leurs Altesses Sérénissimes
le Prince et la Princesse de Monaco,
ont l'honneur de vous faire part du mariage de
leur fille, Son Altesse Sérénissime la Princesse
Caroline avec Monsieur Philippe Junot.*

*La Bénédiction Nuptiale leur sera donnée par son
Excellence Monseigneur Abelé, Evêque de Monaco,
dans la plus stricte intimité, le Jeudi 29 Juin 1978
en la Chapelle du Palais Princier.*

*Monsieur et Madame Aage Thykjaer,
Monsieur Michel Junot, Officier de la
Légion d'Honneur, Maire Adjoint de Paris,
et Madame Pierre Chassin, ont l'honneur
de vous faire part du mariage de Monsieur
Philippe Junot, leur petit-fils et fils, avec
Son Altesse Sérénissime la Princesse
Caroline de Monaco.*

*La Bénédiction Nuptiale leur sera donnée par son
Excellence Monseigneur Abelé, Evêque de Monaco,
dans la plus stricte intimité, le Jeudi 29 Juin 1978
en la Chapelle du Palais Princier.*

*"La Vaucouleur" Avenue des Mauruches - 06220 Vallauris
14, Rue de Condé - 75006 Paris
Le Clos des Oliviers, 80 Av. de Lattre de Tassigny - 06400 Cannes*

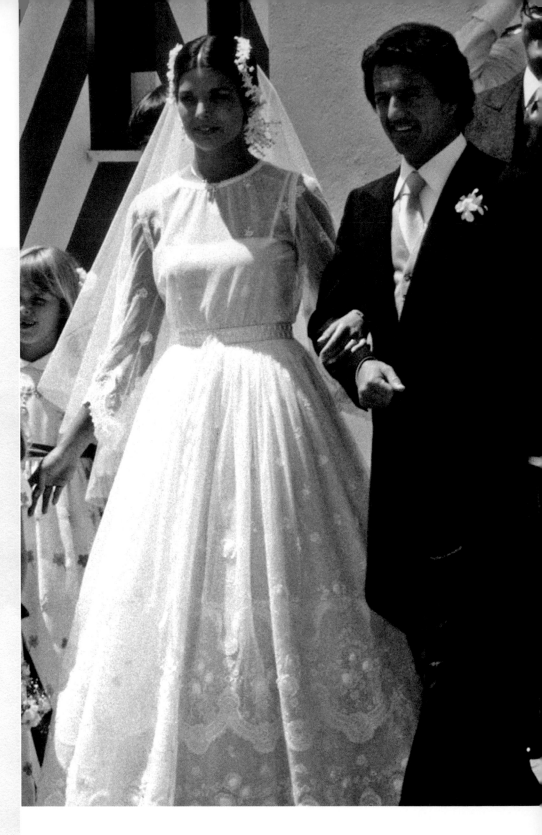

Princess Grace & Prince Rainier

Opposite: Prince Rainier III of Monaco, Louis Henri Maxence
Bertrand de Grimaldi and Grace Patricia Kelly

April 19, 1956
Monte Carlo, Monaco

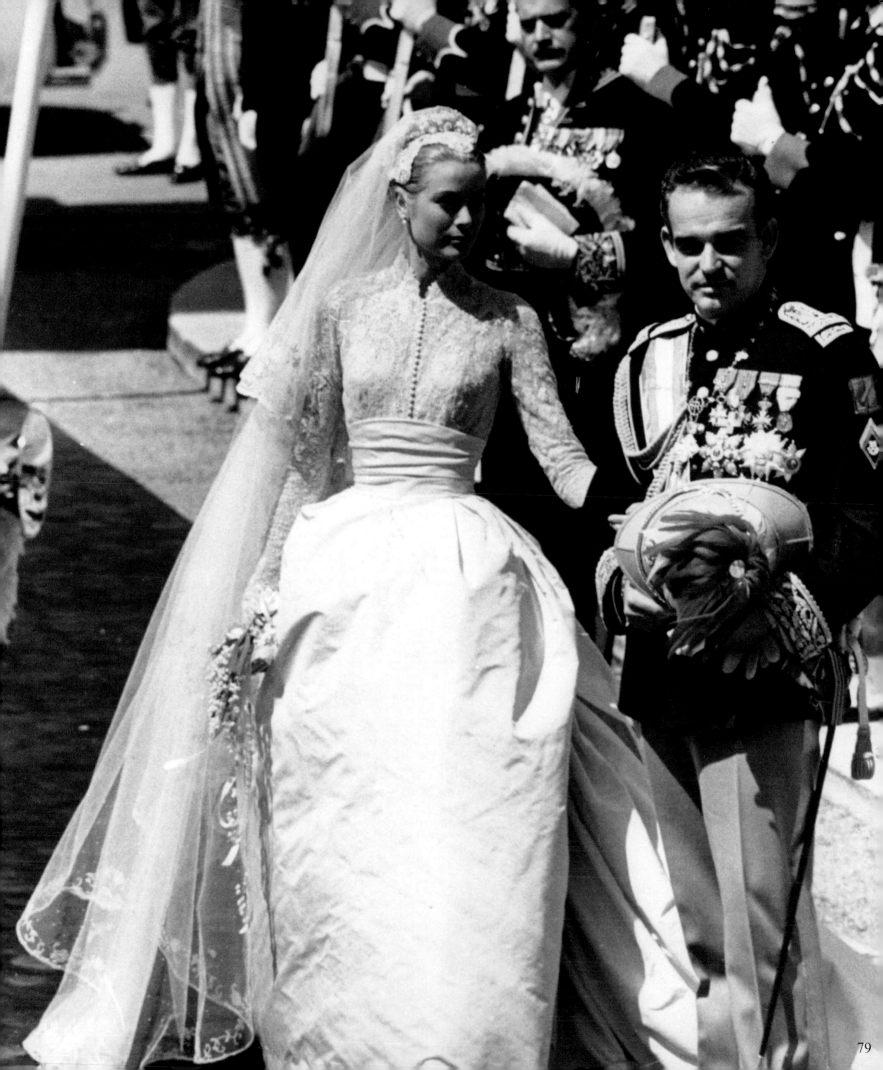

Prince Jean
&
Philomena

May 4, 2009

Prince Jean Carl Pierre Marie d'Orléans, Dauphin of France, Duke of Vendôme and his Spanish wife Philomena of Tornos and Steinhart wed at a religious ceremony at the gothic 12th century cathedral, Notre Dame de Senlis.

The wedding party then moved on to a reception in the Château de Chantilly, the historic former home of King Luis Felipe of Orleans, an ancestor of the groom.

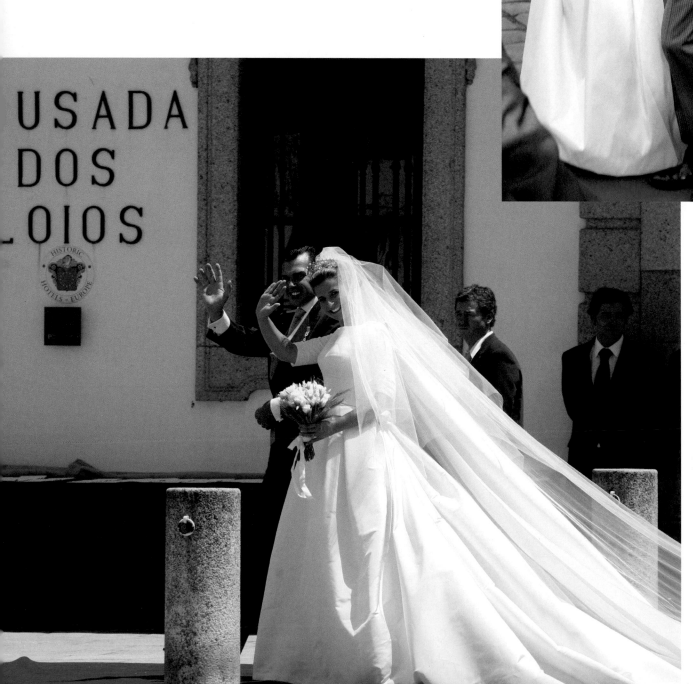

Charles
&
Diana

June 21, 2008

Prince Charles-Philippe Marie Louis d'Orleans of France, Duke of Anjou, married Diana Alveres 11th Duchess of Cadaval at the Evora Cathedral in Portugal

The Engagement Dinner at Le Cirque, NYC, featured Oleg Cassini crystal diamond paperweights as wedding gifts for all.

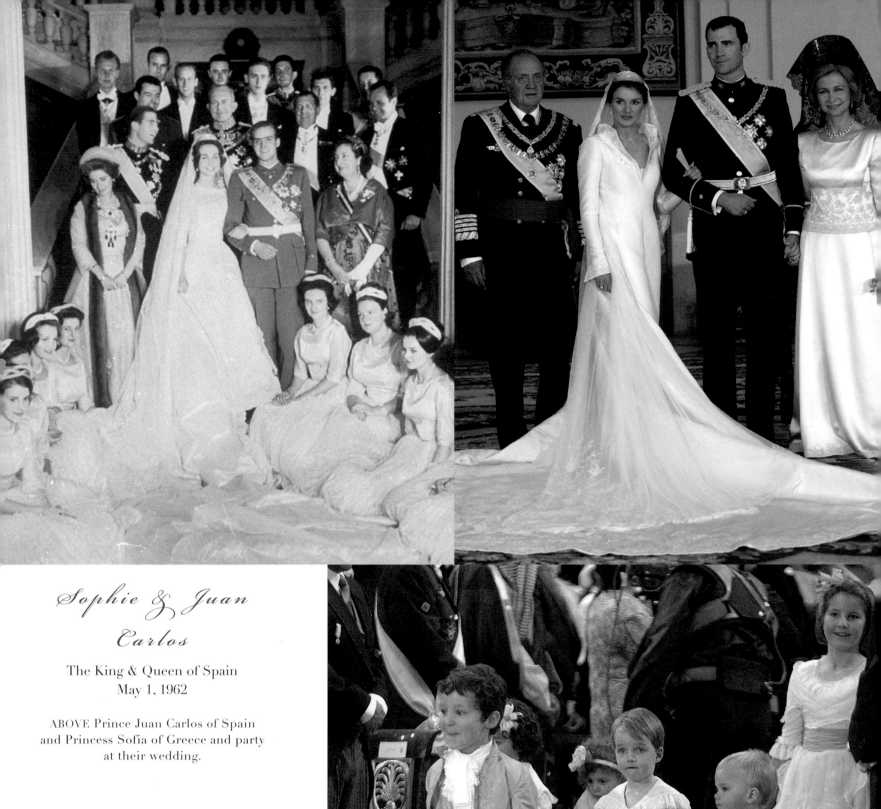

Sophie & Juan Carlos

The King & Queen of Spain
May 1, 1962

ABOVE Prince Juan Carlos of Spain and Princess Sofia of Greece and party at their wedding.

Felipe & Letizia

May 22, 2004

ABOVE, RIGHT The wedding of the Prince & Princess of Asturias with his parents, the Spanish King and Queen, Juan Carlos and Sofia, in Almudena Cathedral in Madrid, Spain.

RIGHT The flower children's outfits were inspired by the paintings of the great Spanish painter Goya.

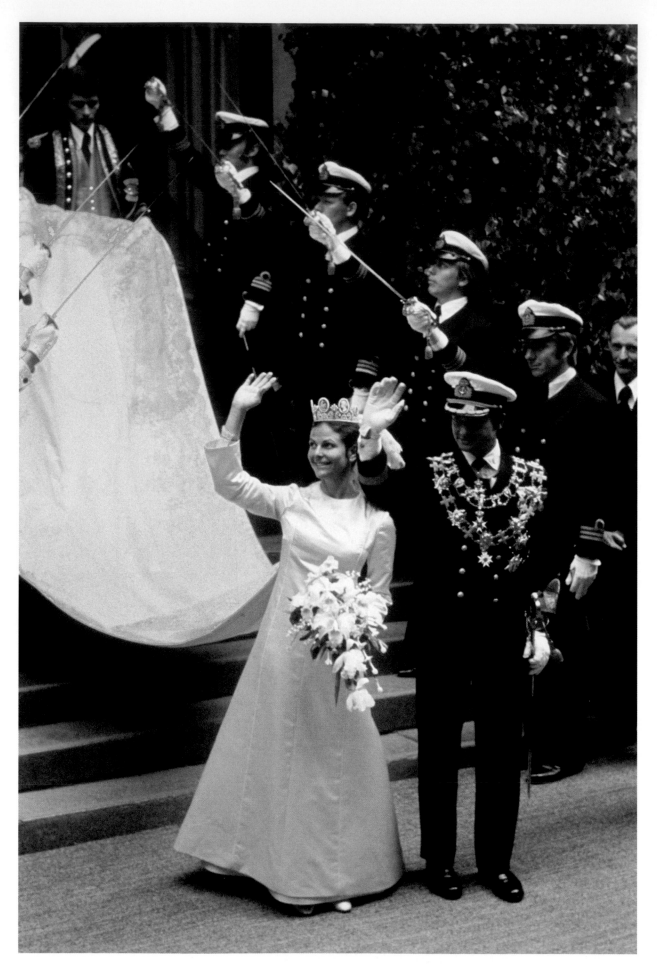

Carl Gustaf

&

Silvia

Sommerlath

June 1976
Sweden

King Carl Gustaf, of
Sweden and German-born
Silvia Sommerlath met
at the Munich Olympics
in 1972.

Abba dedicated their hit
song *Dancing Queen*
to Queen Silvia.

Danish Crown Prince Frederik

&

Mary Donaldson

May 14, 2004 (Below)

"From today you are a real Princess who has got both the Prince and all the kingdom."

BISHOP ERIK SVENDSEN
(IN HIS SERMON)

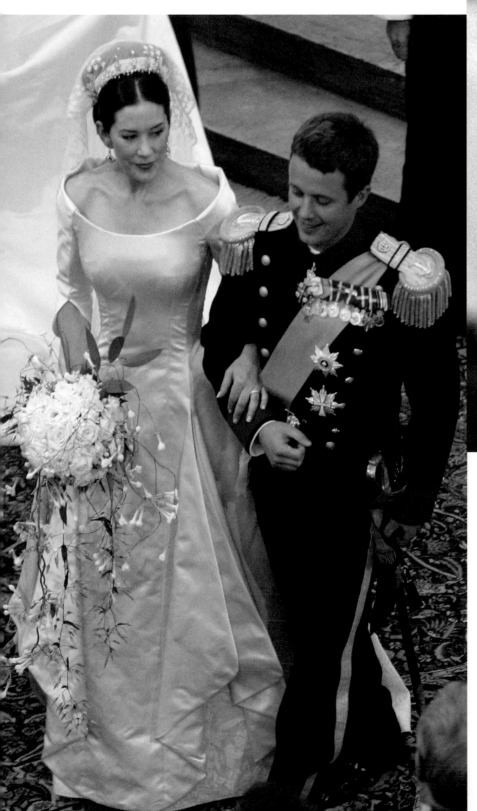

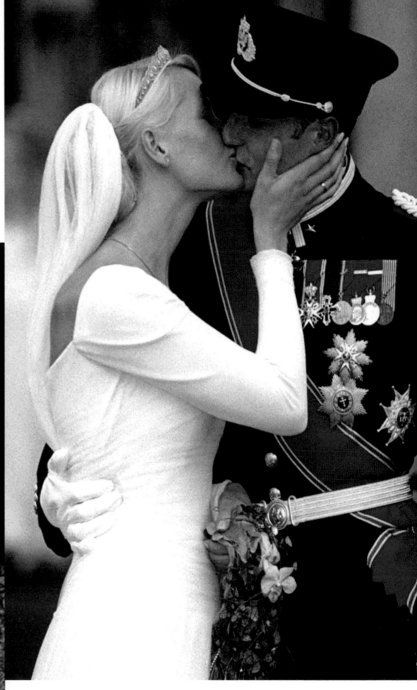

Crown Prince Haakon

&

Mette-Marit

August 25, 2001
Oslo, Norway

ABOVE Crown Prince Haakon the Norwegian heir to the throne and Crown Princess Mette-Marit on their wedding day.

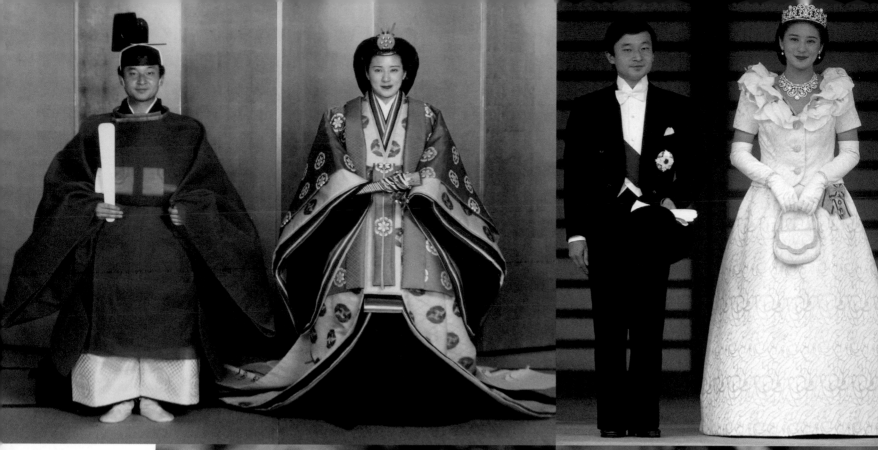

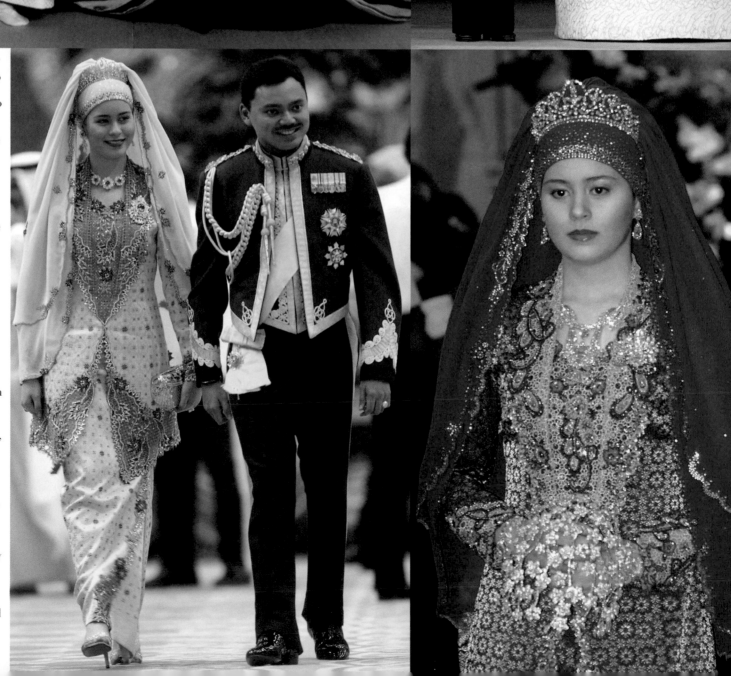

ABOVE, LEFT & RIGHT
Crown Prince Naruhito
&
Crown Princess Masako
June 9, 1993

The Royal couple wore traditional garments, then the Prince changed into a tuxedo and top hat. His bride, Masako Oswada, a Harvard graduate, wore an ivory gown with a diamond tiara.

RIGHT
The Crown Prince of Brunei
&
Princess Sarah
September 9, 2004

Oxford educated, Crown Prince Al Muhtadee Billah of Brunei, and Sarah Salleh, of Zurich, Switzerland, had 14 days of wedding celebration. Their wedding was said to have cost more than 40 million dollars.

The beautiful bride of seventeen wore many outfits, one of which was sapphire blue with which she carried a gold and diamond floral bouquet.

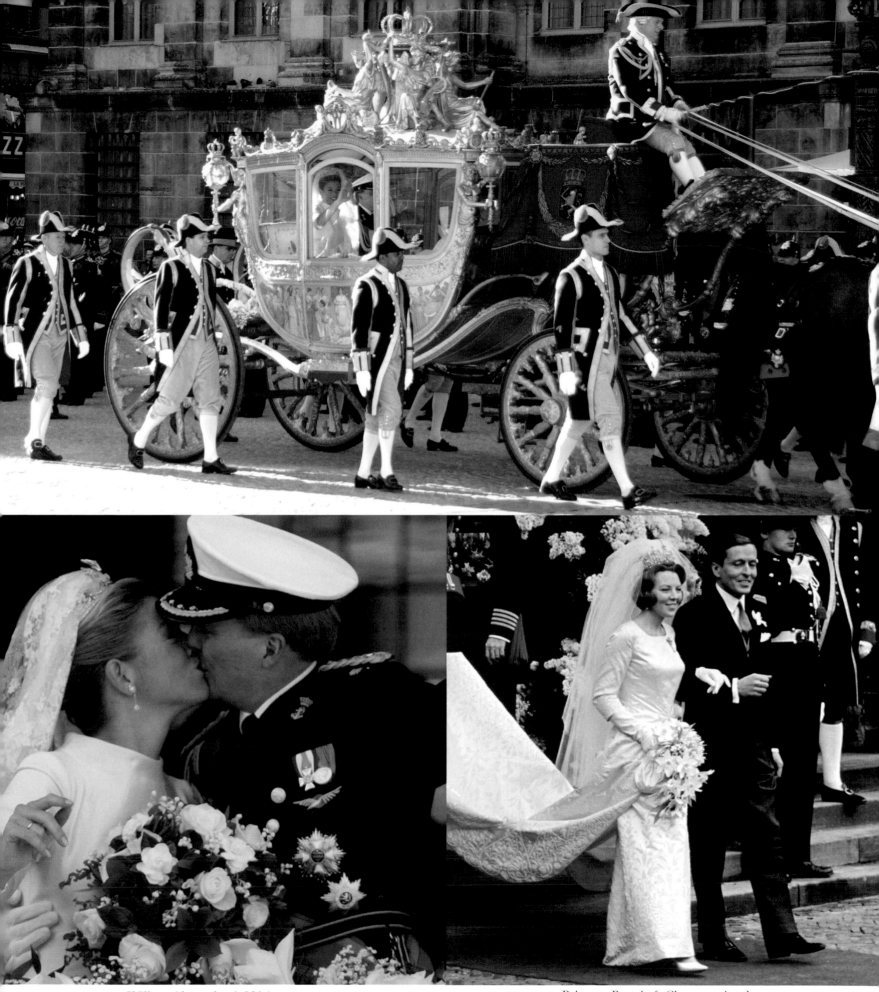

Willem-Alexander & Máxima
February 2, 2002, Amsterdam
Crown Prince Willem-Alexander of the Netherlands married
Argentine born Máxima Zorreguieta. They rode in the Royal golden coach (top).

Princess Beatrix & Claus von Amsberg
March 10, 1966
Beatrix, Willem-Alexander's mother, became Queen of the Netherlands
and German born Claus became known as her Prince Consort.

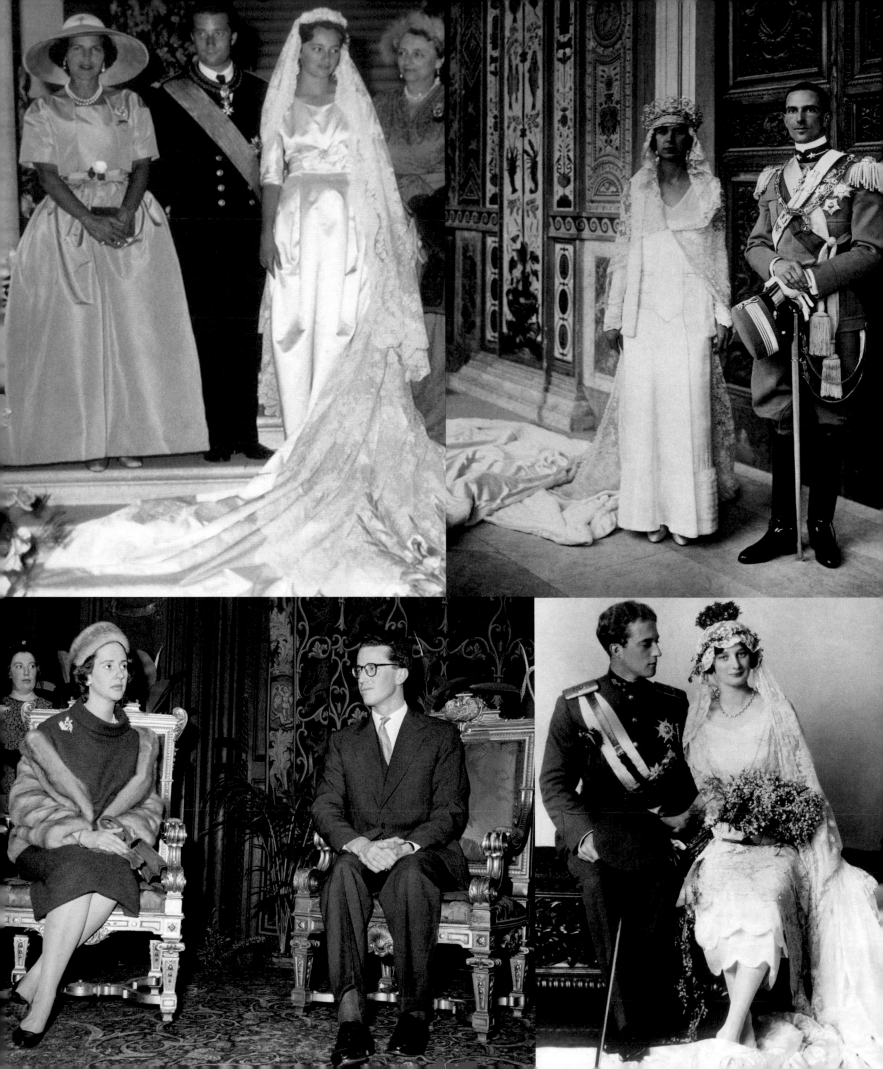

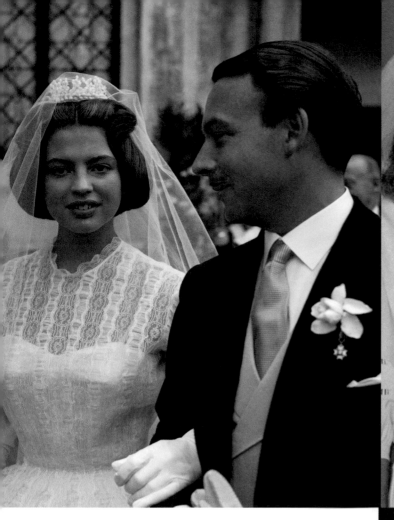

THIS PAGE

ABOVE Fifteen year old Princess Virginia (Ira) von Fürstenberg, dubbed, "the school girl bride" and her prince, Alfonso von Hohenlohe-Langenburg, in Venice on September 30, 1955. Ira is the daughter of Clara Agnelli & Prince Tasillo von Fürstenberg, niece of Gianni Agnelli, sister of Egon, sister-in-law (to be) of Diane.

ABOVE, RIGHT Lisa Najeeb Halaby, an American architect, became the fourth wife of King Hussein on June 15, 1978, in Amman. Her first name was changed from Lisa to Noor, an Arabic word meaning "light." Queen Noor and King Hussein had four children.

RIGHT Prince Karim Aga Khan & The Begum Sarah in Paris on October 31, 1969.

OPPOSITE

TOP, LEFT Prince Albert of Belgium (now King) and Princess Paola (now Queen) wed on July 2, 1959. Princess Maria Pia di Savoia was Maid of Honor.

TOP, RIGHT Princess Marie José & King Umberto II of Italy in Rome on January 8, 1930.

BOTTOM, LEFT Queen Fabiola de Mora y Aragón & King Baudouin I of Belgium in Brussels on December 15, 1960.

BOTTOM, RIGHT Belgium King Leopold III & Queen Astrid in Stockholm on November 4, 1926.

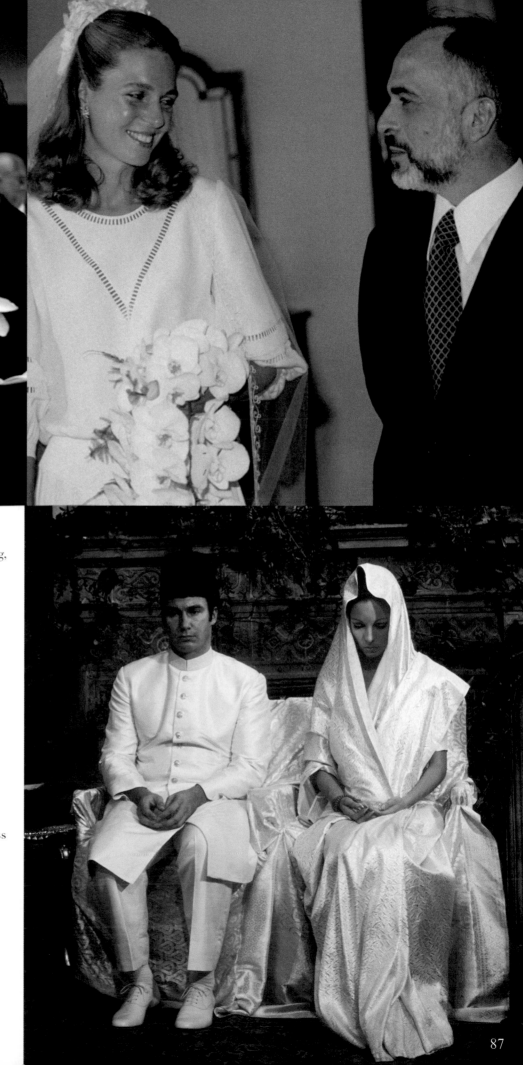

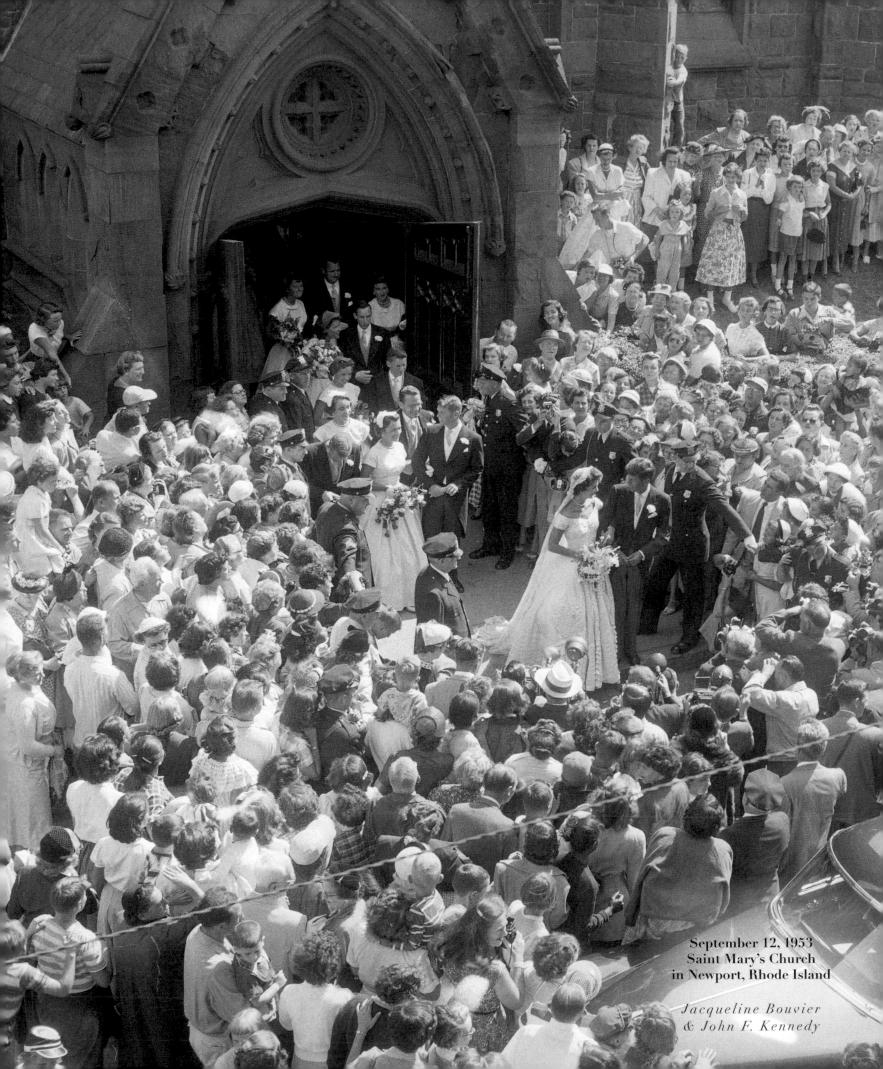

September 12, 1953
Saint Mary's Church
in Newport, Rhode Island

*Jacqueline Bouvier
& John F. Kennedy*

The best weddings in the world

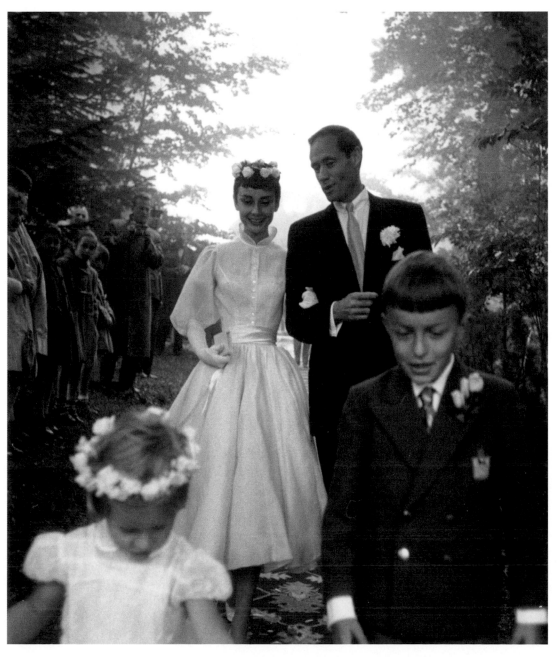

September 25, 1954

Audrey Hepburn and Mel Ferrer on their wedding day in Burgenstock,
Switzerland. Her tea-length gown with satin cummerbund is by Balmain.

It was a very good year for iconic beauties...

Born the same year:
Audrey, a Taurus
Jackie, a Leo
Grace, a Scorpio

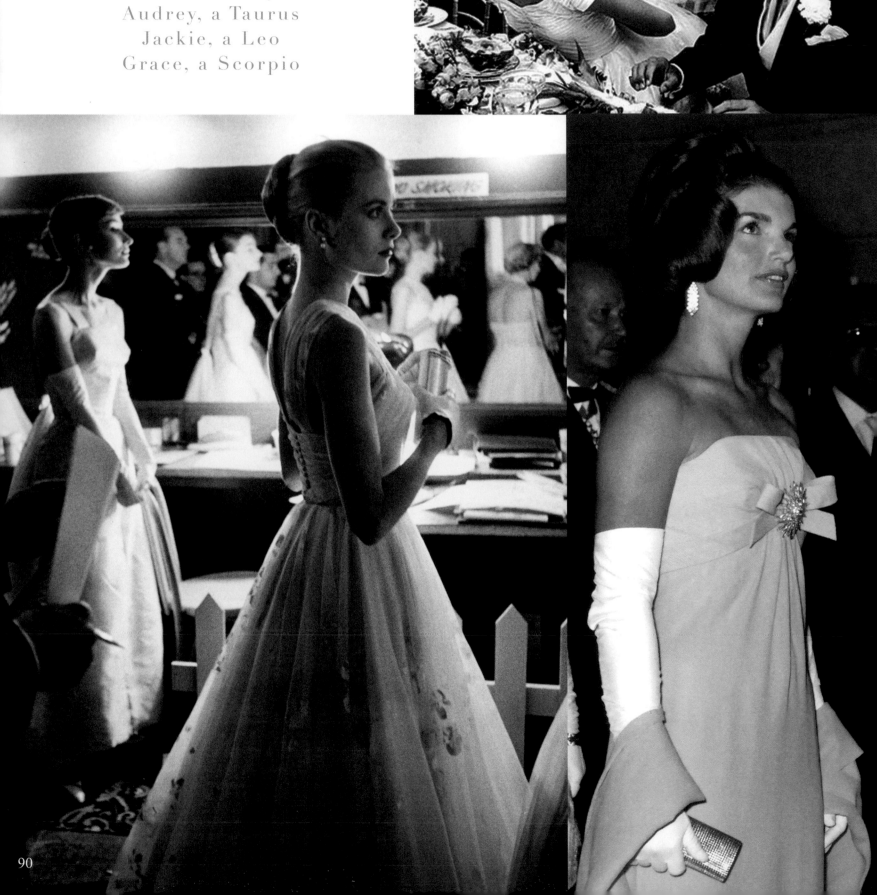

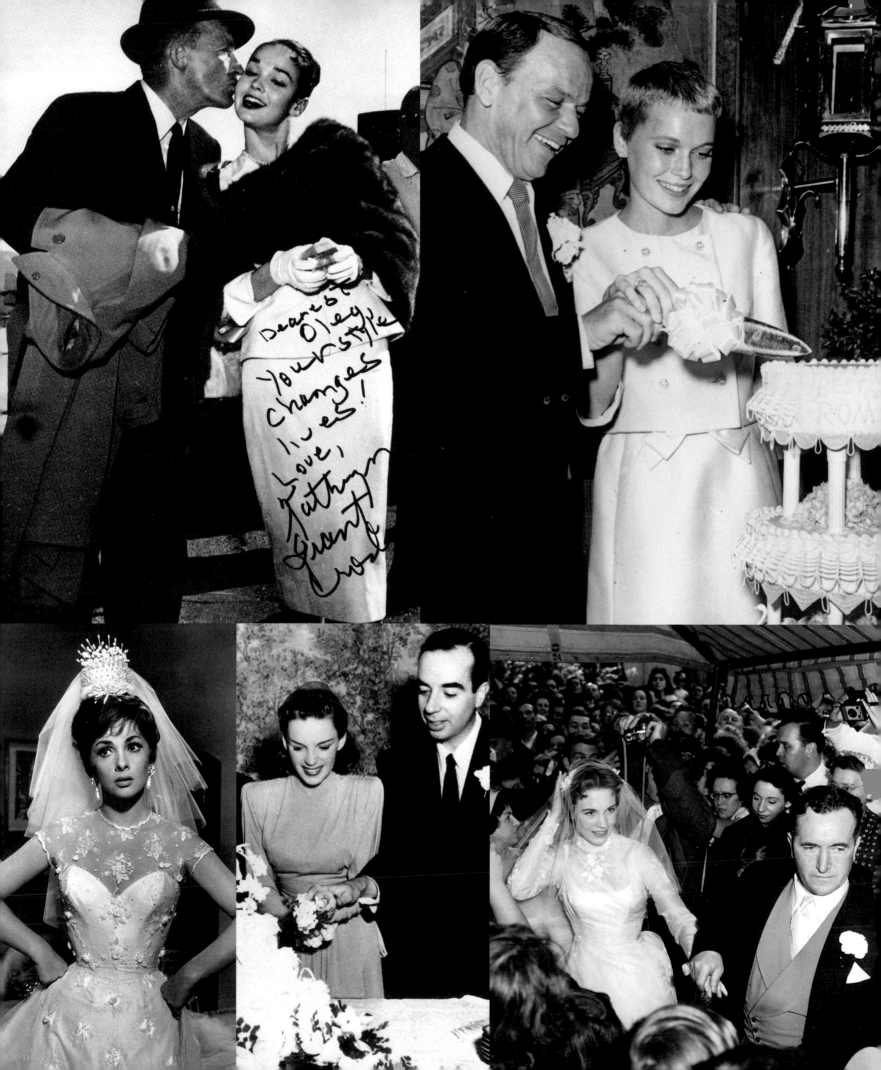

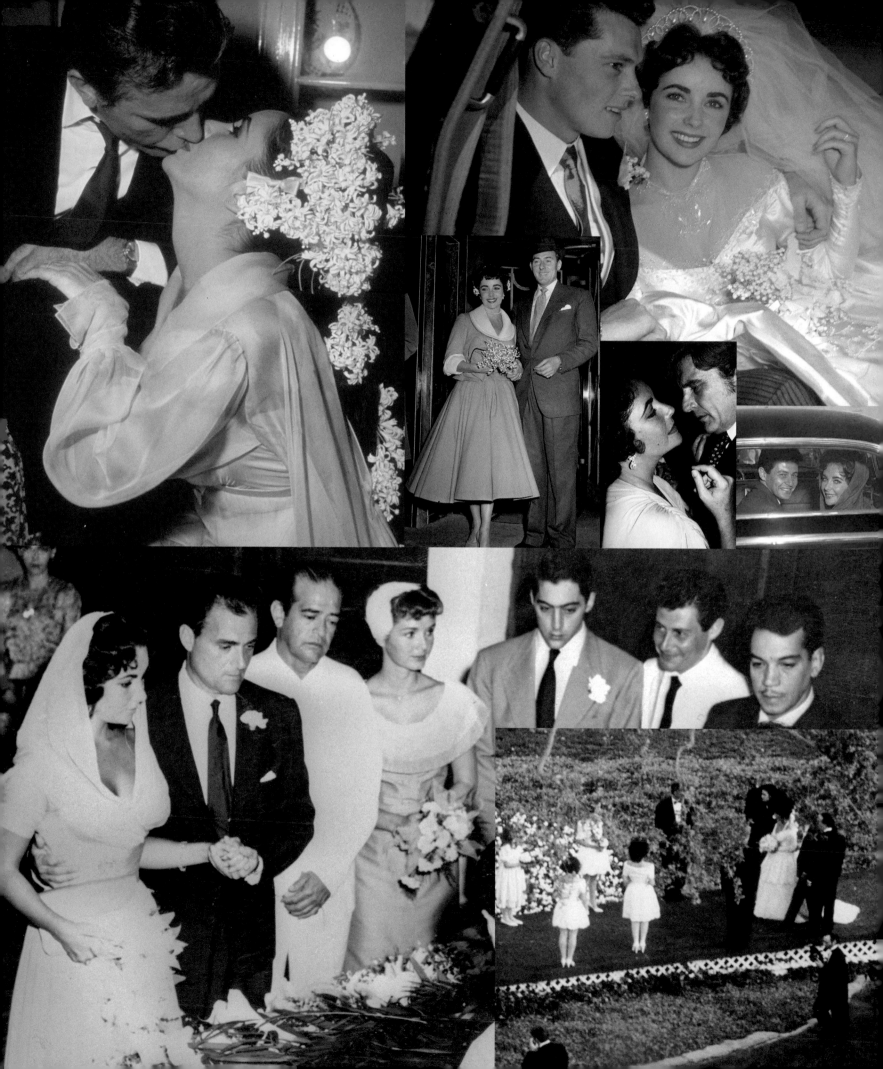

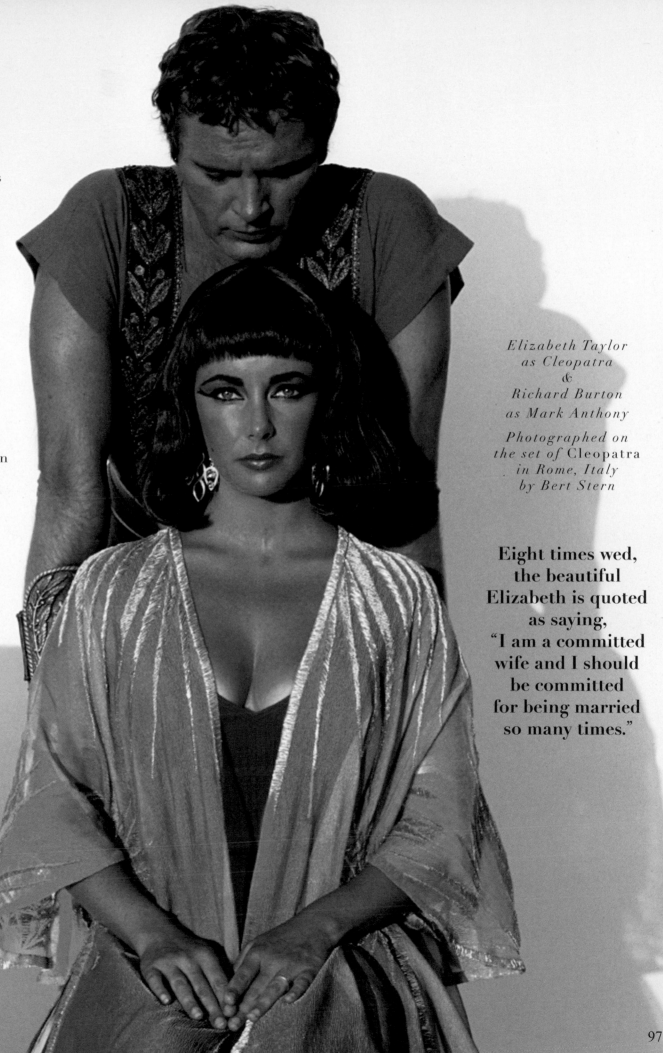

Elizabeth Taylor
&
Nicky Hilton

May 6, 1950

Nicky was the hotel heir and
great-uncle of Paris Hilton.
Elizabeth's wedding gown was
designed by Helen Rose.

Elizabeth Taylor
&
Michael Wilding

February 21, 1952

Elizabeth wore a tea-length
dress with portrait collar.

Elizabeth Taylor
&
Mike Todd

February 2, 1957

Todd was a stage & film
producer. Elizabeth wore a gown
designed by Helen Rose.

Elizabeth Taylor
&
Eddie Fisher

May 12, 1959

Elizabeth Taylor
&
Richard Burton

March 15, 1964
Montreal, Canada

The dress was designed
by Irene Sharaff.
(Elizabeth and Richard would
remarry on October 10, 1975.)

Elizabeth Taylor
&
Senator John Warner

December 4, 1976

Elizabeth Taylor
&
Larry Fortensky

October 6, 1990
at Neverland Ranch
with Michael Jackson

The dress was designed
by Valentino.

Elizabeth Taylor
as Cleopatra
&
Richard Burton
as Mark Anthony

Photographed on
the set of Cleopatra
in Rome, Italy
by Bert Stern

**Eight times wed,
the beautiful
Elizabeth is quoted
as saying,
"I am a committed
wife and I should
be committed
for being married
so many times."**

97

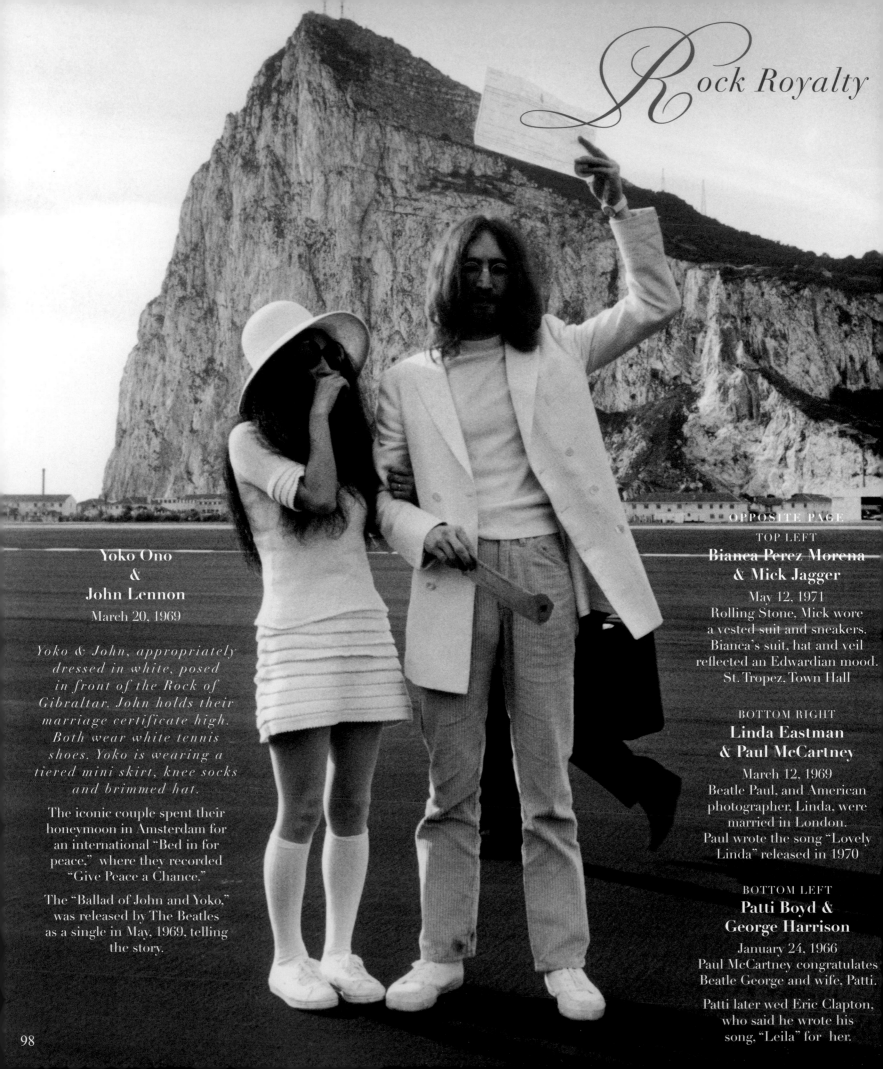

Yoko Ono & John Lennon

March 20, 1969

Yoko & John, appropriately dressed in white, posed in front of the Rock of Gibraltar. John holds their marriage certificate high. Both wear white tennis shoes. Yoko is wearing a tiered mini skirt, knee socks and brimmed hat.

The iconic couple spent their honeymoon in Amsterdam for an international "Bed in for peace," where they recorded "Give Peace a Chance."

The "Ballad of John and Yoko," was released by The Beatles as a single in May, 1969, telling the story.

OPPOSITE PAGE

TOP LEFT

Bianca Perez Morena & Mick Jagger

May 12, 1971
Rolling Stone, Mick wore a vested suit and sneakers. Bianca's suit, hat and veil reflected an Edwardian mood. St. Tropez, Town Hall

BOTTOM RIGHT

Linda Eastman & Paul McCartney

March 12, 1969
Beatle Paul, and American photographer, Linda, were married in London. Paul wrote the song "Lovely Linda" released in 1970

BOTTOM LEFT

Patti Boyd & George Harrison

January 24, 1966
Paul McCartney congratulates Beatle George and wife, Patti.

Patti later wed Eric Clapton, who said he wrote his song, "Leila" for her.

98

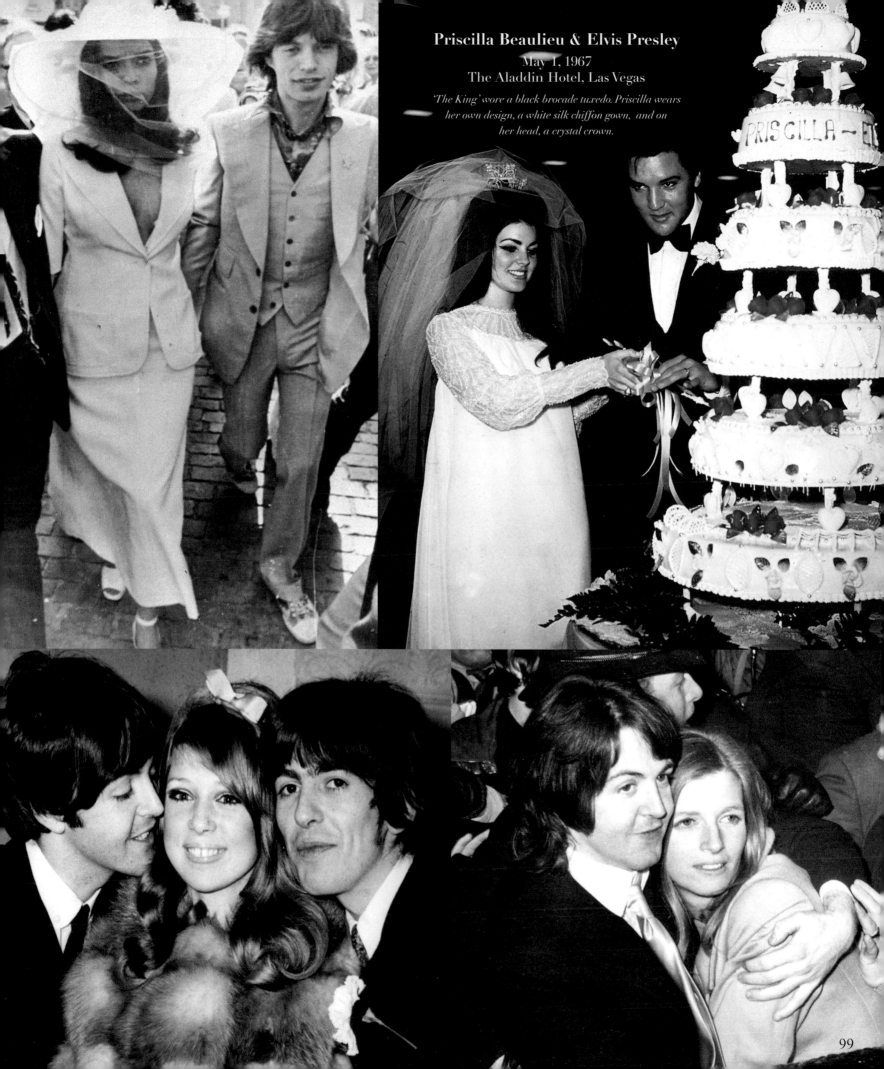

Priscilla Beaulieu & Elvis Presley
May 1, 1967
The Aladdin Hotel, Las Vegas

*'The King' wore a black brocade tuxedo. Priscilla wears
her own design, a white silk chiffon gown, and on
her head, a crystal crown.*

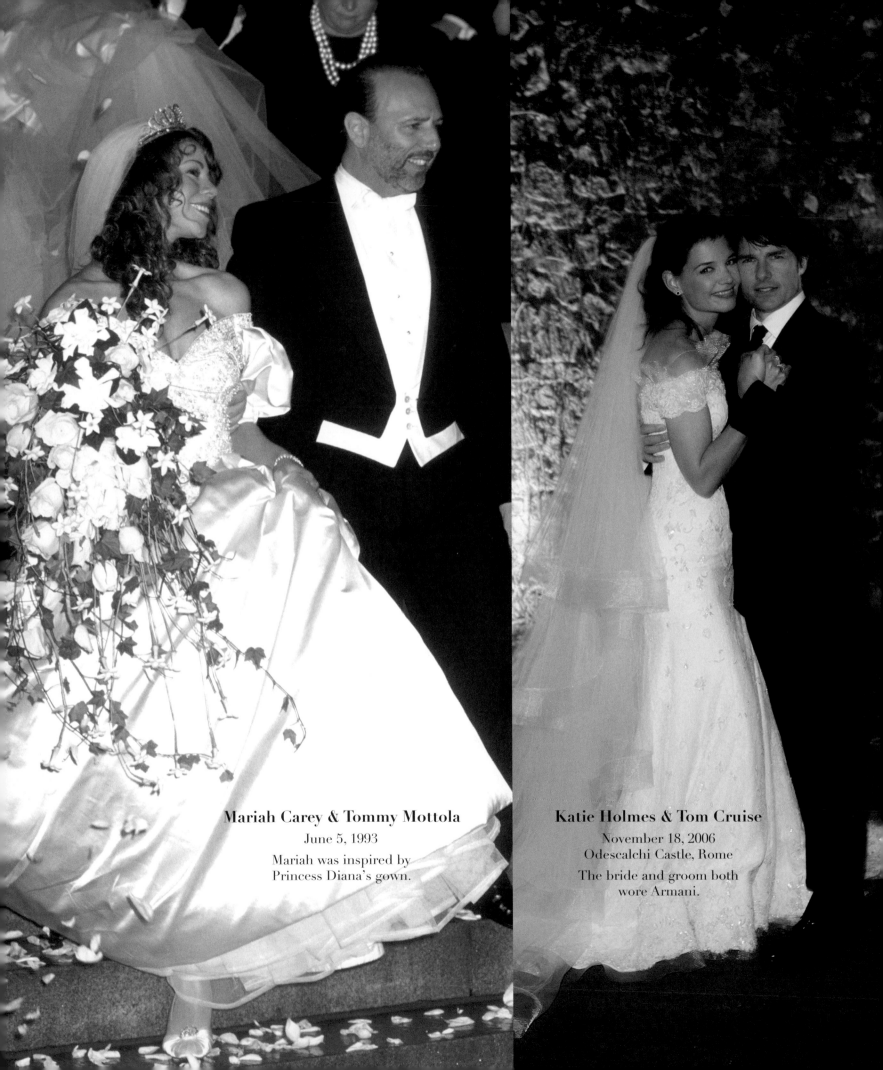

Mariah Carey & Tommy Mottola

June 5, 1993

Mariah was inspired by
Princess Diana's gown.

Katie Holmes & Tom Cruise

November 18, 2006

Odescalchi Castle, Rome

The bride and groom both
wore Armani.

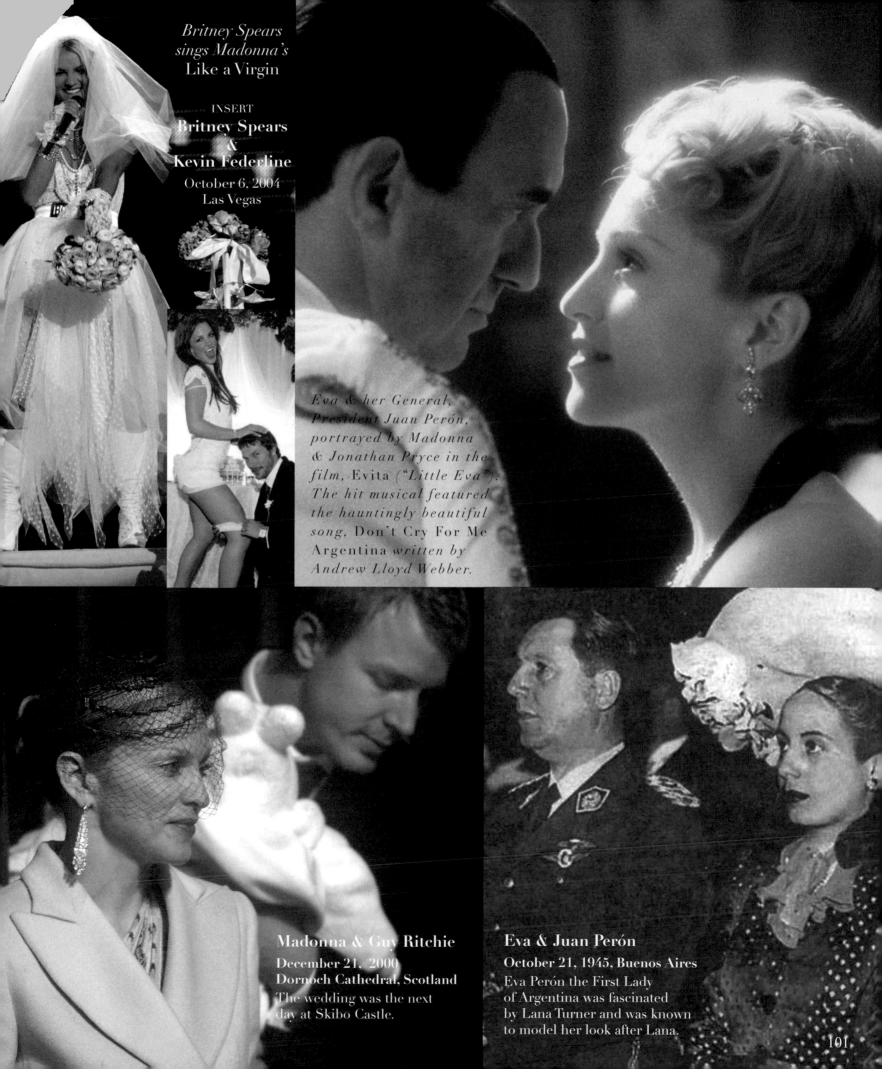

Britney Spears sings Madonna's Like a Virgin

INSERT
Britney Spears & Kevin Federline
October 6, 2004
Las Vegas

Eva & her General, President Juan Perón, portrayed by Madonna & Jonathan Pryce in the film, Evita *("Little Eva"). The hit musical featured the hauntingly beautiful song,* Don't Cry For Me Argentina *written by Andrew Lloyd Webber.*

Madonna & Guy Ritchie
December 21, 2000
Dornoch Cathedral, Scotland
The wedding was the next day at Skibo Castle.

Eva & Juan Perón
October 21, 1945, Buenos Aires
Eva Perón the First Lady of Argentina was fascinated by Lana Turner and was known to model her look after Lana.

101

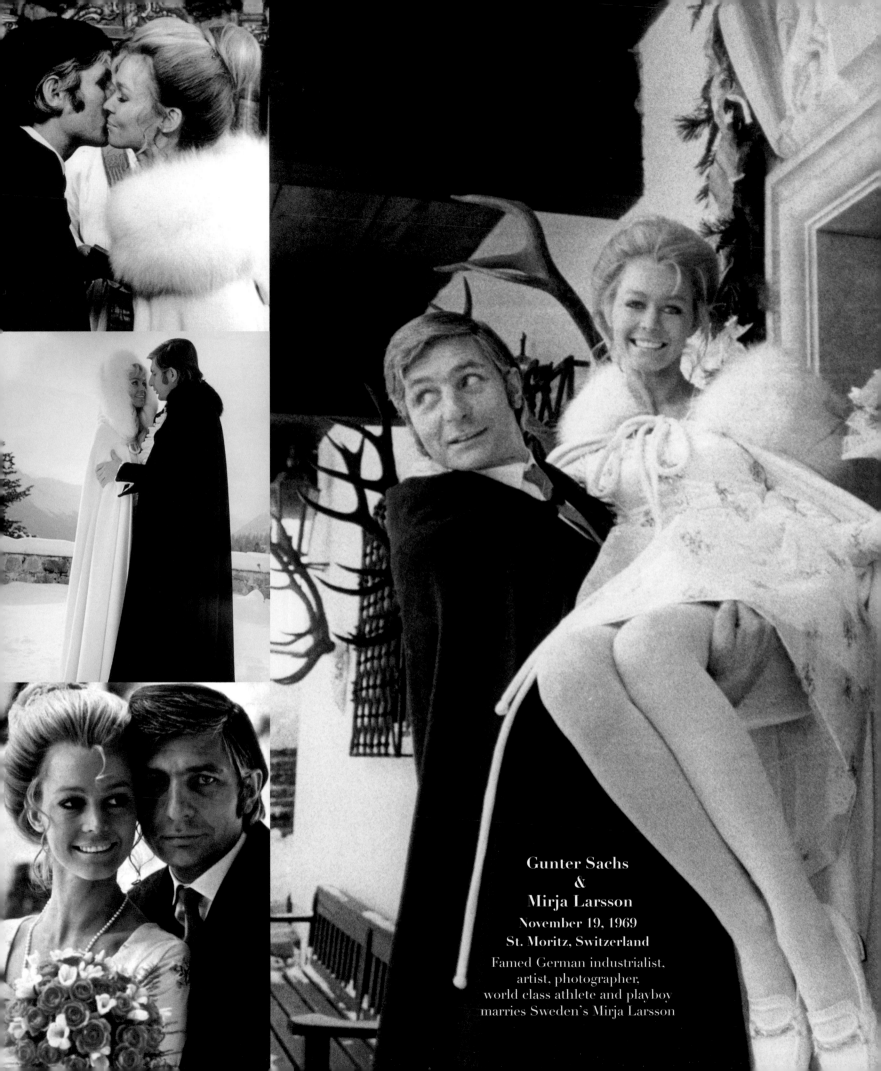

**Gunter Sachs
&
Mirja Larsson**
November 19, 1969
St. Moritz, Switzerland

Famed German industrialist,
artist, photographer,
world class athlete and playboy
marries Sweden's Mirja Larsson

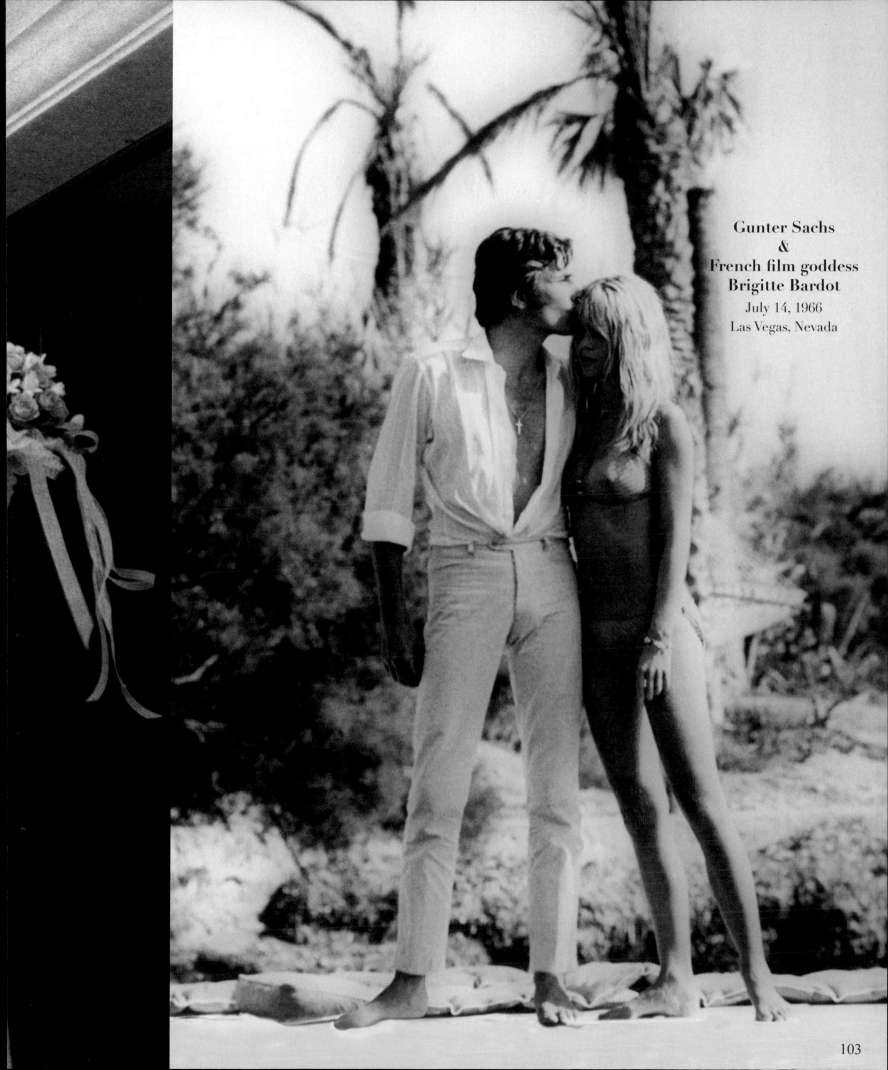

Gunter Sachs
&
French film goddess
Brigitte Bardot
July 14, 1966
Las Vegas, Nevada

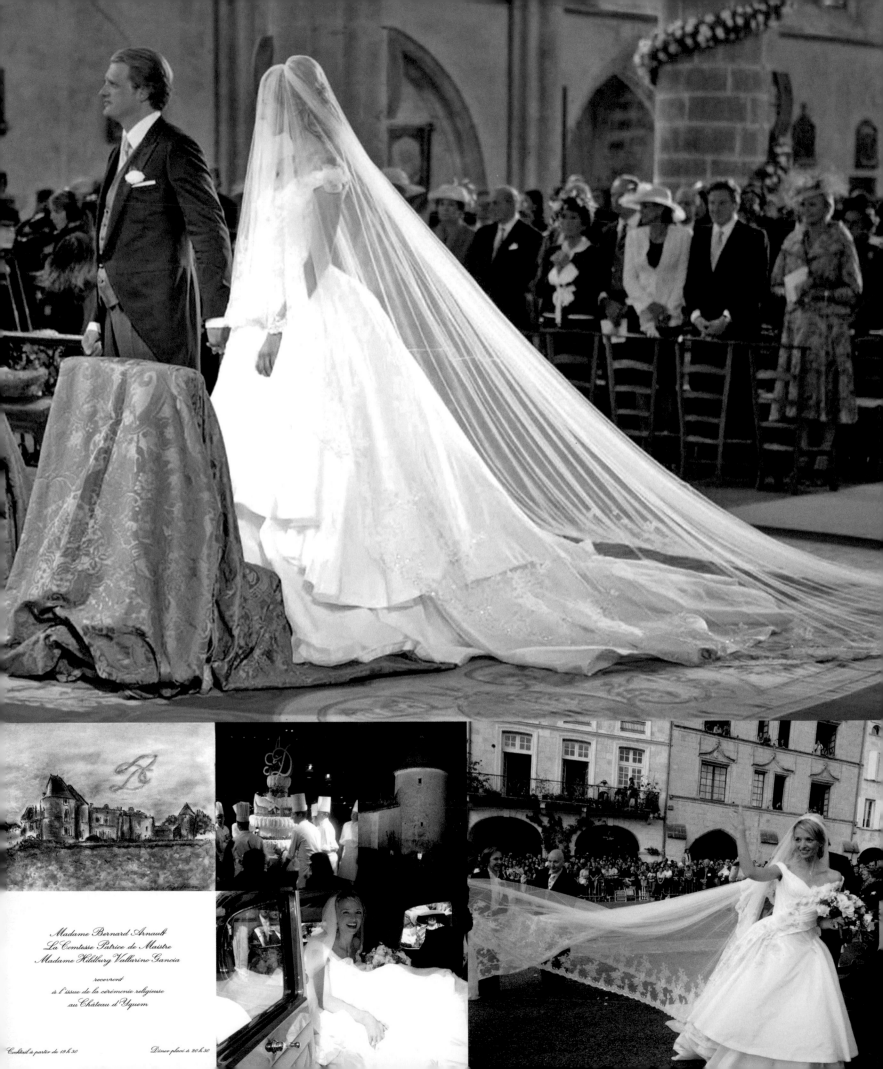

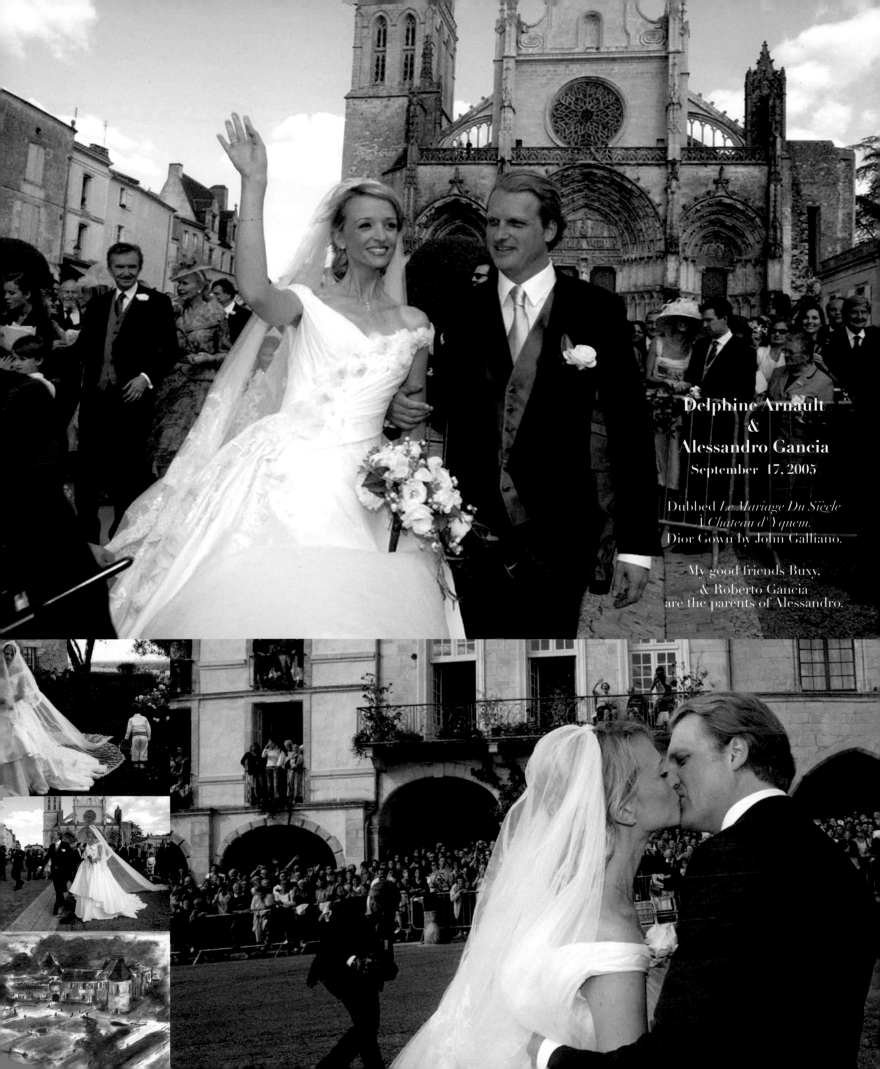

**Delphine Arnault
&
Alessandro Gancia**
September 17, 2005

Dubbed *Le Mariage Du Siècle*
À *Château d'Yquem*.
Dior Gown by John Galliano.

My good friends Buxy,
& Roberto Gancia
are the parents of Alessandro.

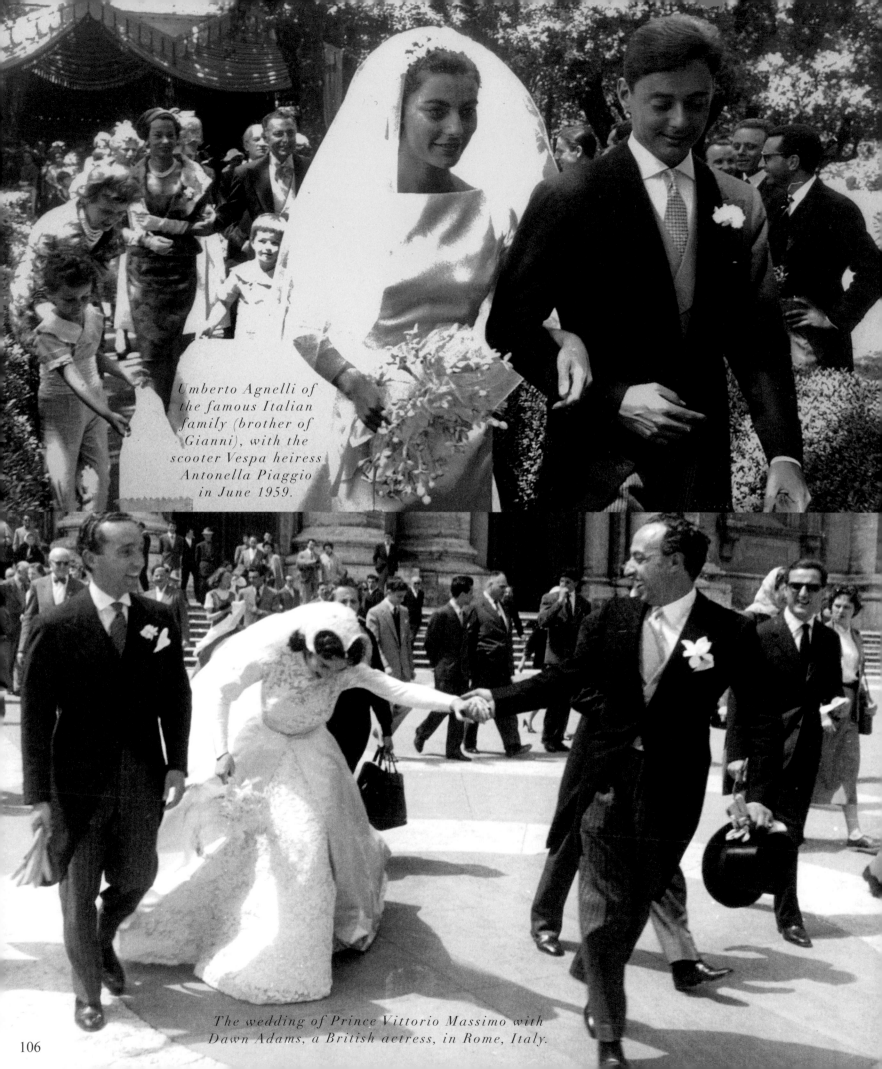

Umberto Agnelli of the famous Italian family (brother of Gianni), with the scooter Vespa heiress Antonella Piaggio in June 1959.

The wedding of Prince Vittorio Massimo with Dawn Adams, a British actress, in Rome, Italy.

Gianni and I were friends.

I knew Gianni Agnelli and Emilio Pucci since we were children playing on the beach at Forte dei Marmi in Italy. Fiat was Gianni's company, and he liked to be called simply 'avvocato' (lawyer).

Slim and elegant, Gianni's every gesture was distinctive. Always immensely well dressed, he lived dangerously, roaring along the haute corniche to Cannes at 100 miles per hour from his villa La Leopolda, formerly the summer home of King Leopold of Belgium.

I would spend weeks at La Leopolda with Gianni and the tall, regal and beautiful, Marella.

At La Leopolda, I would be given my own guest pavillion set off from the main house with a separate swimming pool and liveried servants in attendance.

RIGHT The wedding of the Princess Marella Caracciolo di principi Castagneto and Gianni Agnelli in Strasbourg, France on November 29, 1953.

107

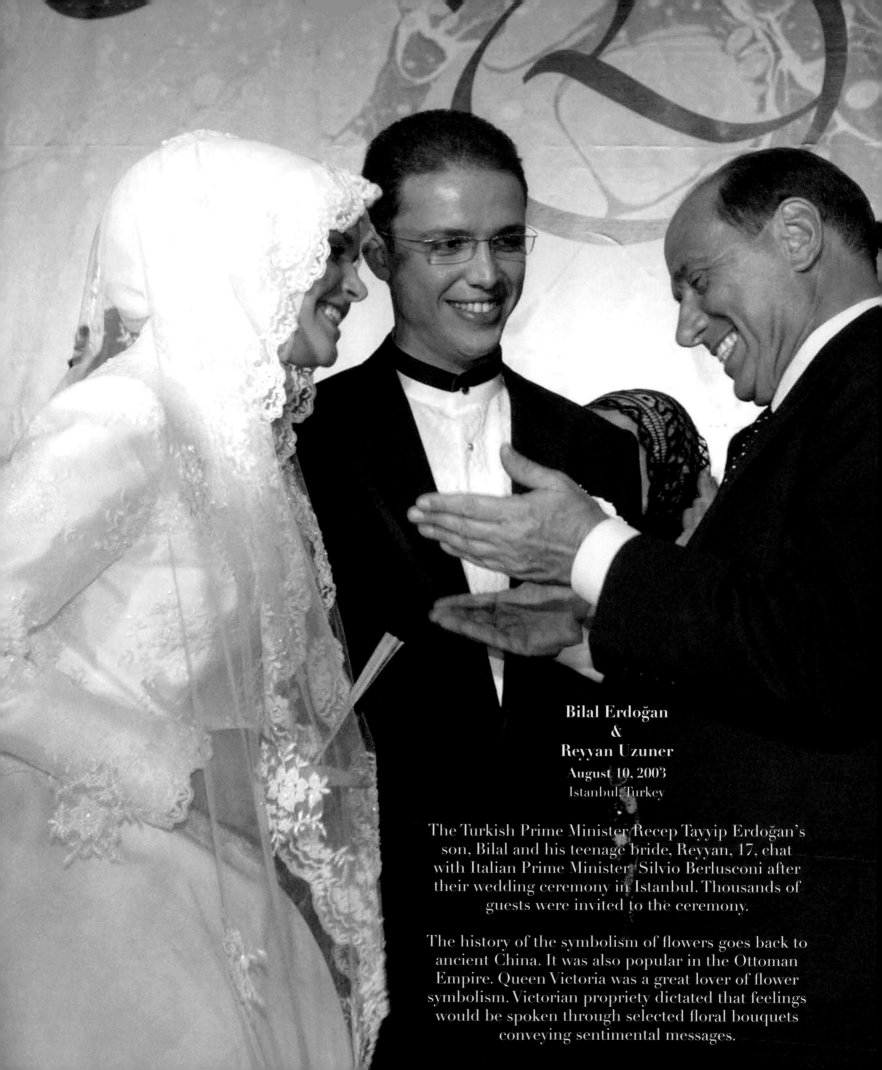

Bilal Erdoğan
&
Reyyan Uzuner
August 10, 2003
Istanbul, Turkey

The Turkish Prime Minister Recep Tayyip Erdoğan's son, Bilal and his teenage bride, Reyyan, 17, chat with Italian Prime Minister Silvio Berlusconi after their wedding ceremony in Istanbul. Thousands of guests were invited to the ceremony.

The history of the symbolism of flowers goes back to ancient China. It was also popular in the Ottoman Empire. Queen Victoria was a great lover of flower symbolism. Victorian propriety dictated that feelings would be spoken through selected floral bouquets conveying sentimental messages.

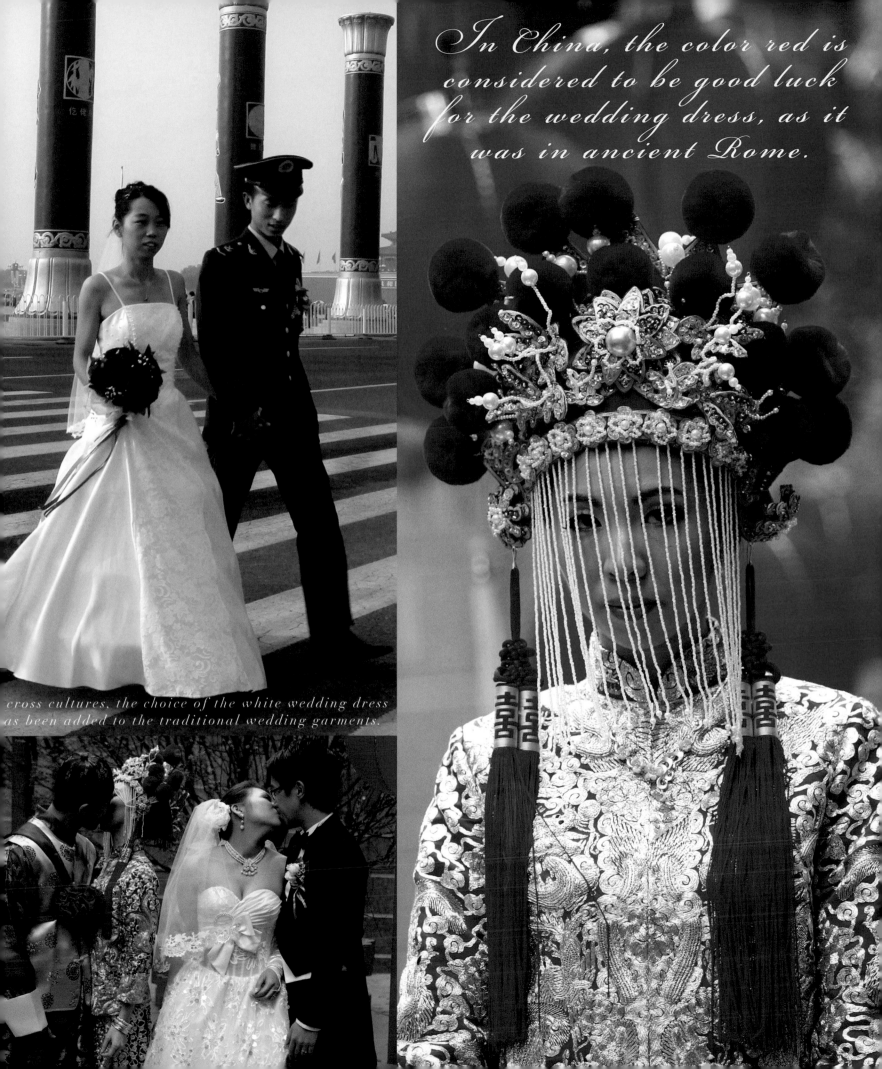

In China, the color red is considered to be good luck for the wedding dress, as it was in ancient Rome.

cross cultures, the choice of the white wedding dress as been added to the traditional wedding garments.

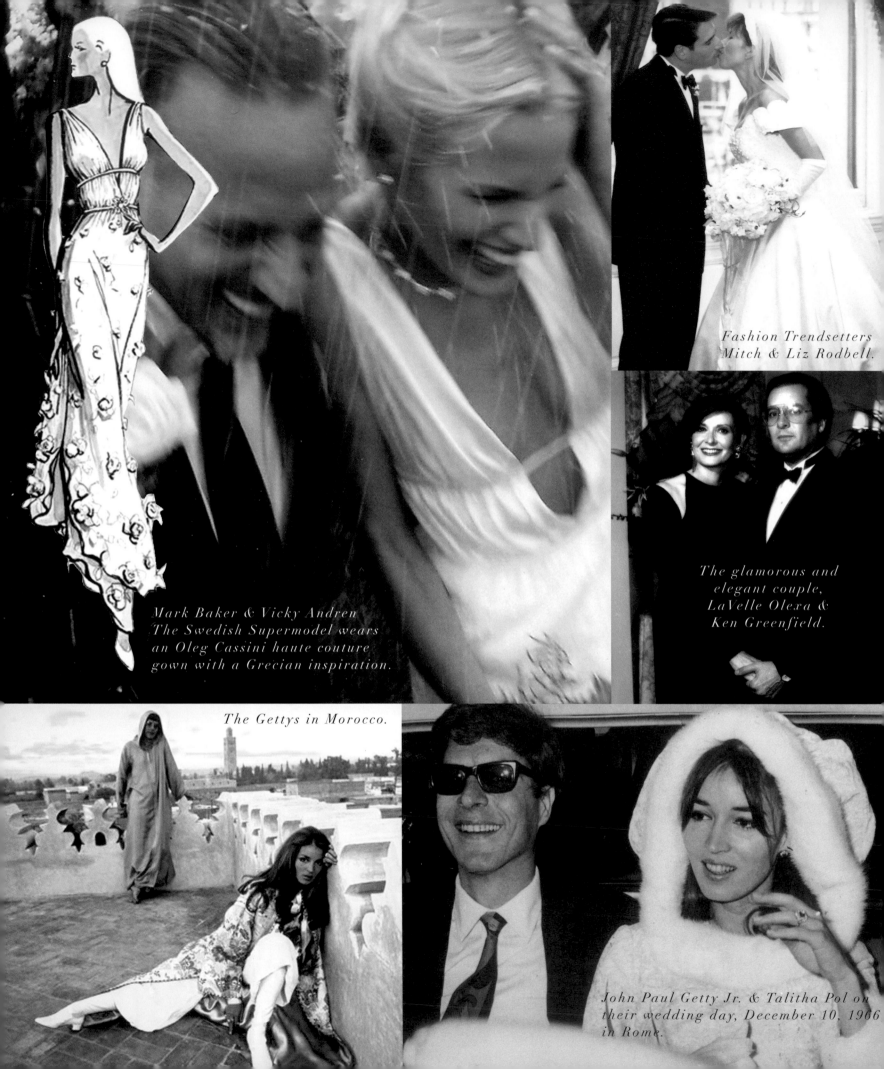

Mark Baker & Vicky Andren
The Swedish Supermodel wears
an Oleg Cassini haute couture
gown with a Grecian inspiration.

Fashion Trendsetters
Mitch & Liz Rodbell.

The glamorous and
elegant couple,
LaVelle Olexa &
Ken Greenfield.

The Gettys in Morocco.

John Paul Getty Jr. & Talitha Pol on
their wedding day, December 10, 1966
in Rome.

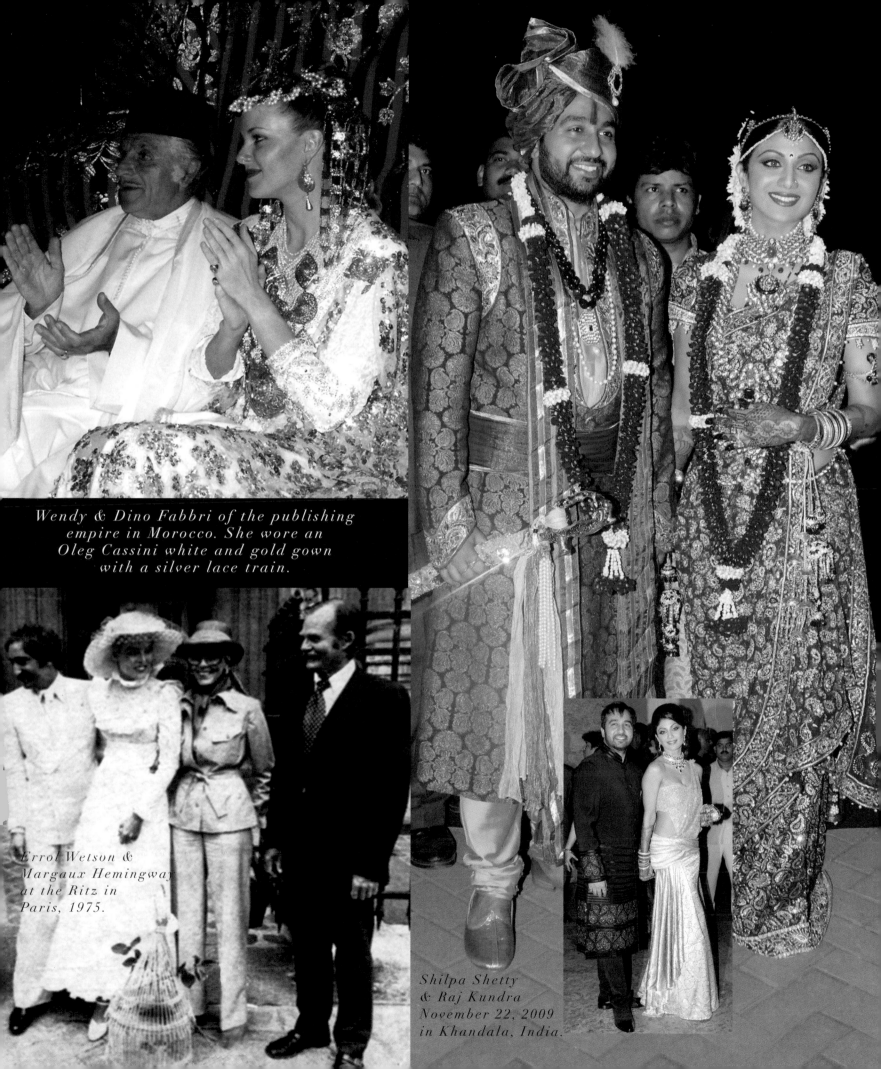

Wendy & Dino Fabbri of the publishing empire in Morocco. She wore an Oleg Cassini white and gold gown with a silver lace train.

Errol Wetson & Margaux Hemingway at the Ritz in Paris, 1975.

Shilpa Shetty & Raj Kundra November 22, 2009 in Khandala, India.

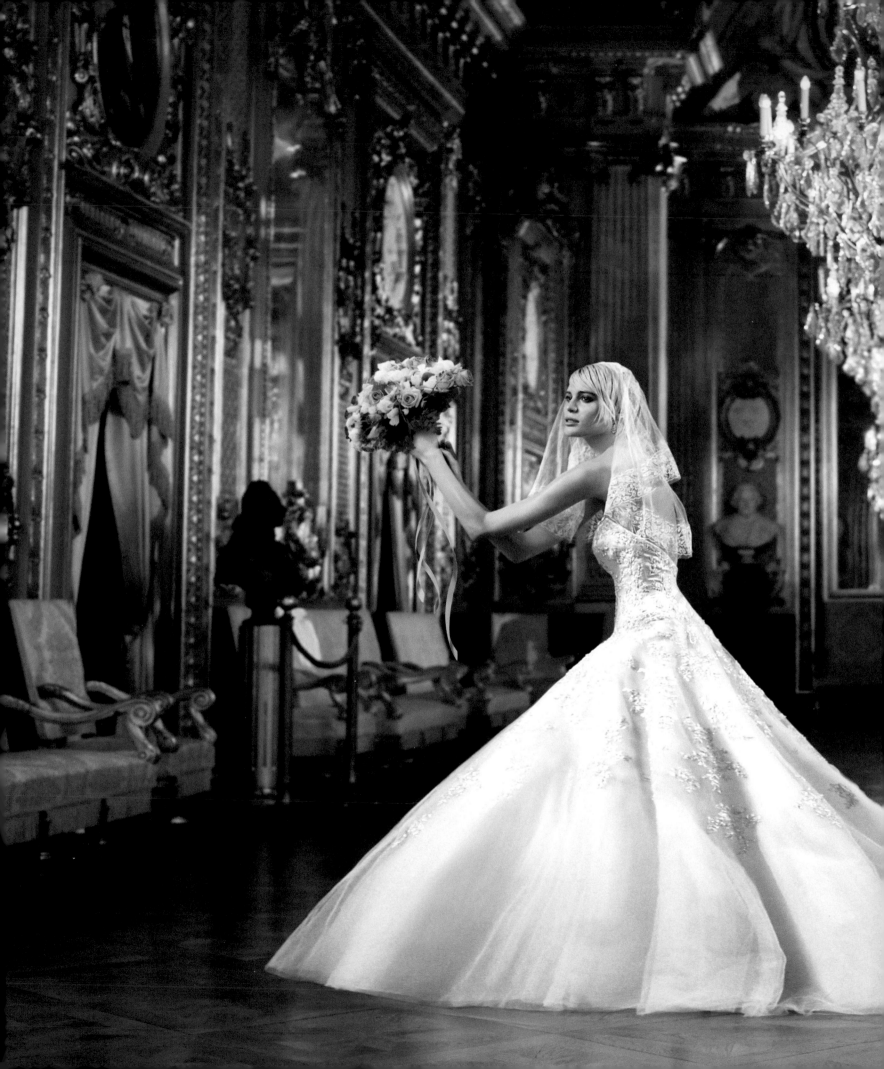

"IT'S ALL ABOUT THE DRESS."

OLEG CASSINI

The ultra feminine wedding dress, a tribute to old world elegance and glamour, captures the most magical, memorable moments of her life.

THE *raditional White*

The costume the bride chooses for her wedding is unique and special to her. Since this is the moment that surpasses all others, what the bride chooses to wear as adornment is key to the entire event.

For one of the most significant royal weddings of all time, the bride, Queen Victoria, wore a white wedding dress. She chose white silk with a Honiton lace overlay for her gown and train, trimmed with fresh orange blossoms. Her bridesmaids were dressed in similar white gowns. She also had her bridesmaids carry her long train, setting another tradition, which along with the traditional wearing of white has continued from the 19th century into the 21st. Today the Maid of Honor traditionally helps to arrange the train, if needed, and holds the floral bouquet during the ceremony.

White comes in many tonal shades, and becomes the perfect palette for embroidery and embellishments of crystals, pearls, and lace over satin and ethereal tulle. Color has been used as an accent to white very successfully, and although white is assumed to be the color for a wedding dress, blue preceded white as a symbol of romance, and fidelity. Shades of golden yellow trimmed with gold became an important color choice for brides in the 18th century. Today's wedding is a ceremony that celebrates the joy of romance, yet through the centuries, wars have been fought because of marriages.

Royal marriages set traditions for brides, as the celebrities of their day and most royal marriages were of political importance since they involved kingdoms and future dynasties.

Symbols of wealth were displayed on the outer garments, which were encrusted with precious stones stitched with silver and gold on opulent fabrics. The overall impression of these royal robes was one of power, prosperity, beauty, and above all, optimism.

The bride is a vision in traditional white lace embroidered with crystal and pearl beading on white satin and tulle. She wears a lace mantilla and carries a bouquet of white orchids. The orchid, with its rare and delicate beauty is historically known as a symbol of wealth, love, beauty, and luxury. In ancient Greece, the orchid was thought to represent virility and strength.

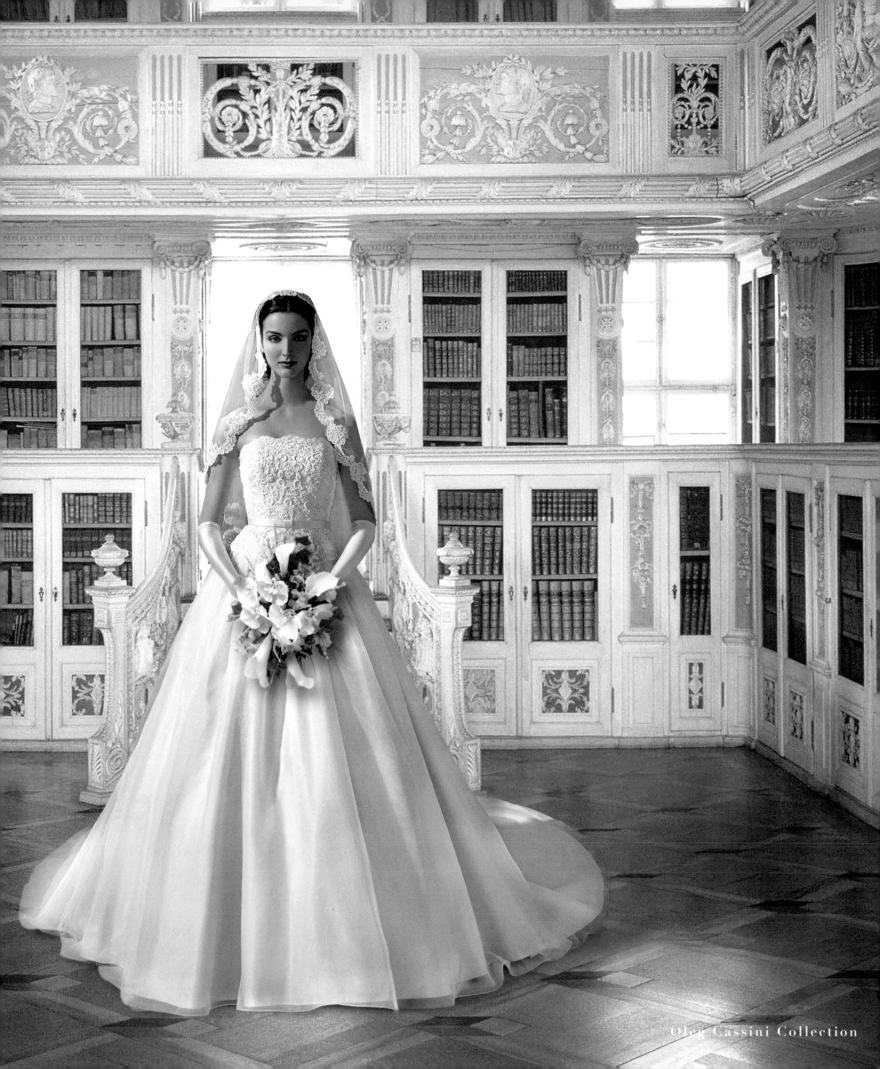

Oleg Cassini Collection

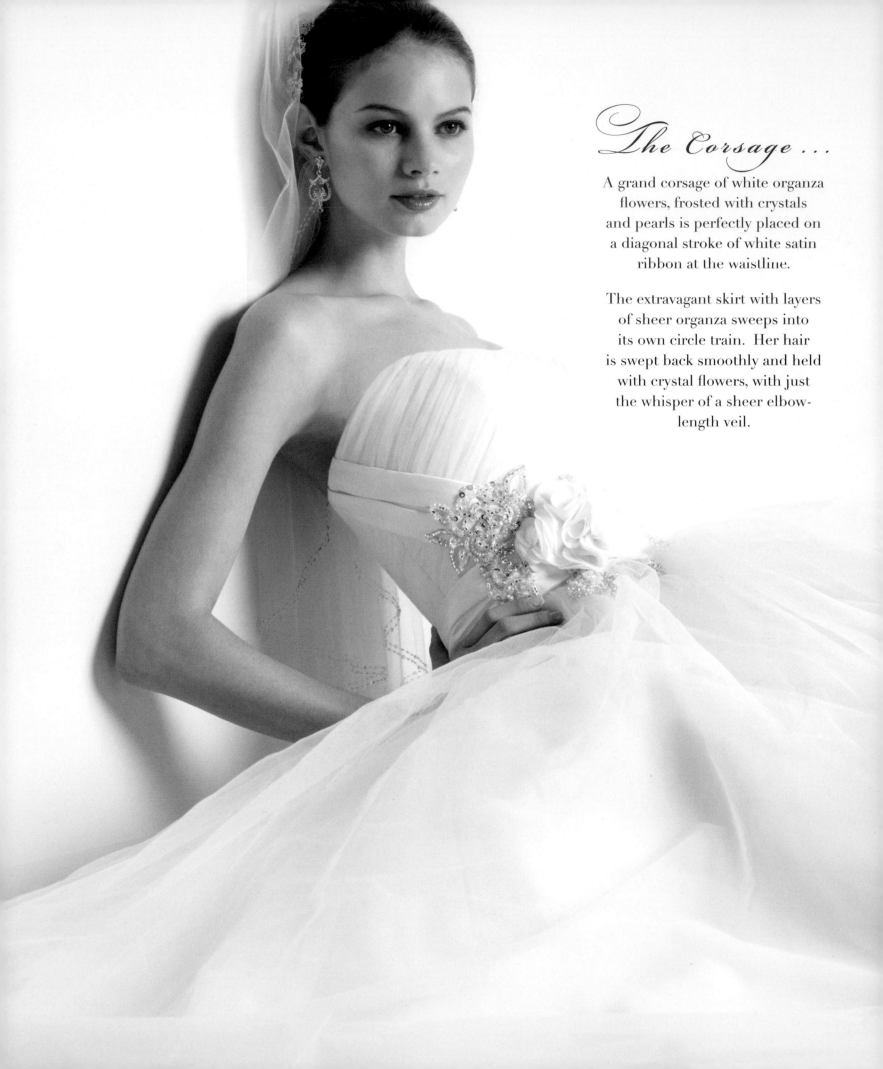

The Corsage ...

A grand corsage of white organza flowers, frosted with crystals and pearls is perfectly placed on a diagonal stroke of white satin ribbon at the waistline.

The extravagant skirt with layers of sheer organza sweeps into its own circle train. Her hair is swept back smoothly and held with crystal flowers, with just the whisper of a sheer elbow-length veil.

The look of
flawless perfection . . .

*Nights in
white satin
with a twist
of iced crystal*

The luminous quality of pure white satin is the perfect backdrop for a band of diamond shaped floral motifs of crystals stitched with silver threads. The strapless bodice has a dropped waistline set into a skirt with inverted pleats that explode into a wide circle train. Her hair is smoothed into a chignon and topped with a crescent tiara and an elbow length jeweled veil.

Oleg Cassini
Collection

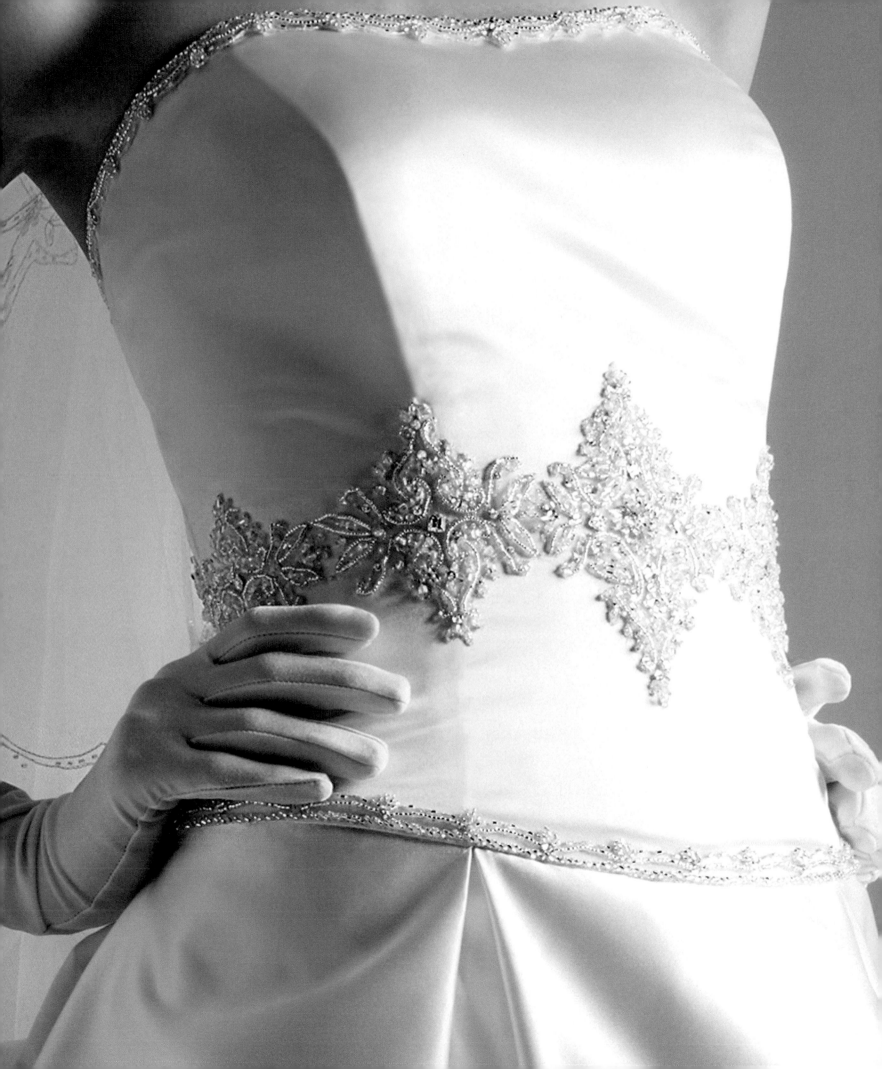

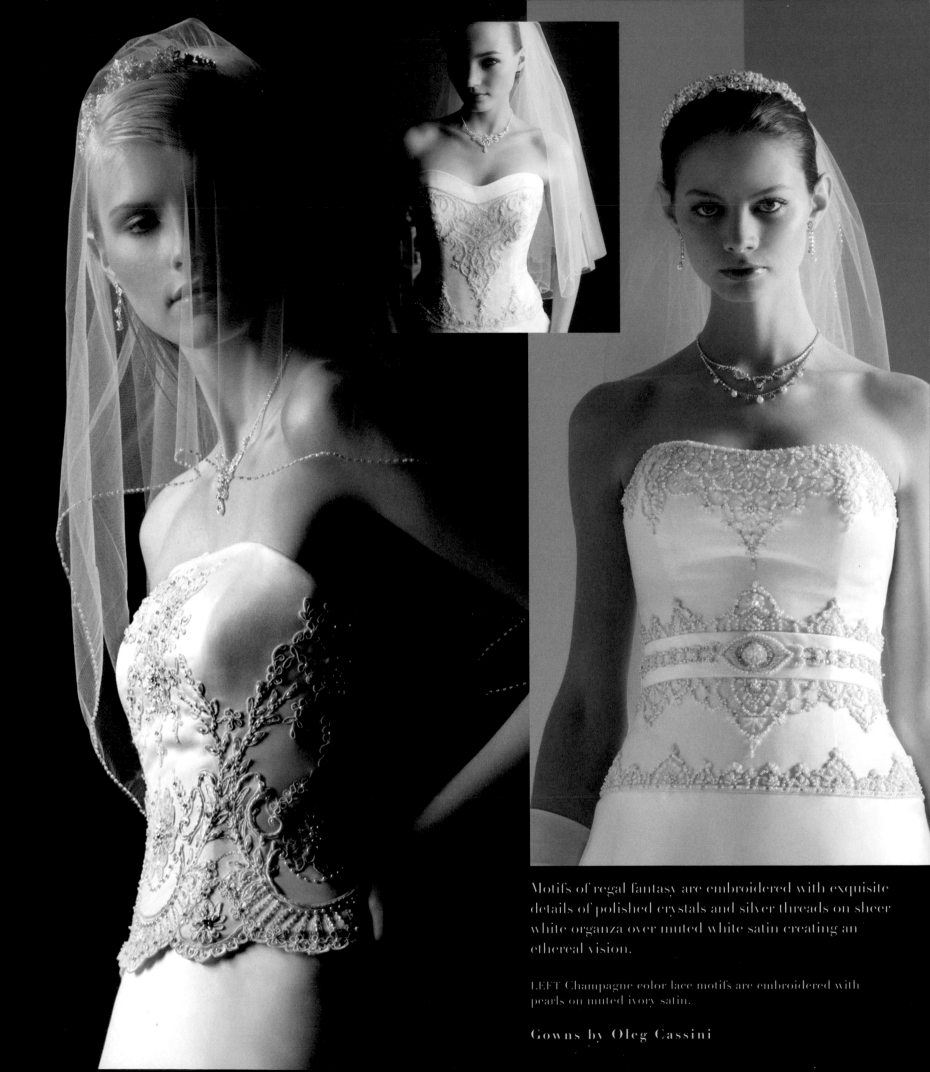

Motifs of regal fantasy are embroidered with exquisite details of polished crystals and silver threads on sheer white organza over muted white satin creating an ethereal vision.

LEFT Champagne color lace motifs are embroidered with pearls on muted ivory satin.

Gowns by Oleg Cassini

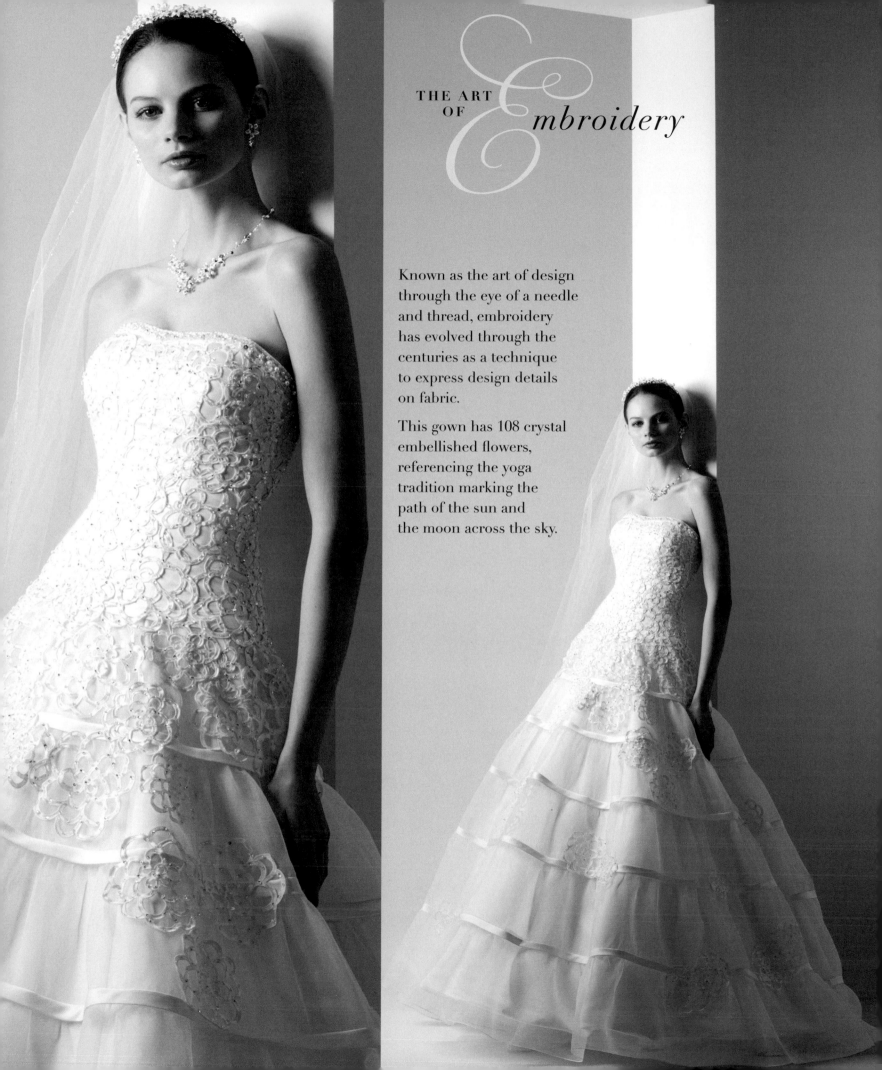

THE ART OF *Embroidery*

Known as the art of design through the eye of a needle and thread, embroidery has evolved through the centuries as a technique to express design details on fabric.

This gown has 108 crystal embellished flowers, referencing the yoga tradition marking the path of the sun and the moon across the sky.

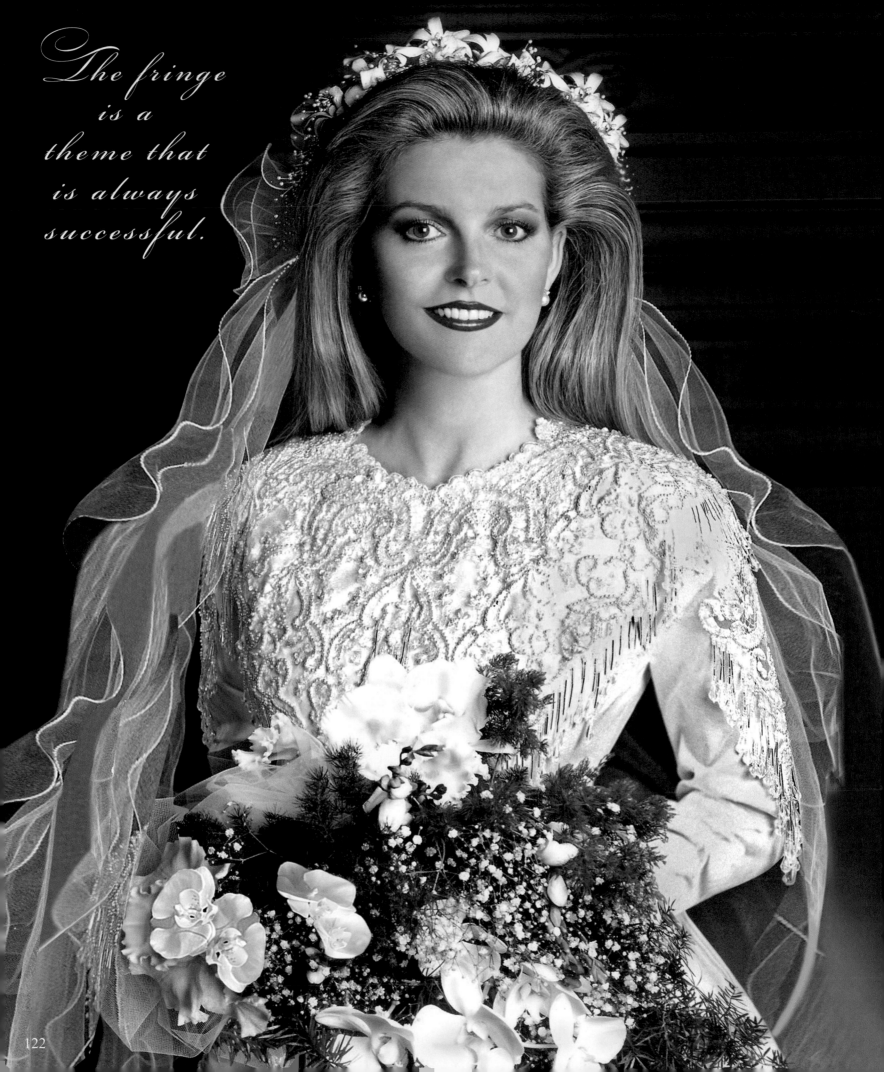

The fringe is a theme that is always successful.

122

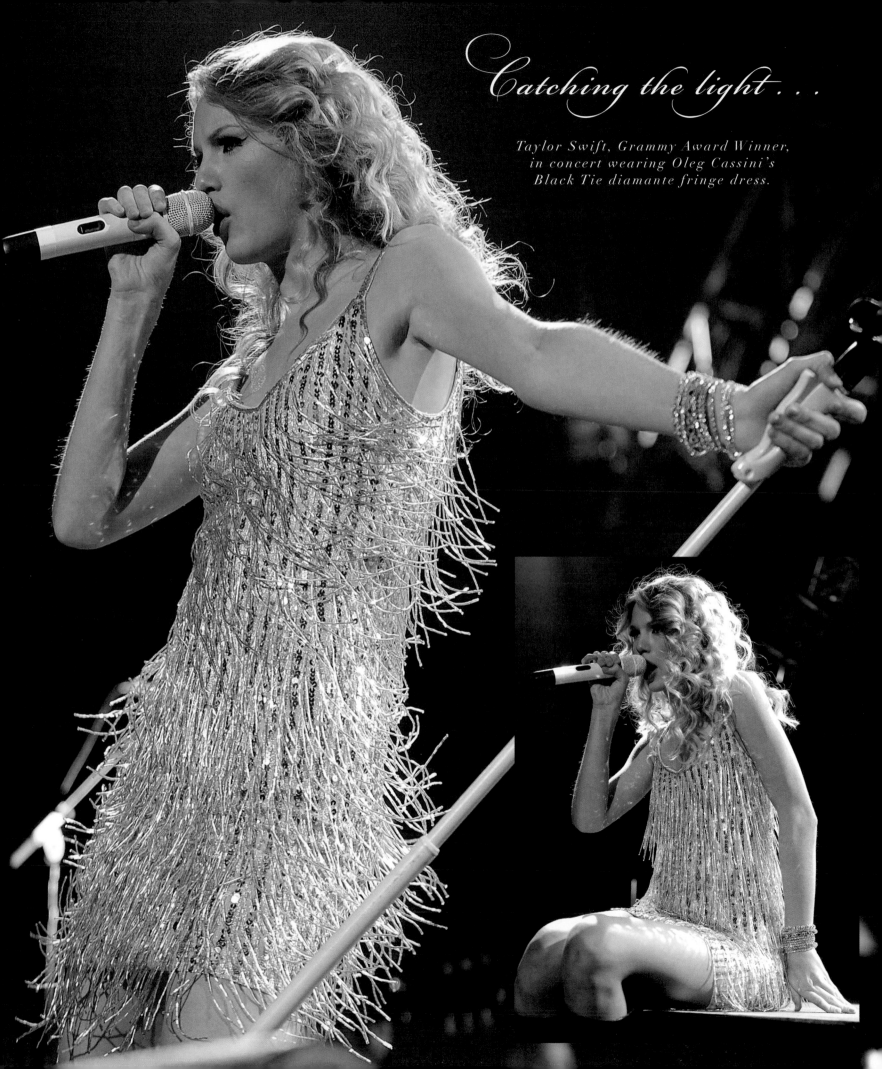

Catching the light . . .

Taylor Swift, Grammy Award Winner,
in concert wearing Oleg Cassini's
Black Tie diamante fringe dress.

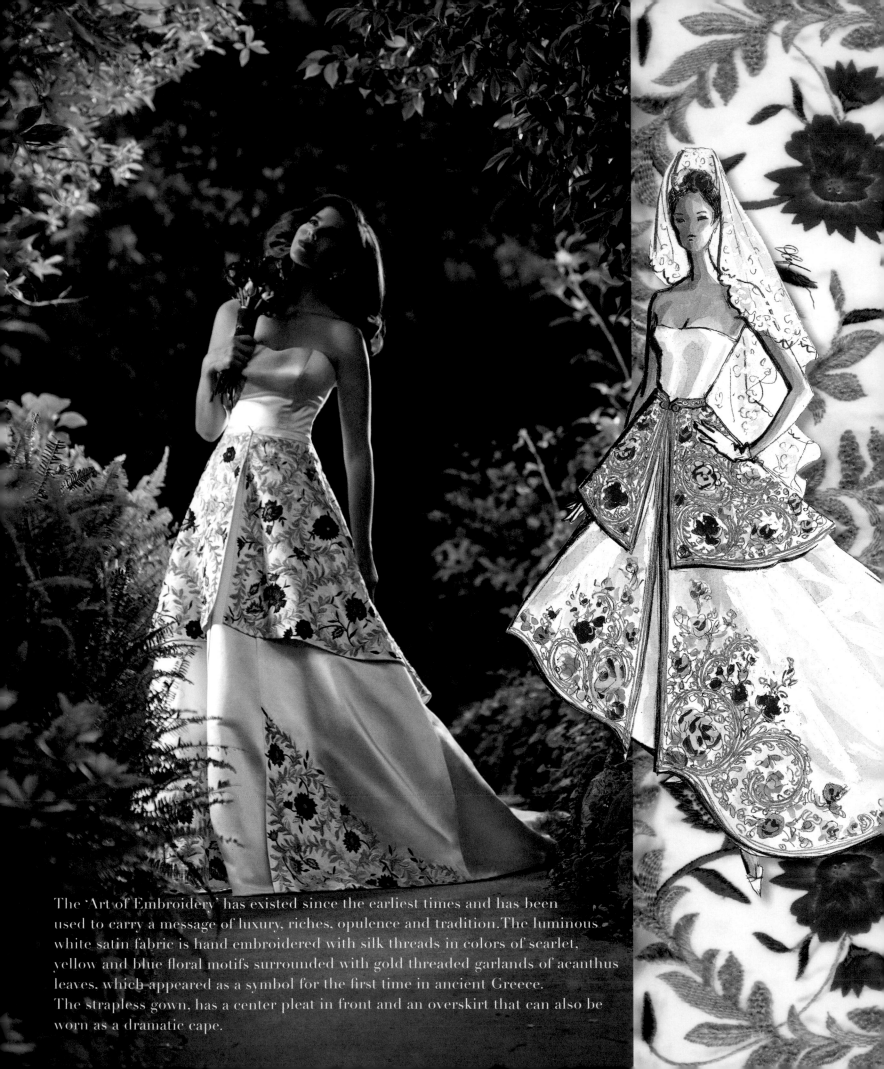

The 'Art of Embroidery' has existed since the earliest times and has been used to carry a message of luxury, riches, opulence and tradition. The luminous white satin fabric is hand embroidered with silk threads in colors of scarlet, yellow and blue floral motifs surrounded with gold threaded garlands of acanthus leaves, which appeared as a symbol for the first time in ancient Greece. The strapless gown, has a center pleat in front and an overskirt that can also be worn as a dramatic cape.

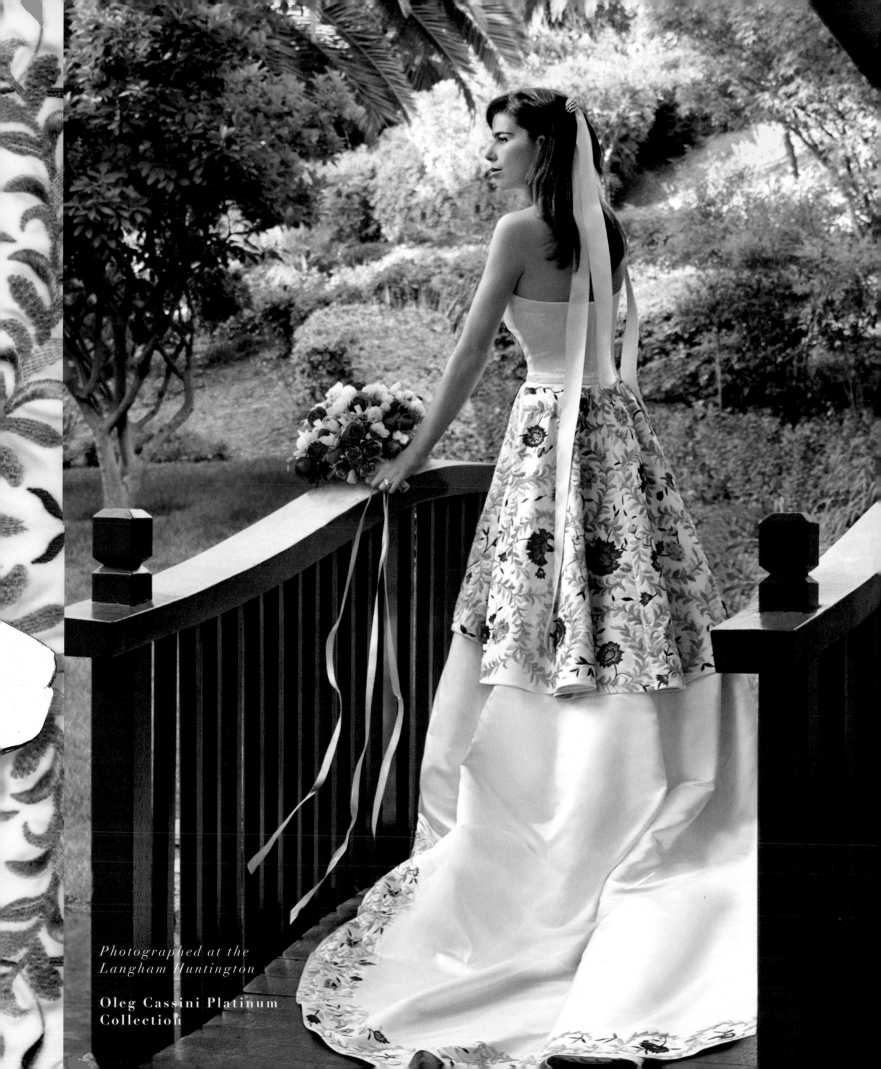

Photographed at the Langham Huntington

Oleg Cassini Platinum Collection

The Cassini cover look exemplifies the timeless allure of sheer layers of tulle. The shirred satin bodice is accented with satin flowers at the waist.

BRIDES

over look

39
NEW IDEAS
customize
your party!

dresses
for moms
**of every
shape**

67
PERFECT
first-dance
songs

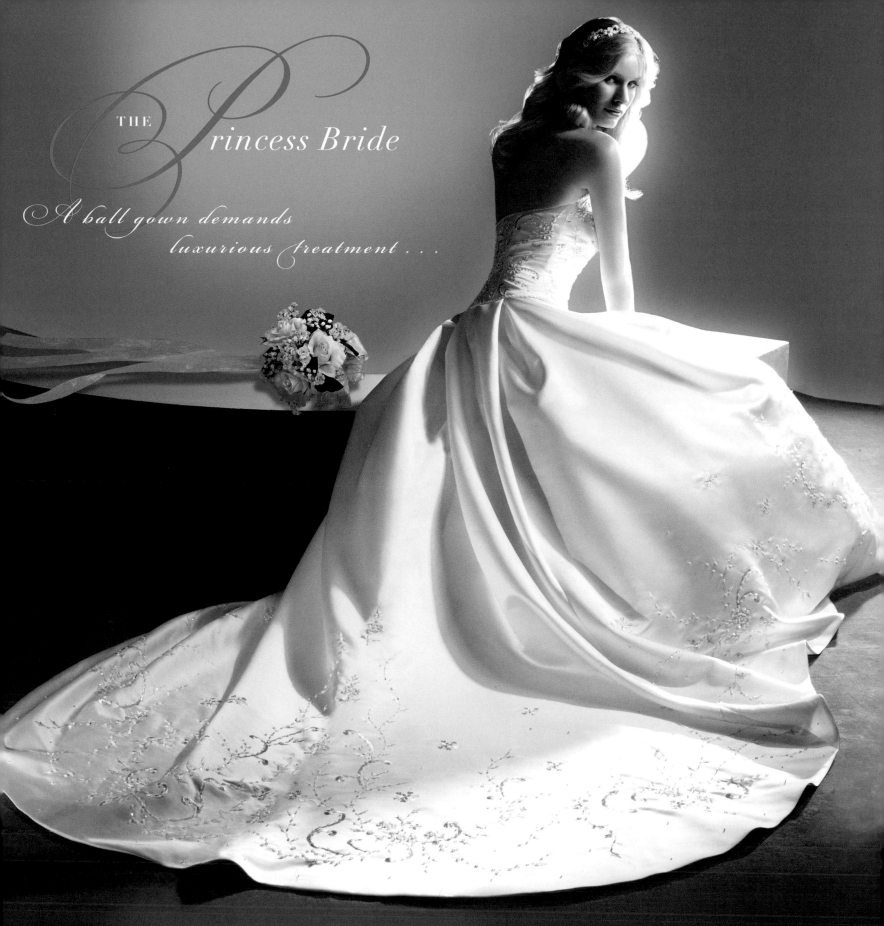

THE Princess Bride

A ball gown demands luxurious treatment . . .

As a term, the Princess Bride is perfect for the bride taking center stage, evoking all the glamour and expectation of a young débutante. The silhouette is storybook, enhancing the romance of a narrow waist and the drama of a very full skirt.

ABOVE The strapless ball gown evokes movie star glamour with the crystal embroidered bodice and circle-train giving red carpet impact.

Oleg Cassini Collection

Belle of the Ball

Like a magnificent still life portrait, a ball gown recalls the glamour of royalty.

Its silhouette is débutante in mood, and fun to wear. Both grand yet modest, it achieves a regal impression with a flattering silhouette.

It is most often designed with a strapless, very fitted bodice giving a dramatic contrast to the fullness of the skirt.

The ball gown lends a creative palette for details. The bodice of opalescent sequins reflects prisms of light, a marvelous combination with the softness of the matte finish tulle skirt.

Oleg Cassini Collection

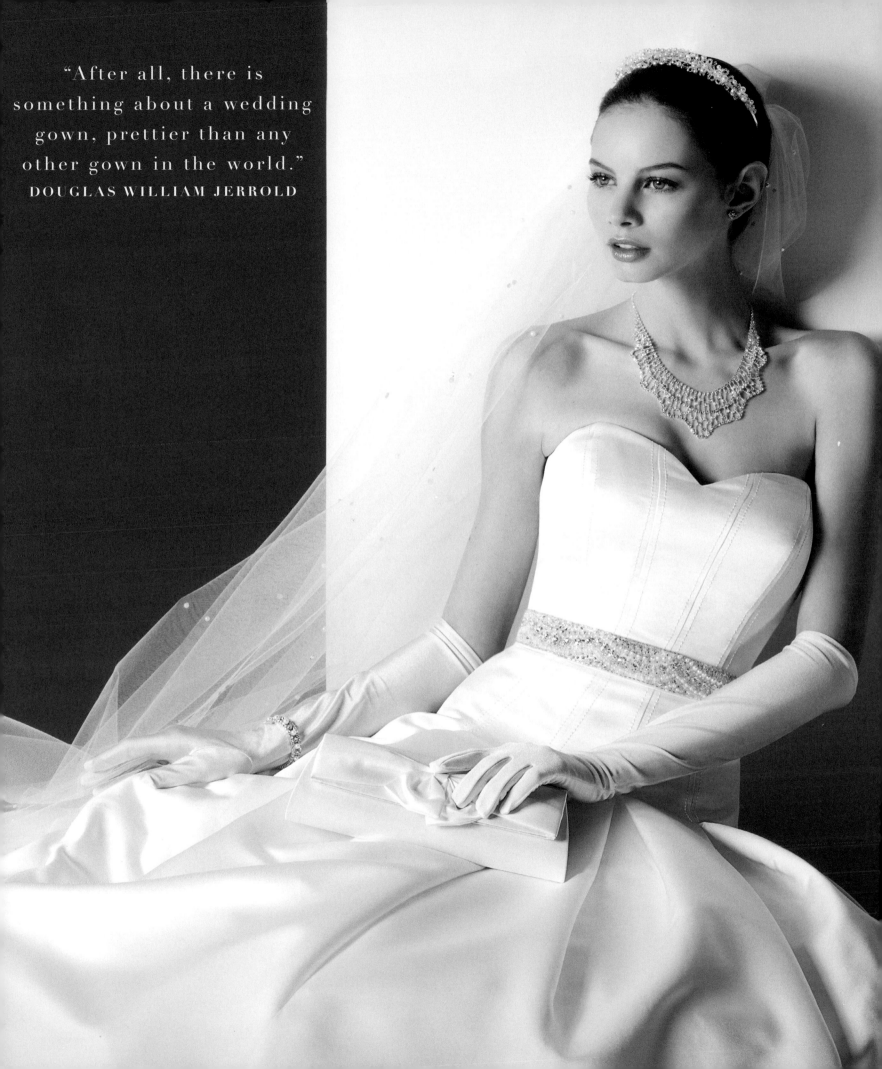

"After all, there is something about a wedding gown, prettier than any other gown in the world."
DOUGLAS WILLIAM JERROLD

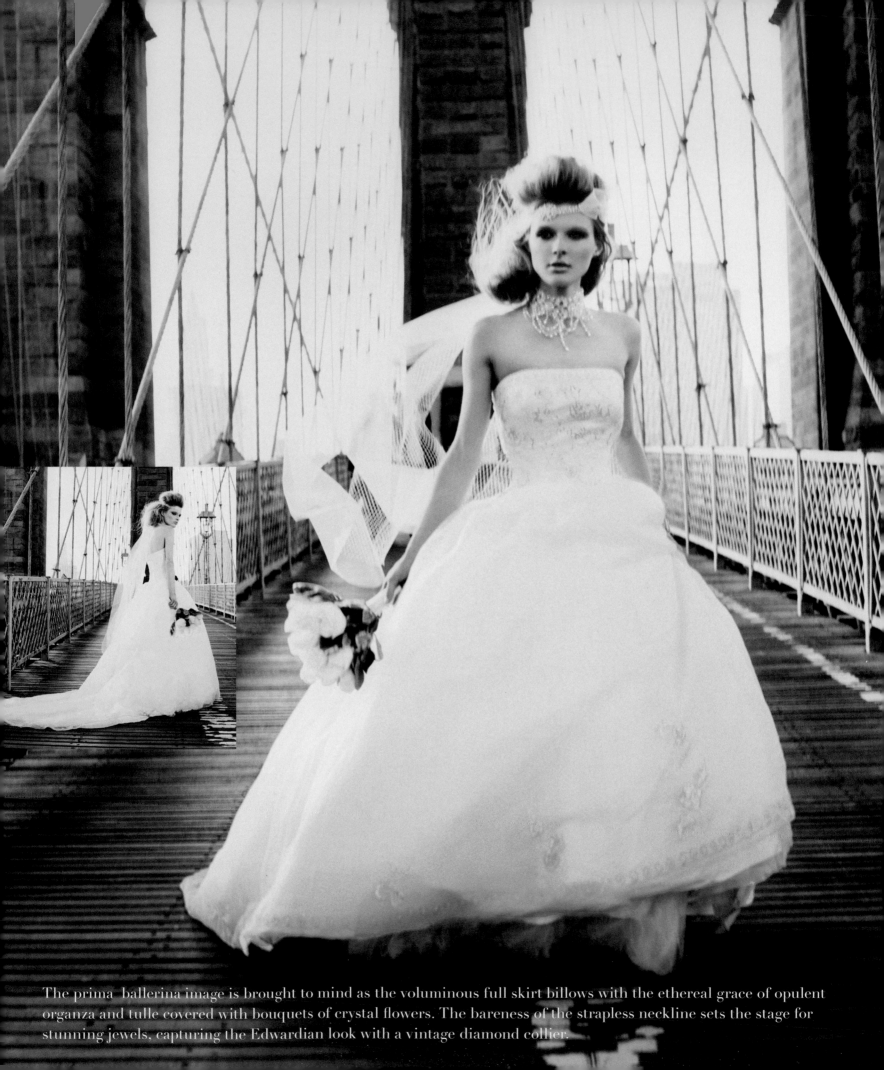

The prima ballerina image is brought to mind as the voluminous full skirt billows with the ethereal grace of opulent organza and tulle covered with bouquets of crystal flowers. The bareness of the strapless neckline sets the stage for stunning jewels, capturing the Edwardian look with a vintage diamond collier.

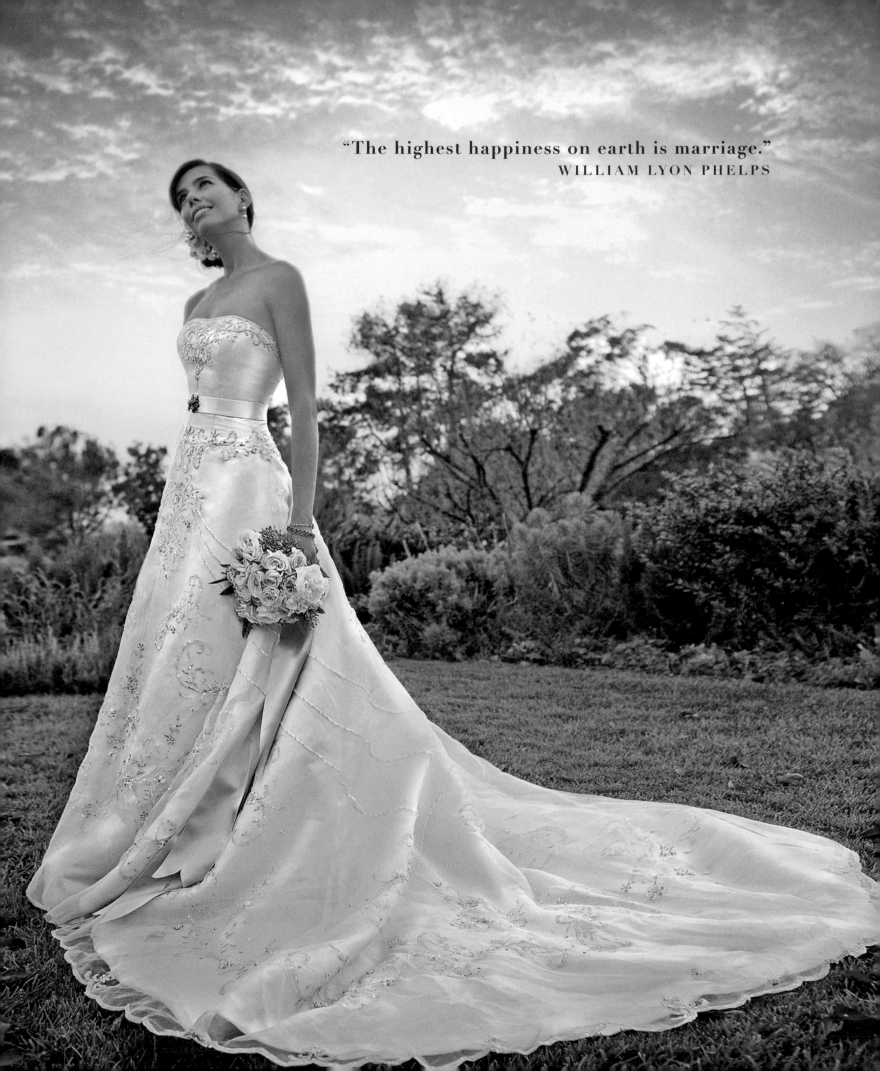

"The highest happiness on earth is marriage."
WILLIAM LYON PHELPS

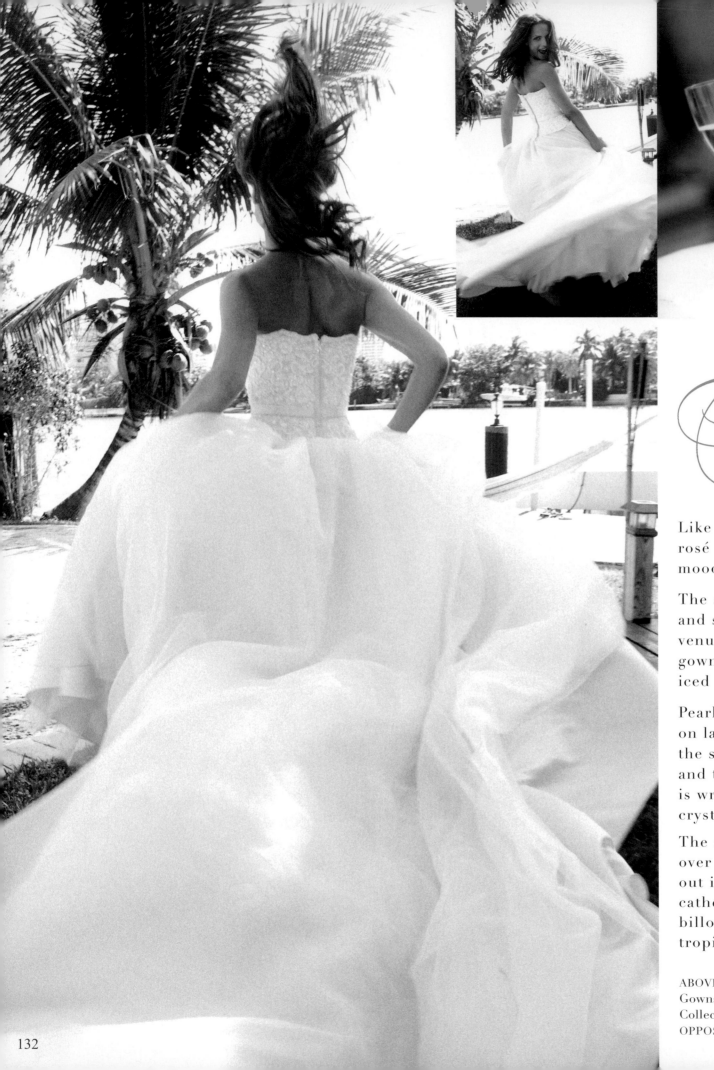

Formal & Fun

Like a crystal glass of rosé champagne, the mood is light and lovely.

The setting of blue sea, and sky is the perfect venue for a fantasy gown, in the color of iced rosé champagne.

Pearls and crystals on lace over satin for the scalloped bodice, and the dropped waist is wrapped with a crystal belt.

The fabulous organza over satin skirt swings out into its own cathedral train that billows in the soft tropical breezes.

ABOVE Casa Cassini Crystal Flute Gowns by Oleg Cassini Collection
OPPOSITE photo by Antoine Vergla

132

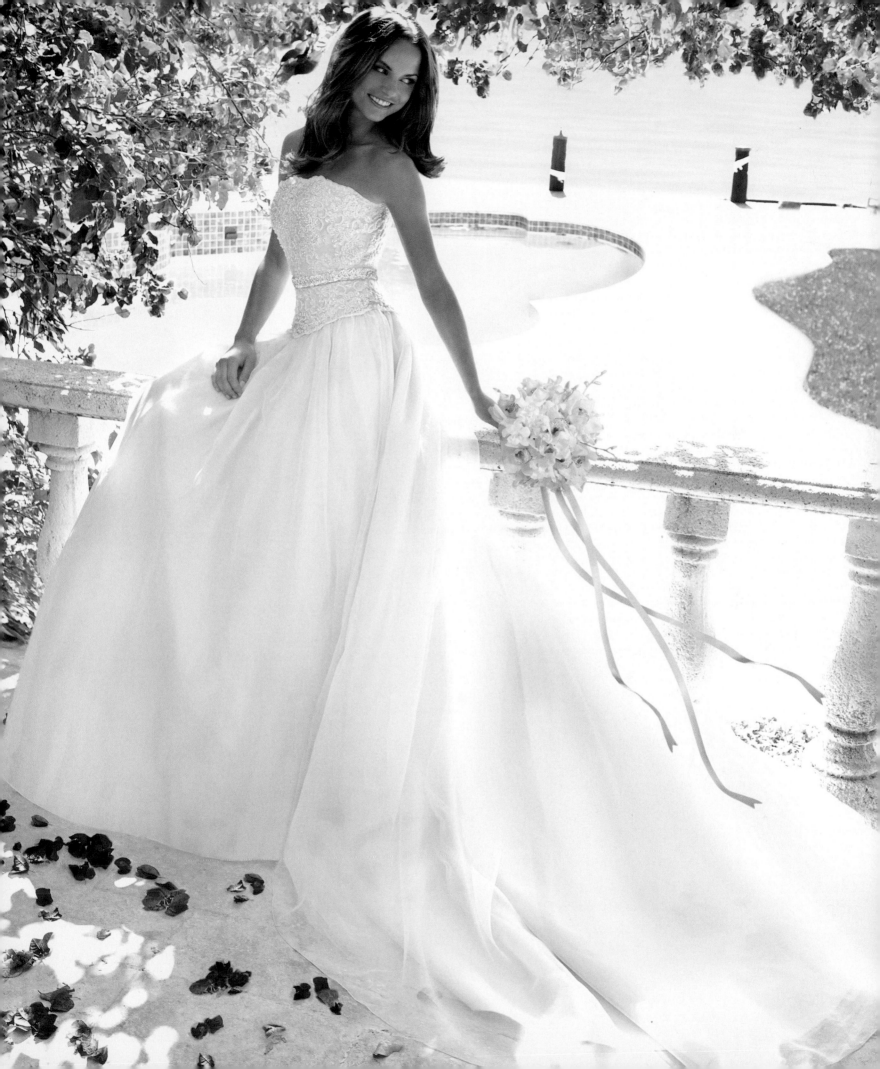

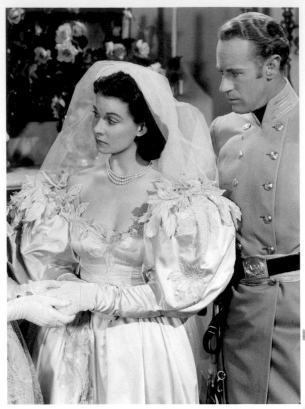

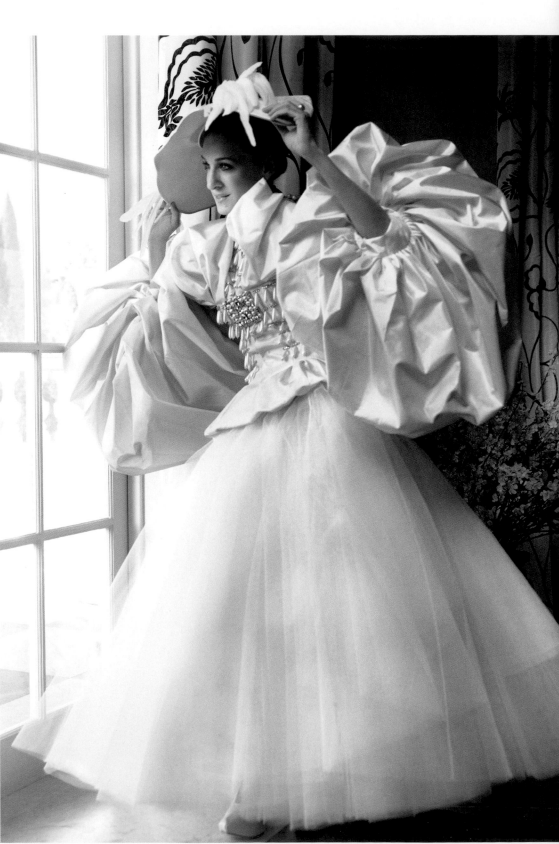

Whisper pink and blush are used for gown colors as an "almost white."

Pink is a perfect choice for spring weddings since flowers are in bloom in many shades of pink.

The vastly flattering clean line of the classic Cassini A-line silhouette is the perfect foil for the intricate floral embroidery which frames the bodice and court-length skirt with a circle train.

RIGHT AND ABOVE

Sarah Jessica Parker (right) wearing a pink Dior gown in the film *Sex and the City* evokes the image of Vivien Leigh as Scarlet O'Hara in *Gone with the Wind* (above).

Right photo by Patrick Demarchelier / Vogue ©Condé Nast Publications

OPPOSITE

Oleg Cassini Gown

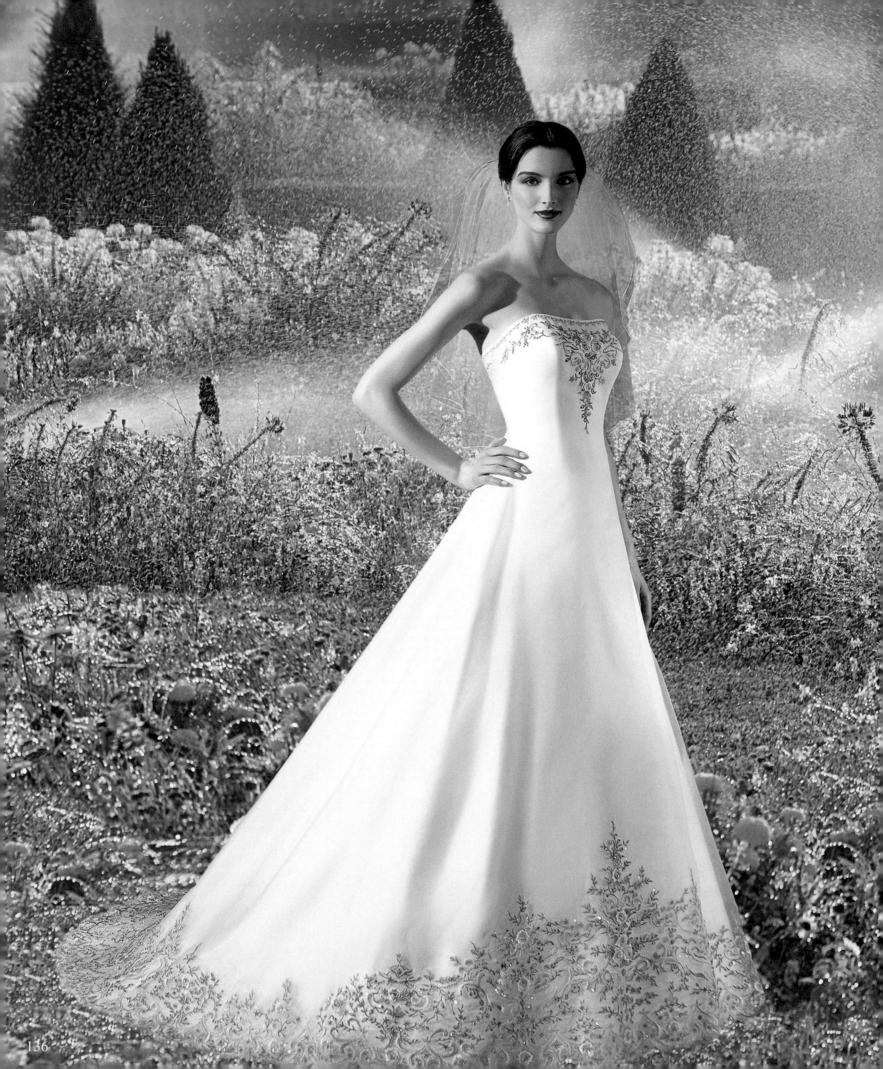

The Wedding Dress

is meant to exude subtlety and femininity,
be refined, yet gloriously romantic.
Beautiful shapes, simple lines and rich fabrics
create a mood of absolute romanticism
for a momentous gathering.
Large or intimate, the gathering and
the event itself is the most significant moment
for the bride, who is the star of the show.

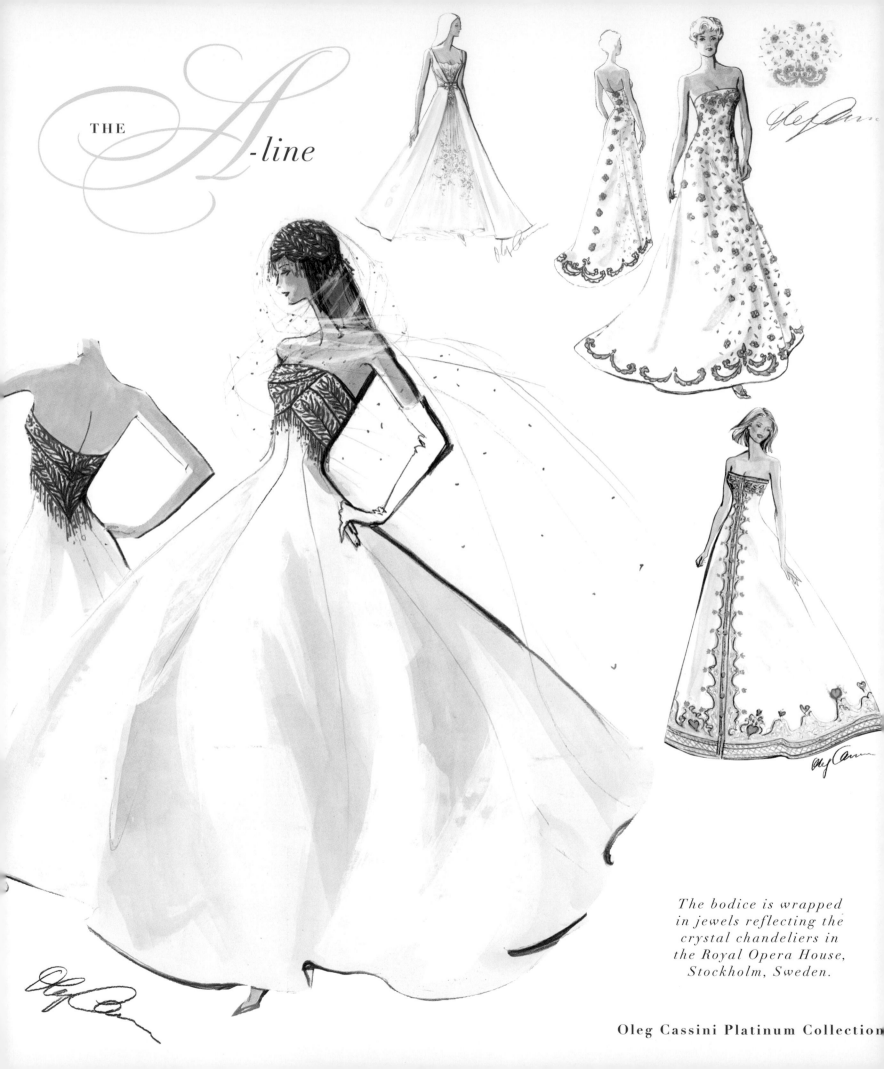

THE *A*-line

The bodice is wrapped in jewels reflecting the crystal chandeliers in the Royal Opera House, Stockholm, Sweden.

Oleg Cassini Platinum Collection

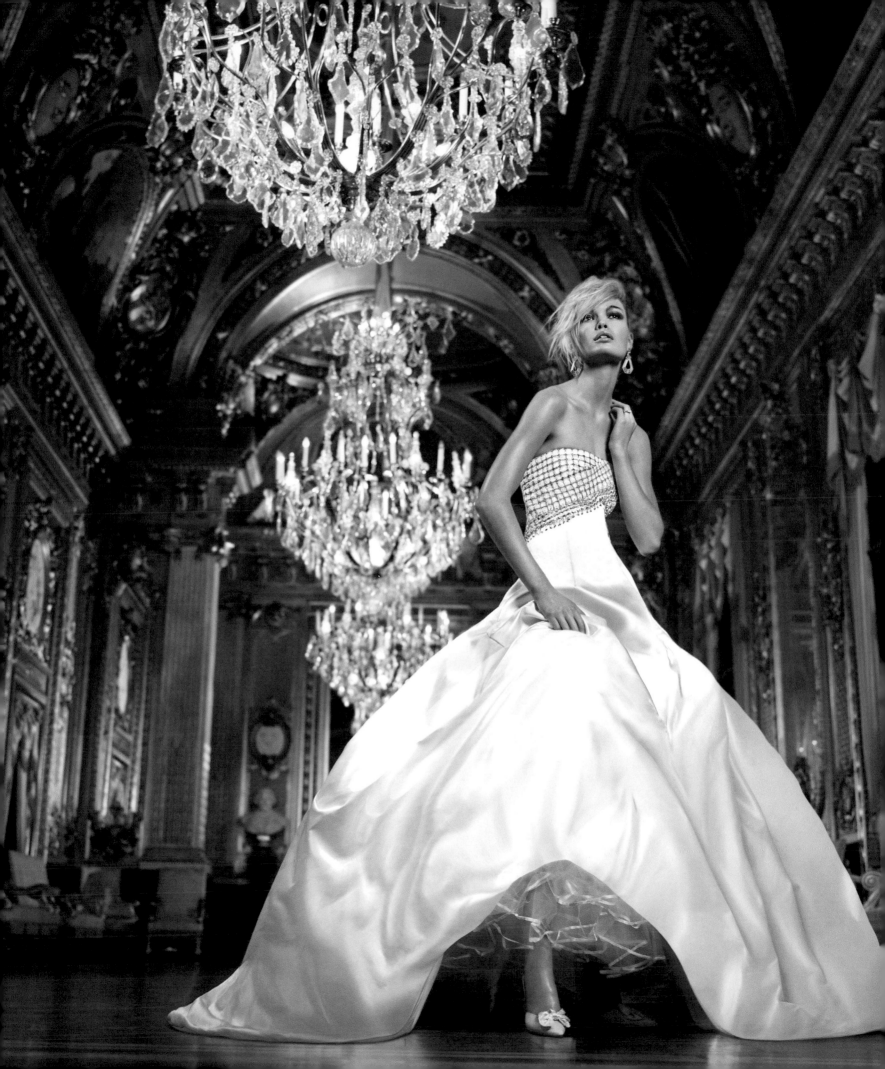

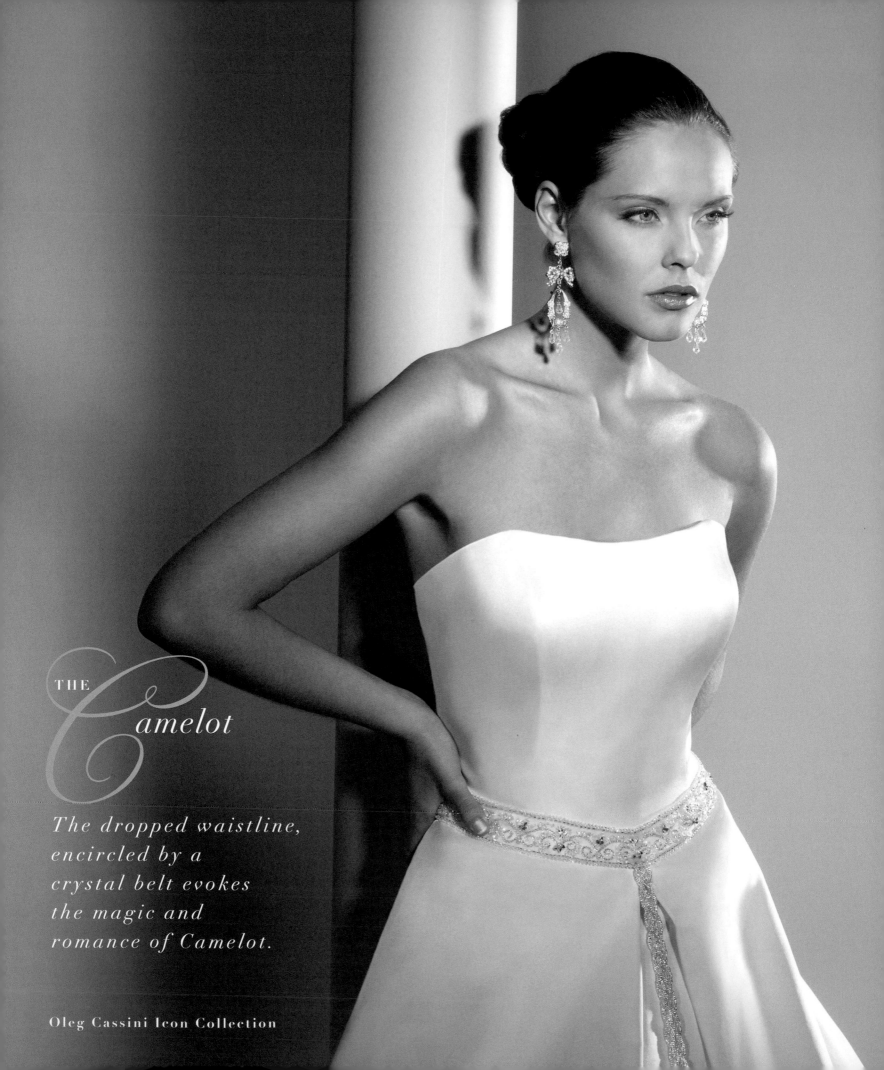

THE

Camelot

The dropped waistline,
encircled by a
crystal belt evokes
the magic and
romance of Camelot.

Oleg Cassini Icon Collection

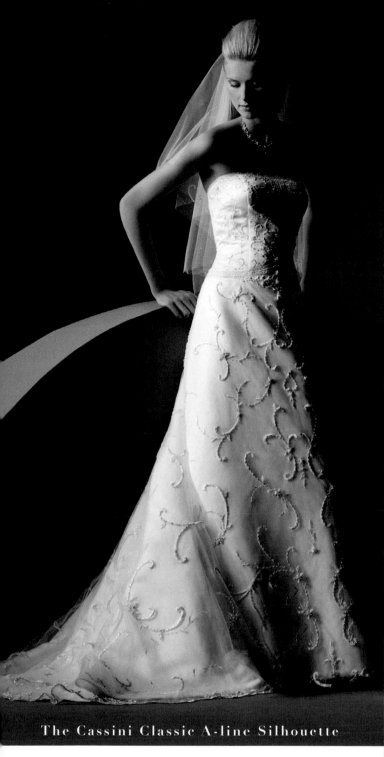

The Cassini Classic A-line Silhouette

The Cassini A-line silhouette reached international iconic status when Jackie wore her Oleg Cassini dresses, coats and gowns. Since then, this silhouette has become a favorite choice of brides for their wedding dress. The A-line shape never fails to exude taste, and subtle style. It is an elegant and flattering silhouette.

An A-line dress can be stunningly simple in shimmering satin, rustlings of taffeta, or dressed up with overlays of lace, organza, chiffon, and embellished with jeweled embroidery. The multitude of choices, coupled with the A-line's unconditionally becoming line from bodice to hemline makes this silhouette suitable for all, an excellent canvas on which to paint a unique vision for each bride. The possibilities of the A-line silhouette are endless, and the only requirement is a lush imagination.

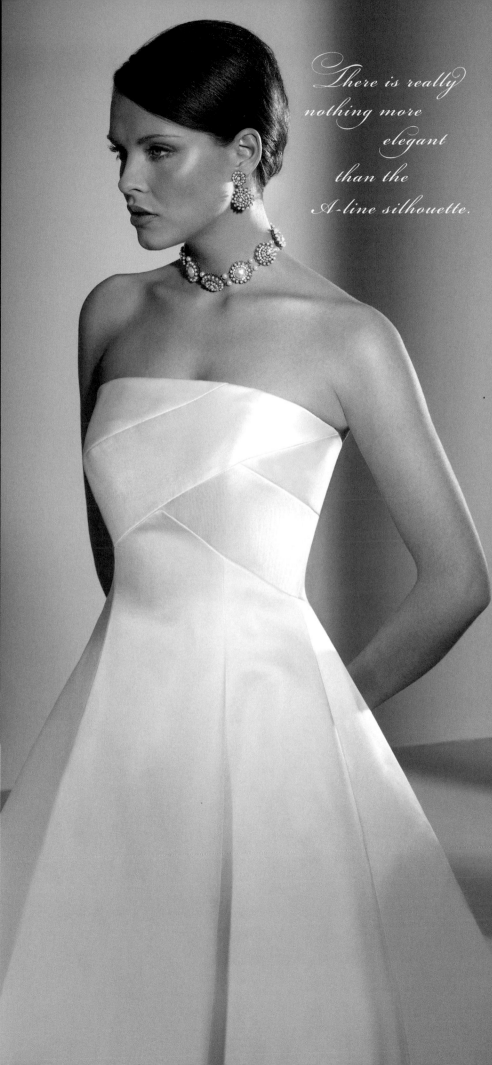

There is really nothing more elegant than the A-line silhouette.

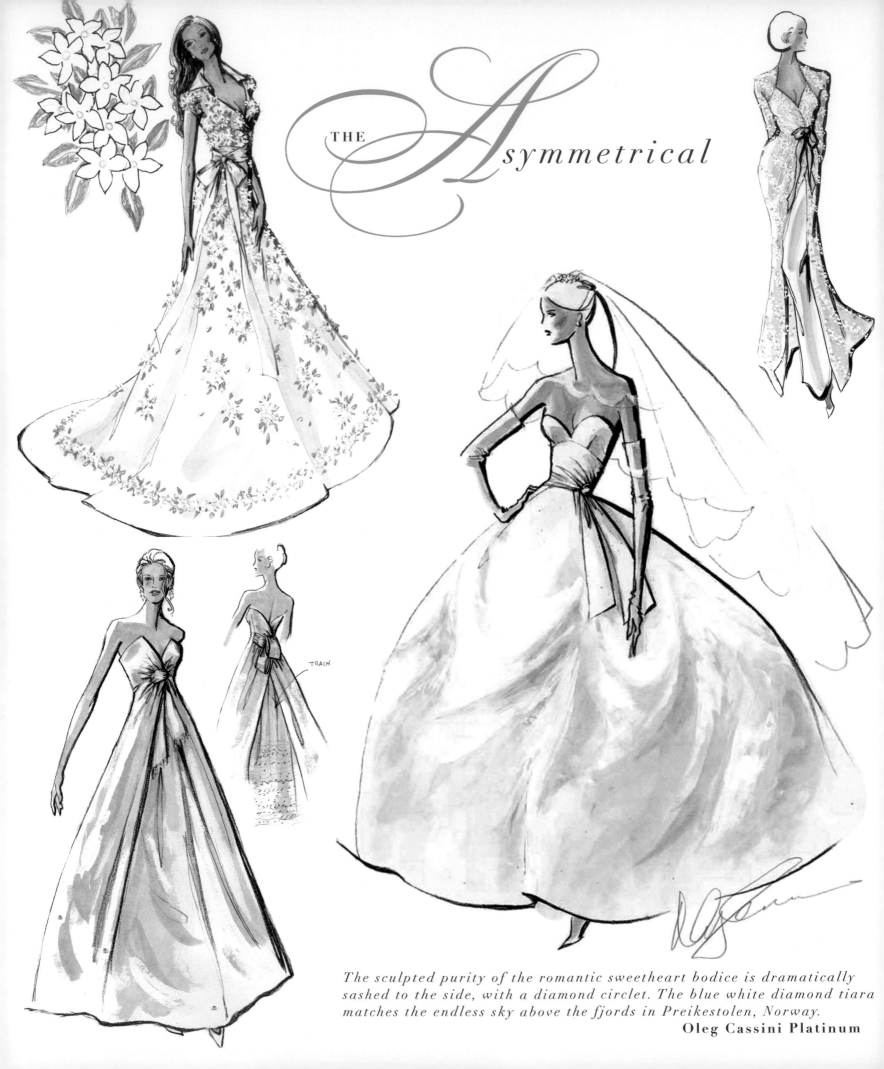

THE *Asymmetrical*

TRAIN

The sculpted purity of the romantic sweetheart bodice is dramatically sashed to the side, with a diamond circlet. The blue white diamond tiara matches the endless sky above the fjords in Preikestolen, Norway.

Oleg Cassini Platinum

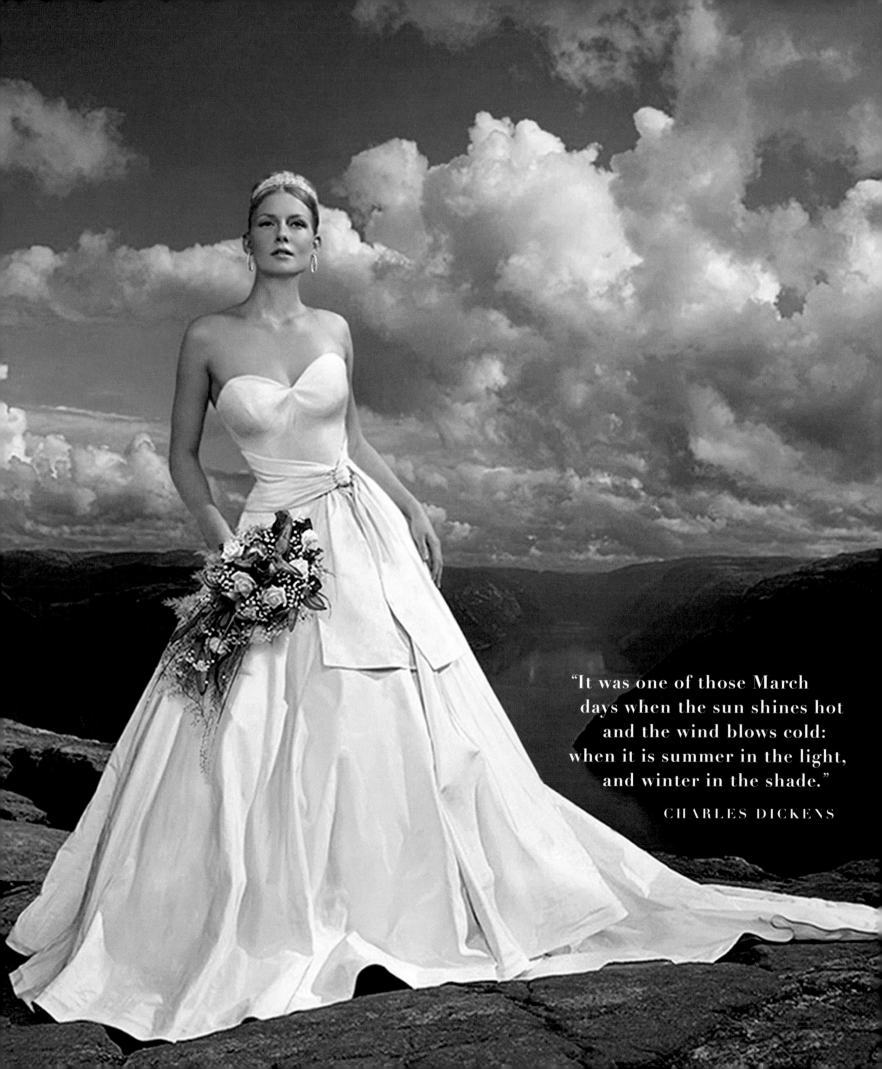

"It was one of those March days when the sun shines hot and the wind blows cold: when it is summer in the light, and winter in the shade."

CHARLES DICKENS

"I think this is the most extraordinary collection of talent, of human knowledge, ever gathered at The White House, with the possible exception of when Thomas Jefferson dined alone." J.F.K.

At The White House dinner for Nobel Prize Laureates, President Kennedy made a memorable toast to the group.

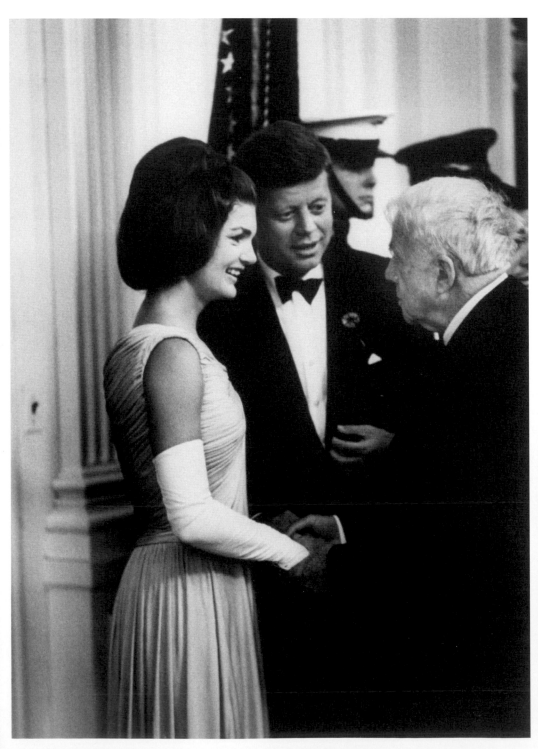

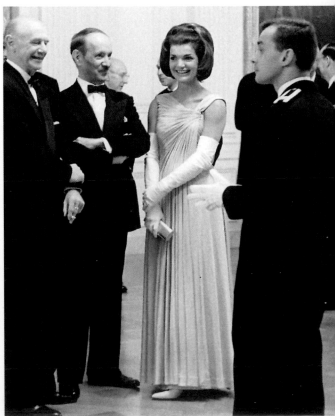

This Grecian style gown was done in a Veronese green supple silk jersey.

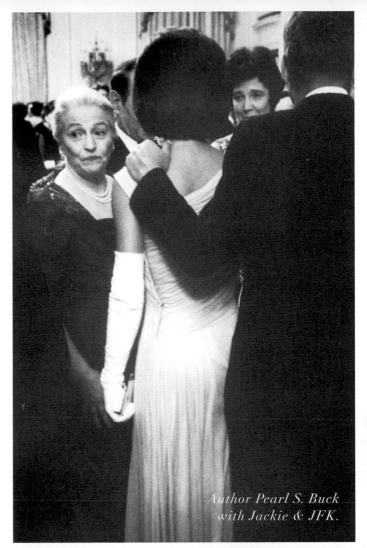

Author Pearl S. Buck with Jackie & JFK.

DURING HIS TOAST,
POET ROBERT FROST
SAID OF
THE FIRST LADY:
"There have been some great wives in the White House—like Abigail Adams and Dolley Madison— so great you can't think of the Presidents, their husbands, without thinking of them. It looks like we're having another one now."

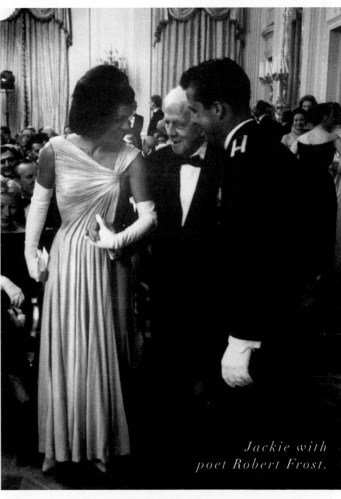

Jackie with poet Robert Frost.

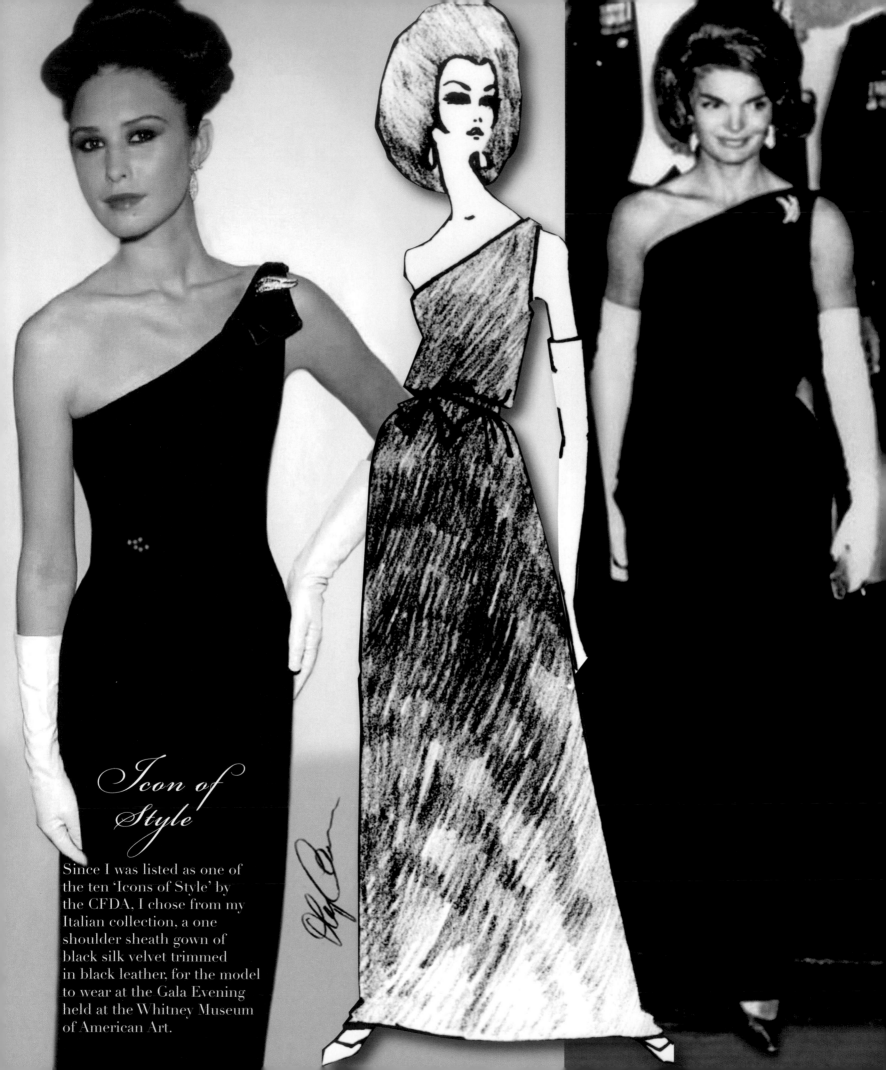

Icon of Style

Since I was listed as one of the ten 'Icons of Style' by the CFDA, I chose from my Italian collection, a one shoulder sheath gown of black silk velvet trimmed in black leather, for the model to wear at the Gala Evening held at the Whitney Museum of American Art.

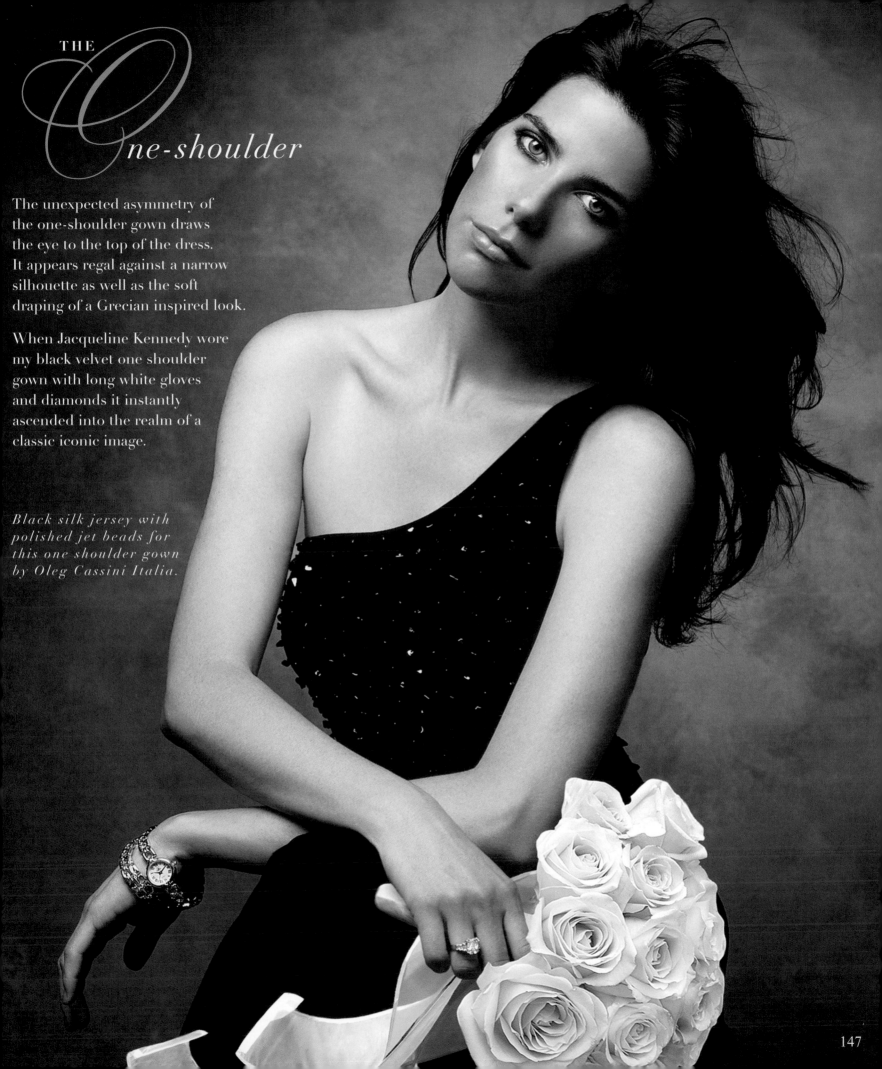

THE One-shoulder

The unexpected asymmetry of the one-shoulder gown draws the eye to the top of the dress. It appears regal against a narrow silhouette as well as the soft draping of a Grecian inspired look.

When Jacqueline Kennedy wore my black velvet one shoulder gown with long white gloves and diamonds it instantly ascended into the realm of a classic iconic image.

Black silk jersey with polished jet beads for this one shoulder gown by Oleg Cassini Italia.

147

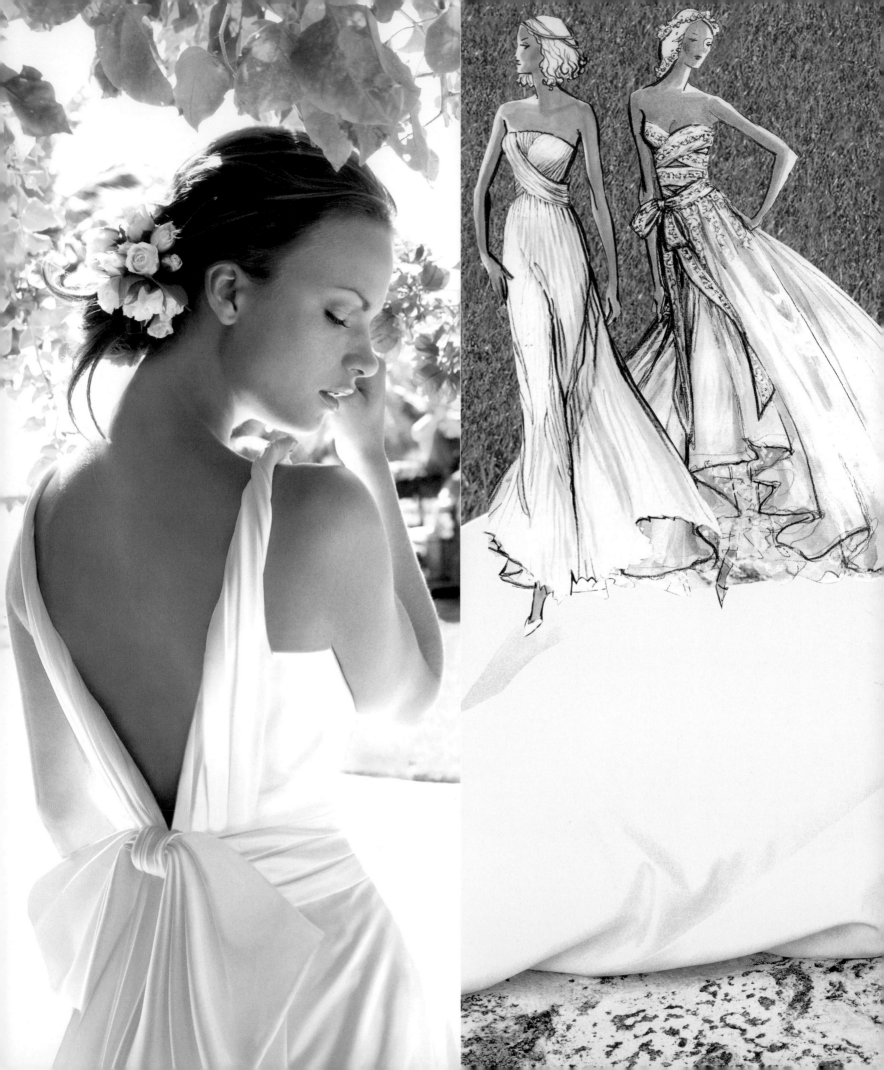

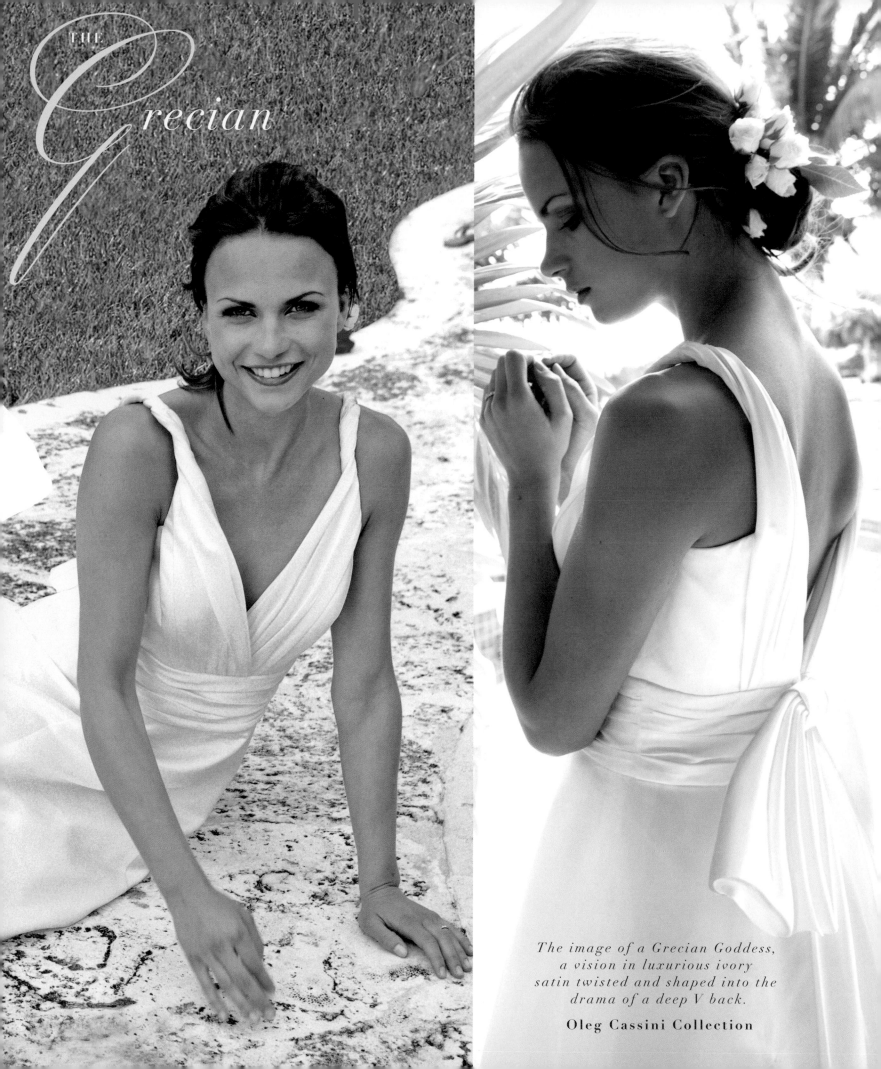

*The image of a Grecian Goddess,
a vision in luxurious ivory
satin twisted and shaped into the
drama of a deep V back.*

Oleg Cassini Collection

THE *Empire*

Recalling Napoleonic era royalty, the Empire is a silhouette dignified by its history, yet is stylistically free and unconstrained. First seen on the figures of goddesses in Greek and Roman antiquities, the Empire is a timeless look.

Although it is a shape with the weight of history behind it, the Empire has the stylistic ease and versatility to be utterly romantic. The defining feature of the Empire is its raised waistline, which rests just under the bust and can extend to the ribs, from which the skirt of the gown flows in a single vertical line to the hem. Lighter fabrics are particularly lovely and the extended length of the gown accentuates the luxurious draping of fabric choices like chiffon, jersey, silk, organza, velvet.

The Empire first became popular in the late 18th century and reached the height of its popularity in France during the early 19th century. The trend began with Pauline Bonaparte, sister of Napoleon, yet the silhouette is usually associated with the image of Napoleon's Empress, Josephine. Evoking the grandeur of a Royal wedding, the magnificent portrait by David of the Coronation shows both Josephine and her court wearing richly trimmed Empire gowns.

Regal and romantic, a bride in an Empire gown calls on rich historical tradition and is totally memorable.

Gown by Oleg Cassini

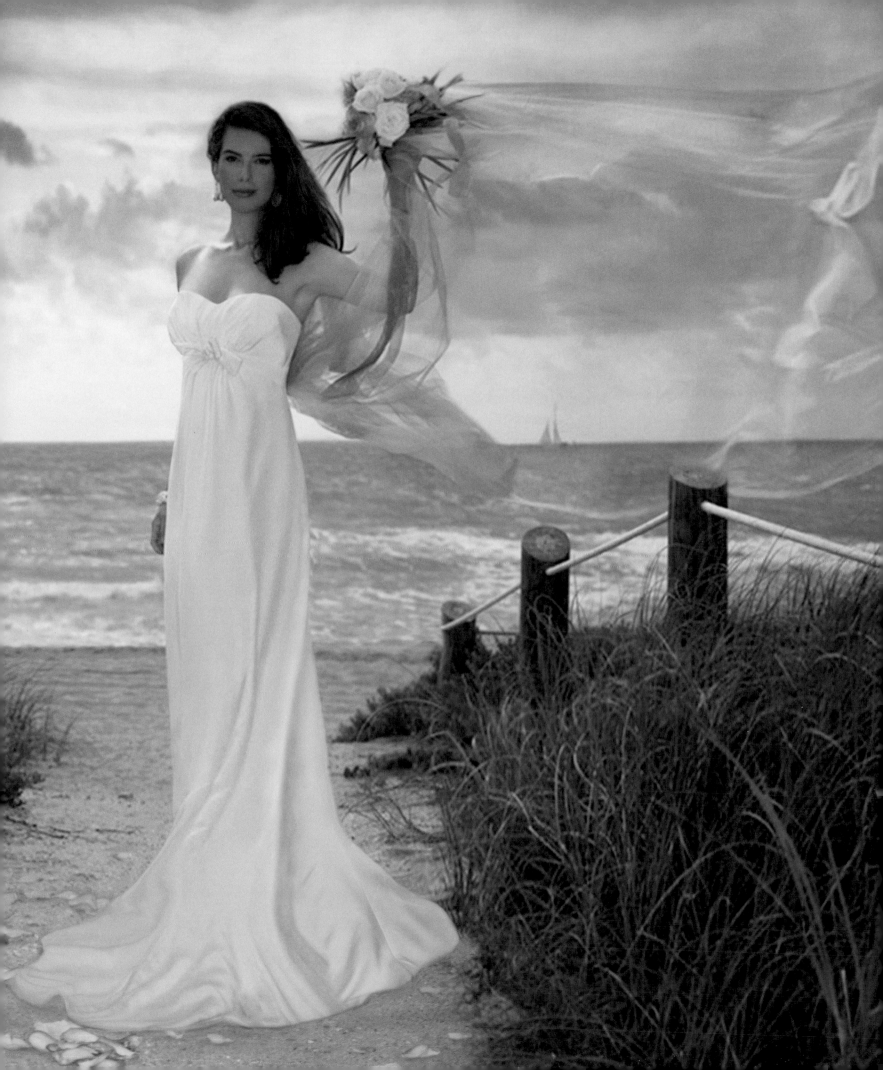

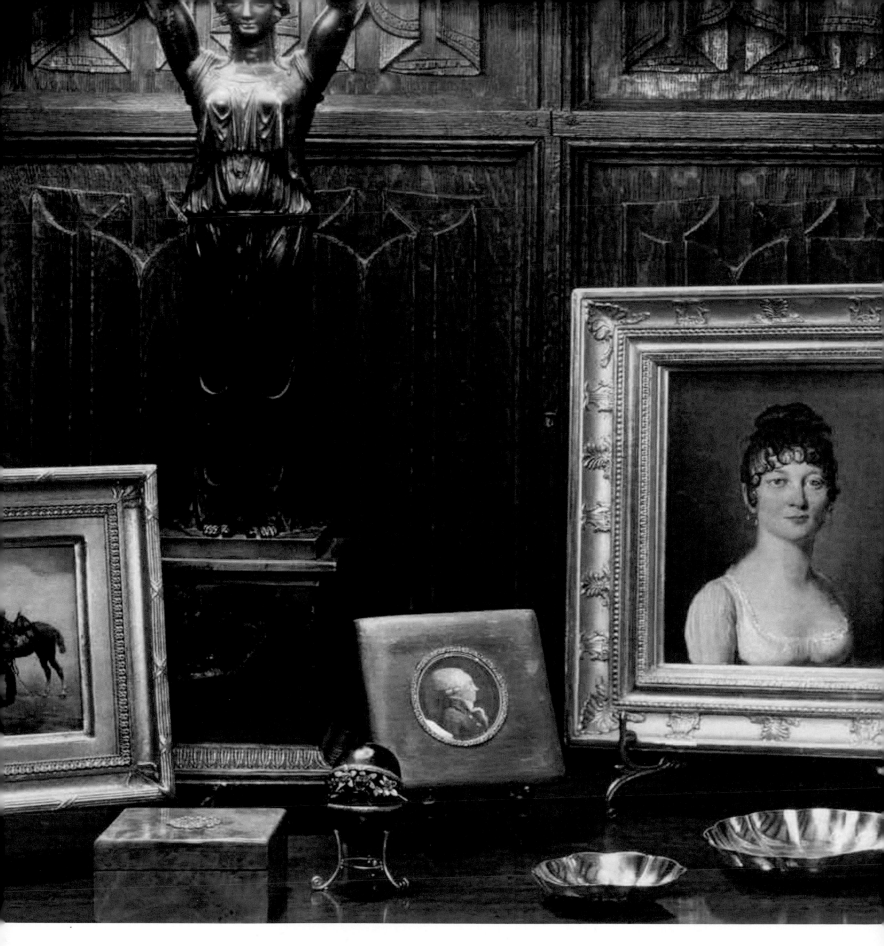

The early 19th century portrait of 'a jeune dame' by the French artist, Louis-Léopold Boilly, features
a classical Empire image from 1785. Boilly was an important artist who chronicled the Empire period . . .
It is placed amongst treasures, a Meissonier painting, and objets d'art of the same vintage.

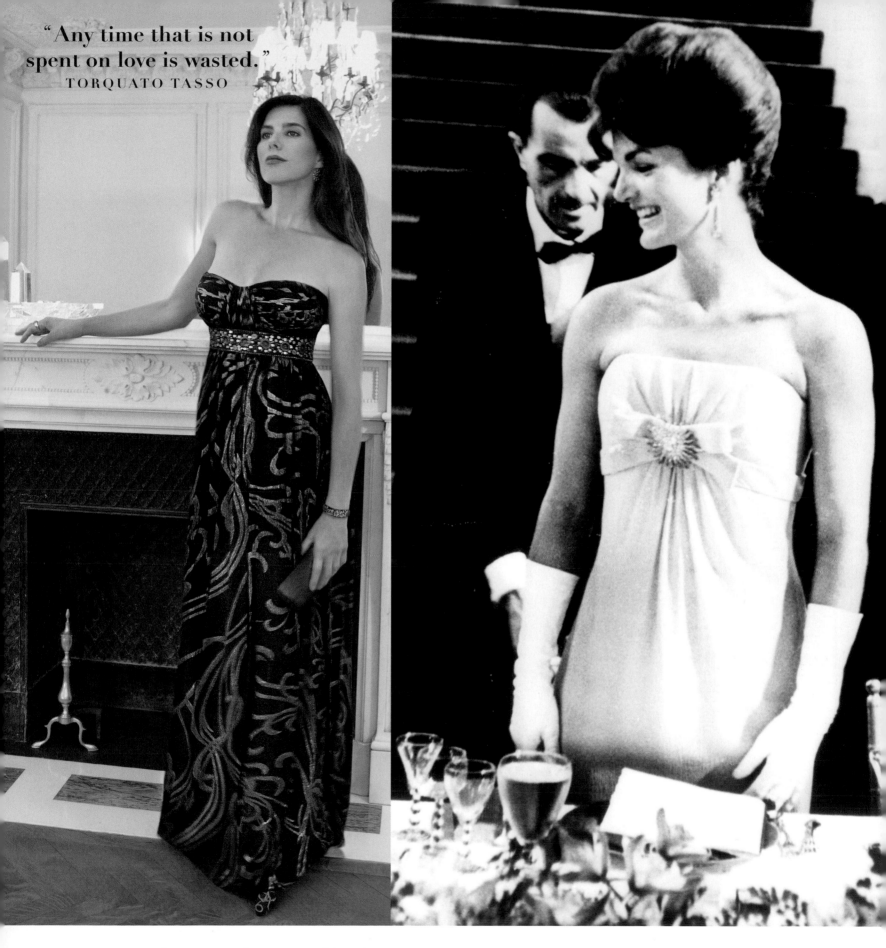

"Any time that is not spent on love is wasted."
TORQUATO TASSO

Jacqueline Kennedy in one of her favorite dresses—Empire Nattier Blue Cassini gown.
She wore this gown during the Kennedy Administration and years after.
The Empire continues to be an important silhouette in the Cassini collections.

The most daring statement the design of the back of the dress can make is bareness. A backless style is often created with halter necklines. In a classic setting, the V neck halter gown is embroidered with a lace and pearl overlay on champagne colored satin.

Oleg Cassini Collection

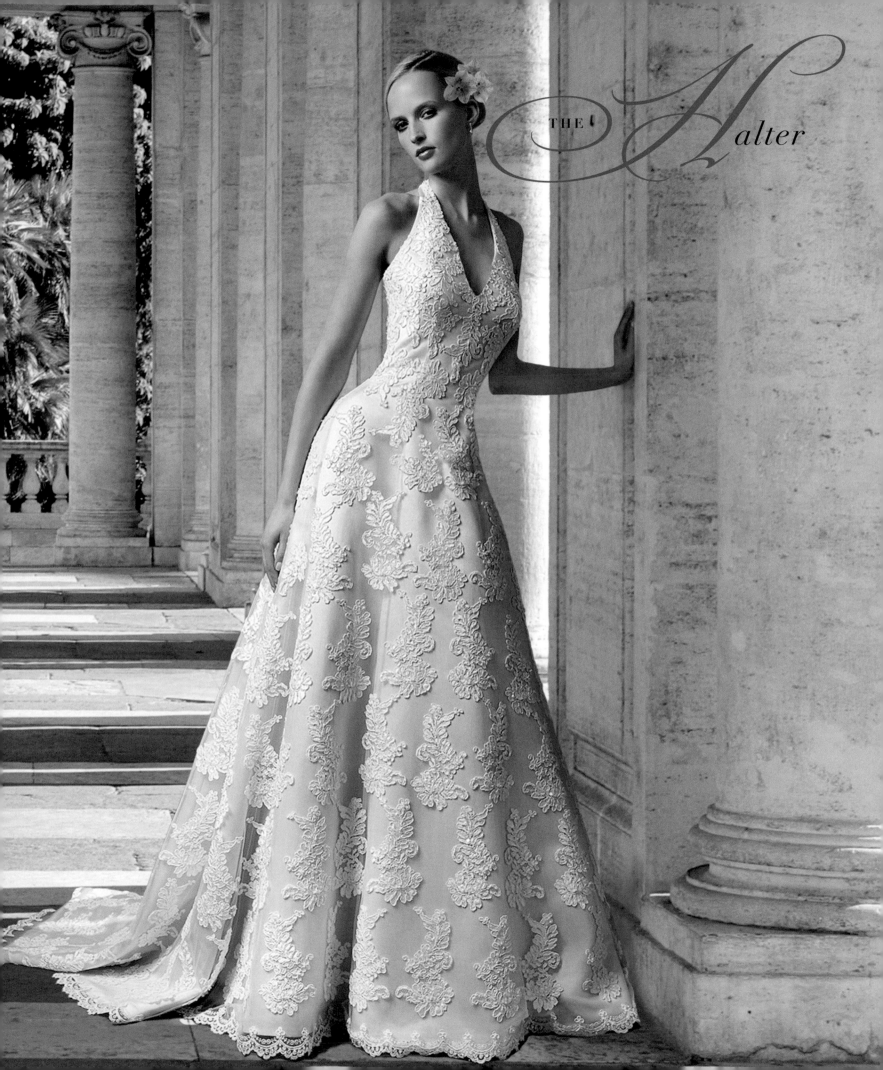

THE *Halter*

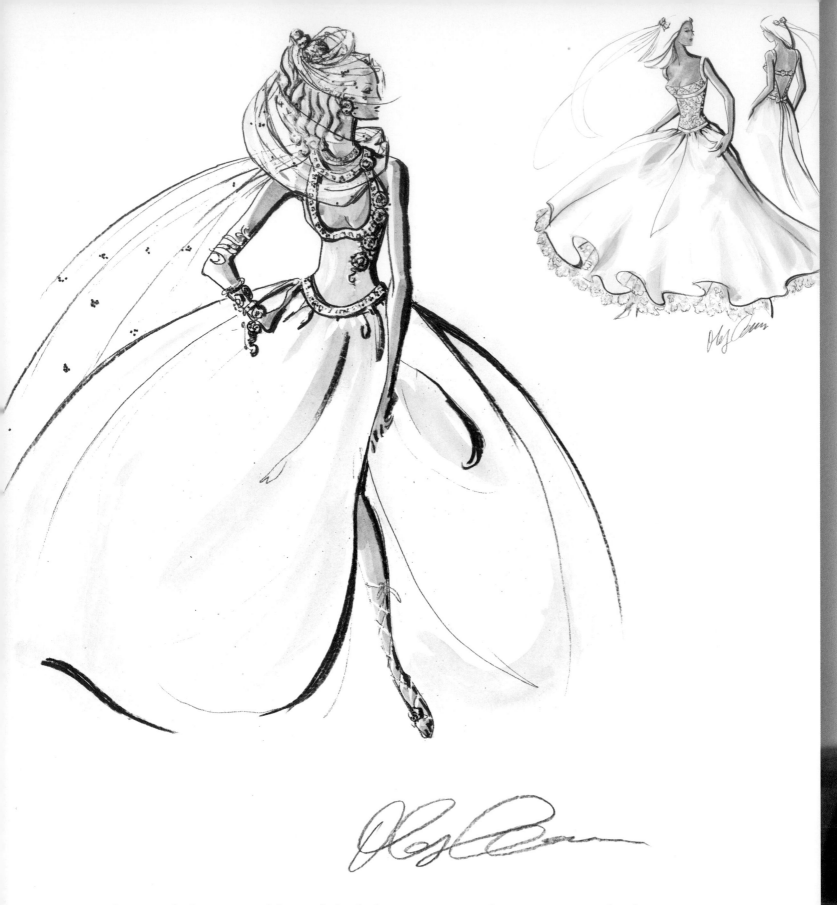

The rounded scoop neckline of the halter gown reveals an unexpected voluptuousness above the drama of the lavishly embroidered and corseted midriff. The fabric is a shimmering pure white satin richly detailed with polished crystals and silver trim. Playful as well as provocative, the halter is a shape that goes with any silhouette, from the full skirt of a ball gown to a breezy, free flowing toga, to a form fitting sheath. The halter is bare on the back and sides and fastened around the neck, and draws attention to its own distinctive shape as well as the shoulders, back and decolletage that it showcases.

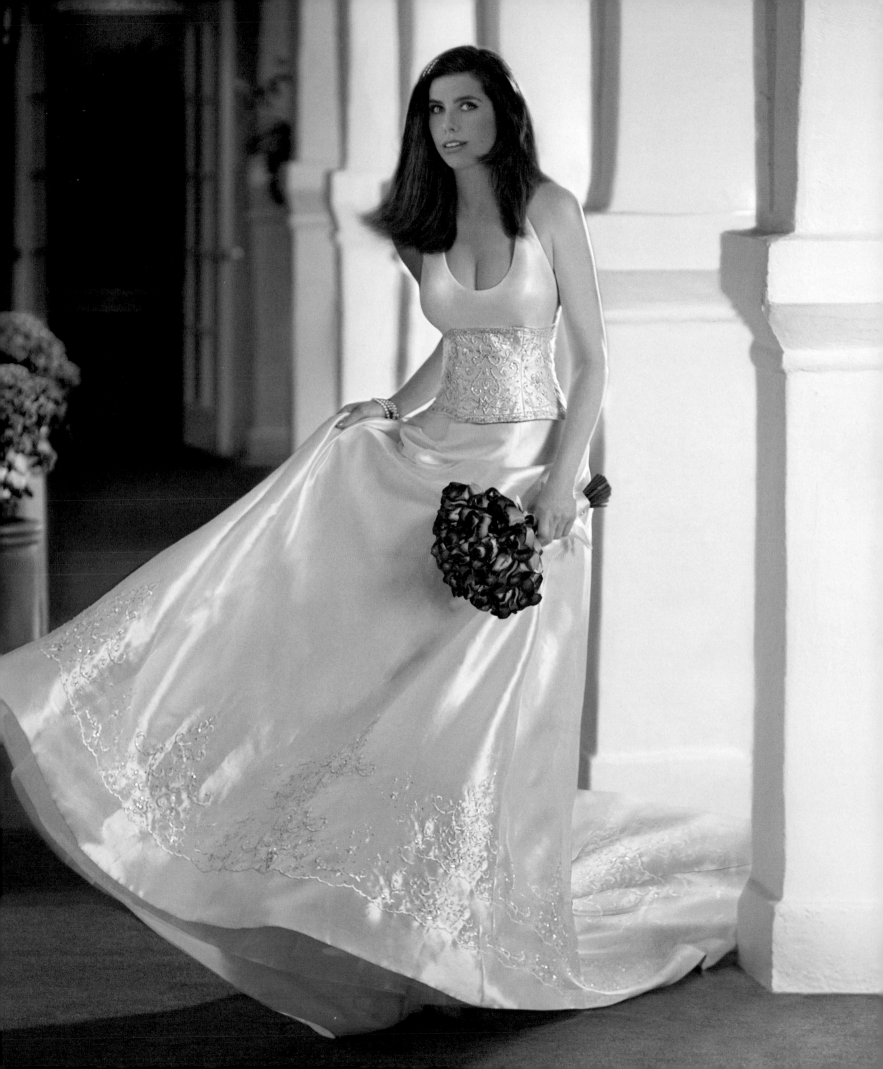

"Beauty is a form of genius."
OSCAR WILDE

Lady Brenda Nestor

On the edge of bareness, the Oleg Cassini halter with a touch of strap, in silk jersey is caught at the center of the bodice with jewels

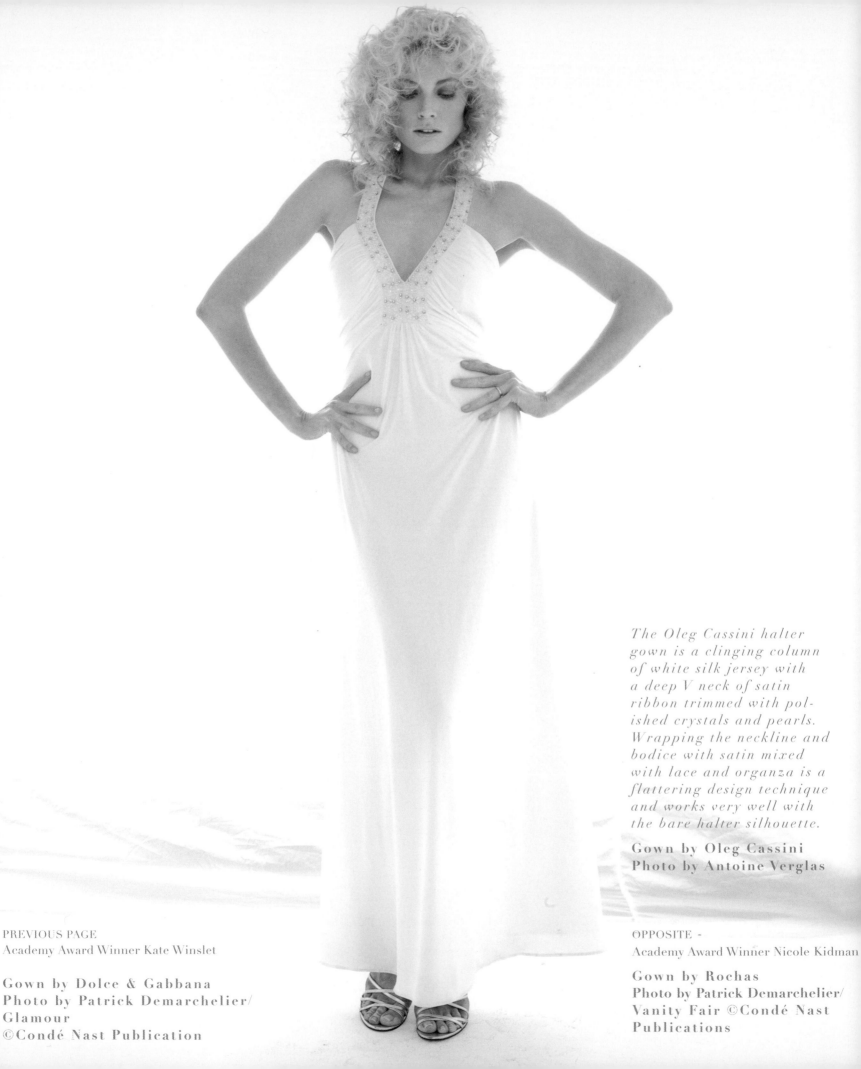

The Oleg Cassini halter gown is a clinging column of white silk jersey with a deep V neck of satin ribbon trimmed with polished crystals and pearls. Wrapping the neckline and bodice with satin mixed with lace and organza is a flattering design technique and works very well with the bare halter silhouette.

Gown by Oleg Cassini
Photo by Antoine Verglas

PREVIOUS PAGE
Academy Award Winner Kate Winslet

Gown by Dolce & Gabbana
Photo by Patrick Demarchelier/
Glamour
©Condé Nast Publication

OPPOSITE -
Academy Award Winner Nicole Kidman

Gown by Rochas
Photo by Patrick Demarchelier/
Vanity Fair ©Condé Nast
Publications

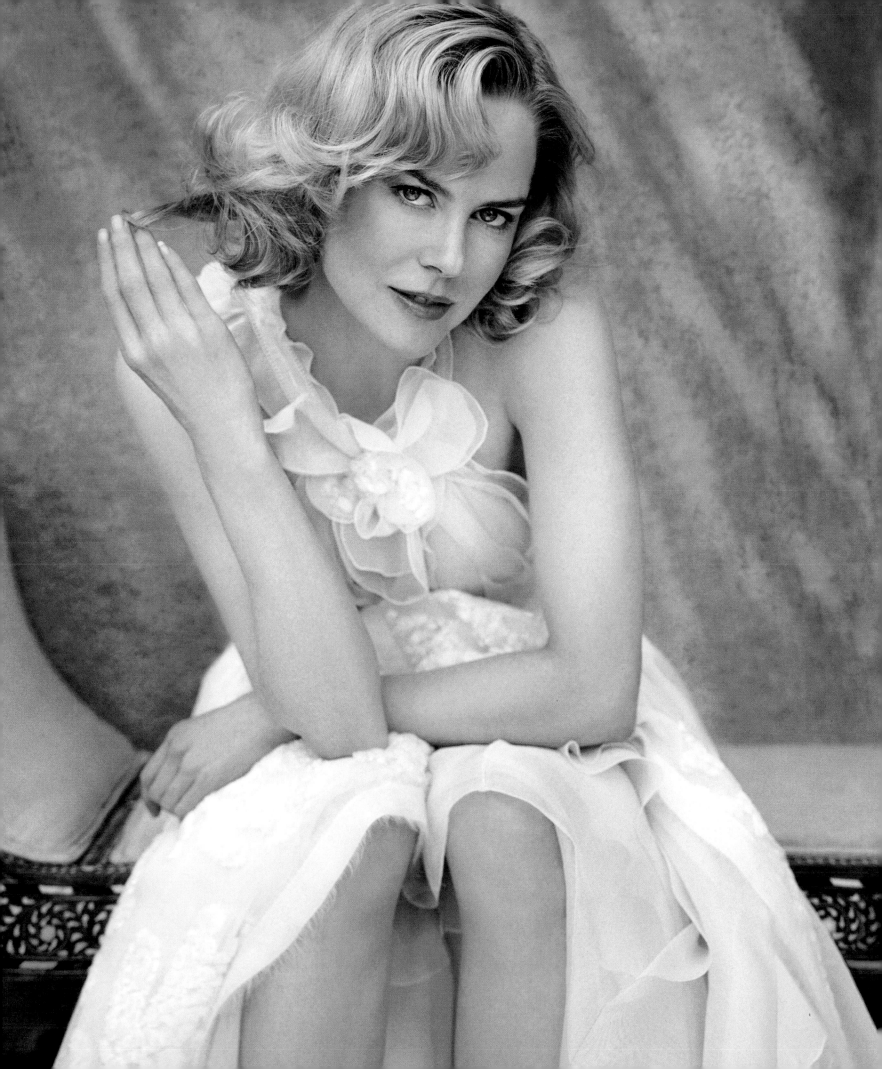

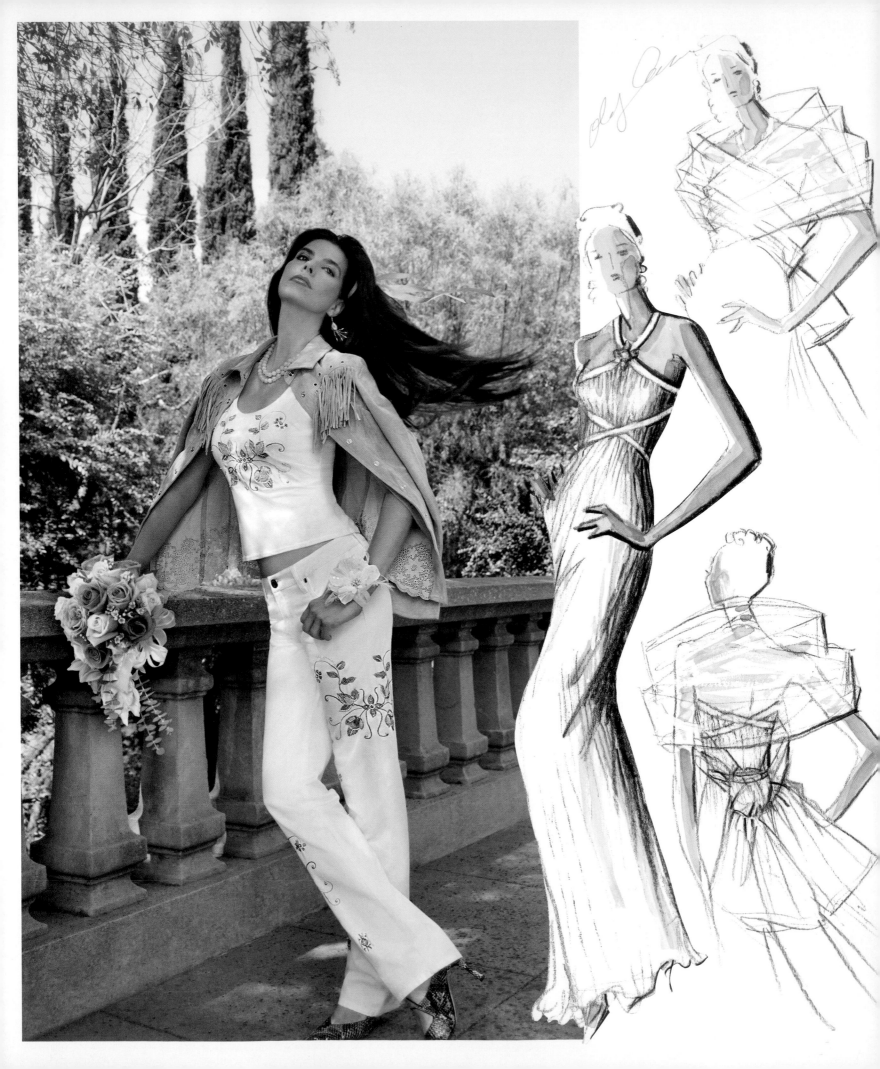

Barely there

in ombre pink silk chiffon

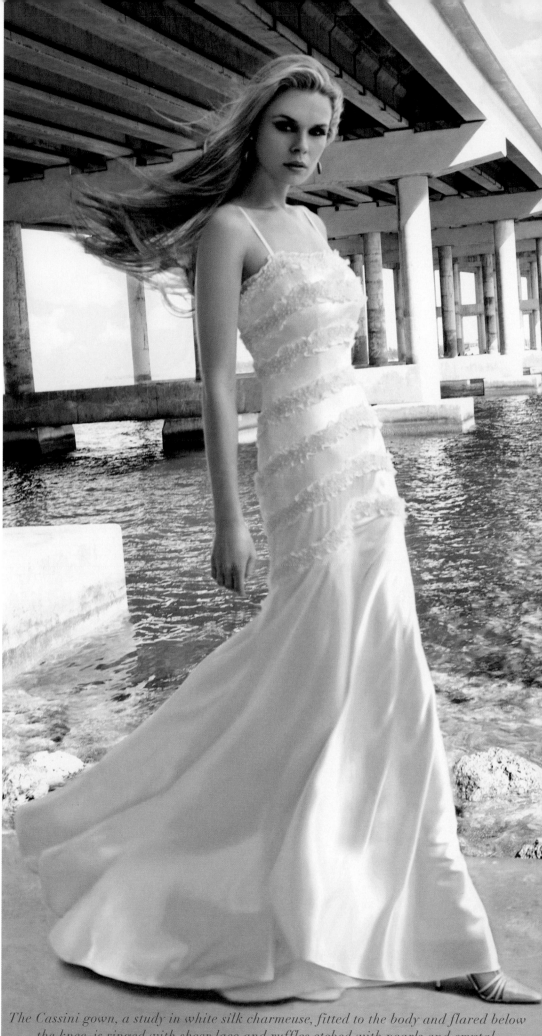

The Cassini gown, a study in white silk charmeuse, fitted to the body and flared below the knee, is ringed with sheer lace and ruffles etched with pearls and crystal.

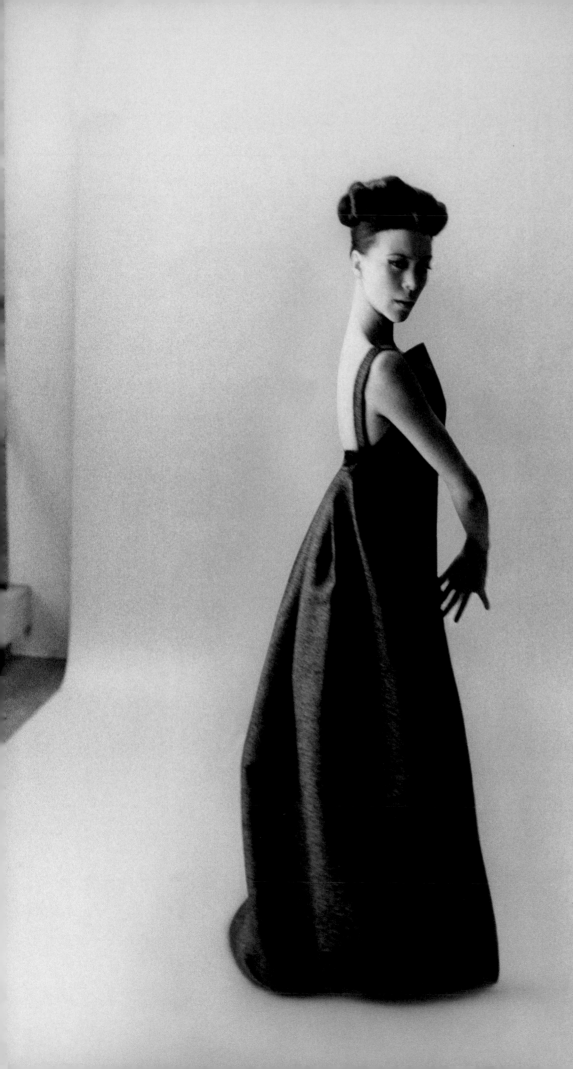

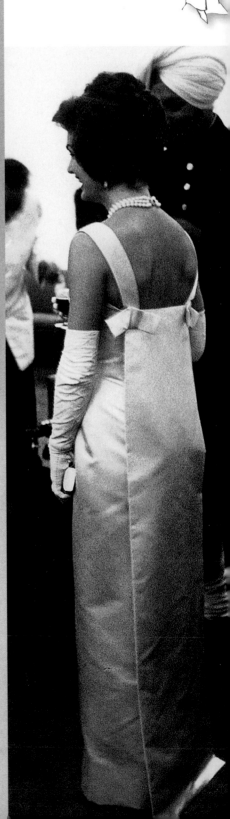

*Sheer silk chiffon
caught around the
neck with a copper
circlet matches the
copper trim of the
car design, all by
Oleg Cassini.*

*"Fashion anticipates, and elegance
is a state of mind.
It is the mirror of the time in which we live . . .
a translation of the future,
and should never be static."*

OLEG CASSINI

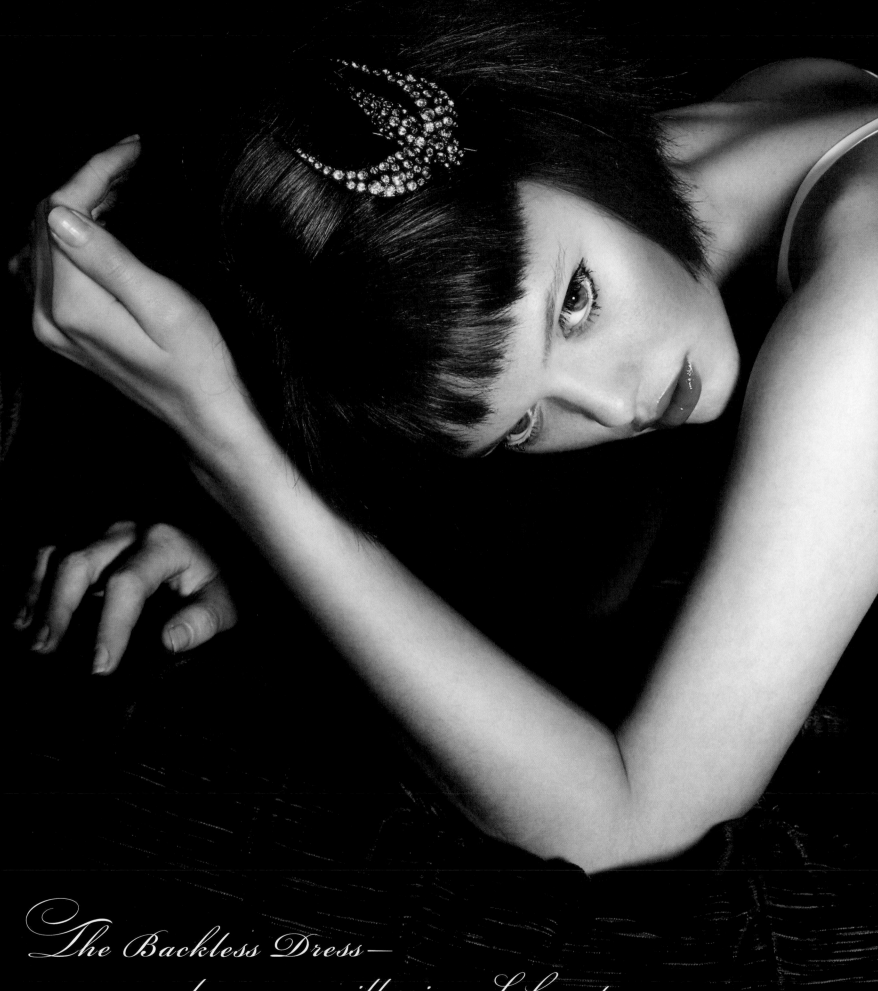

The Backless Dress—

always an illusion of beauty.

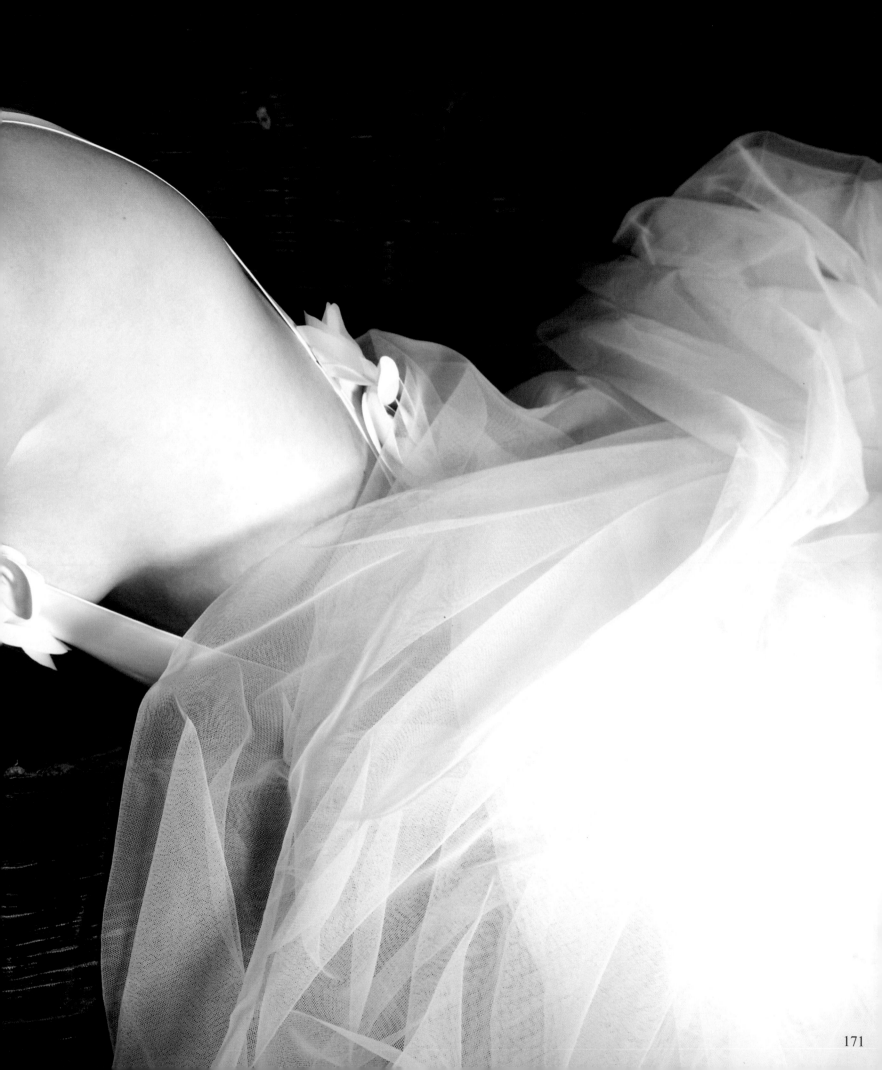

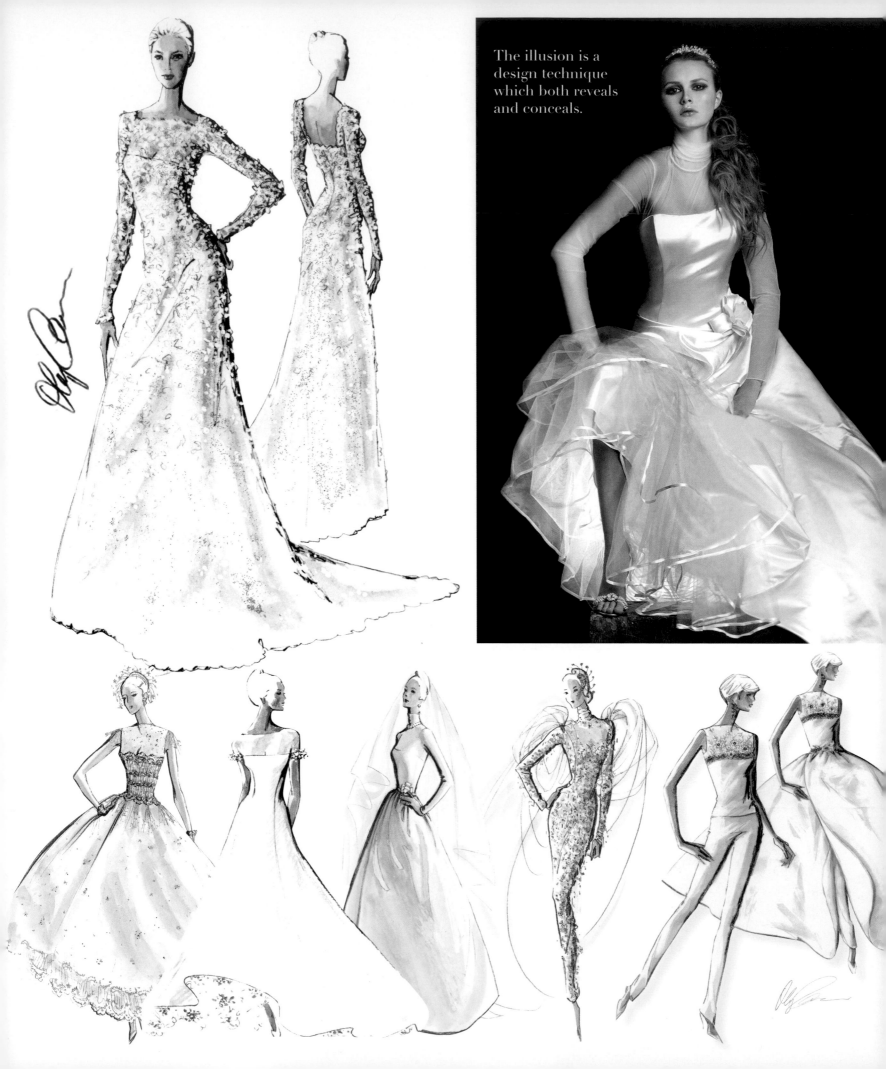

The illusion is a
design technique
which both reveals
and conceals.

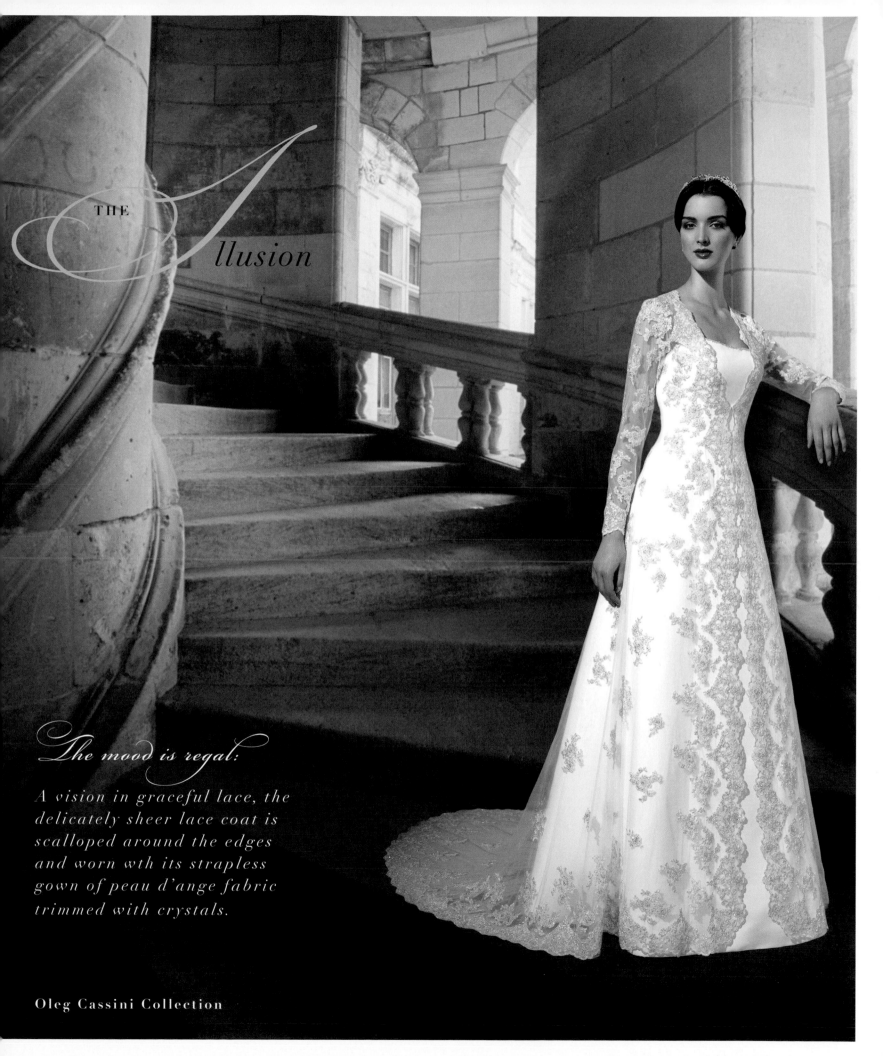

THE *Illusion*

The mood is regal:

A vision in graceful lace, the delicately sheer lace coat is scalloped around the edges and worn wth its strapless gown of peau d'ange fabric trimmed with crystals.

Oleg Cassini Collection

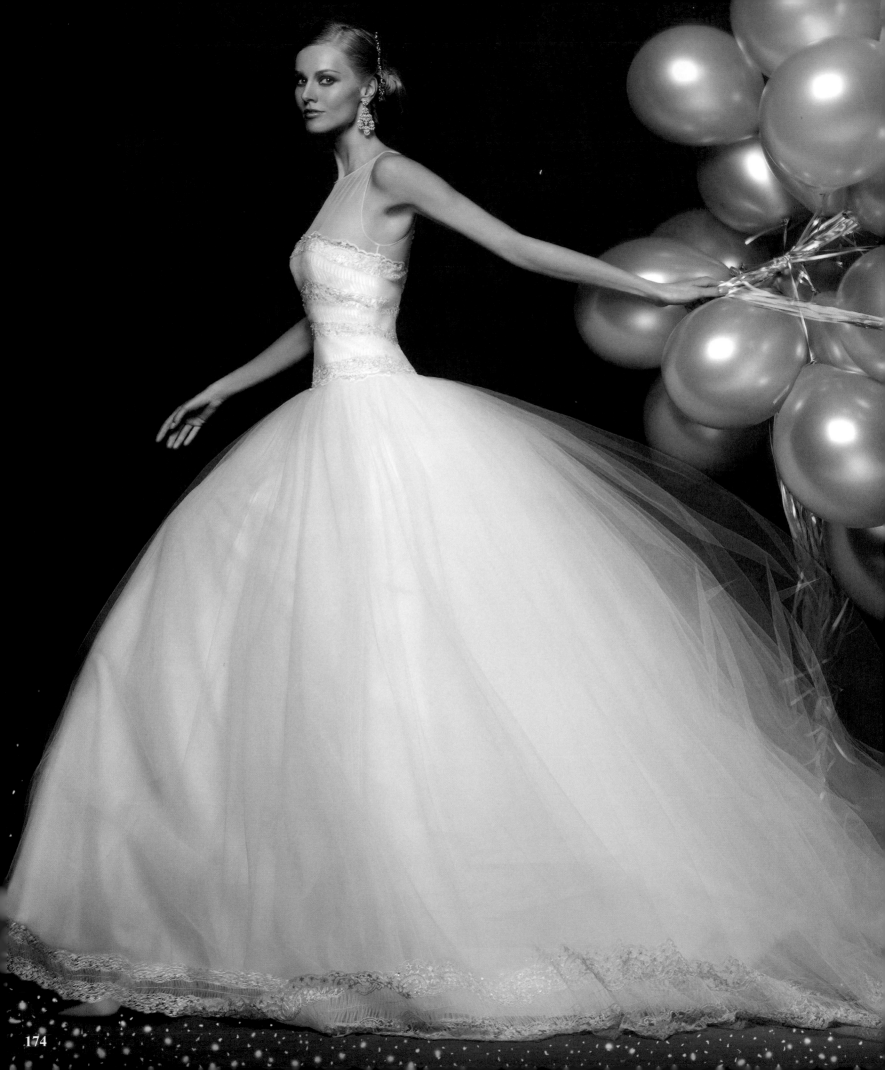

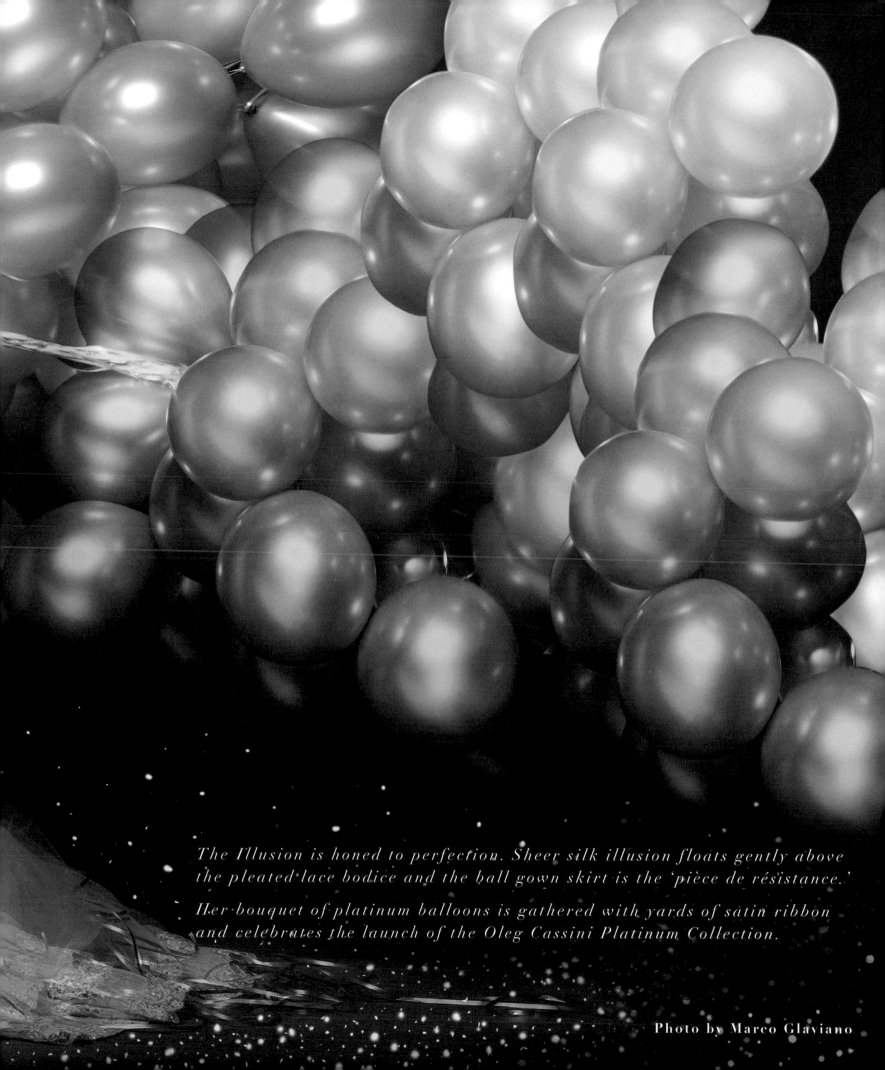

The Illusion is honed to perfection. Sheer silk illusion floats gently above the pleated lace bodice and the ball gown skirt is the 'pièce de résistance.'

Her bouquet of platinum balloons is gathered with yards of satin ribbon and celebrates the launch of the Oleg Cassini Platinum Collection.

Photo by Marco Glaviano

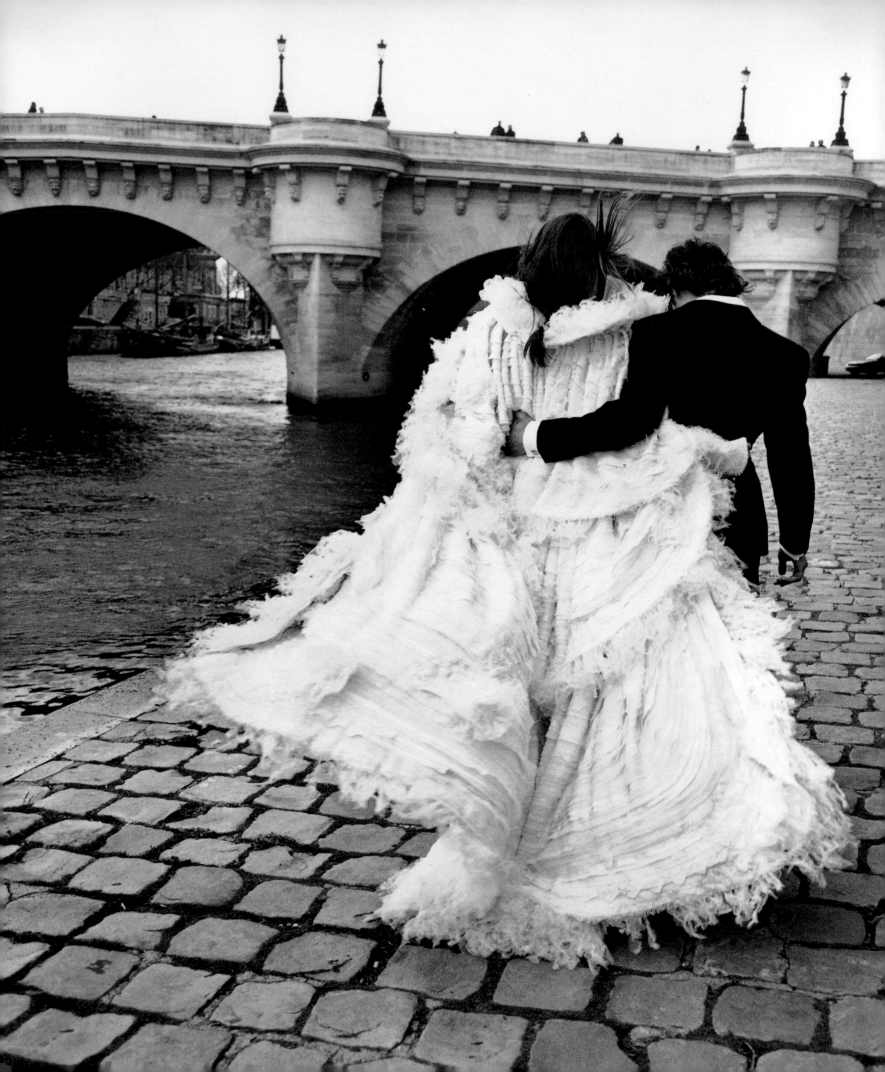

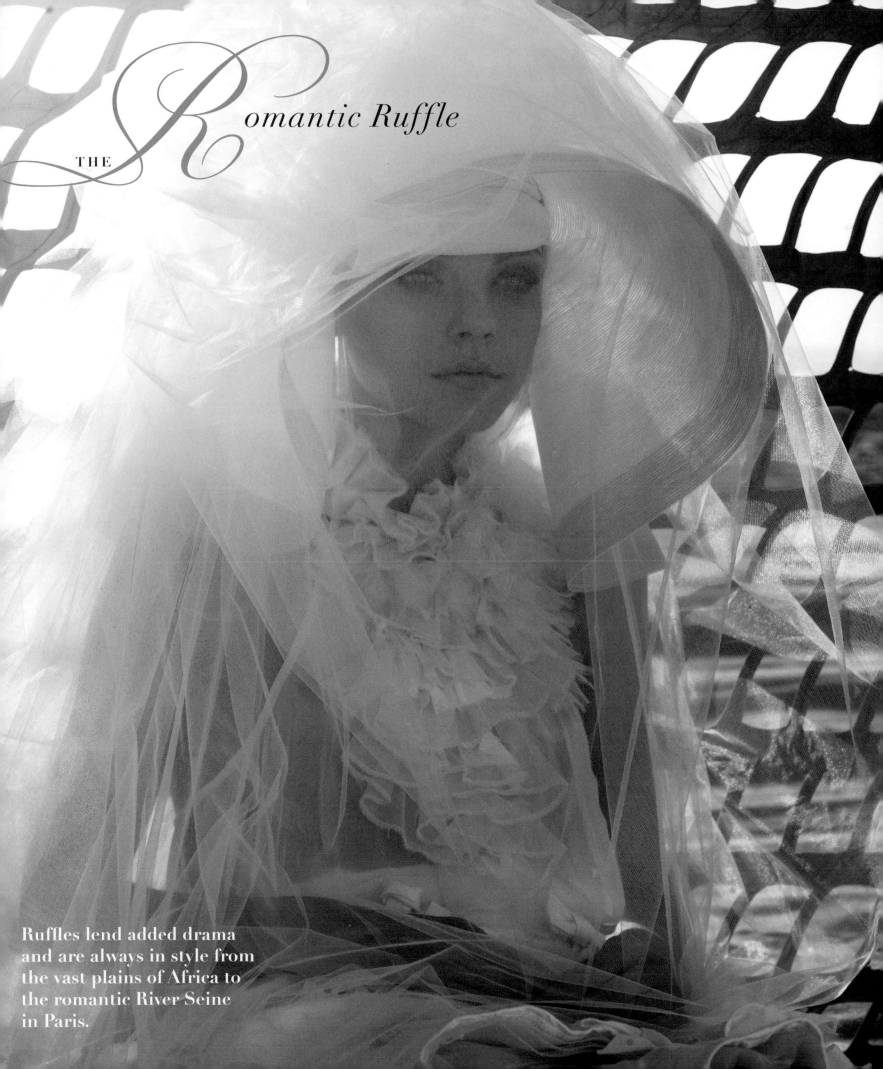

THE Romantic Ruffle

Ruffles lend added drama and are always in style from the vast plains of Africa to the romantic River Seine in Paris.

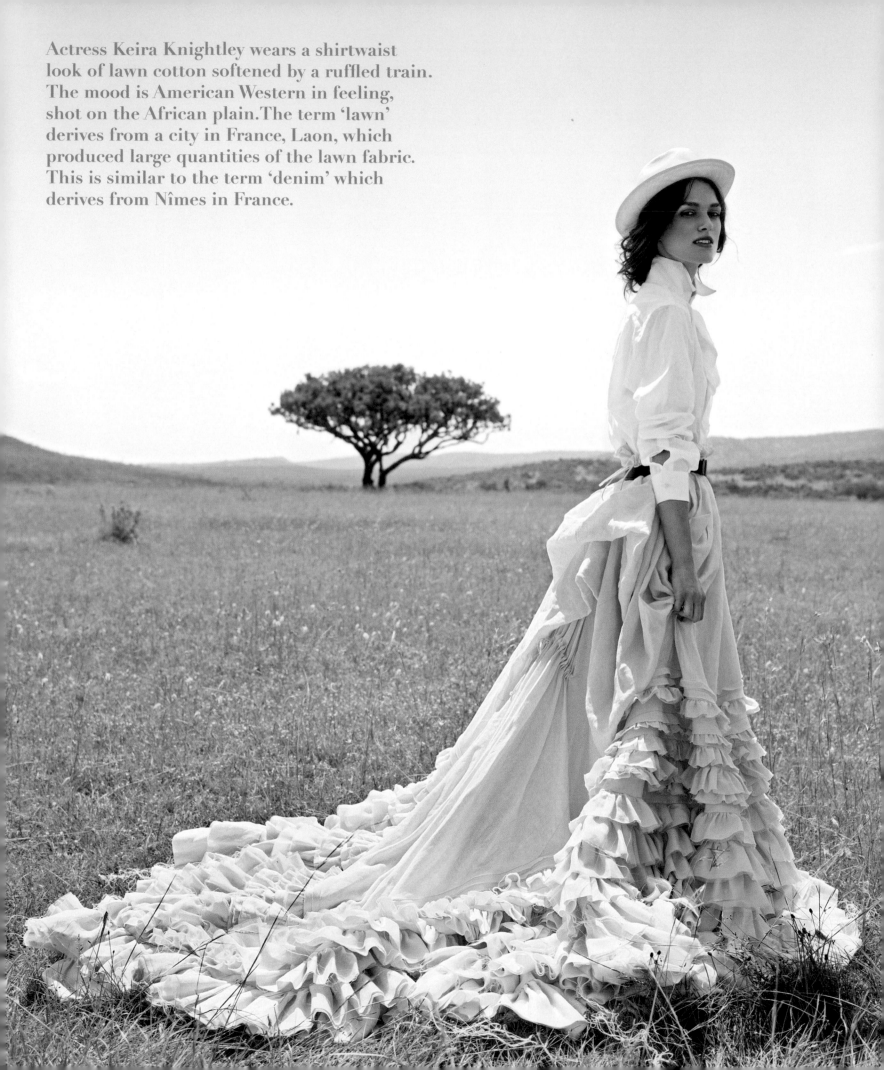

Actress Keira Knightley wears a shirtwaist
look of lawn cotton softened by a ruffled train.
The mood is American Western in feeling,
shot on the African plain. The term 'lawn'
derives from a city in France, Laon, which
produced large quantities of the lawn fabric.
This is similar to the term 'denim' which
derives from Nîmes in France.

East meets West

A wedding in the country evokes
the image of a young Russian Countess
wearing romantic ruffles
of white lawn cotton

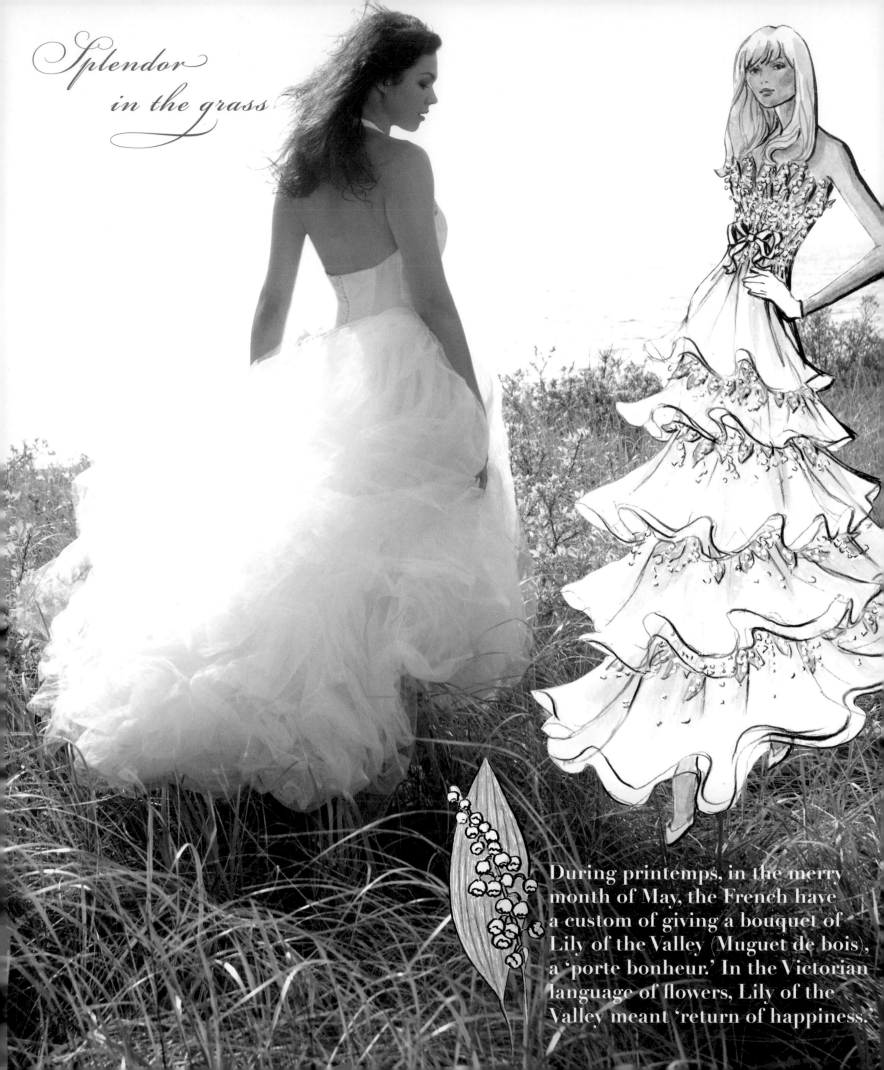

Splendor in the grass

During printemps, in the merry month of May, the French have a custom of giving a bouquet of Lily of the Valley (Muguet de bois), a 'porte bonheur.' In the Victorian language of flowers, Lily of the Valley meant 'return of happiness.'

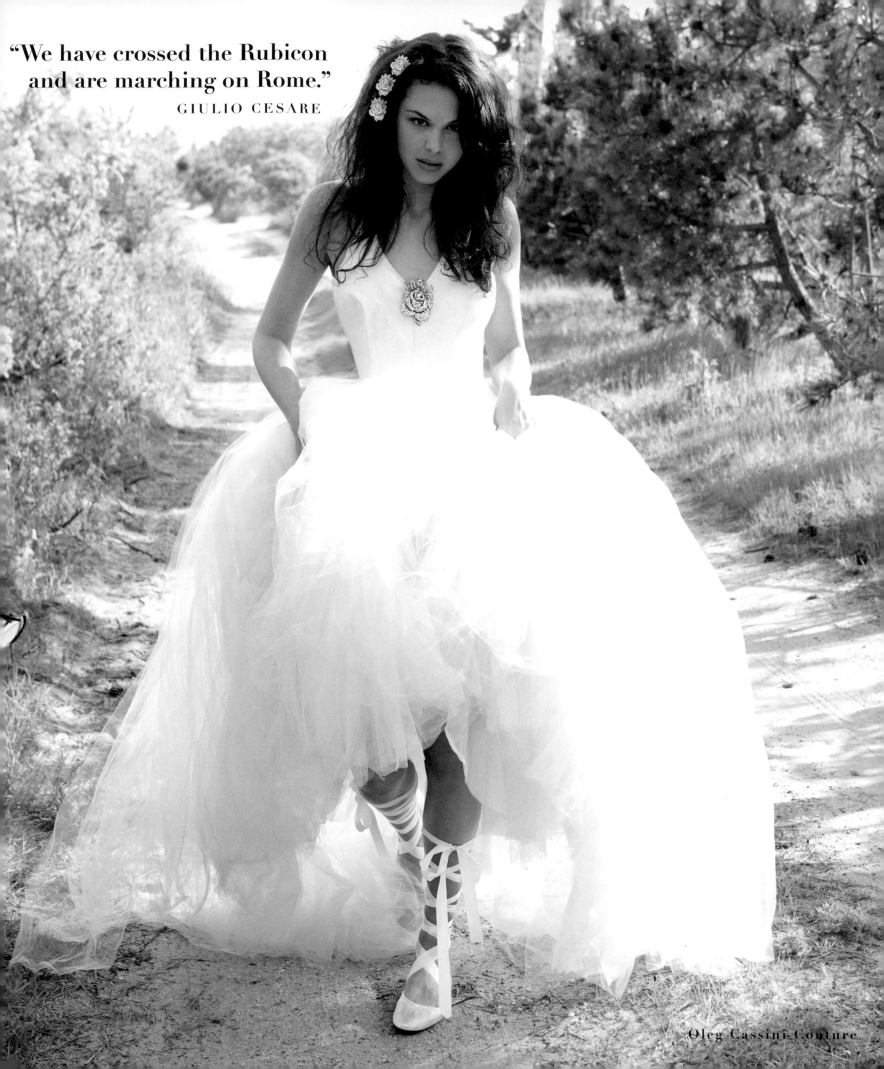

"We have crossed the Rubicon and are marching on Rome."
GIULIO CESARE

Oleg Cassini Couture

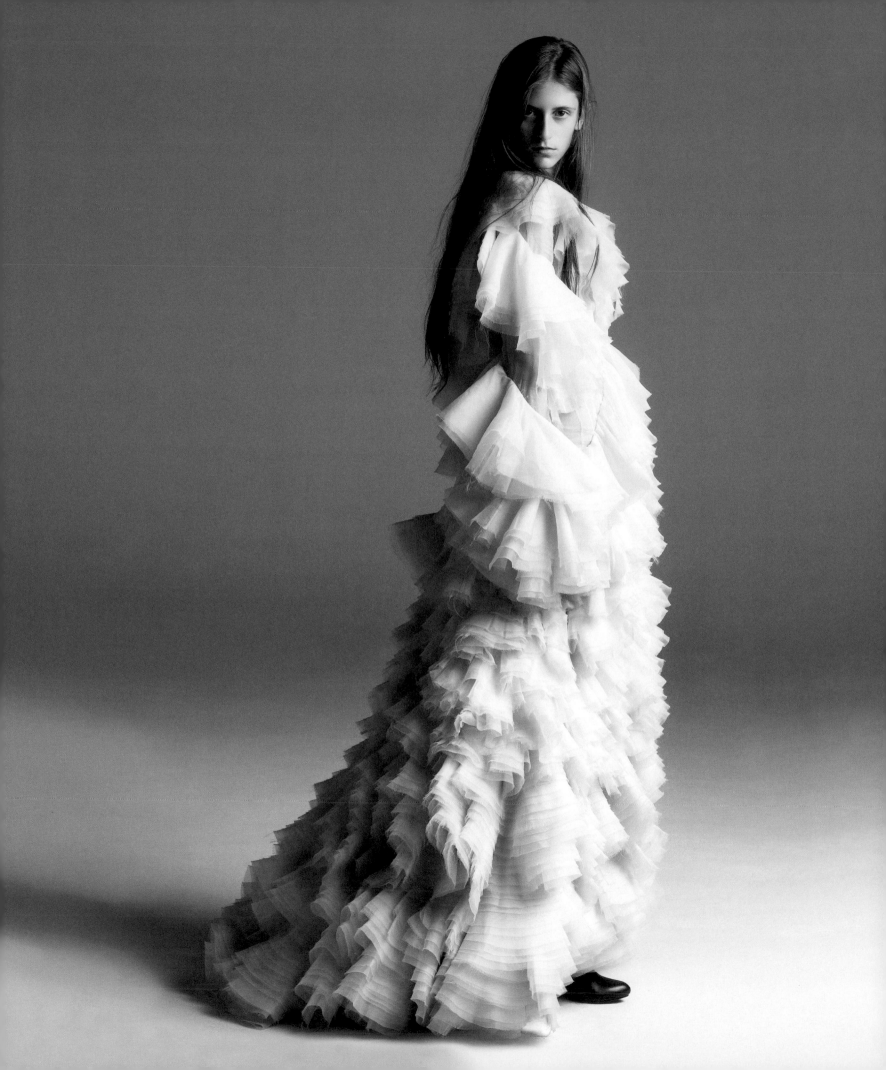

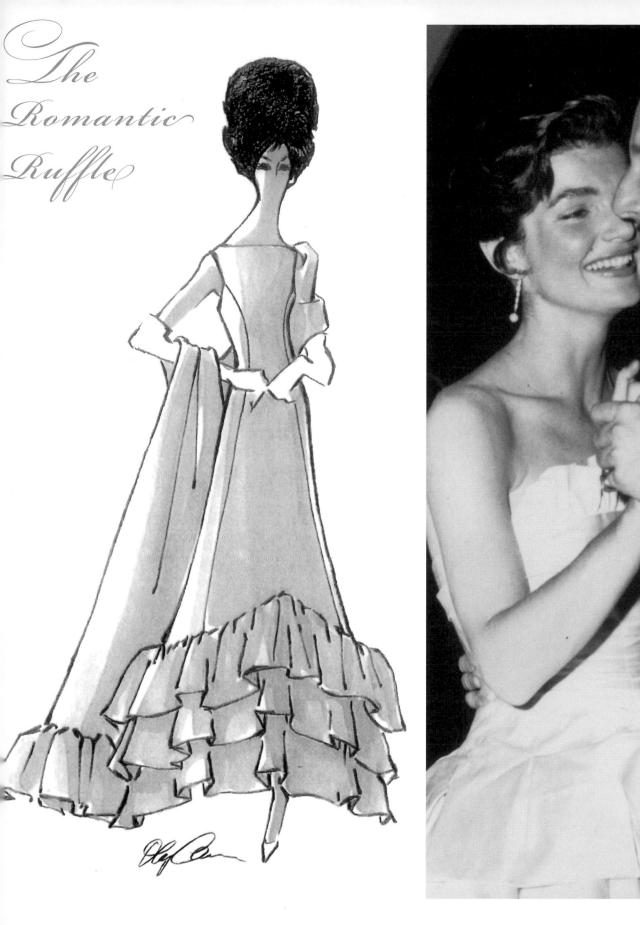

The Romantic Ruffle

In addition to the appealing vision and movement they create, romantic ruffled tiers on the wedding dress bring to mind the tiered cake. The visual allusion to this matrimonial symbol adds another dimension to the overall look. Tiers, whether they be light, subtle layers of fabric, or frothy ruffles, add glamour and volume to the dress. Ruffles shimmer playfully and add an accent of flair and an element of excitement.

Ruffles were an important design element for Jackie. To paraphrase Oscar Wilde, "her tastes were very simple, she only liked the very best."

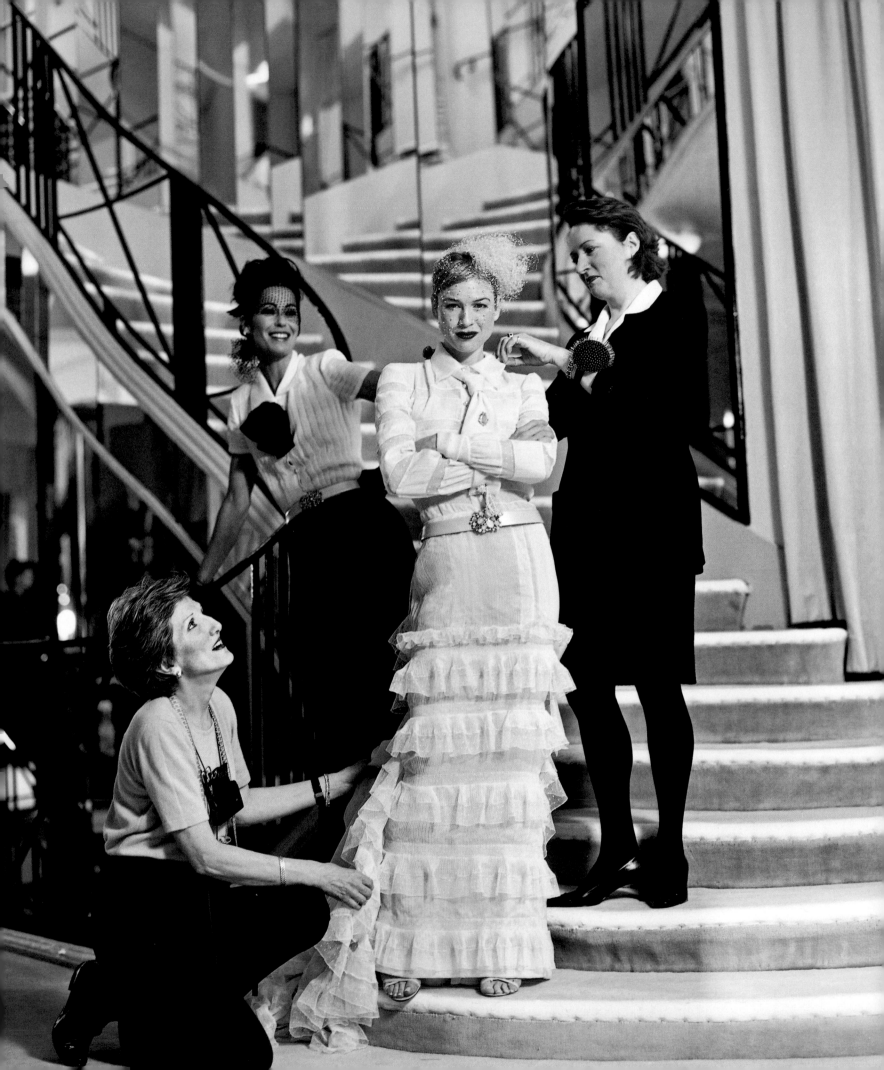

The stage is set . . .

THIS PAGE
Cassini Crystal stems are filled with rosé.
Charmeuse silk is tiered and centered with
signature bows, topped with a black velvet hat.
Photo by Mattias Edwall

OPPOSITE
Academy Award Winning Actress Renée
Zellweger, on the stairway at Chanel,
being wrapped in the ruffled tiers of a
wedding dress.

Photo by Arthur Elgort / Vogue
©Condé Nast Publications
Oleg Cassini gown

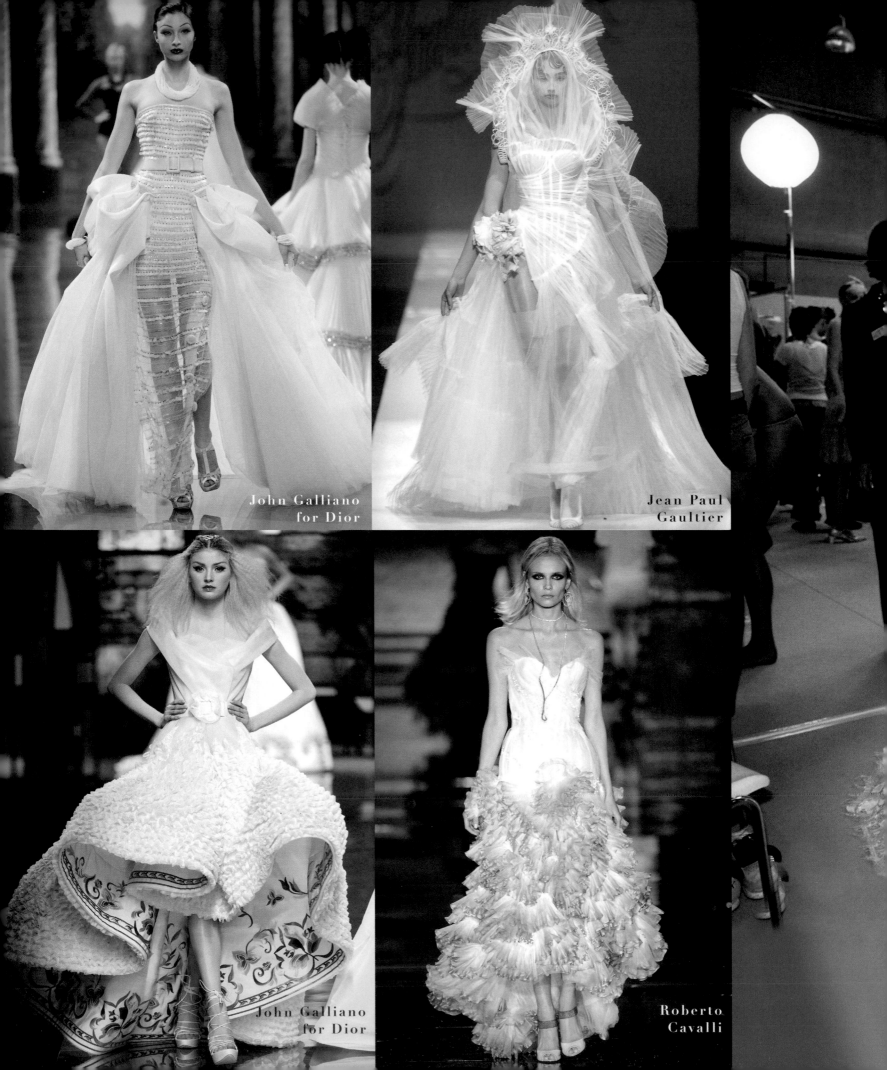

John Galliano
for Dior

Jean Paul
Gaultier

John Galliano
for Dior

Roberto
Cavalli

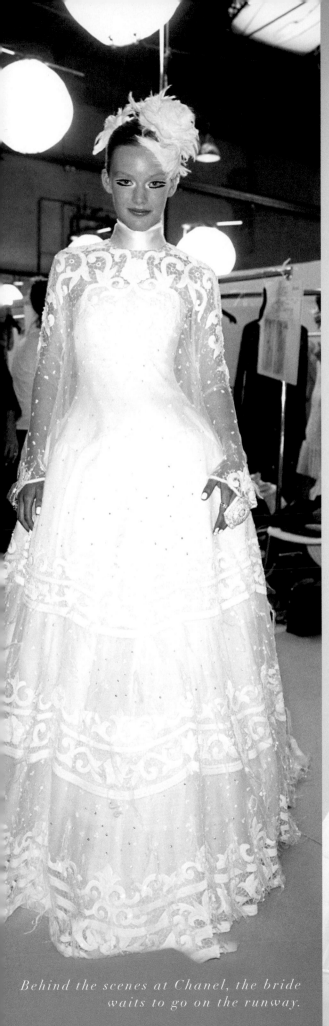

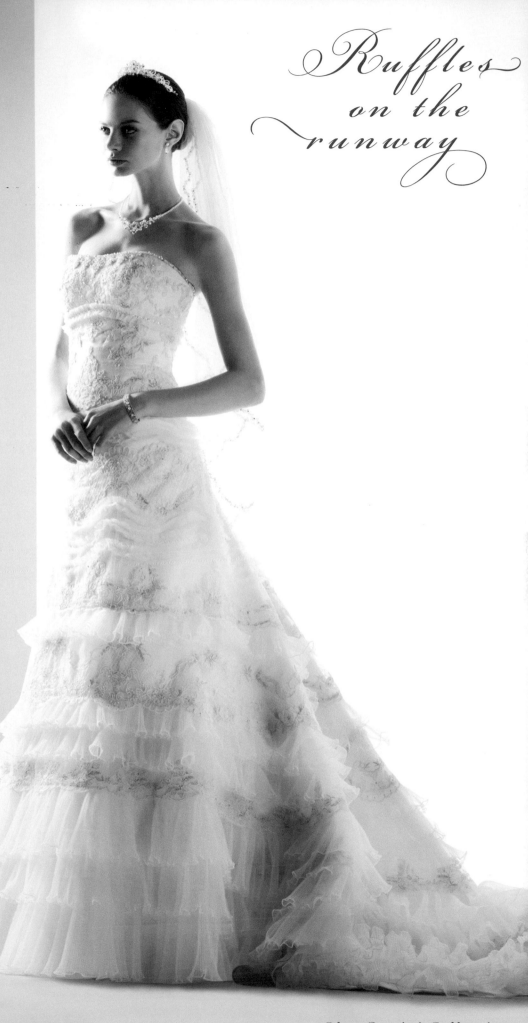

Behind the scenes at Chanel, the bride waits to go on the runway.

Photo by Robert Fairer

Oleg Cassini Collection

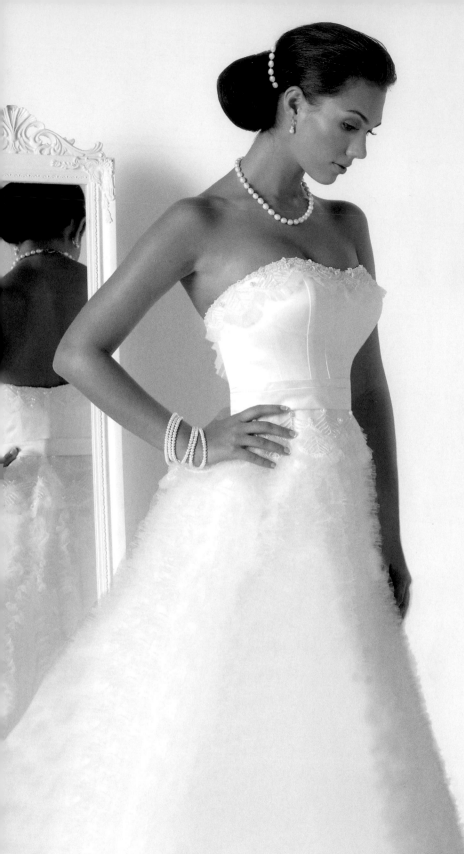

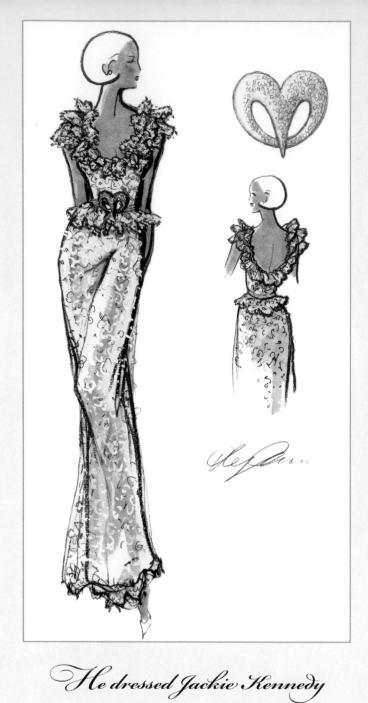

He dressed Jackie Kennedy
& Marilyn Monroe.

Who better to dress you on your wedding day?

Oleg Cassini has created some of the
most memorable moments in international
fashion history. Rated as the number one
designer label in bridal gowns in the
USA today, 50,000 Oleg Cassini wedding dresses are
sold each year. Defined as a "rare combination
of European elegance and new world energy,"
Oleg Cassini wedding dresses offer
brides styles reflecting the designer's love
and understanding of women.

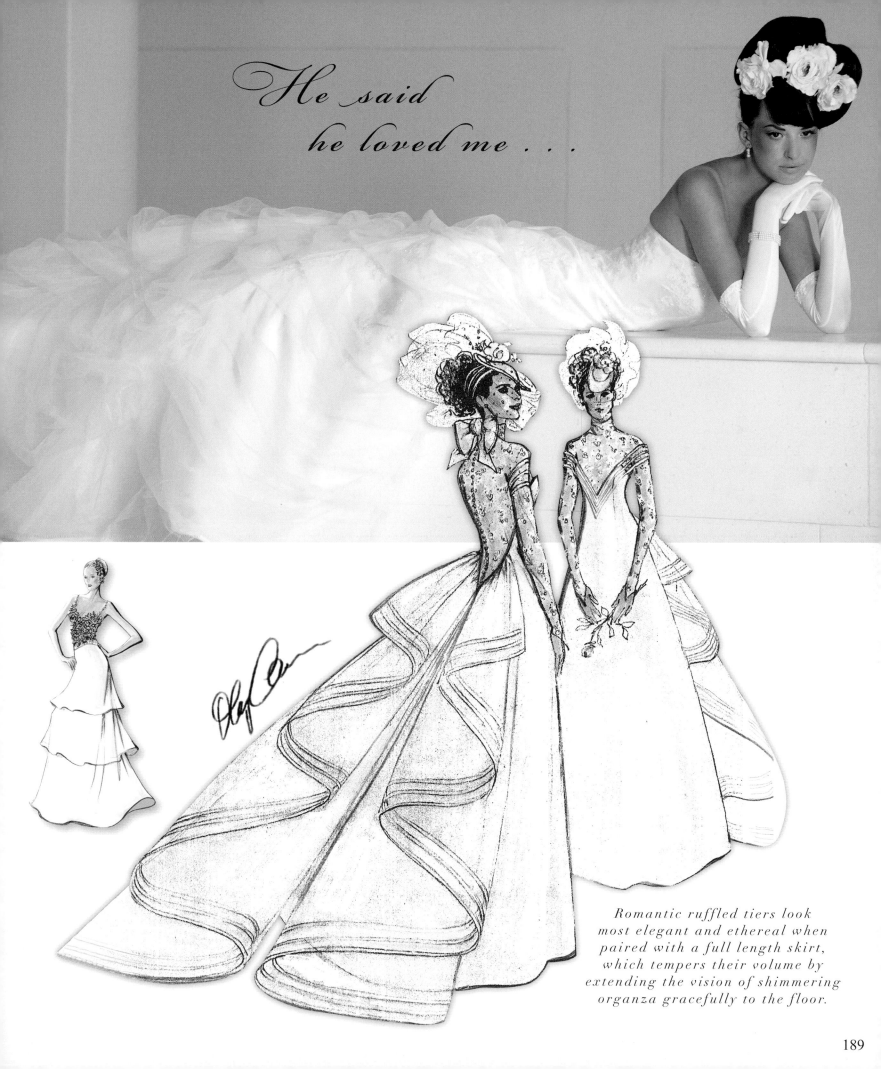

He said
he loved me . . .

*Romantic ruffled tiers look
most elegant and ethereal when
paired with a full length skirt,
which tempers their volume by
extending the vision of shimmering
organza gracefully to the floor.*

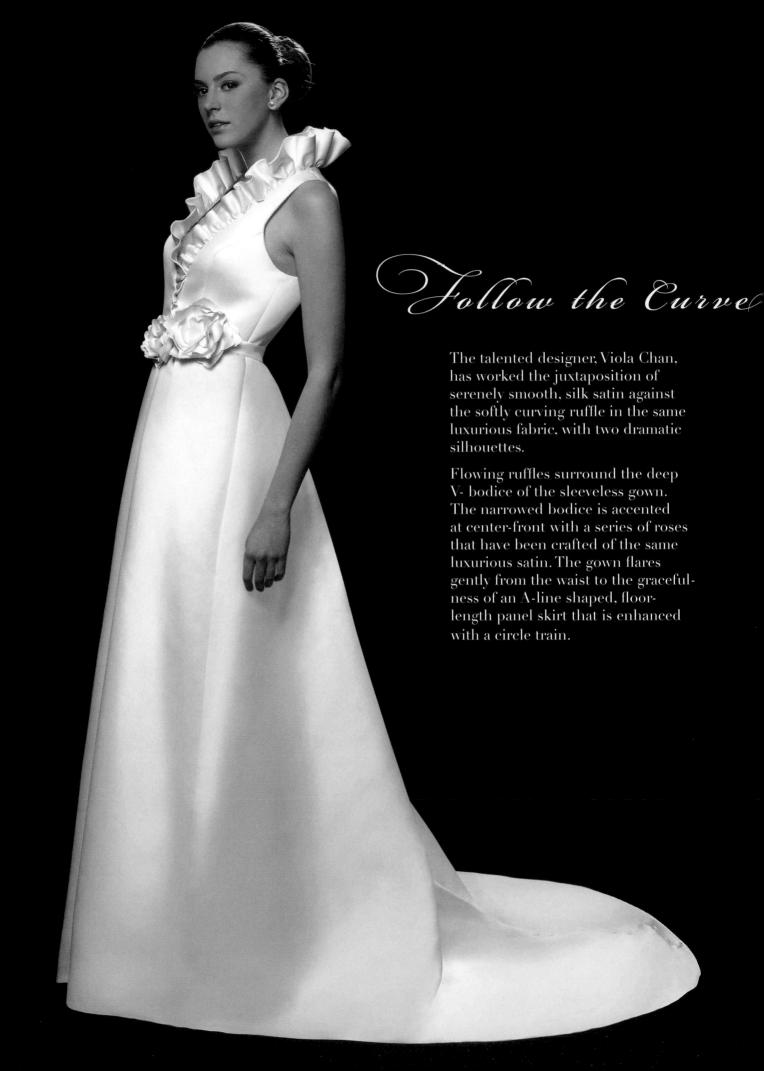

Follow the Curve

The talented designer, Viola Chan, has worked the juxtaposition of serenely smooth, silk satin against the softly curving ruffle in the same luxurious fabric, with two dramatic silhouettes.

Flowing ruffles surround the deep V- bodice of the sleeveless gown. The narrowed bodice is accented at center-front with a series of roses that have been crafted of the same luxurious satin. The gown flares gently from the waist to the gracefulness of an A-line shaped, floor-length panel skirt that is enhanced with a circle train.

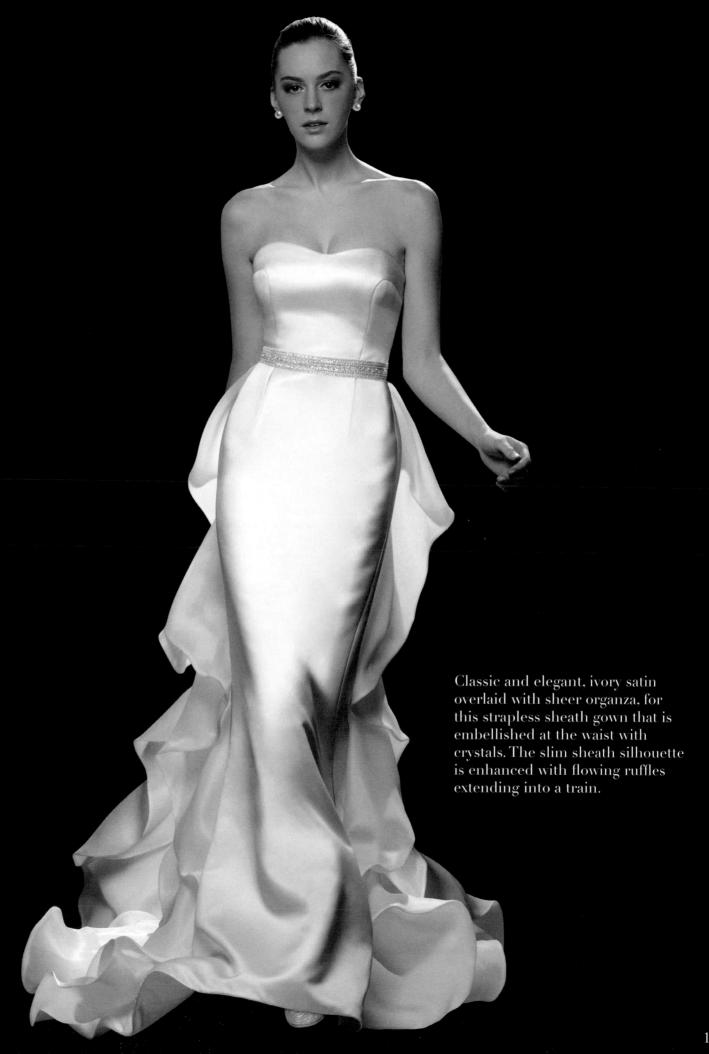

Classic and elegant, ivory satin overlaid with sheer organza, for this strapless sheath gown that is embellished at the waist with crystals. The slim sheath silhouette is enhanced with flowing ruffles extending into a train.

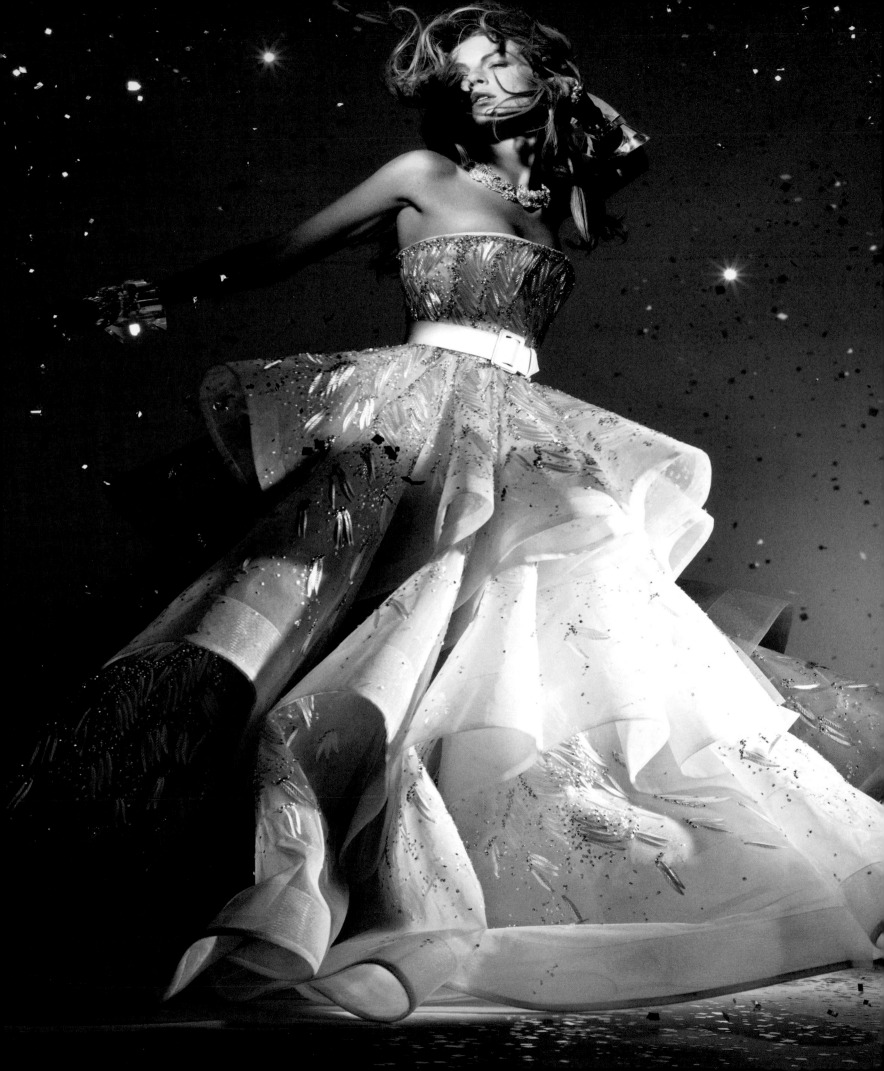

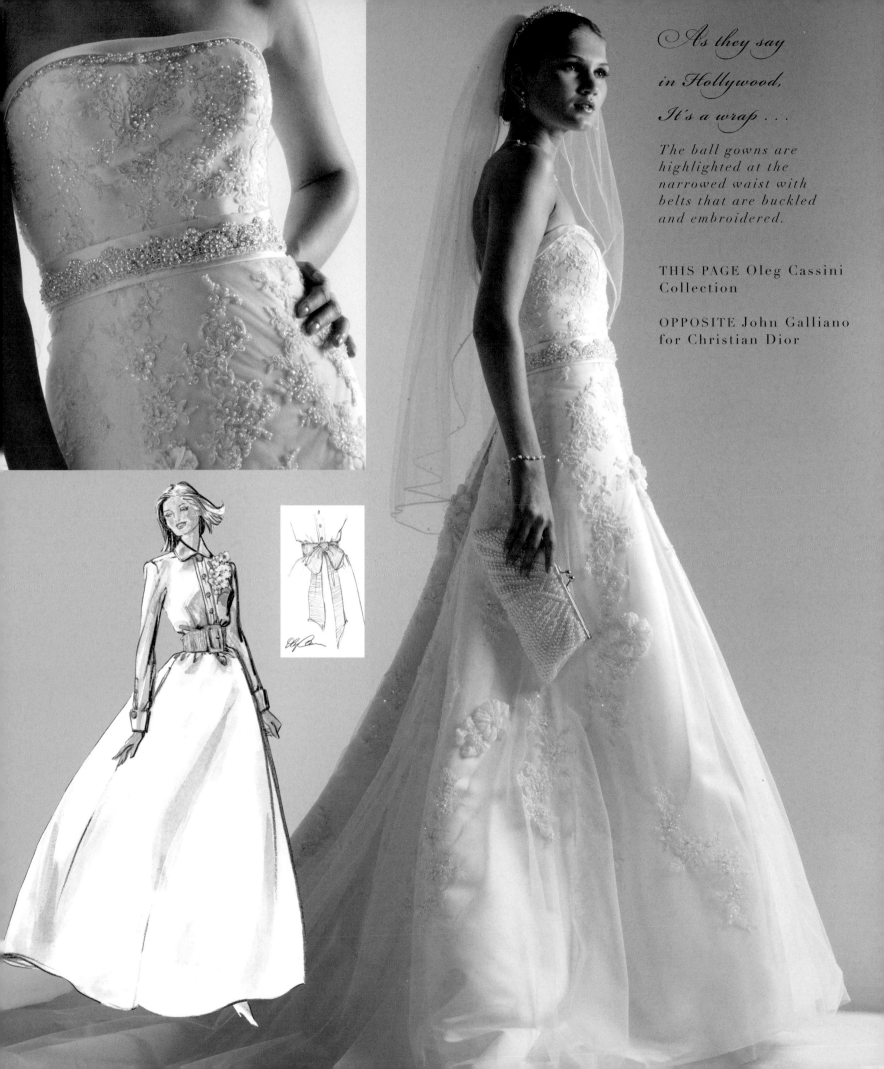

As they say

in Hollywood,

It's a wrap . . .

The ball gowns are highlighted at the narrowed waist with belts that are buckled and embroidered.

THIS PAGE Oleg Cassini Collection

OPPOSITE John Galliano for Christian Dior

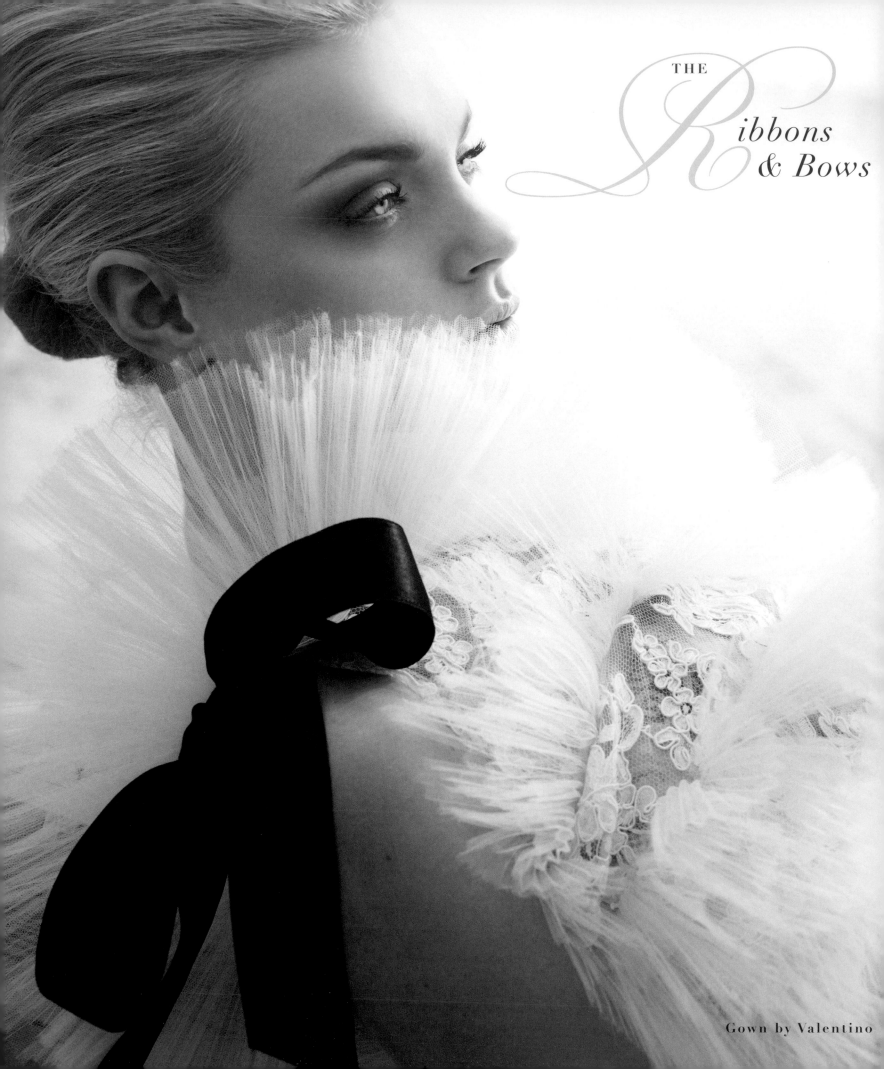

THE *Ribbons & Bows*

Gown by Valentino

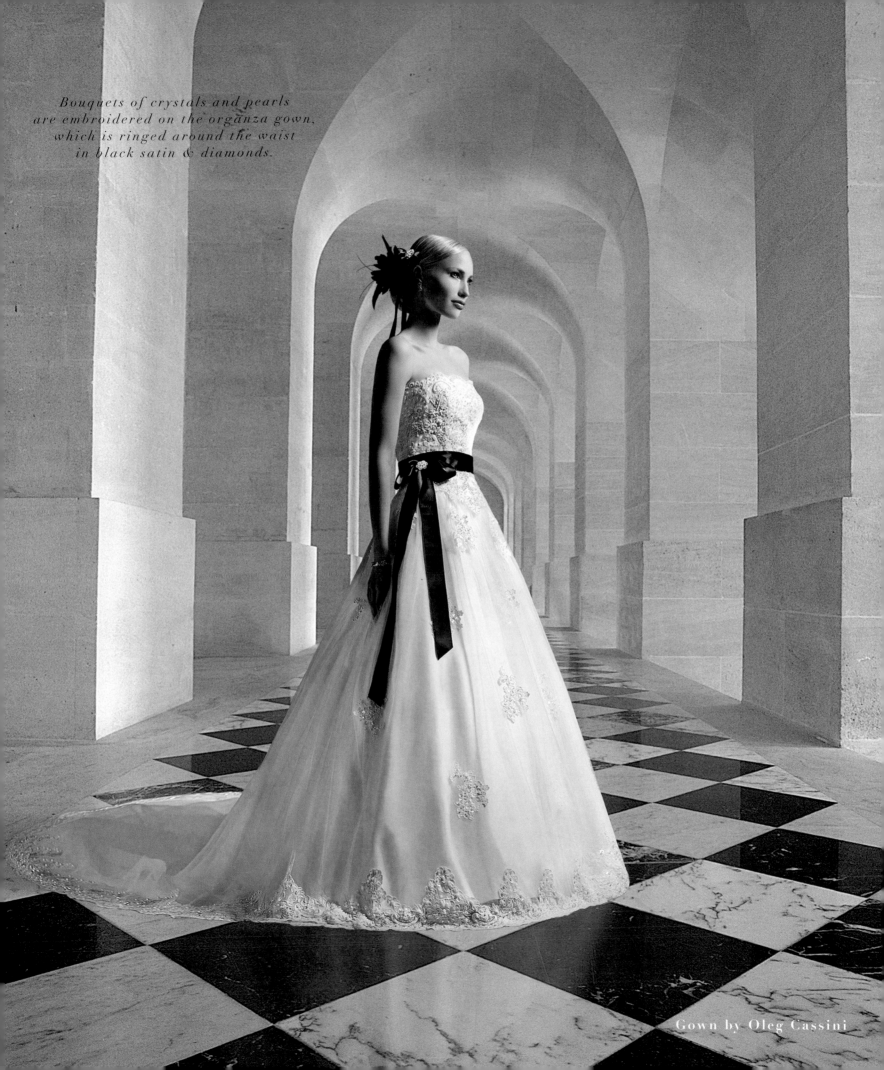

Bouquets of crystals and pearls are embroidered on the organza gown, which is ringed around the waist in black satin & diamonds.

Gown by Oleg Cassini

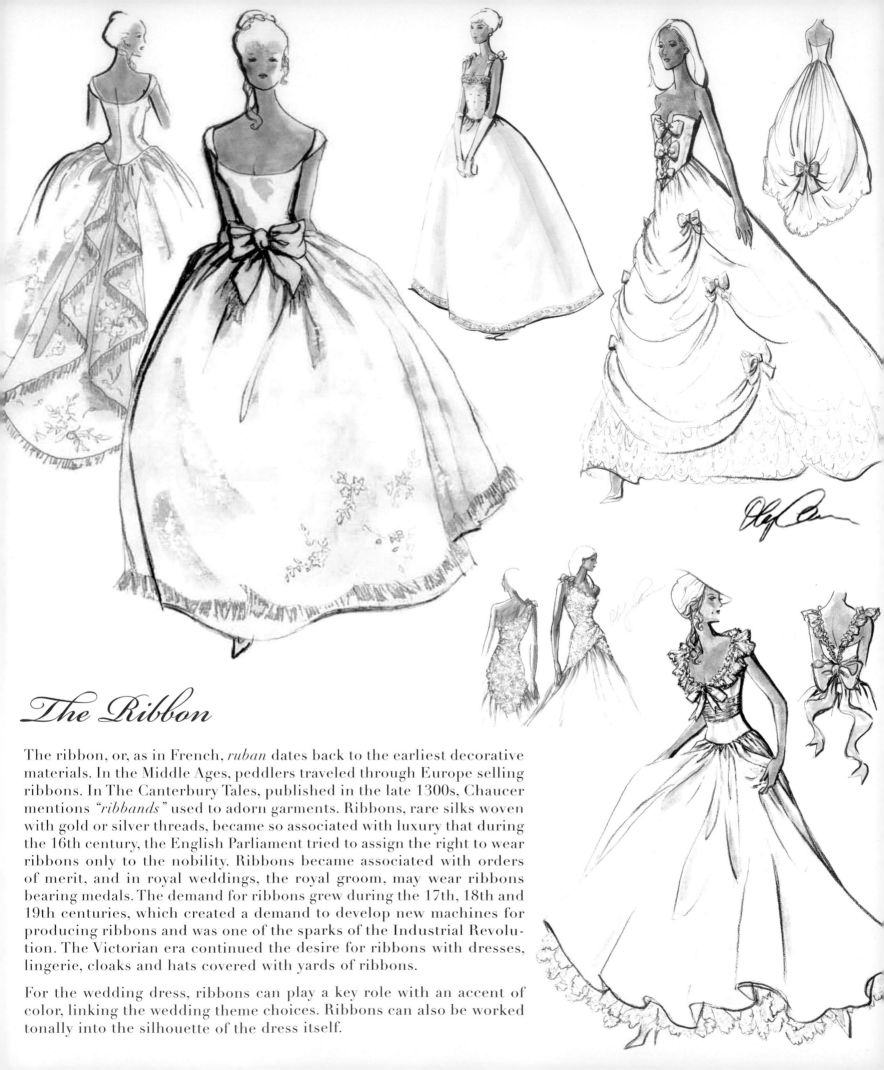

The Ribbon

The ribbon, or, as in French, *ruban* dates back to the earliest decorative materials. In the Middle Ages, peddlers traveled through Europe selling ribbons. In The Canterbury Tales, published in the late 1300s, Chaucer mentions *"ribbands"* used to adorn garments. Ribbons, rare silks woven with gold or silver threads, became so associated with luxury that during the 16th century, the English Parliament tried to assign the right to wear ribbons only to the nobility. Ribbons became associated with orders of merit, and in royal weddings, the royal groom, may wear ribbons bearing medals. The demand for ribbons grew during the 17th, 18th and 19th centuries, which created a demand to develop new machines for producing ribbons and was one of the sparks of the Industrial Revolution. The Victorian era continued the desire for ribbons with dresses, lingerie, cloaks and hats covered with yards of ribbons.

For the wedding dress, ribbons can play a key role with an accent of color, linking the wedding theme choices. Ribbons can also be worked tonally into the silhouette of the dress itself.

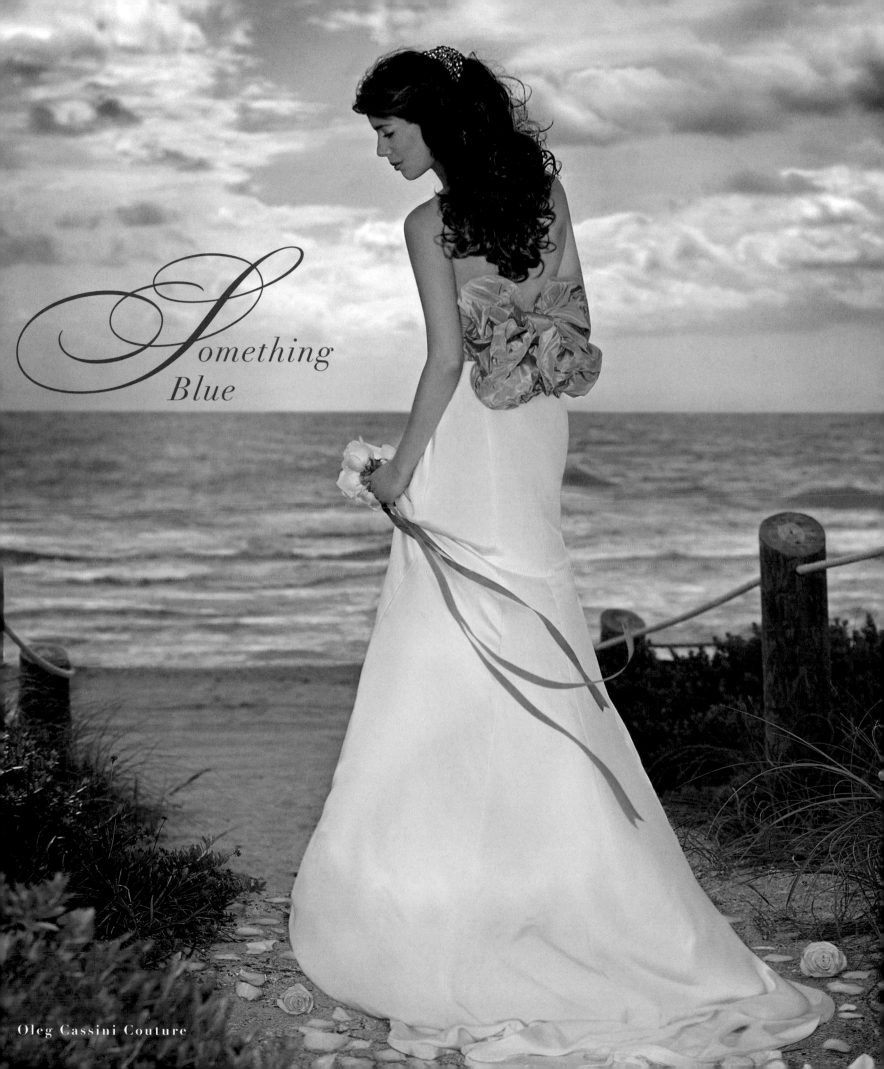

Something Blue

Oleg Cassini Couture

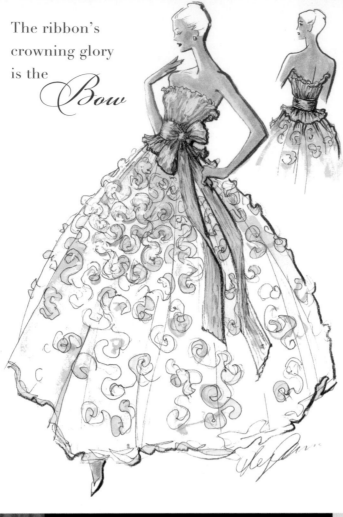

The ribbon's
crowning glory
is the
Bow

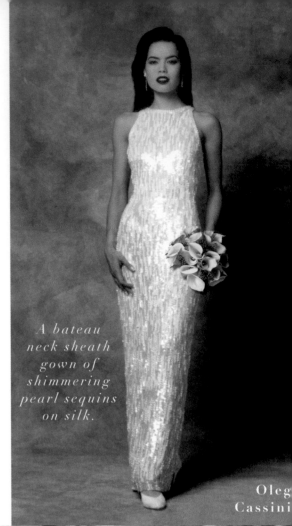

*A bateau
neck sheath
gown of
shimmering
pearl sequins
on silk.*

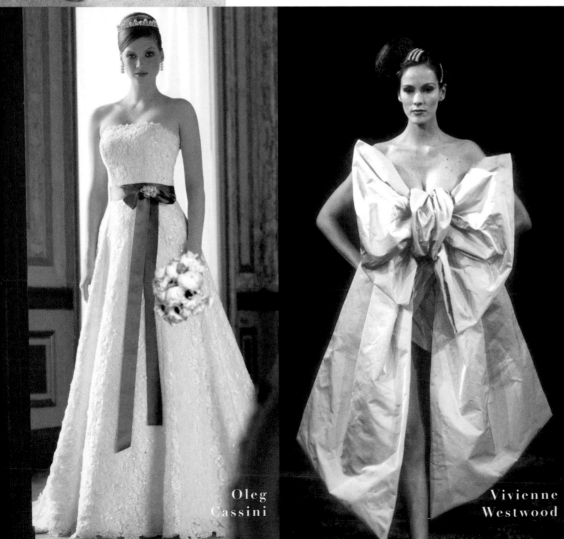

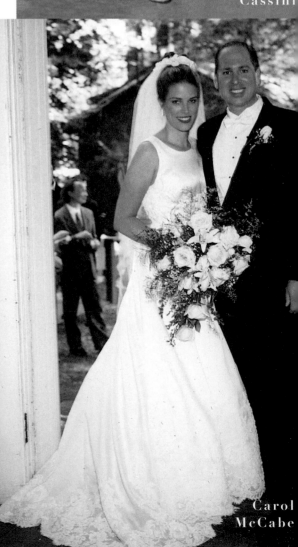

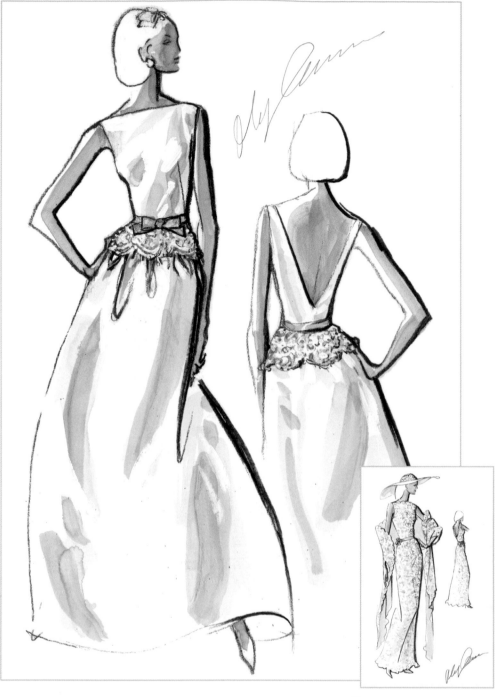

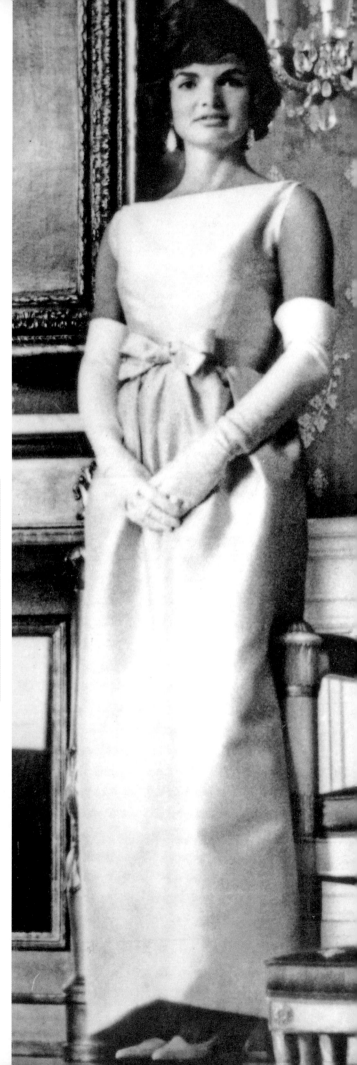

The Bateau Neck

Popularized by the iconic image of First Lady Jacqueline Kennedy wearing Oleg Cassini gowns, with signature bows and bateau necks, the drama of the smooth sophistication of her necklines was at the back, with deep Vs and scooped backs. Stretching gracefully from one shoulder to the other with a subtle, delicate dip, the bateau ('boatneck'), is a neckline that proudly covers with surprising allure. The secret is the natural accentuation of the collarbone and neck, an area that is appealing on almost all women, and is a perfect setting for jewels and necklaces. It's a shape that is flattering, drawing attention to the sleeker, slimmer, neck and collarbone areas. This shape of neckline is often associated with sailors; it is said that it was favored for its wide neck, which made it easier to pull off after going overboard. The bateau works well with bell skirts or the classic sheath embroidered all over with beaded fringes and jewels.

OPPOSITE, BOTTOM RIGHT Fashion Guru Carol McCabe and her husband, Kevin. Carol wears a bateau neck gown of white satin and lace.

A time honored classic.

The 'Ribbon Dress' reflects the
light in a spectacular fashion.
Satin ribbons worked in
circles around the dress are
embroidered with pearls
and polished crystals
on scalloped lace, making
a perfect link of
matte and shine.

All gowns Oleg Cassini
Collection

In the grand tradition...

With an eye for detail, the wide ribbon of luminous satin is caught with crystals in the Cassini signature double loop at the back of the cummerbund waist. The same ribbon signature detail is used as a double bow at the side of the bodice.

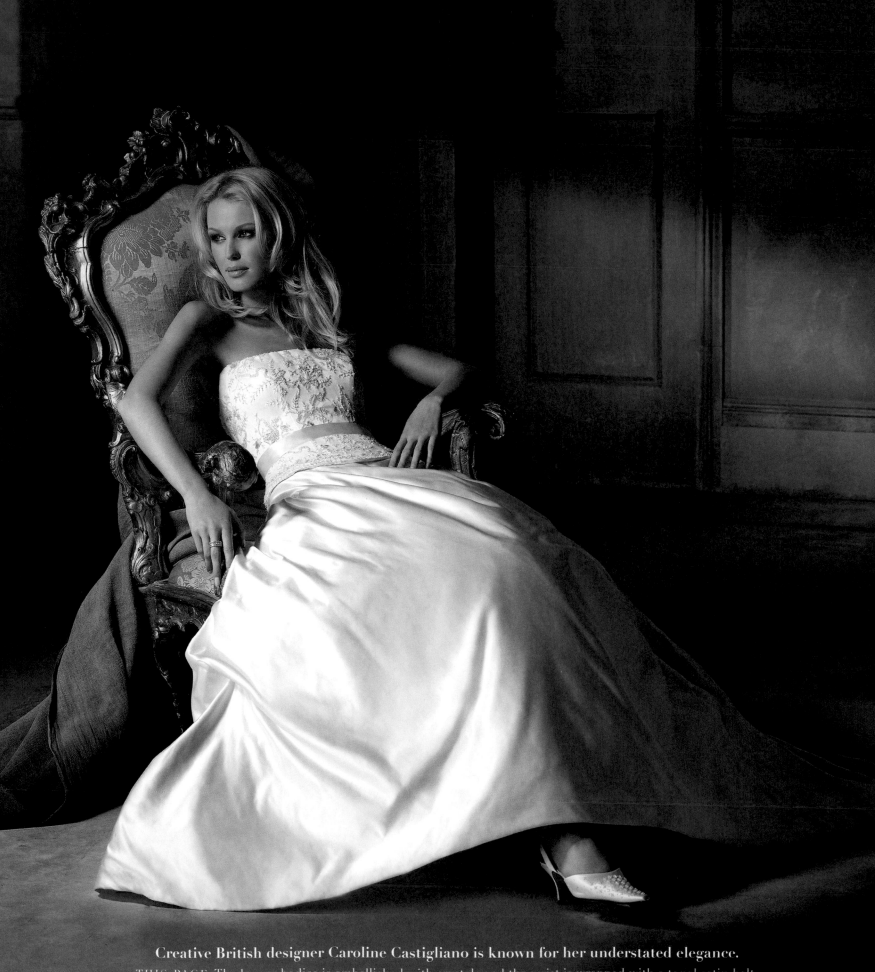

Creative British designer Caroline Castigliano is known for her understated elegance.
THIS PAGE The longer bodice is embellished with crystals and the waist is wrapped with a tonal satin belt.
OPPOSITE The smooth bodice is encircled at the waist with black velvet, teamed with an organza circle skirt.

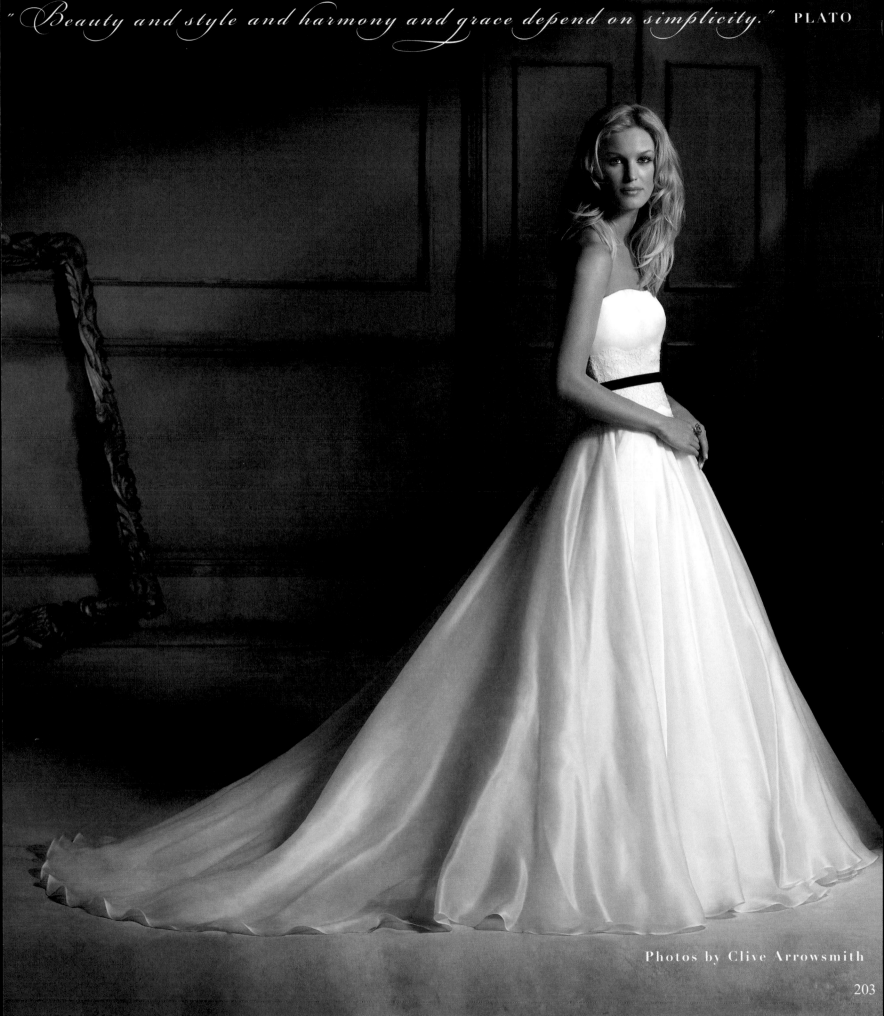

"*Beauty and style and harmony and grace depend on simplicity.*" PLATO

Photos by Clive Arrowsmith

203

"THE DRESS IS AN ENVELOPE FOR THE BODY."

OLEG CASSINI

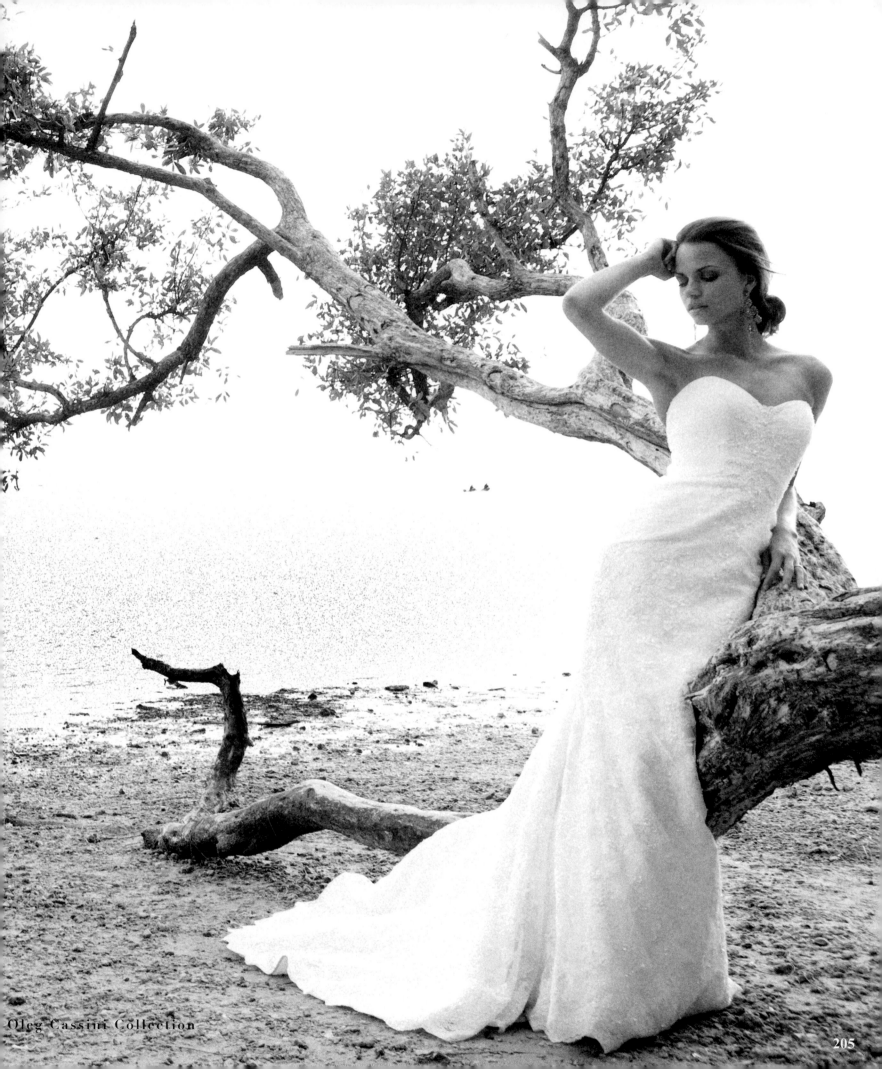

Oleg Cassini Collection

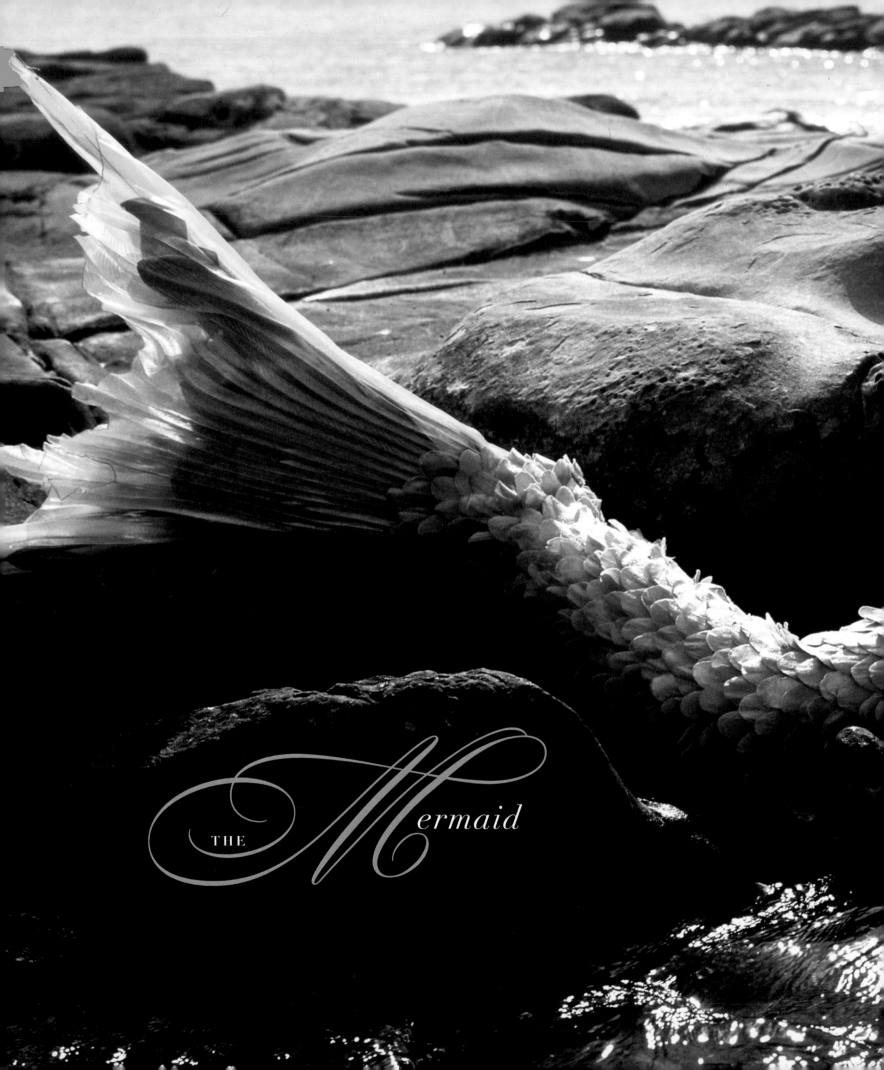

THE *Mermaid*

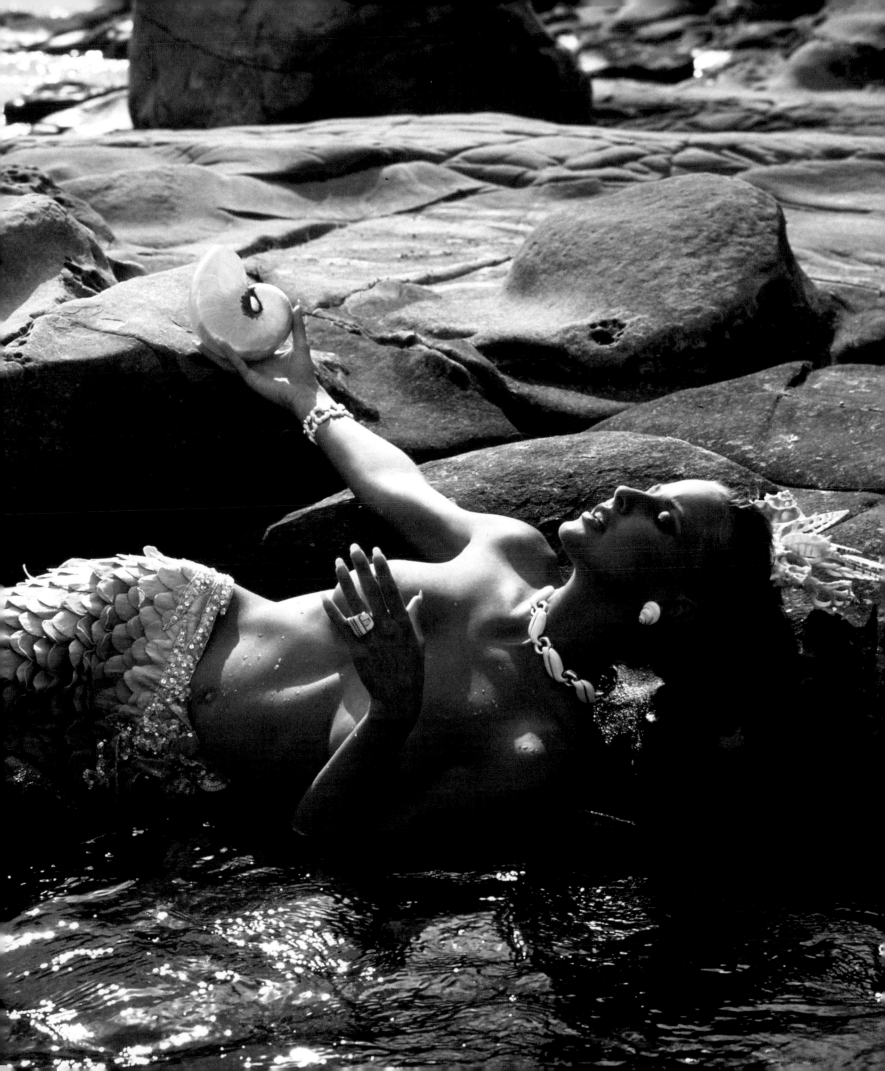

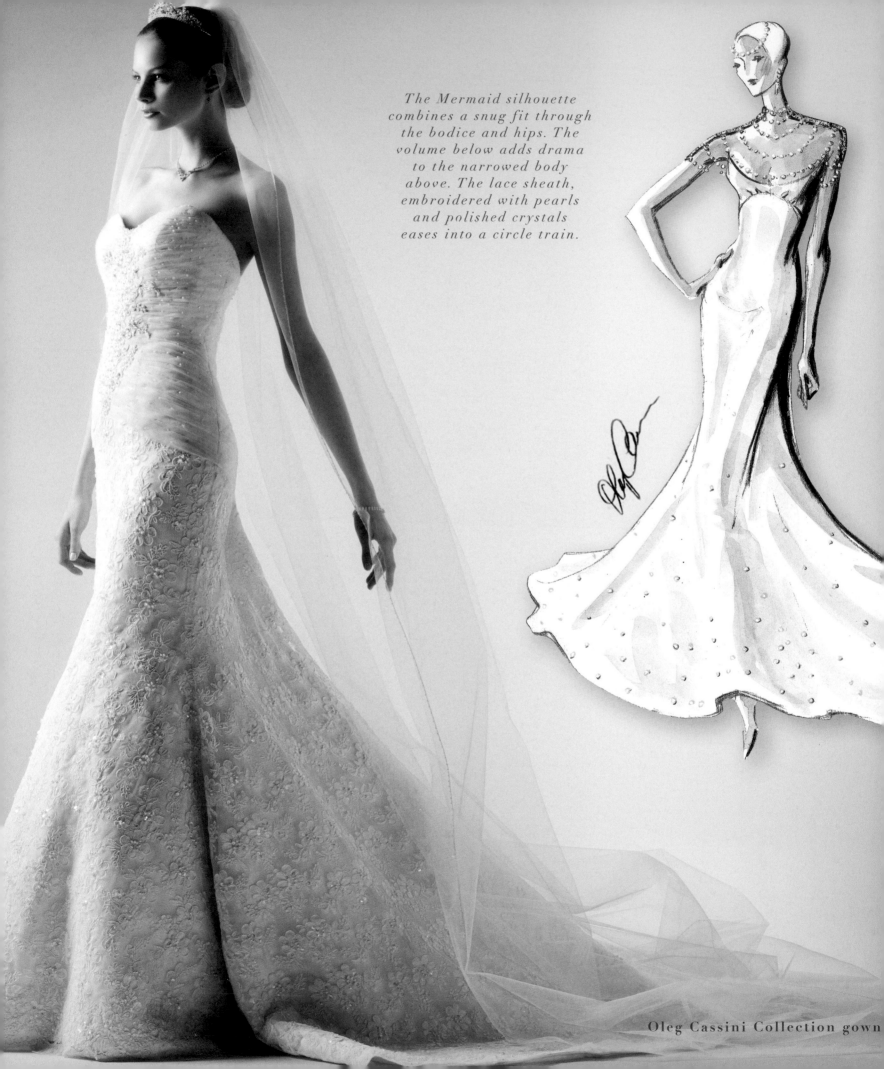

The Mermaid silhouette combines a snug fit through the bodice and hips. The volume below adds drama to the narrowed body above. The lace sheath, embroidered with pearls and polished crystals eases into a circle train.

Oleg Cassini Collection gown

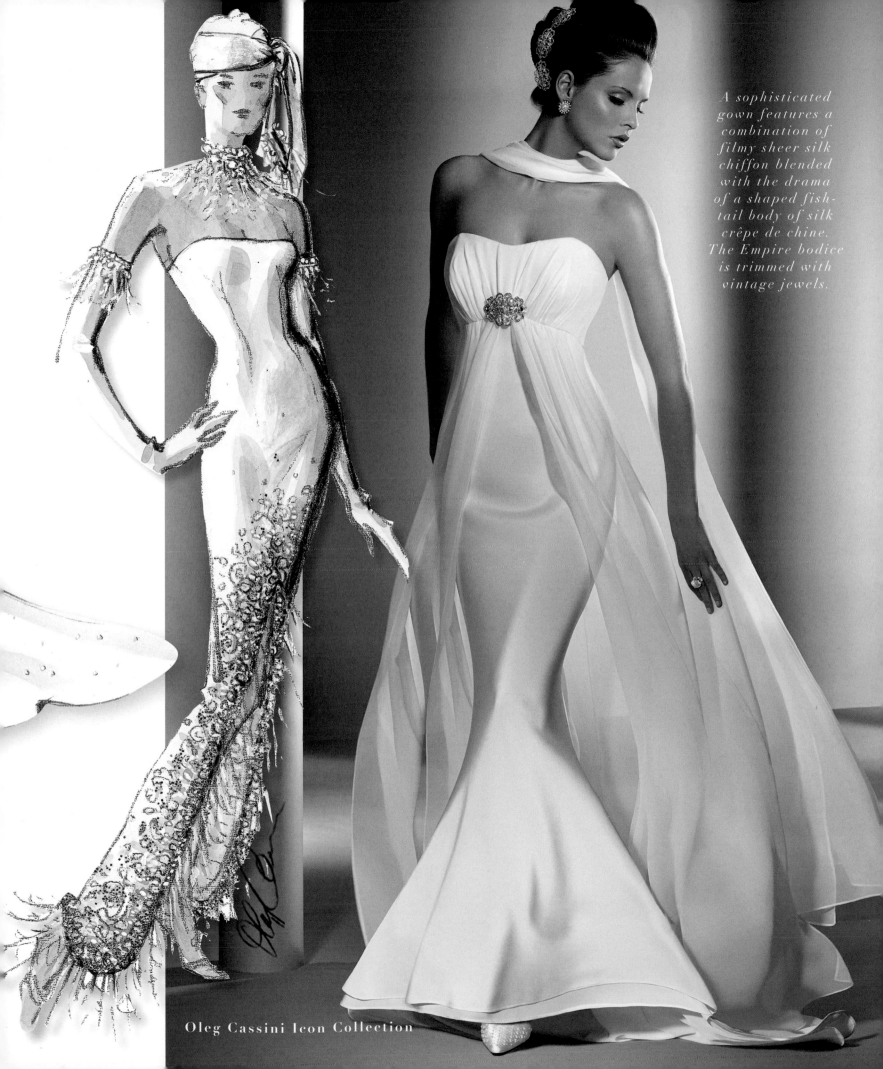

A sophisticated gown features a combination of filmy sheer silk chiffon blended with the drama of a shaped fish-tail body of silk crêpe de chine. The Empire bodice is trimmed with vintage jewels.

Oleg Cassini Icon Collection

At twilight, a wedding...

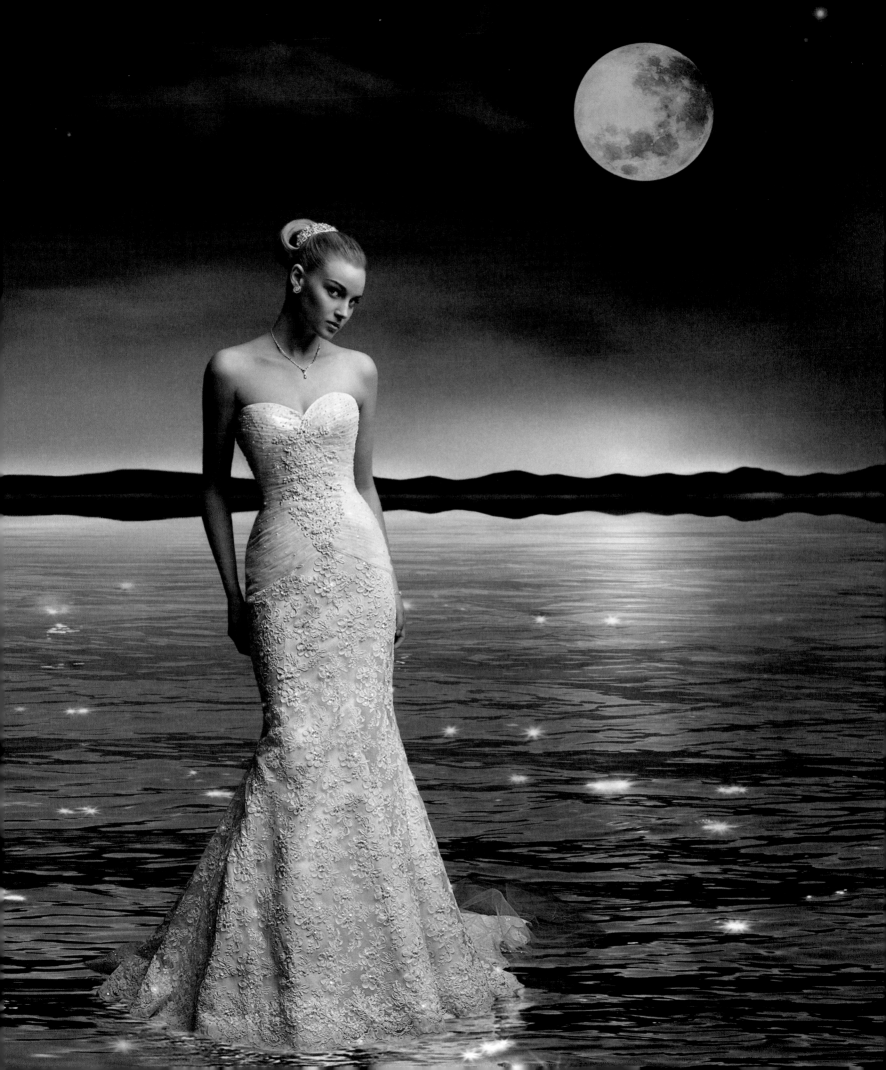

THE *Sheath*

The 'Sheath' is a term I used to reference the fit of a gown to the sheath of a sword. This is one of the most dramatic of silhouette choices.

The embroidered lace gown has a scalloped neckline caught with 'spaghetti' straps.

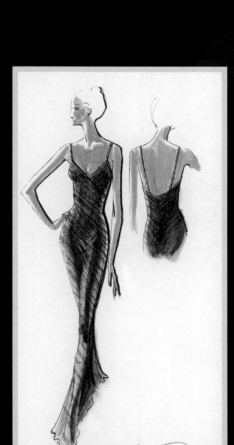

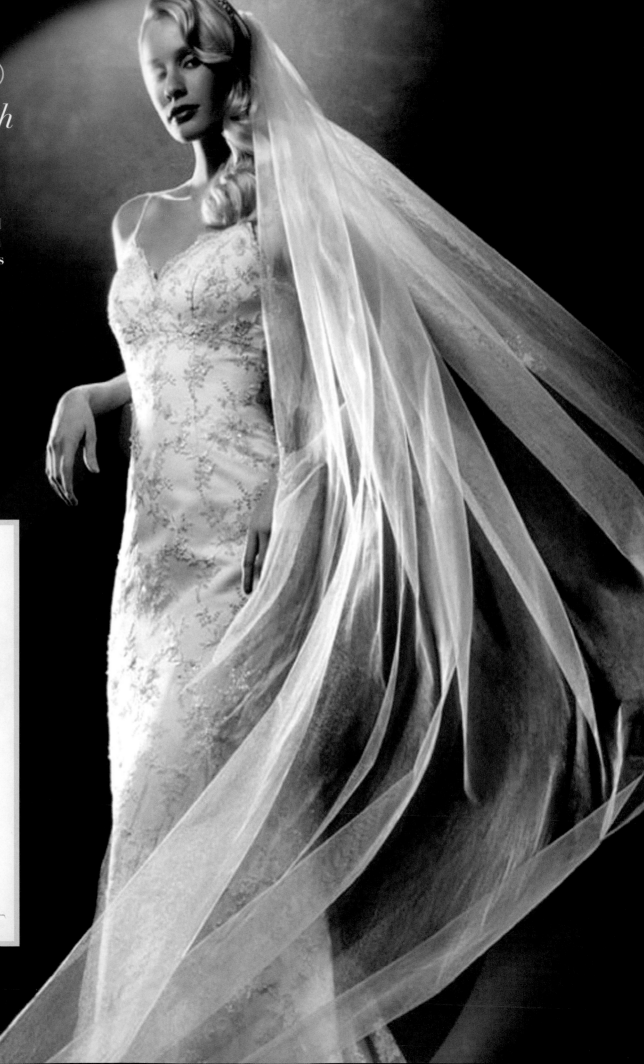

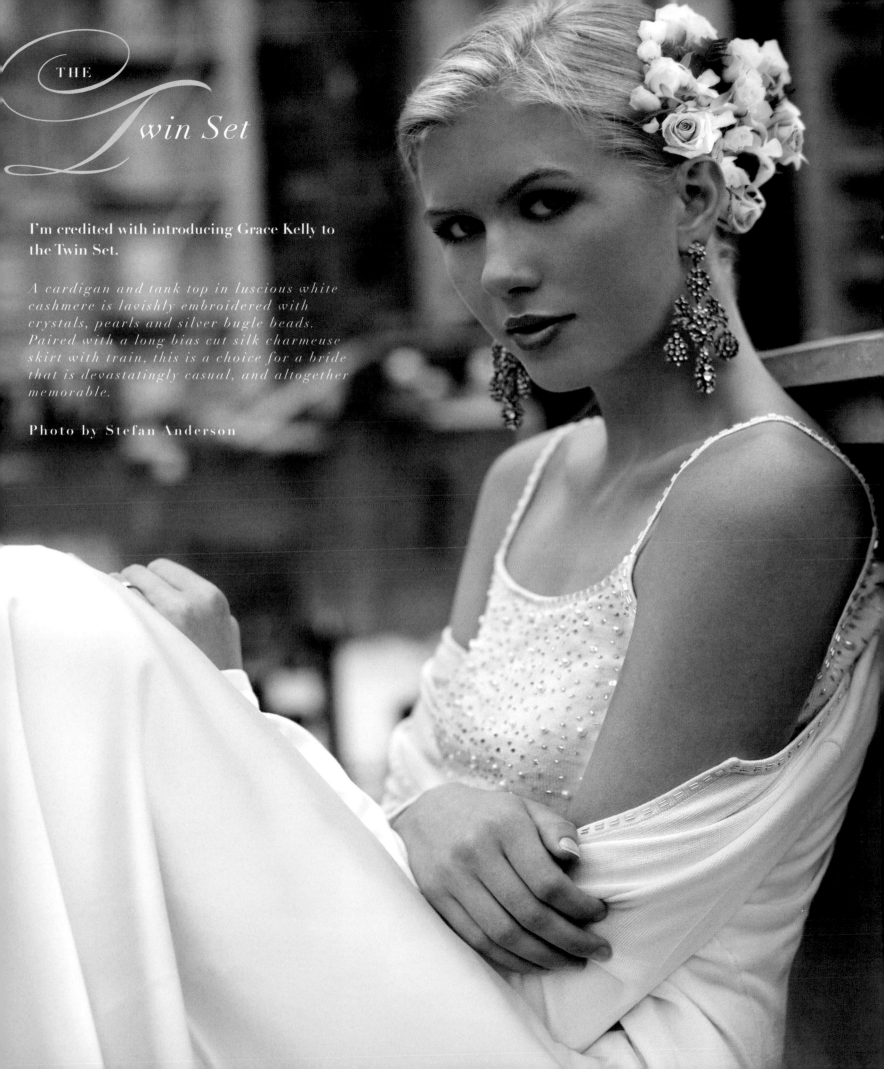

THE Twin Set

I'm credited with introducing Grace Kelly to the Twin Set.

A cardigan and tank top in luscious white cashmere is lavishly embroidered with crystals, pearls and silver bugle beads. Paired with a long bias cut silk charmeuse skirt with train, this is a choice for a bride that is devastatingly casual, and altogether memorable.

Photo by Stefan Anderson

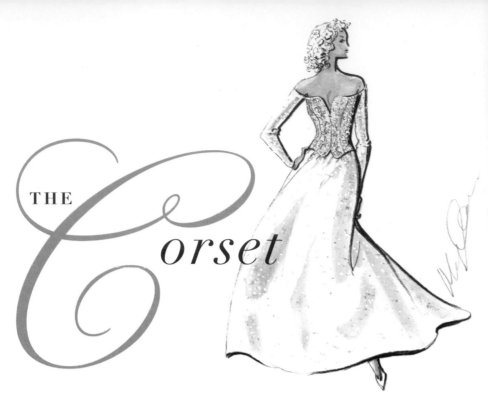

THE Corset

Imagining a romantic literary heroine, the corset bodice is designed to celebrate the narrowed waistline. Actually, the raison d'être of the corset was and is to create and accentuate this distinctive silhouette.

Worn as early as the 16th century by women (and in some circles, men too), this figure enhancing undergarment was created with cloth or leather covered boning (made from ivory, steel, and whalebones) in the front and lacing at the back.

Today's corset style bodices are made to be seen outside the dressing room, and those used in bridal gowns are swathed in lush fabric, decorated with lace, beading and appliqués. The bones can be incorporated as a design element or concealed by layers of fabric and decorative touches. Satin ribbons give an elegant twist to the traditional corset lacing, or, forgoing laces, a row of petite buttons.

A voluminous full length or pick up skirt in lustrous peau de soie or taffeta plays up the corset's historical allusions. The corset can also be paired with an A-line, trumpet, tiered, or sheath skirt. For more of a ball gown silhouette, the corseted bodice can be worn over skirts made from layers of tulle or crinoline. The neckline is simple, either sweetheart, straight across, or off the shoulder, creating a languid, totally romantic effect. The most authentic looking corsets are strapless, yet, full length sleeves or long gloves pair elegantly wth the corset silhouette.

Because of its association with romantic history, there is something about a corset bodice on a bridal gown that evokes nostalgia for an era long gone. This balance between romance and daring is what gives the corset its unique allure.

Gown by **Oleg Cassini Collection**

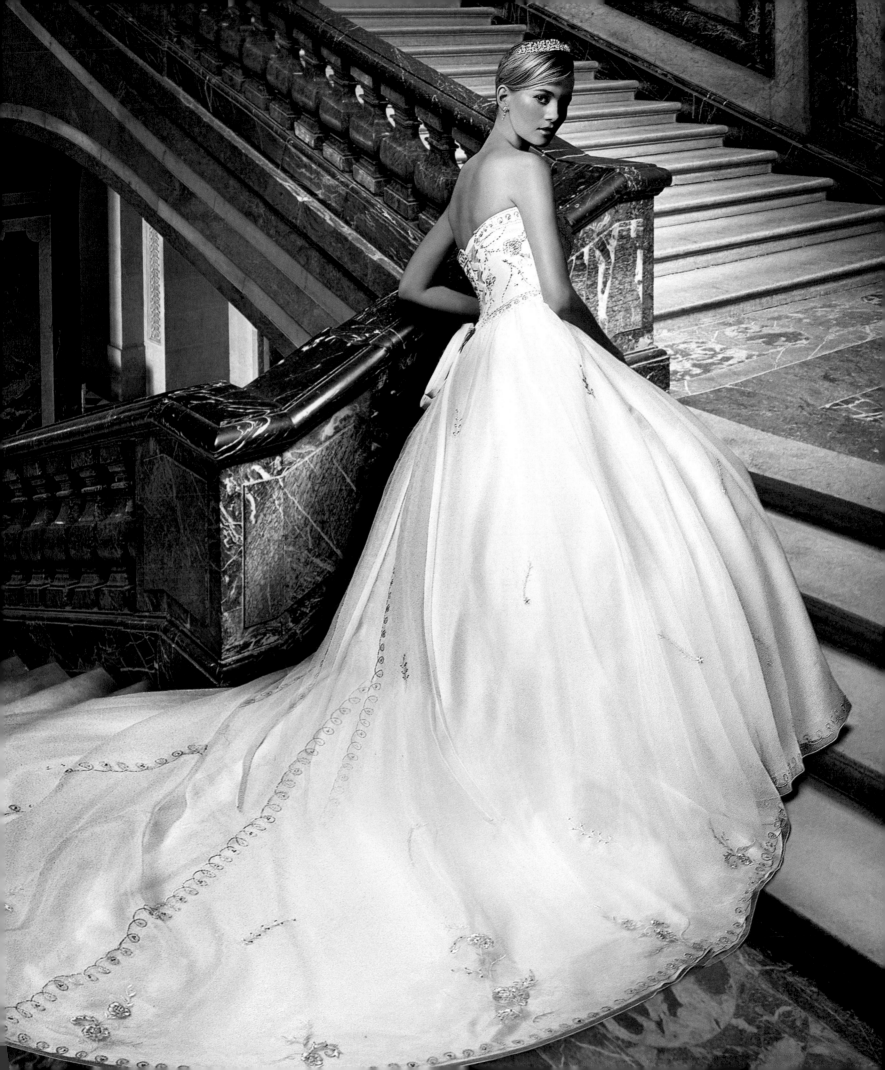

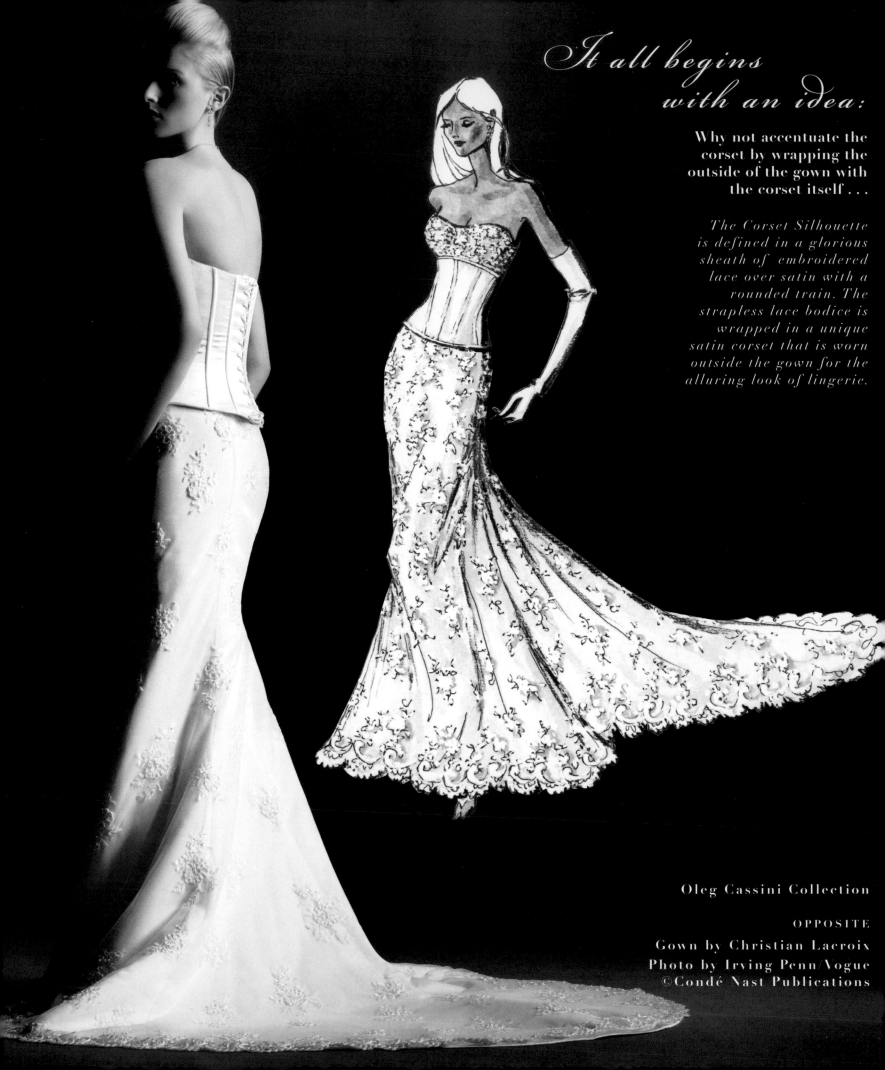

*It all begins
with an idea:*

**Why not accentuate the
corset by wrapping the
outside of the gown with
the corset itself . . .**

*The Corset Silhouette
is defined in a glorious
sheath of embroidered
lace over satin with a
rounded train. The
strapless lace bodice is
wrapped in a unique
satin corset that is worn
outside the gown for the
alluring look of lingerie.*

Oleg Cassini Collection

OPPOSITE
Gown by Christian Lacroix
Photo by Irving Penn/Vogue
©Condé Nast Publications

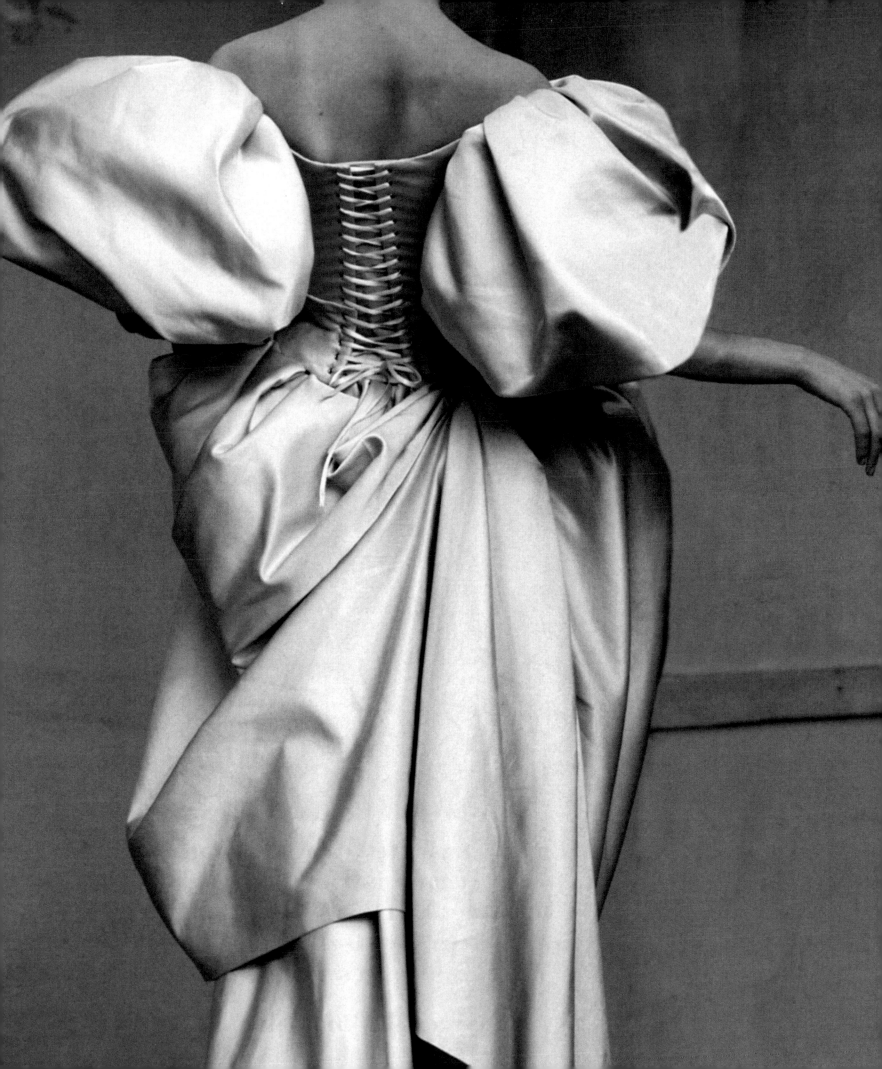

THE \mathcal{K} *not*

A wedding is a ceremonial occasion with its origins in centuries of tradition. The costume of the bride is the pivotal image that sets the theme for the event itself. Traditions evolve out of legend and it is fascinating to explore the many derivatives of the 'taken for granted' sayings associated with weddings. Many ancient beliefs and practices have evolved into modern customs linked with history that have become part of the tapestry that is 'The Wedding.' The wedding band worn on the fourth finger of the left hand derived from the belief that there is a love vein that runs directly from the heart to the ring finger. A diamond is seen as the fire of love, that would never cool, for its brilliance and durability.

"Something old" symbolizes the link with the bride's family and the past. *"Something new,"* means optimism and hope for their new life ahead. *"Something borrowed,"* is usually an item from a happily married member of the family or a friend, whose good fortune in marriage is to carry on to the new bride. The borrowed item is also to remind the bride that she can depend on her friends and family. *"Something blue,"* has been connected to weddings for centuries. In ancient Rome, brides wore blue to symbolize love, modesty, and fidelity. Before the late 19th century, blue was a popular color for wedding gowns, *"Marry in blue, lover be true."* A silver sixpence in the bride's shoe represents wealth and financial security. It dates back to a Scottish custom of a groom putting a silver coin under his left foot for good luck. These days, a dime or a copper penny is substituted.

The Legend of St. Katherine, circa 1225, used the Middle English 'cnotte' ie: 'knot,' night, to mean the tie or bond of wedlock. *'To tie the knot,'* as an expression, has come to mean, getting married. Knots have a place in the folklore of many cultures and usually symbolize unbreakable pledges. It has been widely suggested that the origin of this expression derives from the nets of knotted string which supported beds prior to the introduction of the metal bed frame. The theory goes that, in order to make a marriage bed secure, one needed to *"tie the knot."* Historically, the knot is symbolic of a lasting unity. The bride would also arrive at the altar with an untied shoe, and the groom would tie the lace. Knots were tied in the bridal bouquet as part of the ceremony with a fabric or silken cord. The love knot is a symbol used on garments and jewelry, and, in Italy, a knotted ribbon is tied over the entrance to the reception, and frosted pastries tied in knots are served.

The design of the gown symbolizes the tying of the knot custom, representing the bonds of marriage. The waist is wrapped in a satin sash which dramatically extends to a floor length train.

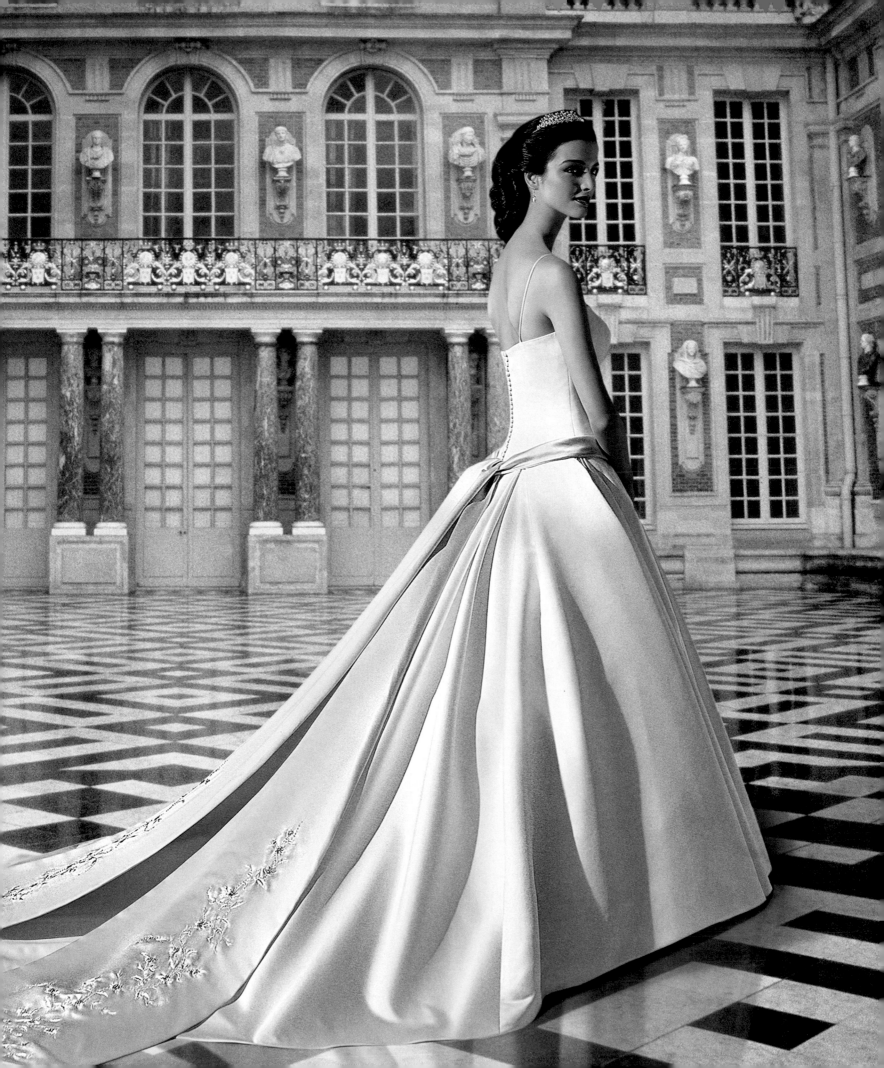

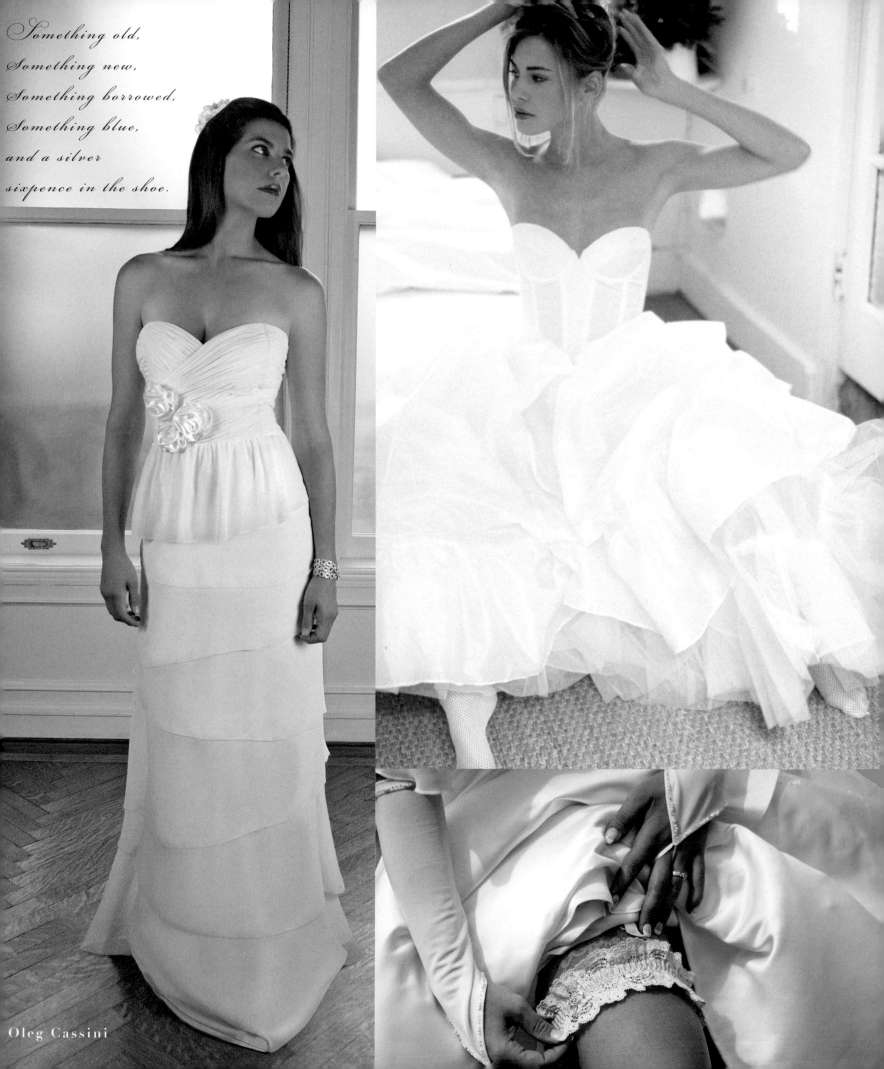

Something old,
Something new,
Something borrowed,
Something blue,
and a silver
sixpence in the shoe.

Oleg Cassini

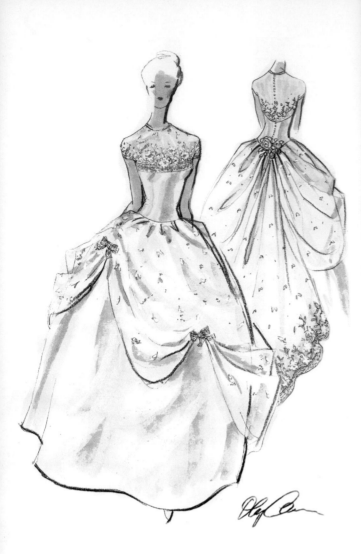

\mathcal{U}nderpinnings

*The way they were...
the bare necessities
of fashion in
the 1950s.*

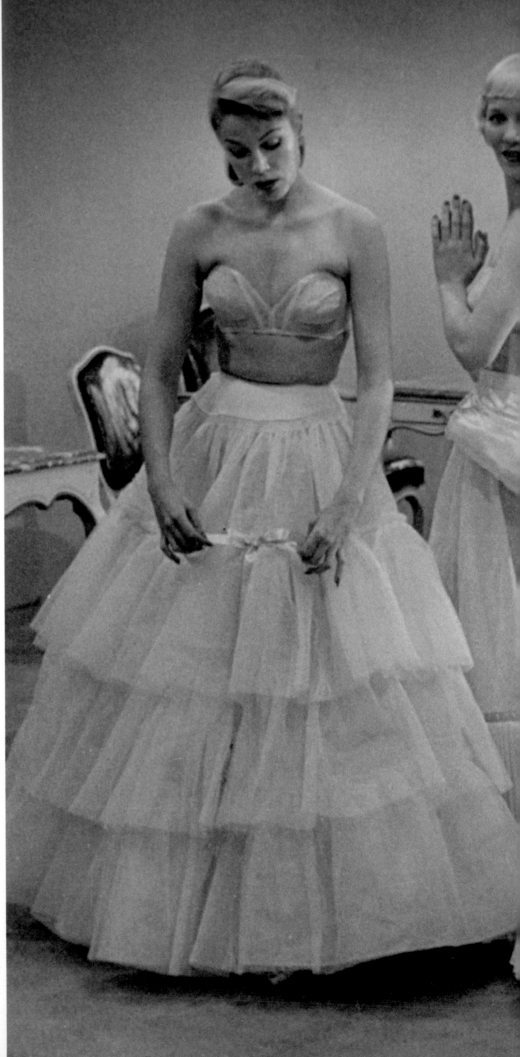

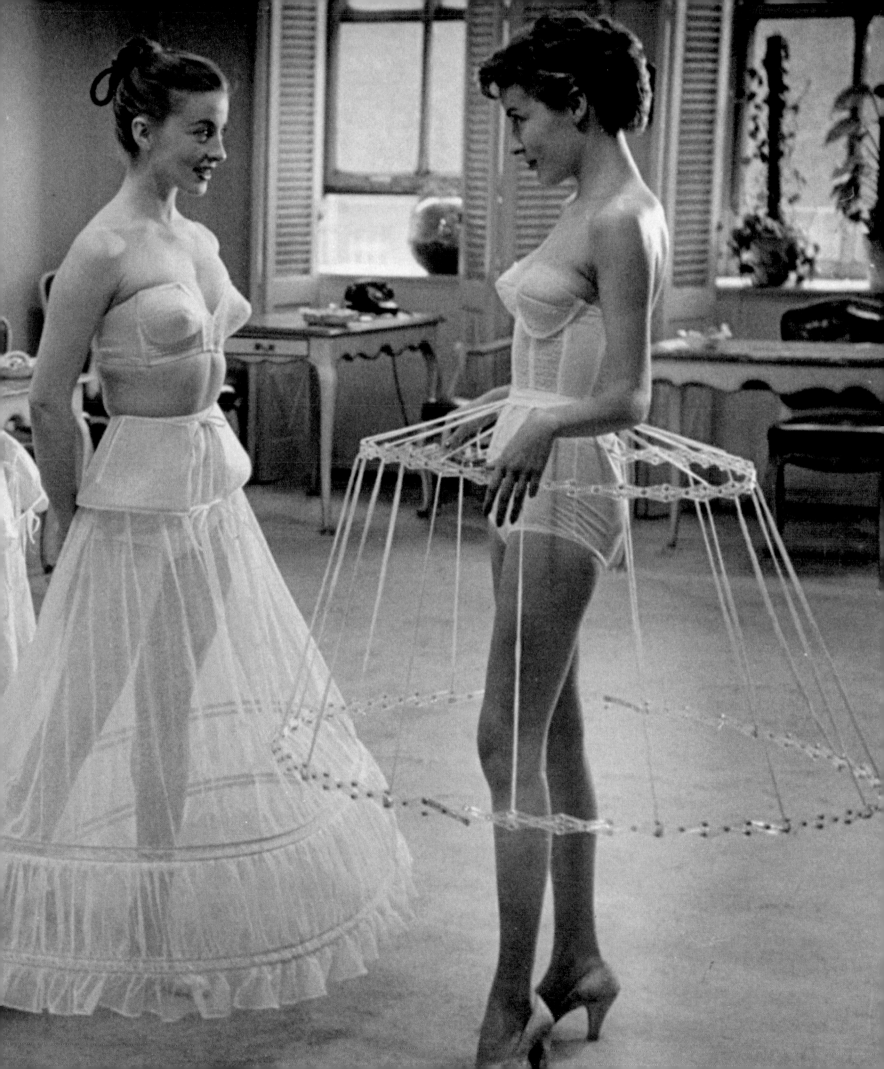

A view from the back

The back of the dress is a key design element, and whether daring or designed, an eye catching detail on the back of a wedding gown never fails to make a splash, and ensures that the bride looks amazing from every angle.

A decoration on the back of the dress such as a bow or silk flowers is a way to add even more eye catching allure.

Traditionally most brides stand with their back to their guests during much of the ceremony, and this side of the dress enjoys its time in the spotlight.

Shot in the Cassini building, Photographed by Horst
©Condé Nast Publications

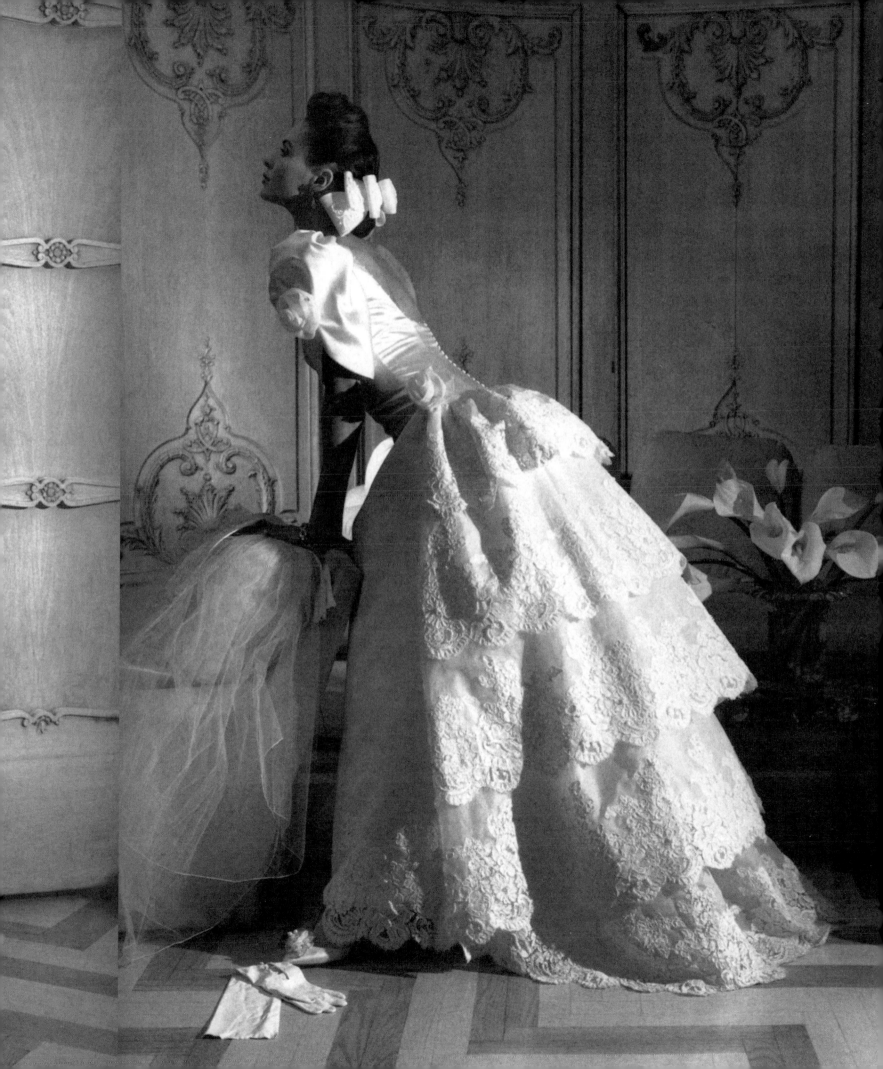

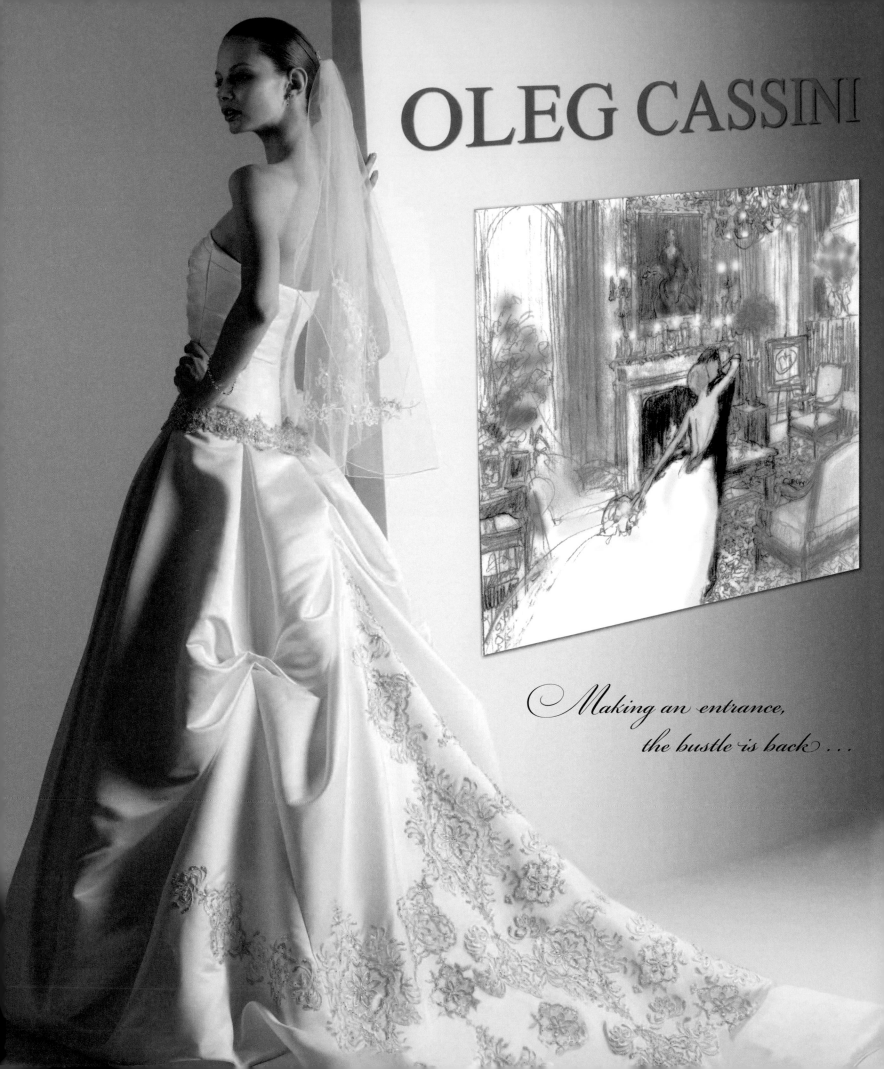

OLEG CASSINI

Making an entrance,
the bustle is back . . .

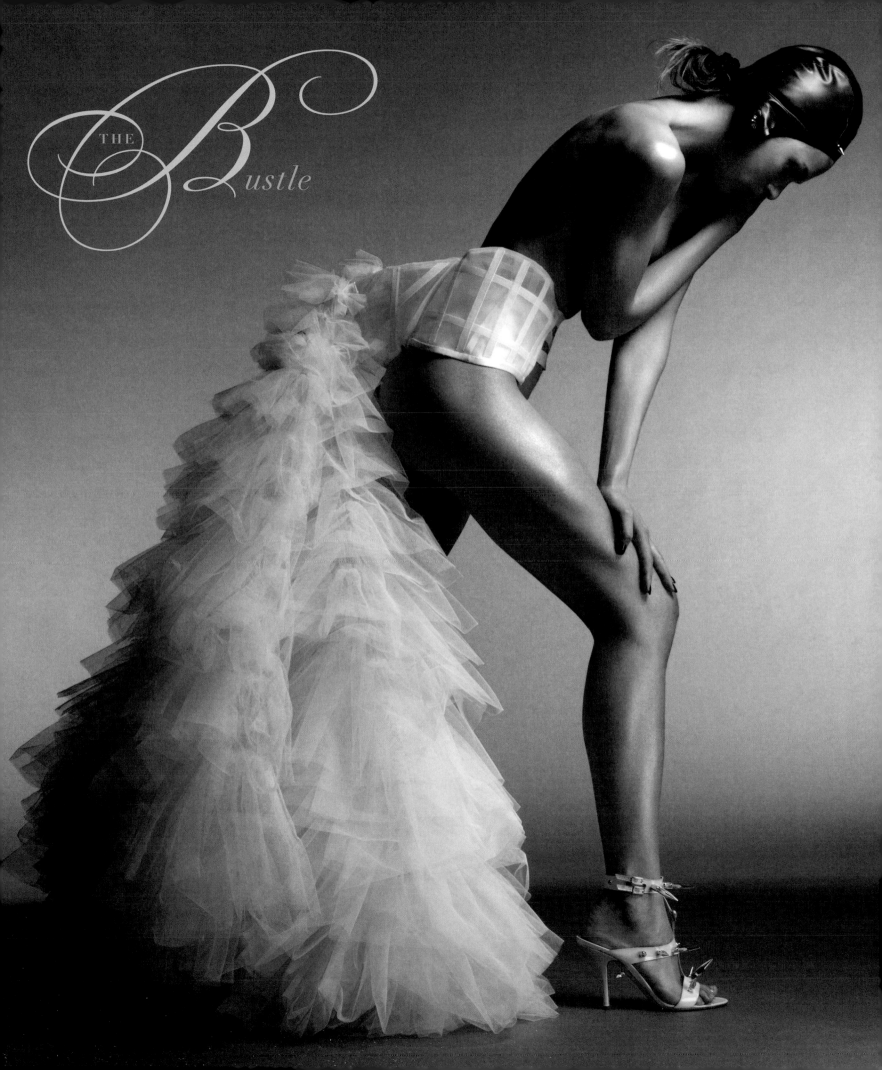

The *Bustle*

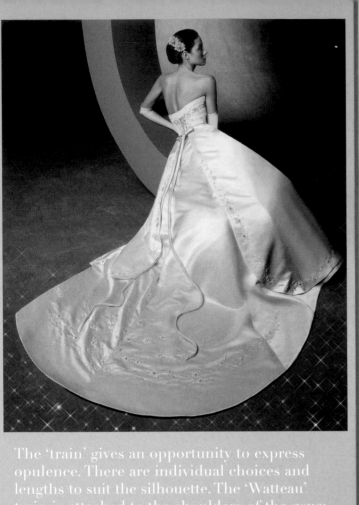

OLEG CASSIN

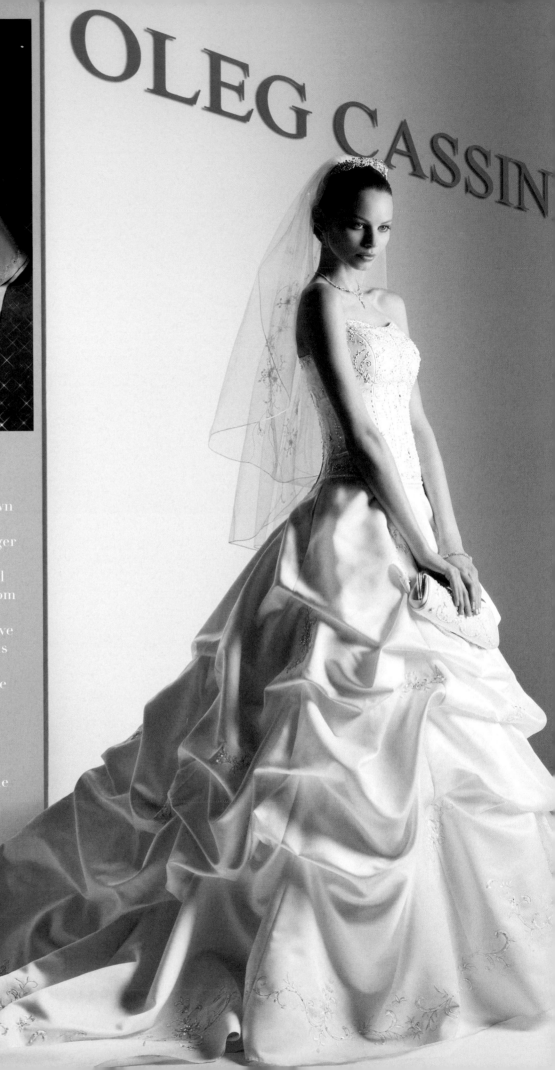

The 'train' gives an opportunity to express opulence. There are individual choices and lengths to suit the silhouette. The 'Watteau' train is attached to the shoulders of the gown in the back and sweeps to the floor. The 'Sweep' or 'Brush' train is a few inches longer than floor length with a rounded or folded train. The 'Chapel' train is a bit more formal and elegant, extending four feet or more from the waist to the floor. The 'Cathedral' train captures the splendor of a royal wedding, five to seven feet from the waist to the floor. This train can have a 'bustling option' or can be removed for dancing. The 'Royal' train is the ultimate choice and can be as long and as dramatic as one wishes.

Veils are also done in lengths, the blusher, a short veil which as tradition dictates, can be worn over the face for the 'walk down the aisle.' Then, there is the Elbow length, the Finger tip, the more formal Chapel veil, and then there is the extravagant Cathedral length, which can work as a train.

The 'Cathedral' train with a 'pick up' skirt is done in white satin embroidered with polished crystals stitched with silver threads.

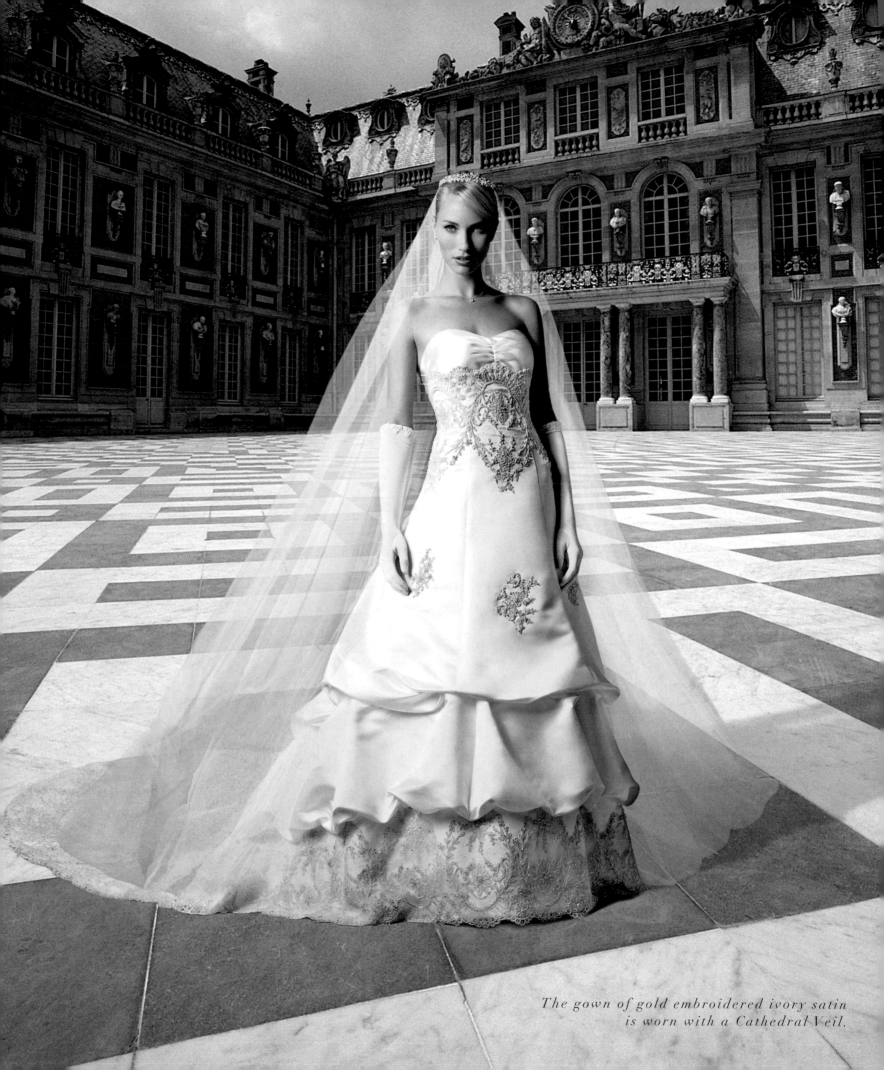

The gown of gold embroidered ivory satin
is worn with a Cathedral Veil.

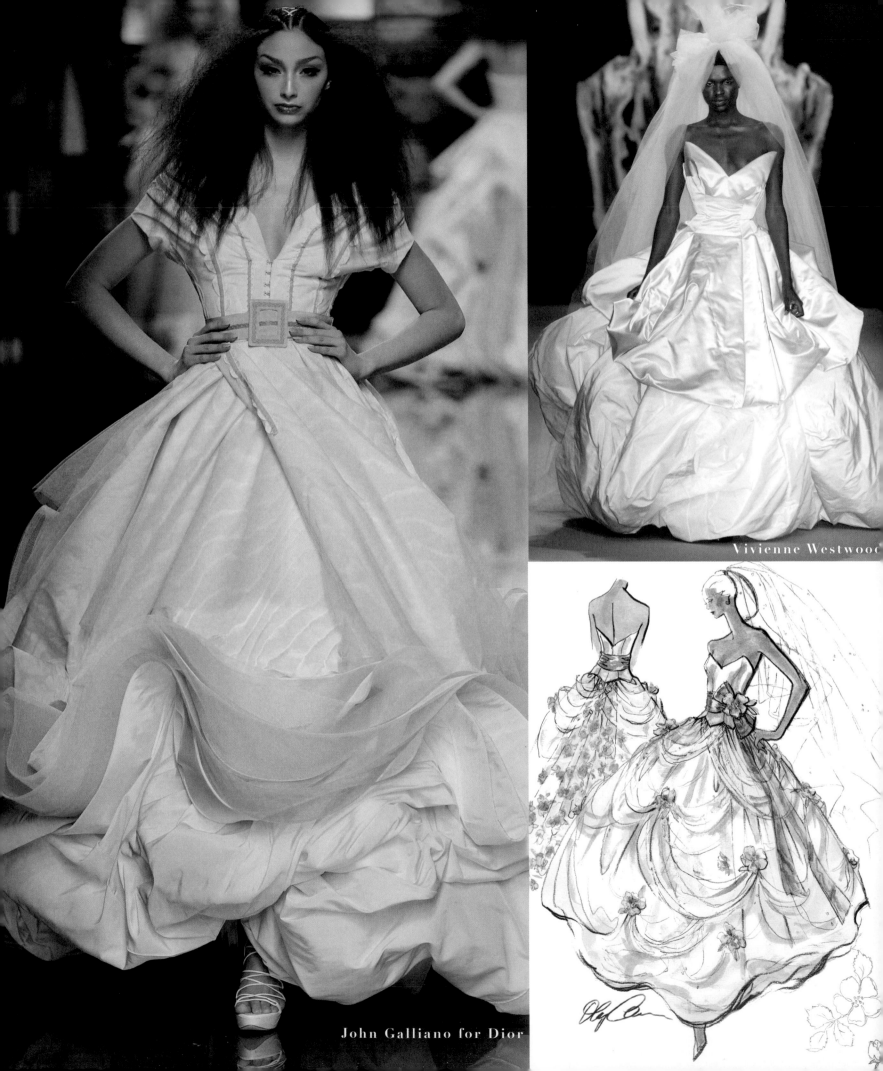

John Galliano for Dior

Vivienne Westwood

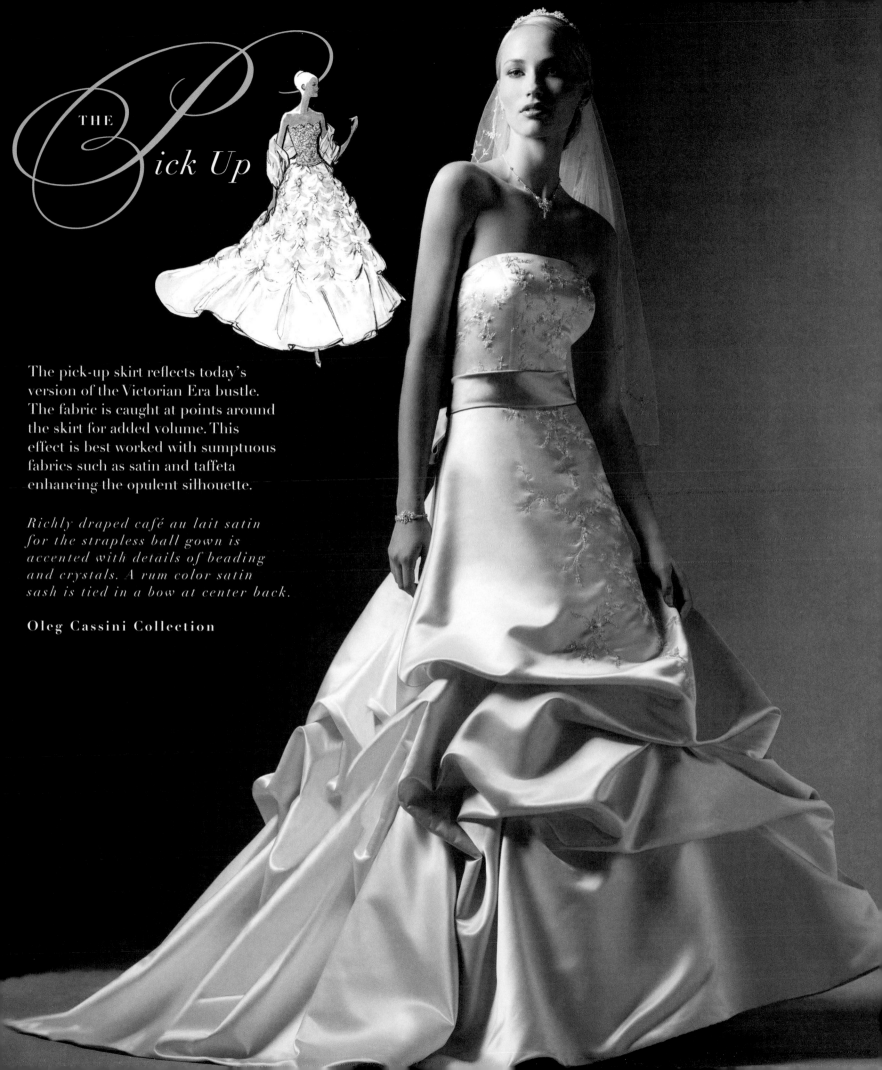

THE Pick Up

The pick-up skirt reflects today's version of the Victorian Era bustle. The fabric is caught at points around the skirt for added volume. This effect is best worked with sumptuous fabrics such as satin and taffeta enhancing the opulent silhouette.

Richly draped café au lait satin for the strapless ball gown is accented with details of beading and crystals. A rum color satin sash is tied in a bow at center back.

Oleg Cassini Collection

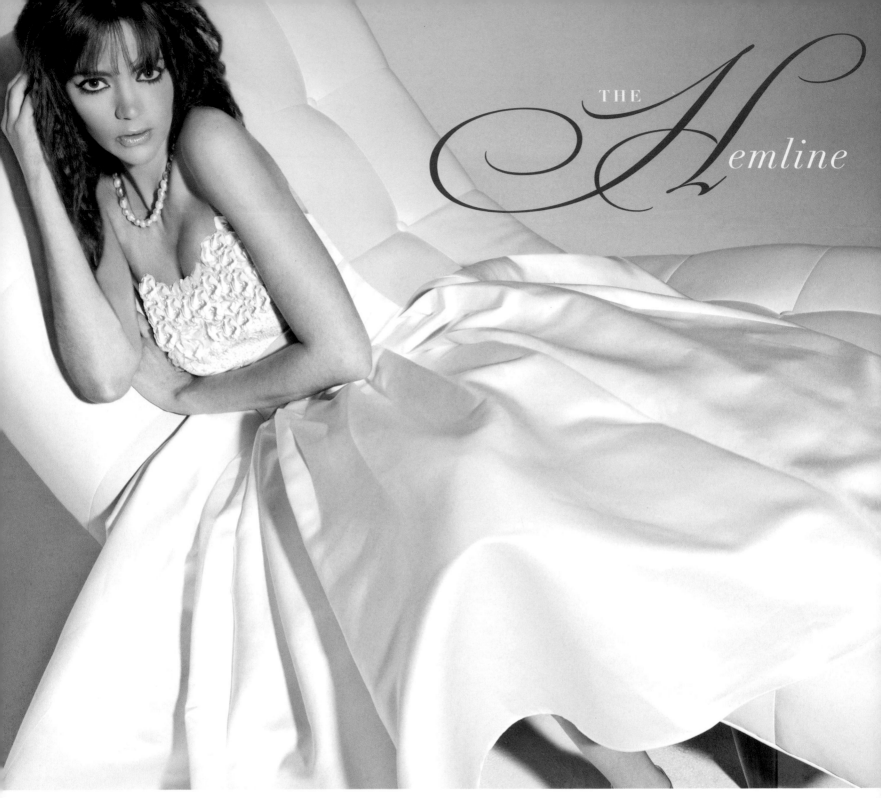

It's time for tea length

Like the variations on the traditional bridal white, 'long' comes in many shades. The few inches between a floor length gown and a tea length gown, can speak volumes about the occasion's mood and formality. Known as a tea, dance, or ballerina length skirt, the shorter skirt is a subtle departure from the traditional floor length gown. A tea length skirt, which hits a few inches above the ankle evokes an ingénue-like sensibility, and when paired with a ball gown silhouette, achieves a glamorous, débutante or ballerina look. The tea length is traditionally less formal than the longer hemlines, so it's a lovely choice for a daytime garden ceremony.

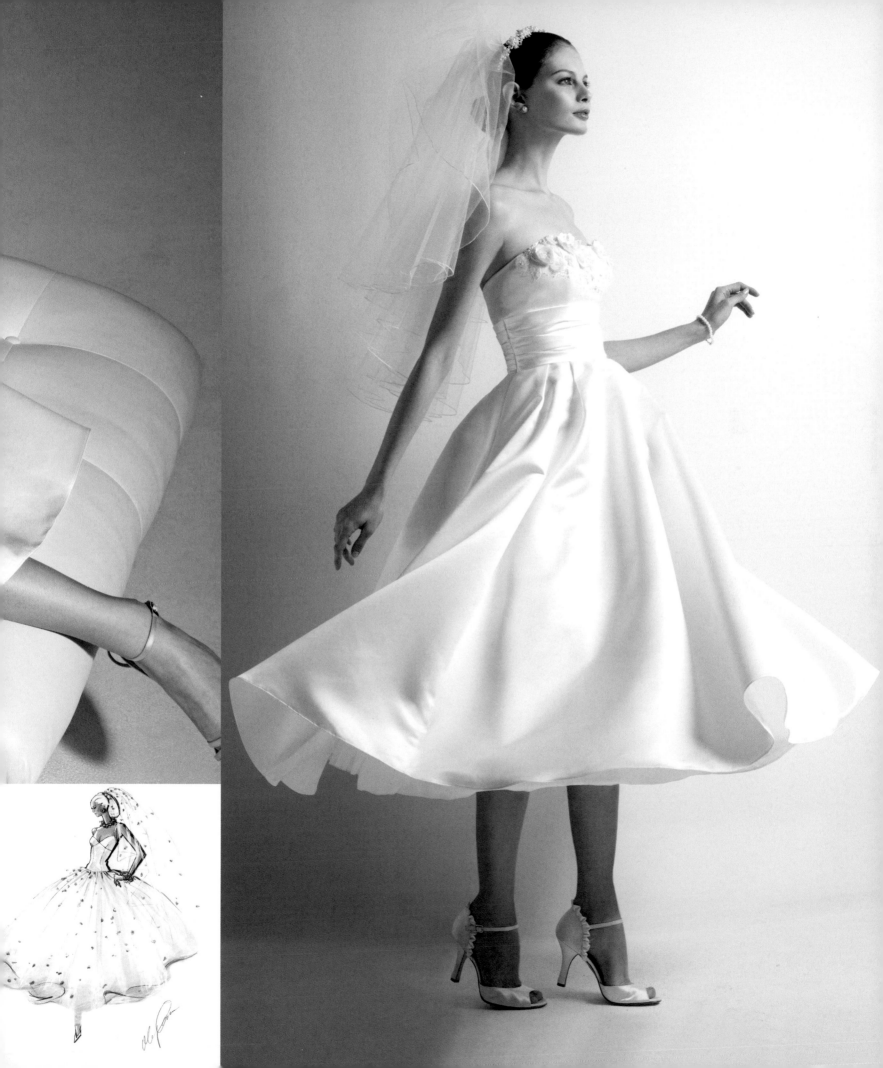

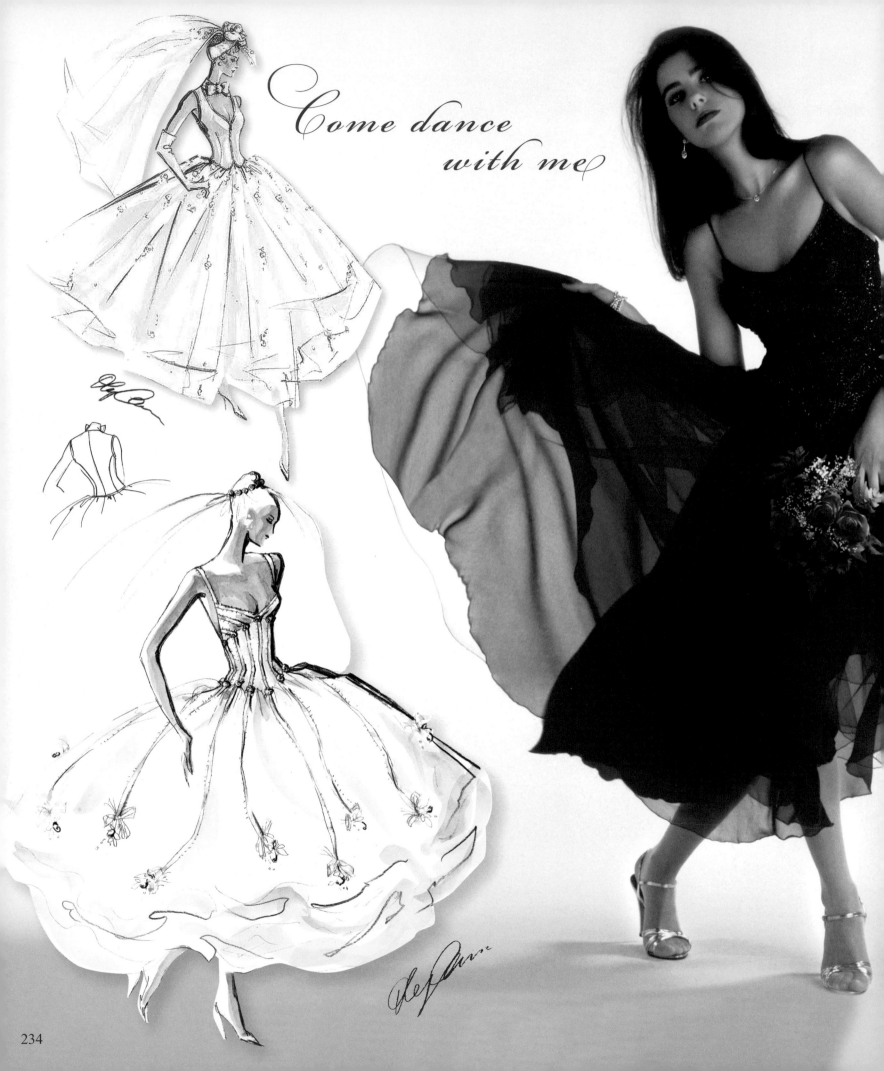

Come dance
with me

234

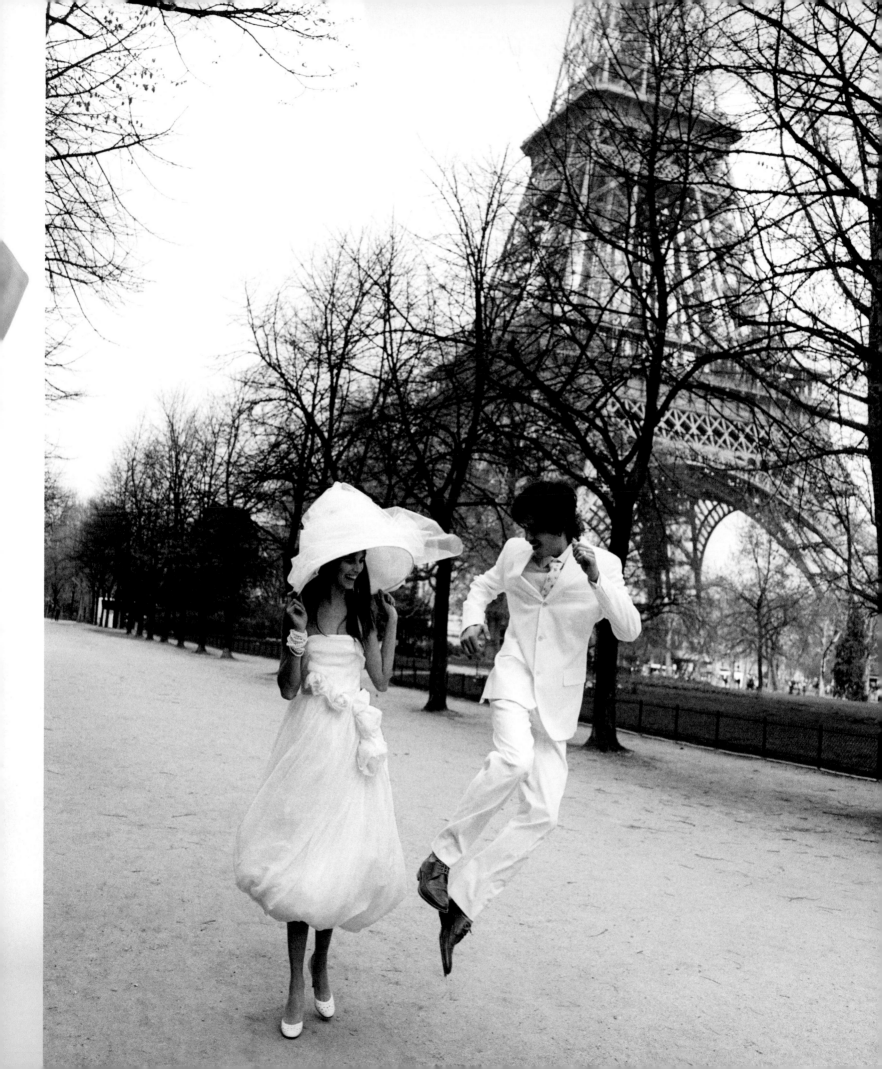

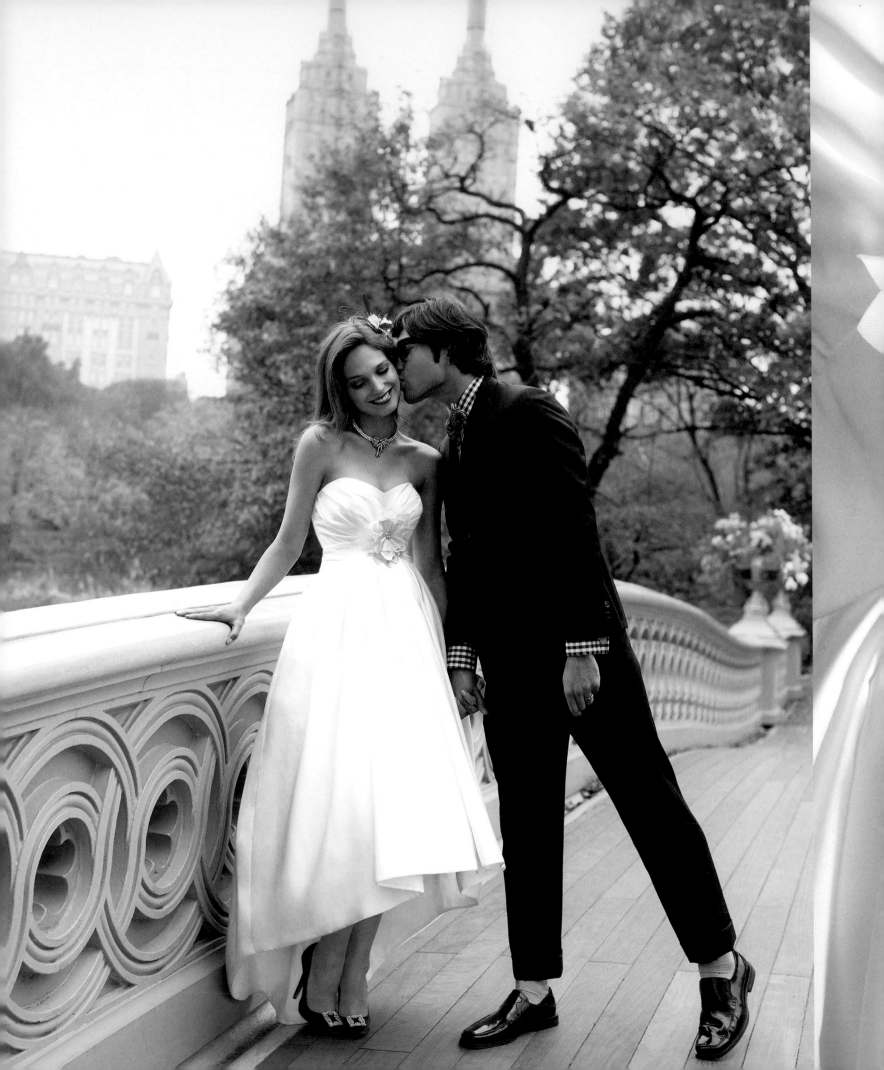

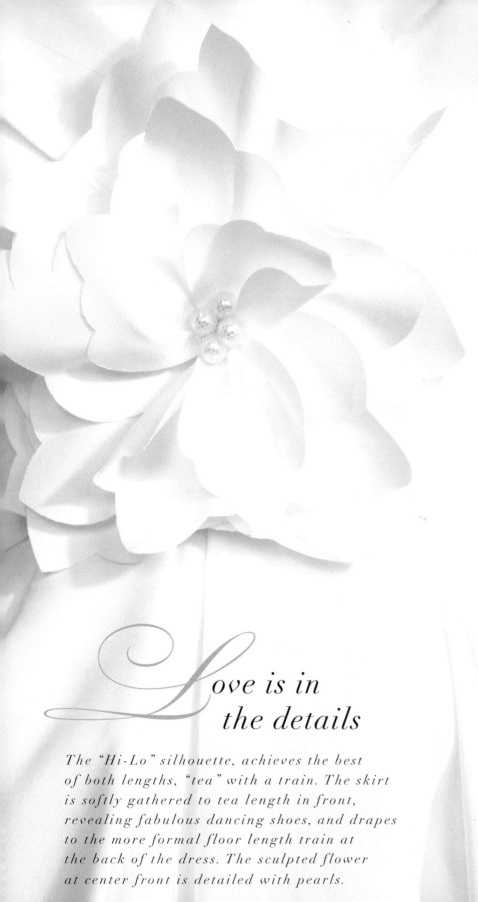

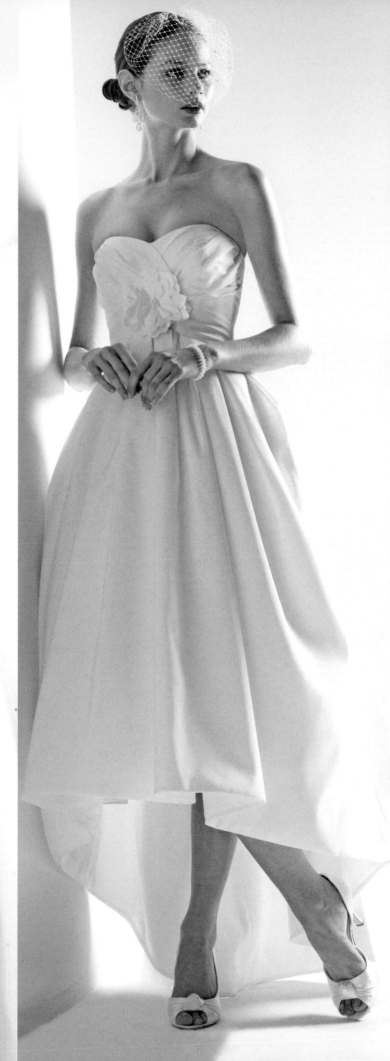

*L*ove is in the details

The "Hi-Lo" silhouette, achieves the best of both lengths, "tea" with a train. The skirt is softly gathered to tea length in front, revealing fabulous dancing shoes, and drapes to the more formal floor length train at the back of the dress. The sculpted flower at center front is detailed with pearls.

This look suits both a sophisticated reception, a twilight ceremony on a beautiful beach, or the legendary curved bridge in Central Park.

OPPOSITE Photo by McConnell / Brides
©Condé Nast Publications

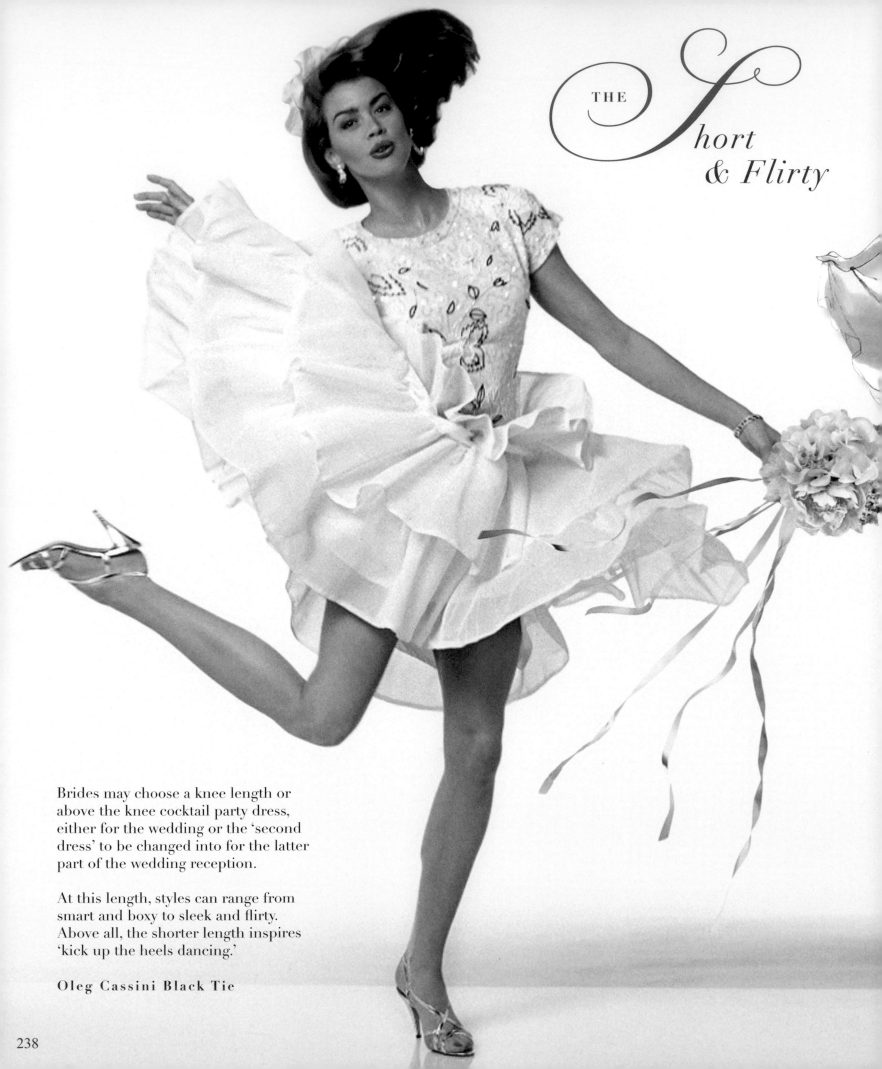

THE *Short & Flirty*

Brides may choose a knee length or above the knee cocktail party dress, either for the wedding or the 'second dress' to be changed into for the latter part of the wedding reception.

At this length, styles can range from smart and boxy to sleek and flirty. Above all, the shorter length inspires 'kick up the heels dancing.'

Oleg Cassini Black Tie

*The Unicorn is a symbol
of strength, integrity and
purity, that together define
the bonds of marriage.*

The Little White Dress

BELOW Naomi Campbell
Photo by Patrick Demarchelier/Vogue
©Condé Nast Publications

RIGHT Photo by Arthur Elgort/Vogue
©Condé Nast Publications

FAR RIGHT Pierre Cardin wedding dress

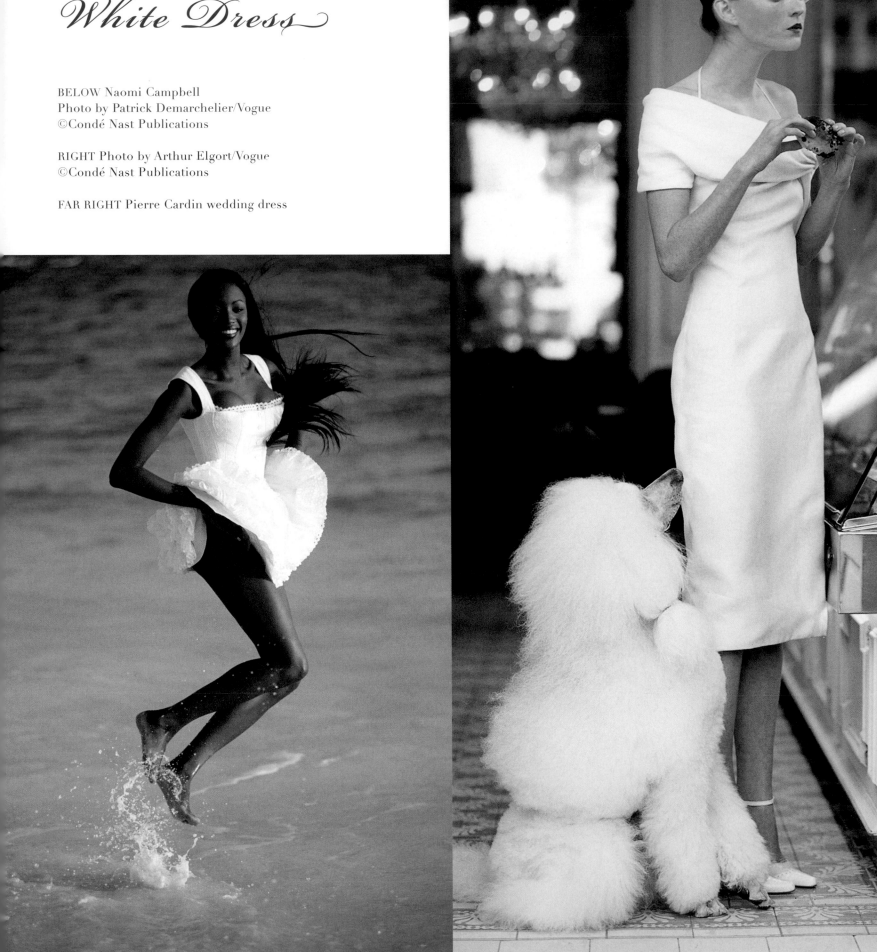

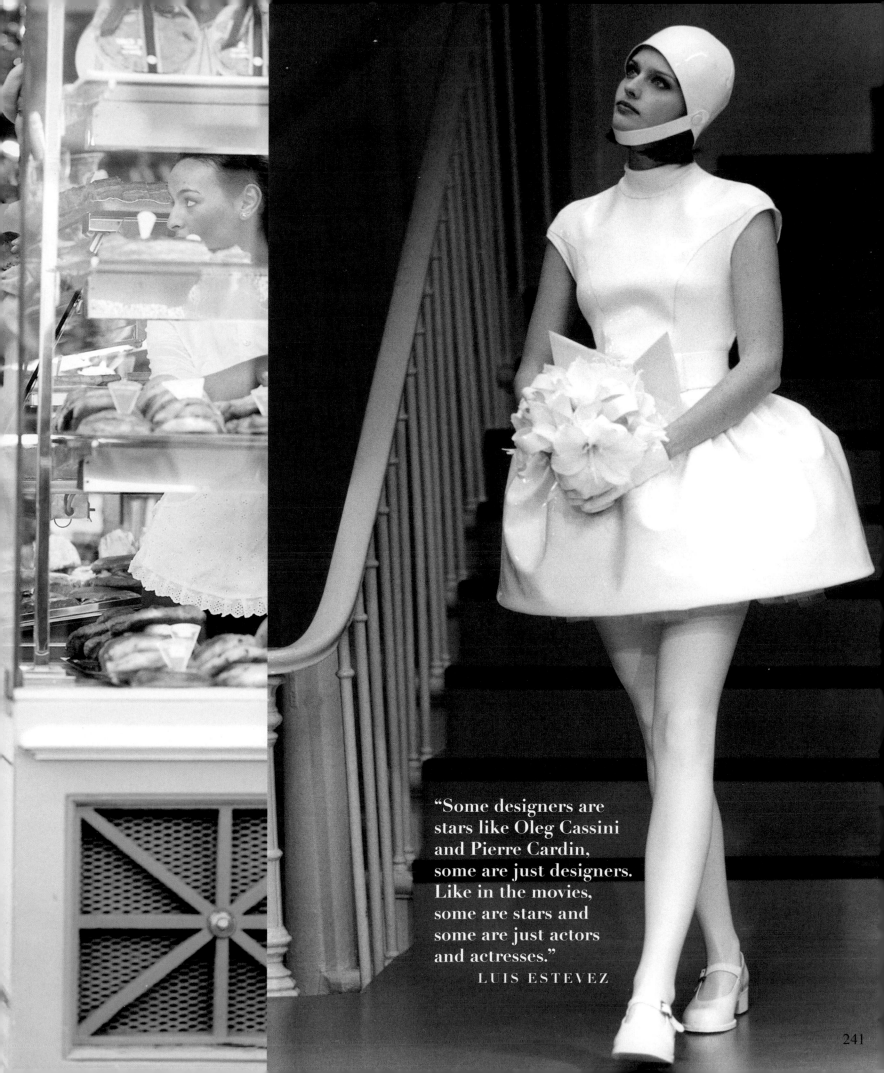

"Some designers are stars like Oleg Cassini and Pierre Cardin, some are just designers. Like in the movies, some are stars and some are just actors and actresses."

LUIS ESTEVEZ

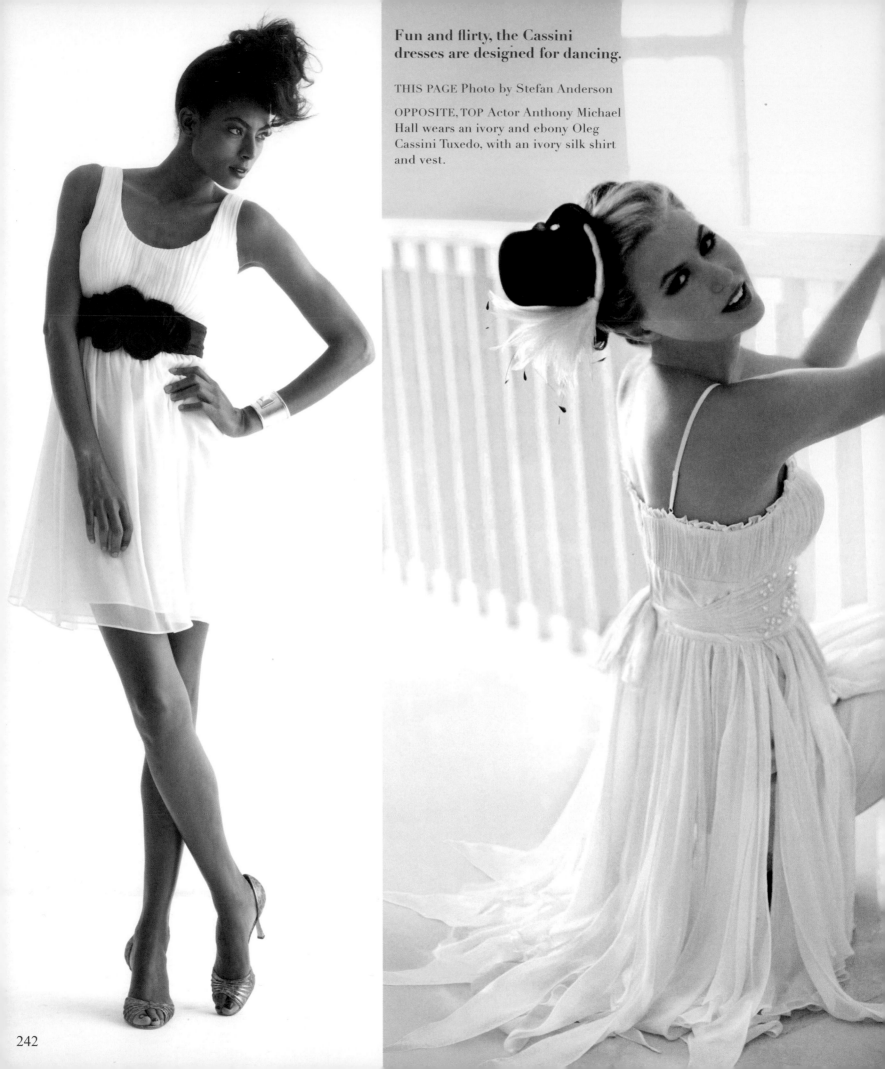

Fun and flirty, the Cassini dresses are designed for dancing.

THIS PAGE Photo by Stefan Anderson

OPPOSITE, TOP Actor Anthony Michael Hall wears an ivory and ebony Oleg Cassini Tuxedo, with an ivory silk shirt and vest.

Beautiful actress and singer, Lee Nestor wears the Oleg Cassini pleated taffeta dress wrapped with a black satin ribbon.

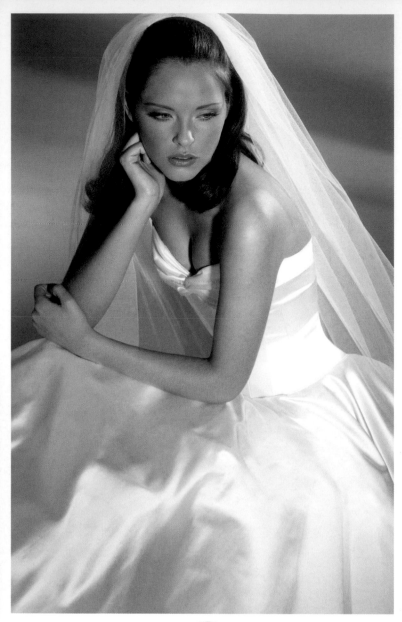

As mentioned in 'Modern Bride' magazine, the 'Jackie' image from the White House days is the most popular look with today's bride and has a far reaching influence, with the strapless look being the prevalent choice.

A casual flip through a bridal book shows that strapless gowns, far from being risqué, are now positively de rigueur. While it has not been so many years since a bride with bare shoulders would guarantee raised eyebrows, in recent years strapless gowns have become such a popular choice for brides, both daring and demure, that this neckline graces dresses that run the full gamut from traditional ball gowns to the dramatic mermaid.

Despite its popularity, there are enough possible variations on a strapless bodice, that it continues to look breathtaking and special each time it appears on a bride.

A notch or sweetheart shape adds eye catching detail to an otherwise unadorned silhouette. Notch necklines are eye candy for a strapless bodice. Ruching, a cowl, a cuff fold, also dress up the strapless bodice.

The inherent simplicity of the strapless silhouette 'sets the stage' for dramatic jewelry.

THE *Strapless*

"I had to go to the
President to ask
permission to allow
Jackie to wear a
shoulder baring gown."
OLEG CASSINI

THIS PAGE
In London: She wears a lustrous silk satin gown with a ruched Sweetheart strapless neckline. The elongated waistline is seamed to the luxury of a full circle skirt. Gown from Oleg Cassini Icon Collection.

OPPOSITE
Strapless and poolside Margaux Hemingway at nineteen.
Photo by Francesco Seavullo / Vogue
© Condé Nast Publications

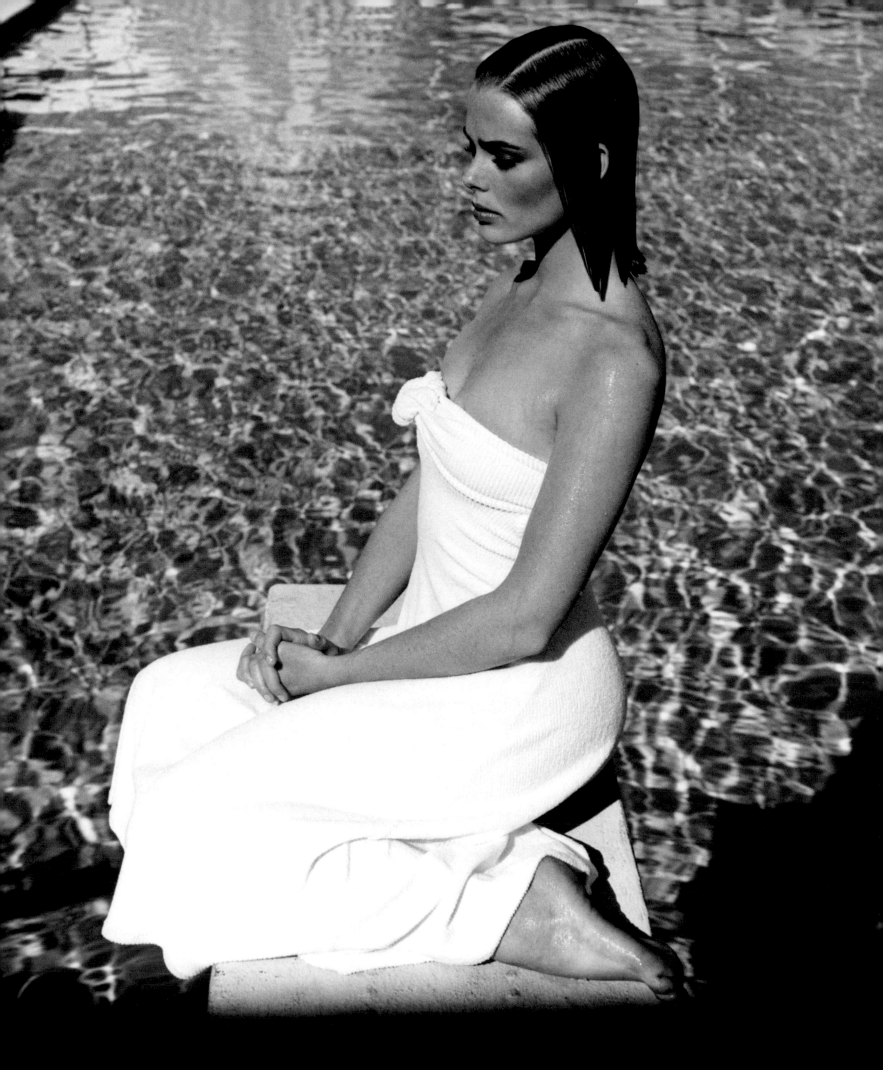

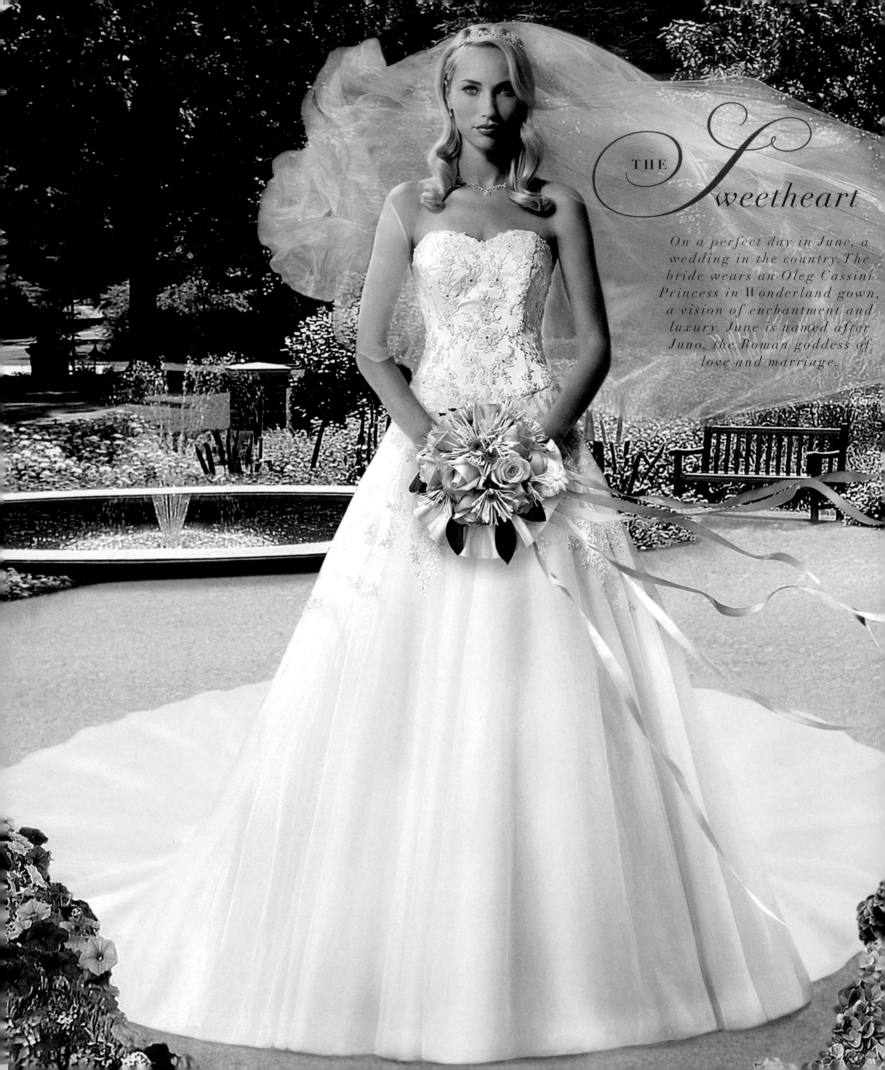

THE *Sweetheart*

On a perfect day in June, a wedding in the country. The bride wears an Oleg Cassini Princess in Wonderland gown, a vision of enchantment and luxury. June is named after Juno, the Roman goddess of love and marriage.

The setting is the elegant and historic Box Hill Mansion set on 400 acres
of rare flowers and rolling hills. This grand historic site, which
brings to mind the mood of an aristocratic English country estate is
in Regents' Glen, York, Pennsylvania, near the Delaware River and
was granted to William Penn in settlement of a debt by the King of England.

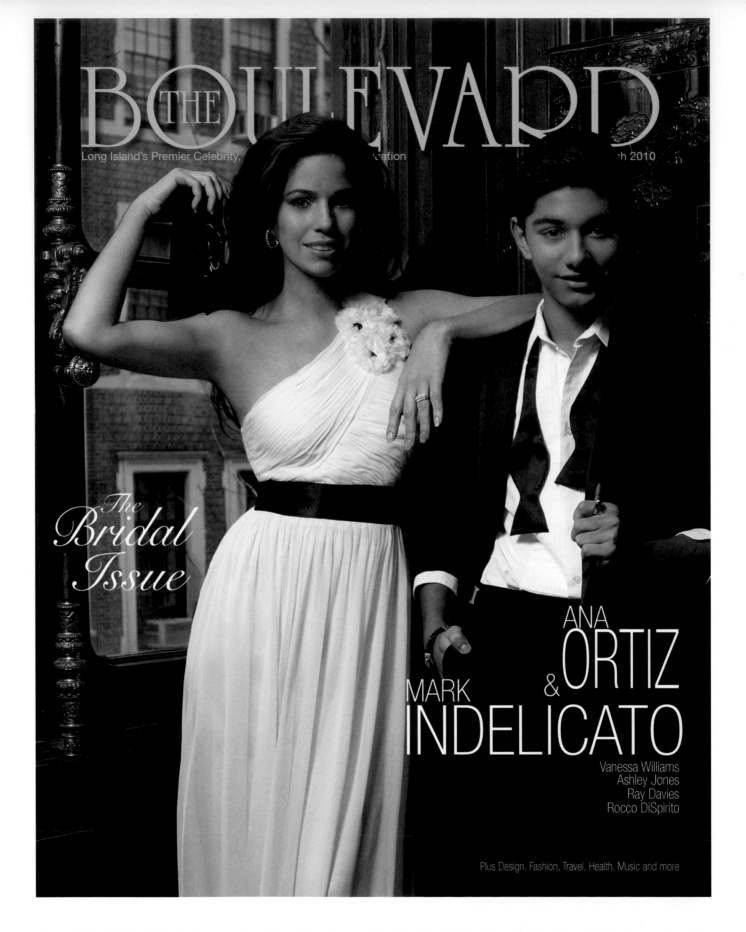

THE BOULEVARD

Long Island's Premier Celebrity, [...] [...]ation [...]h 2010

The
Bridal
Issue

MARK
ANA
ORTIZ
&
INDELICATO

Vanessa Williams
Ashley Jones
Ray Davies
Rocco DiSpirito

Plus Design, Fashion, Travel, Health, Music and more

Ana Ortiz & Mark Indelicato played mother & son in the hit TV series, "Ugly Betty." Photographed by David Needleman, they are both wearing Oleg Cassini. She wears a one shoulder white silk chiffon gown accented with chiffon roses, and he wears a Cassini Tuxedo ensemble.

In Hollywood, Malin Akerman photographed by Jeff Forney wearing a white chiffon Cassini gown trimmed in black chiffon with jet crystals.

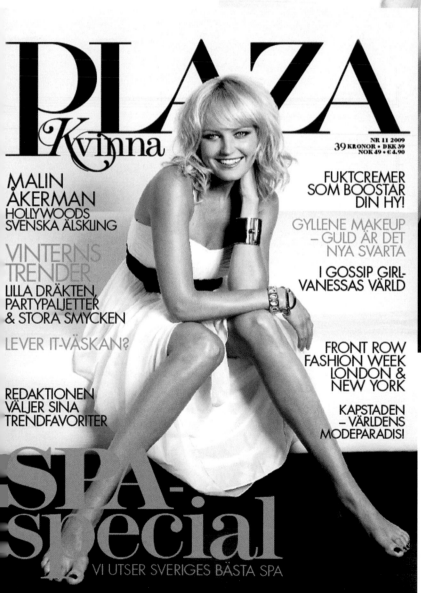

If symbols can be portents of the future, what better choice can a bride make for her dress's neckline than a sweetheart?

So called because it resembles the top of a heart, the meaning imbued in the name of this very popular and flattering style only enhances its appeal.

A sweetheart neckline is most often used with a strapless bodice, though it can be paired with sleeves, to add intrigue to more conservative styles, such as on the sweetheart gown that Queen Elizabeth wore to her 1947 wedding to Prince Philip.

249

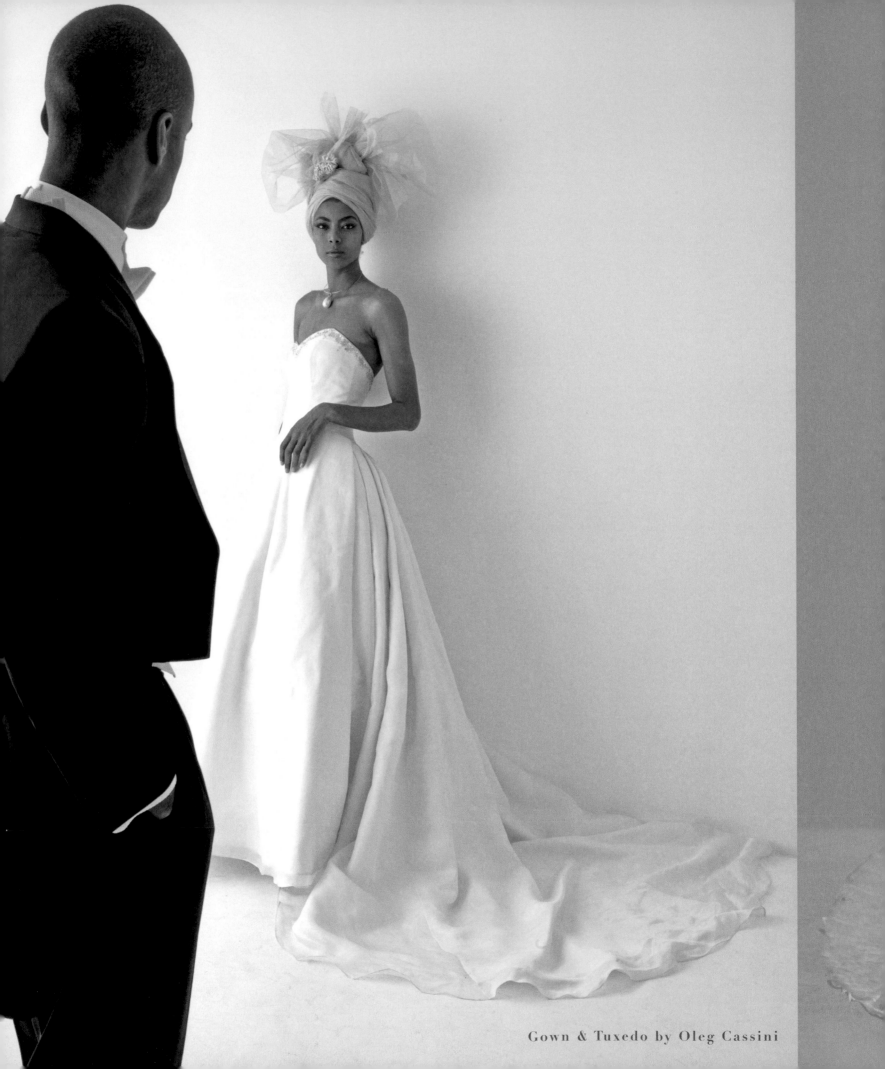

Gown & Tuxedo by Oleg Cassini

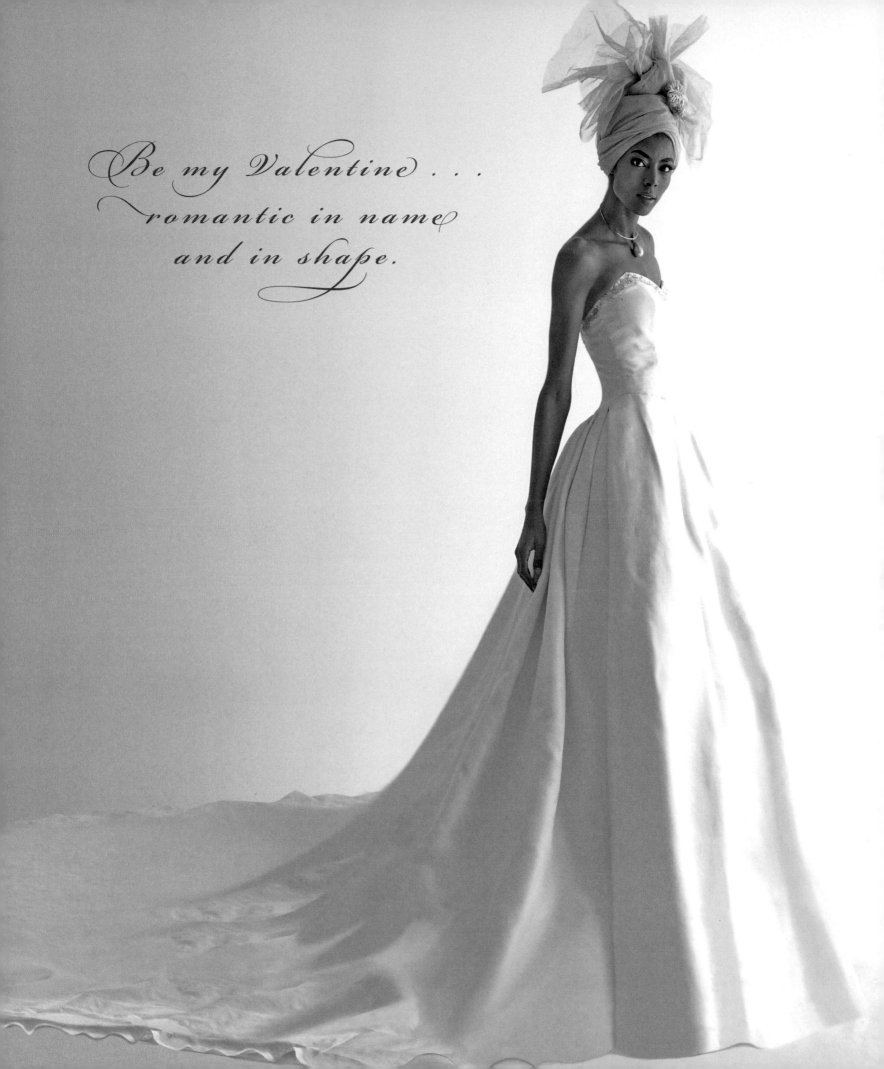

Be my Valentine . . .
romantic in name
and in shape.

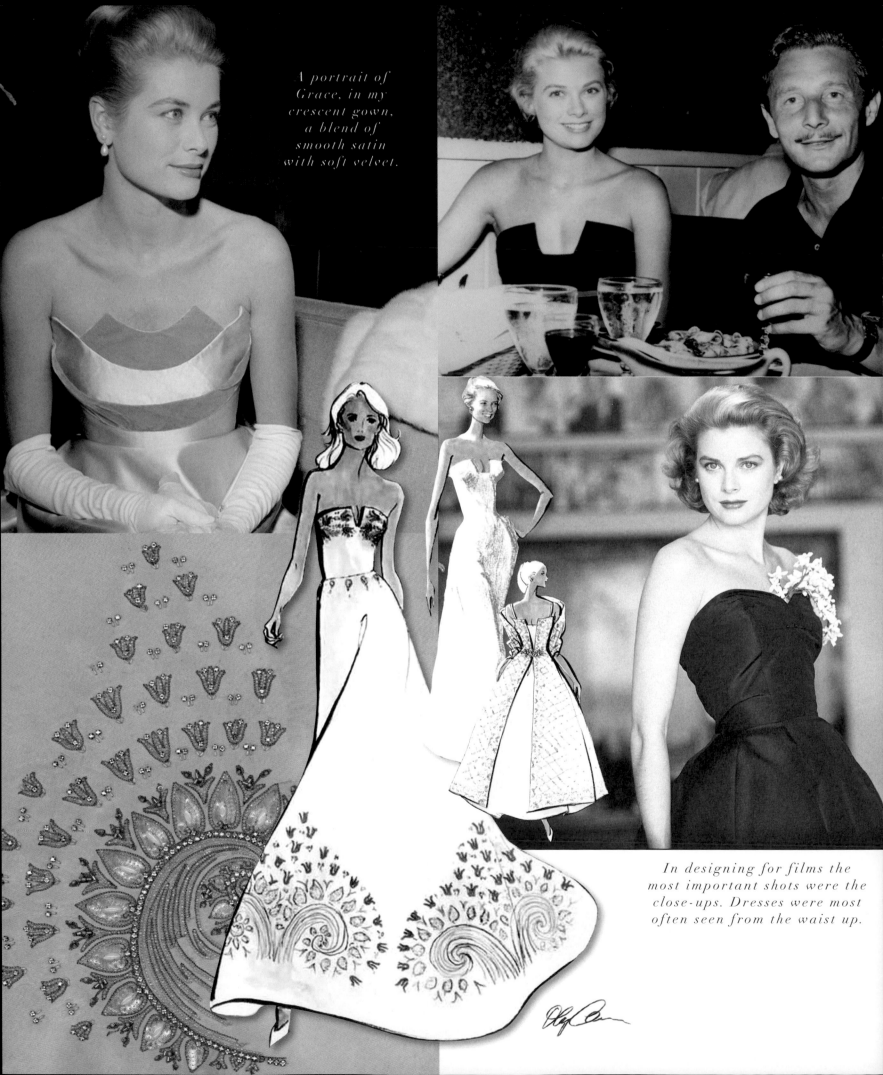

A portrait of Grace, in my crescent gown, a blend of smooth satin with soft velvet.

In designing for films the most important shots were the close-ups. Dresses were most often seen from the waist up.

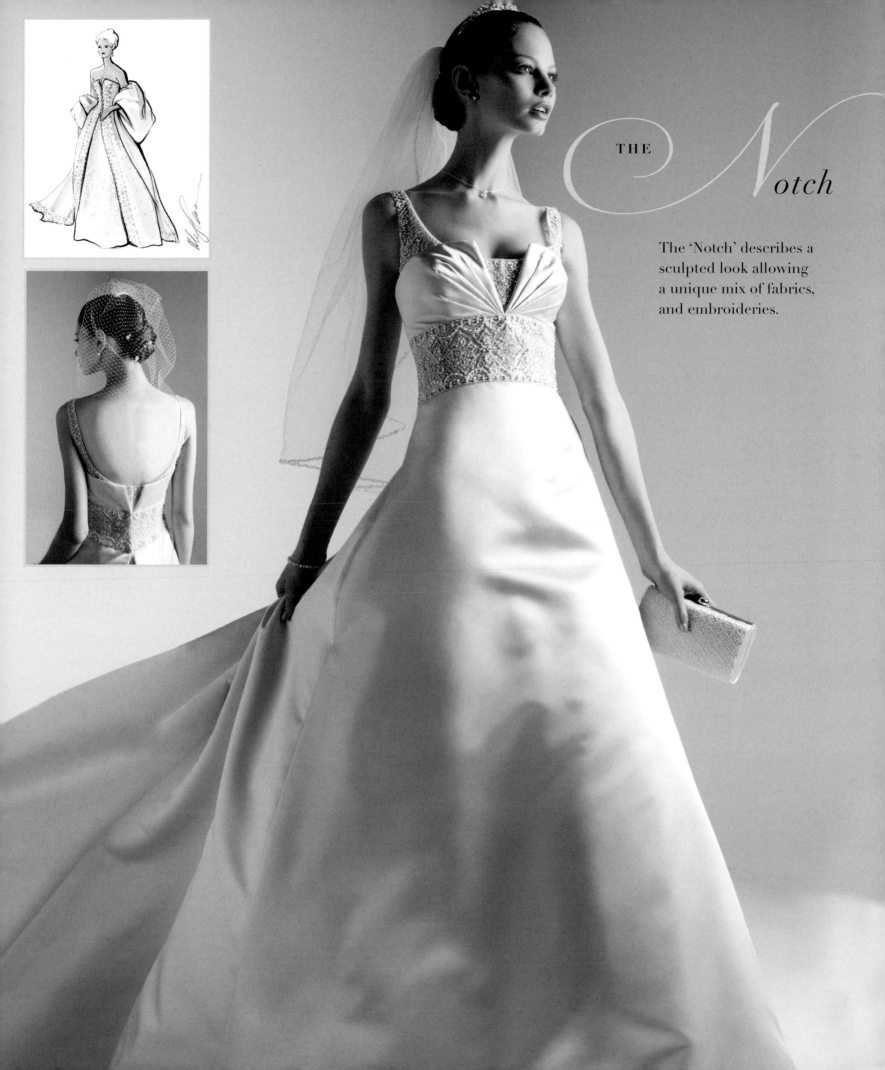

THE *Notch*

The 'Notch' describes a
sculpted look allowing
a unique mix of fabrics,
and embroideries.

THE *Cuff*

EXCLUSIVELY AVAILABLE BY APPOINTMENT ONLY AT
The Wedding Dress

Oleg Cassini
ICON

Harrod

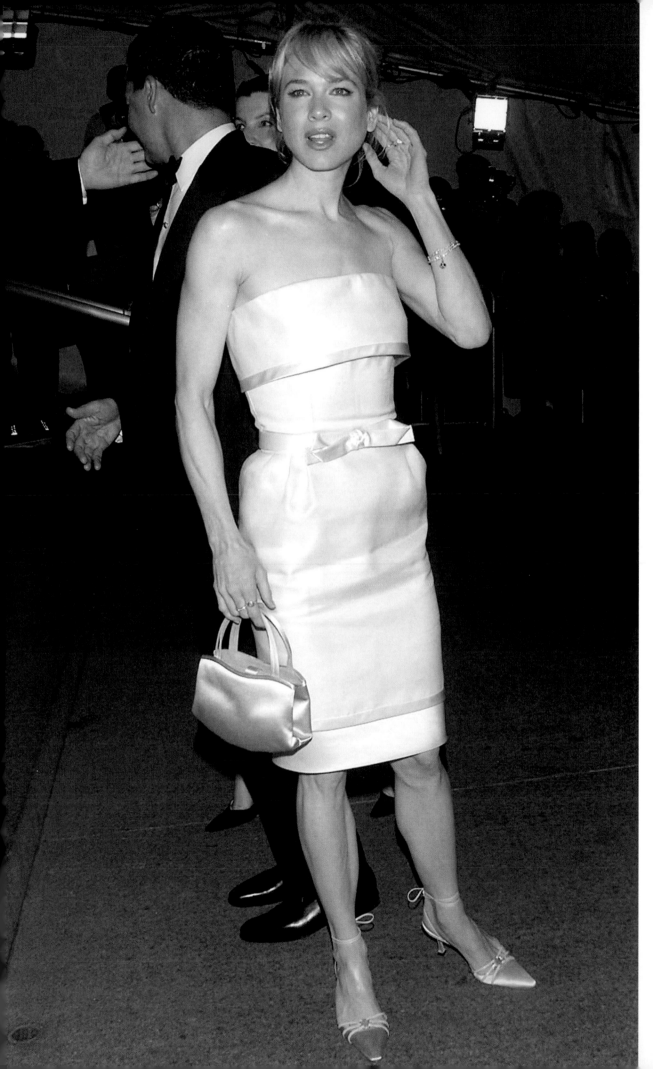

The iconic Cuff neckline reached international recognition with the gown I created for Jackie. She wore the gown in Venezuela and again on her trip to India and Pakistan.

The Cuff gown inspired a wedding dress of exquisite white silk gazar fabric made for the Oleg Cassini Icon Collection in England.

LEFT
Renée Zellweger, wears the Oleg Cassini "Jackie" Cuff dress, at the Metropolitan Museum's gala evening for 'Jacqueline Kennedy, The White House Years' on April 23, 2001.

The oversize cuff is hemmed in a contrasting satin, shaped to the body with a tunic skirt belted at the waist with a satin signature bow.

The fabric of time . . .
"Clothing is the fabric that defines and measures time, an envelope to enhance the form, existing in any given moment, and in some cases, for centuries."
OLEG CASSINI

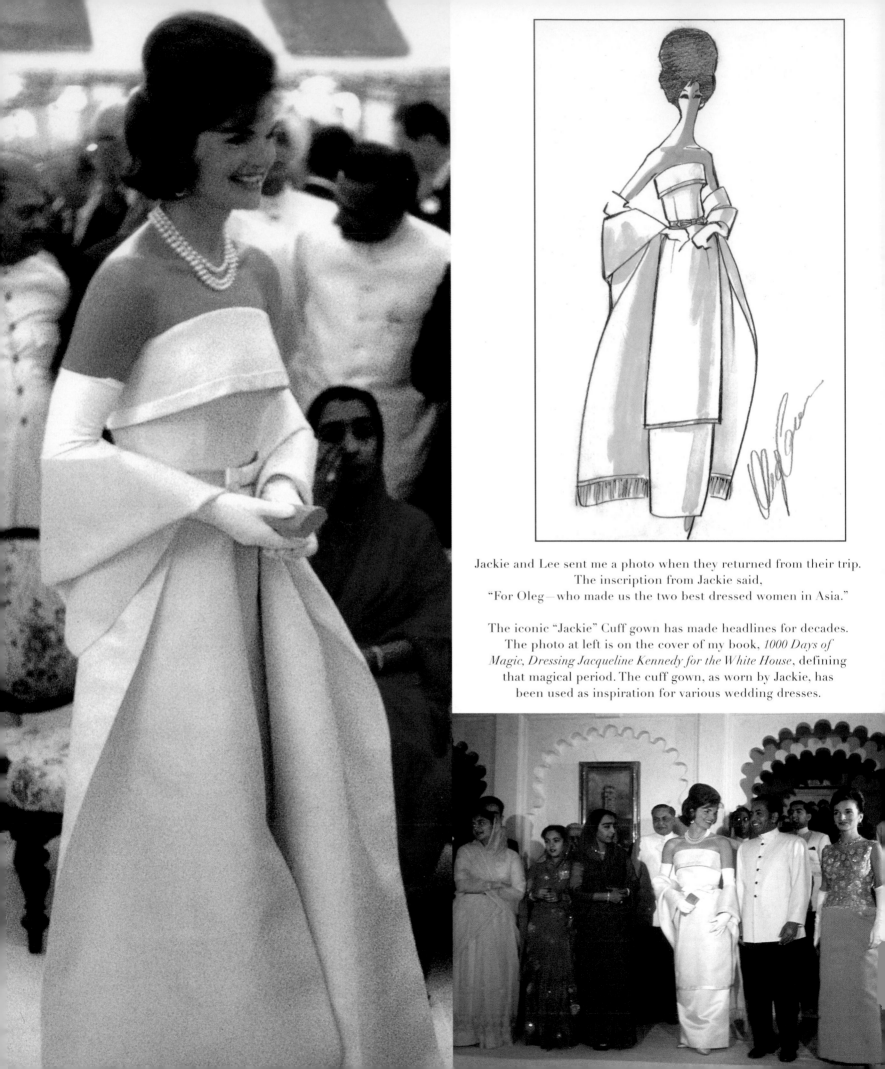

Jackie and Lee sent me a photo when they returned from their trip.
The inscription from Jackie said,
"For Oleg—who made us the two best dressed women in Asia."

The iconic "Jackie" Cuff gown has made headlines for decades.
The photo at left is on the cover of my book, *1000 Days of Magic, Dressing Jacqueline Kennedy for the White House*, defining that magical period. The cuff gown, as worn by Jackie, has been used as inspiration for various wedding dresses.

5.000 LIRE - 2,58 euro (in Italia)
10 MAGGIO 2001 - ANNO XXXIX - N. 19 (1831)

Panorama
www.mondadori.com/panorama

INCHIESTA

Belle, eleganti,
fascinose:
le élite
femminili
riscoprono
una parola
chiave

Jacqueline
Kennedy in un
disegno del grande
sarto americano
Oleg Cassini

chic

Donne, glamour e potere:
la classifica delle «Jacqueline» 2001

TELEFONINI
80 modelli
a confronto.
E in più, i nuovi
videocellulari

HI-TECH da indossare
COMPUTER E CELLULARI SI TRASFORMANO IN ABITI

BERLUSCONI
VS
RUTELLI
Ultimissime dallo
«scontro finale»
di *Bruno Vespa*

■ QUESTA SETTIMANA

Criminalità *È in provincia il vero Far West* **Speciale stipendi** *Dove si guadagna di più*

Super-Internet *Conviene davvero la banda larga?* **Salute** *Quando i medici sbagliano*

257

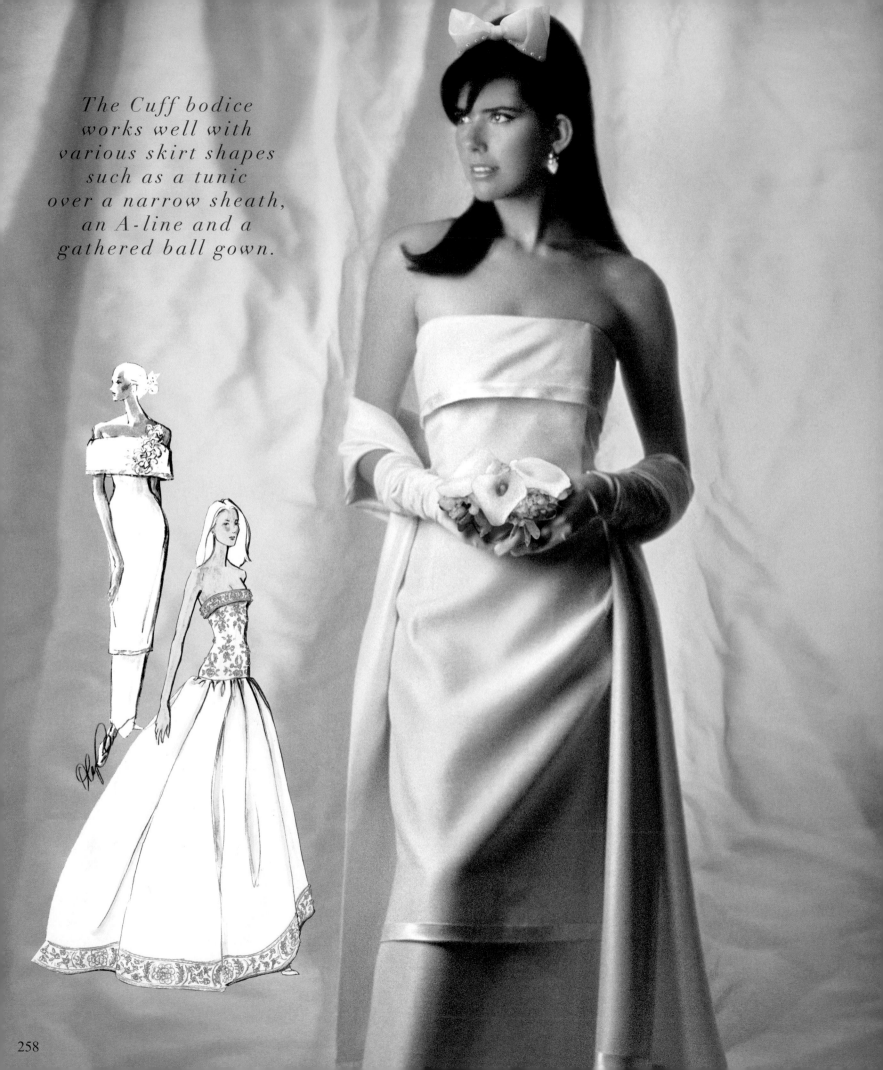

The Cuff bodice works well with various skirt shapes such as a tunic over a narrow sheath, an A-line and a gathered ball gown.

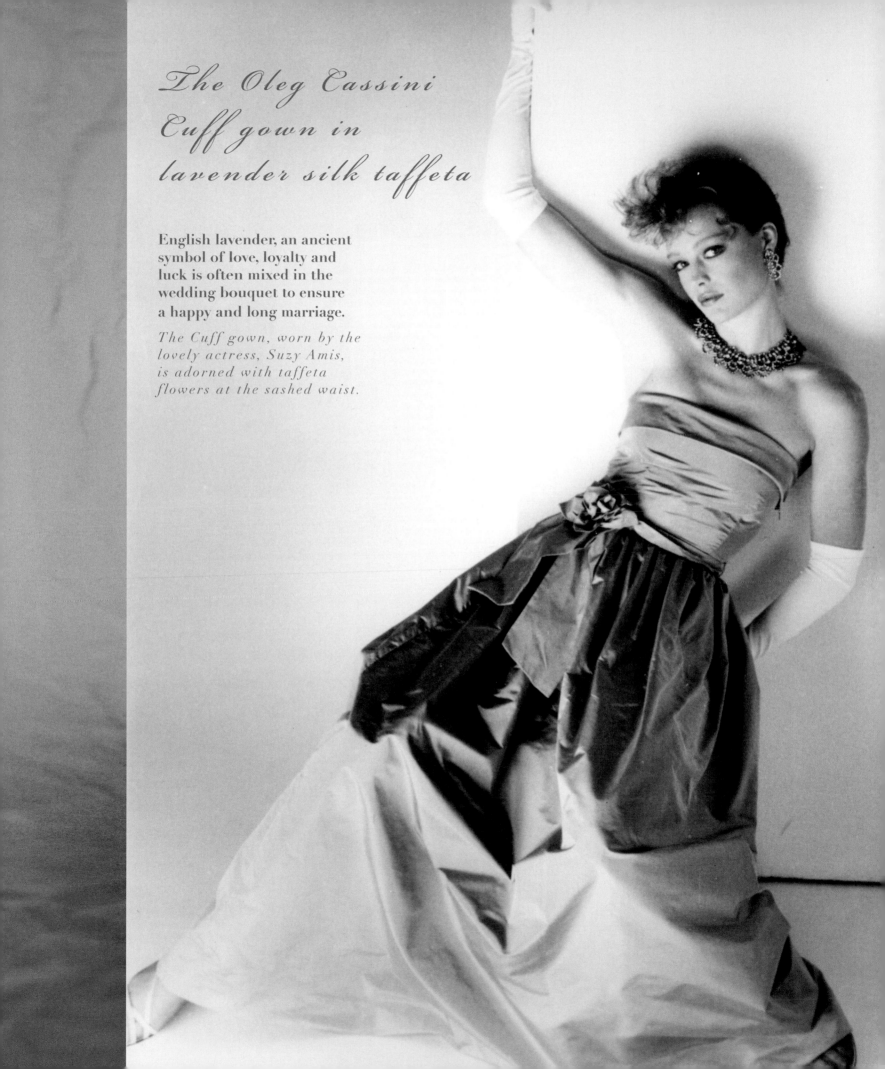

The Oleg Cassini Cuff gown in lavender silk taffeta

English lavender, an ancient symbol of love, loyalty and luck is often mixed in the wedding bouquet to ensure a happy and long marriage.

The Cuff gown, worn by the lovely actress, Suzy Amis, is adorned with taffeta flowers at the sashed waist.

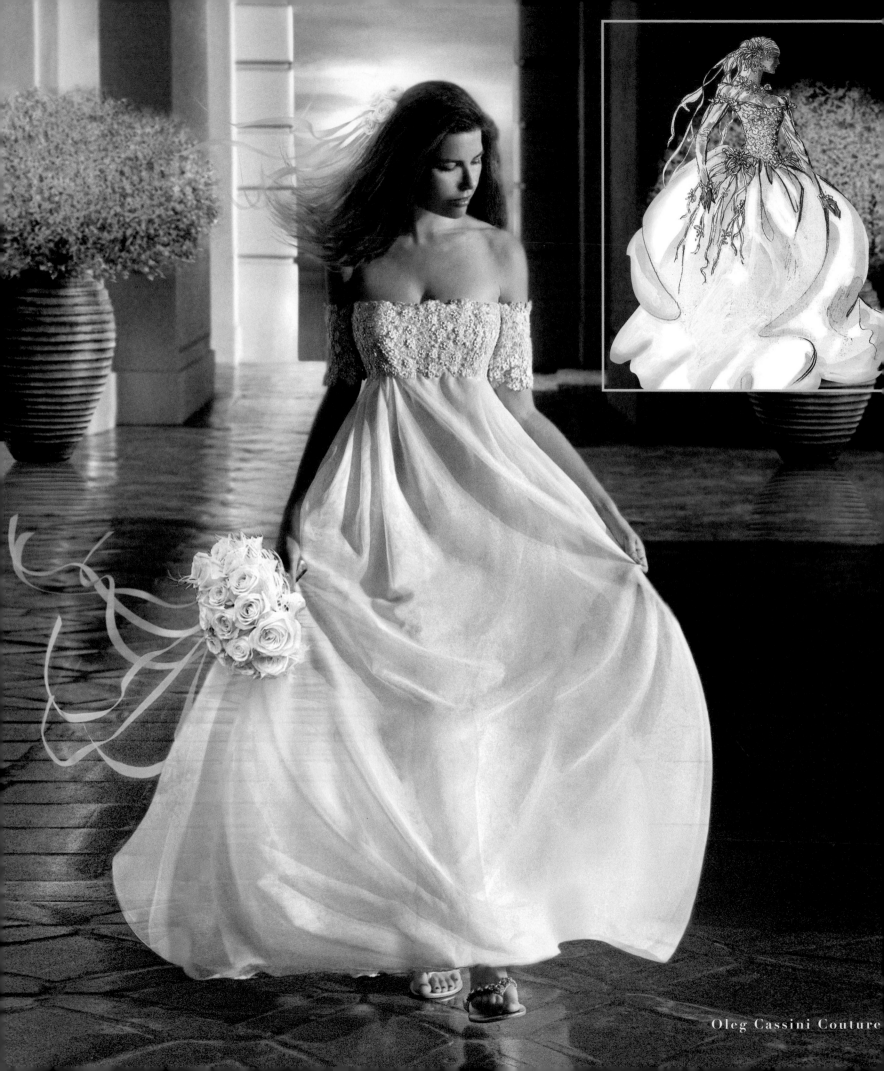

Oleg Cassini Couture

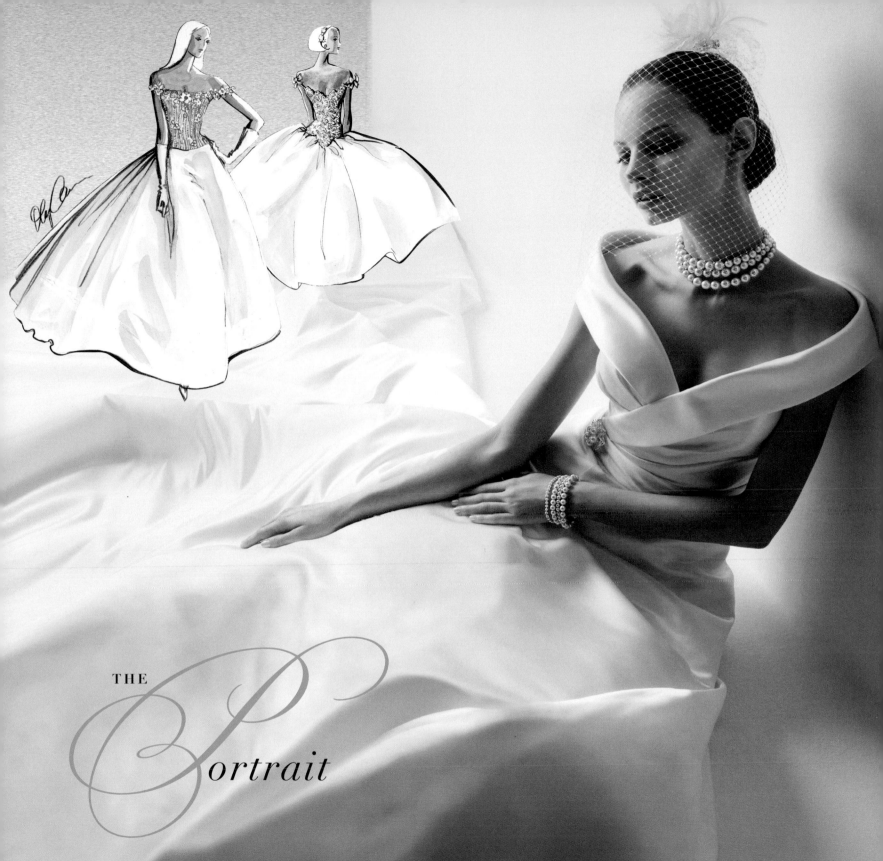

THE

Portrait

The neckline is the element of the dress that draws the eye toward the face of the leading lady, the bride herself. Full of nuance and specific details, each style of neckline accentuates particular features about the wearer, and there is no more important frame for the face than the Portrait neckline. As in Hollywood films, the white collar framing the face sets off the bride in the most flattering fashion. The romantic off the shoulder neckline frames the face and collarbone area with its soft, sweep. It can be worn with many skirt shapes, from voluminous to a delicate flowing Empire. It is also one of the few styles of necklines that pairs nicely with every type of sleeve, and has a very feminine appearance.

Oleg Cassini Collection

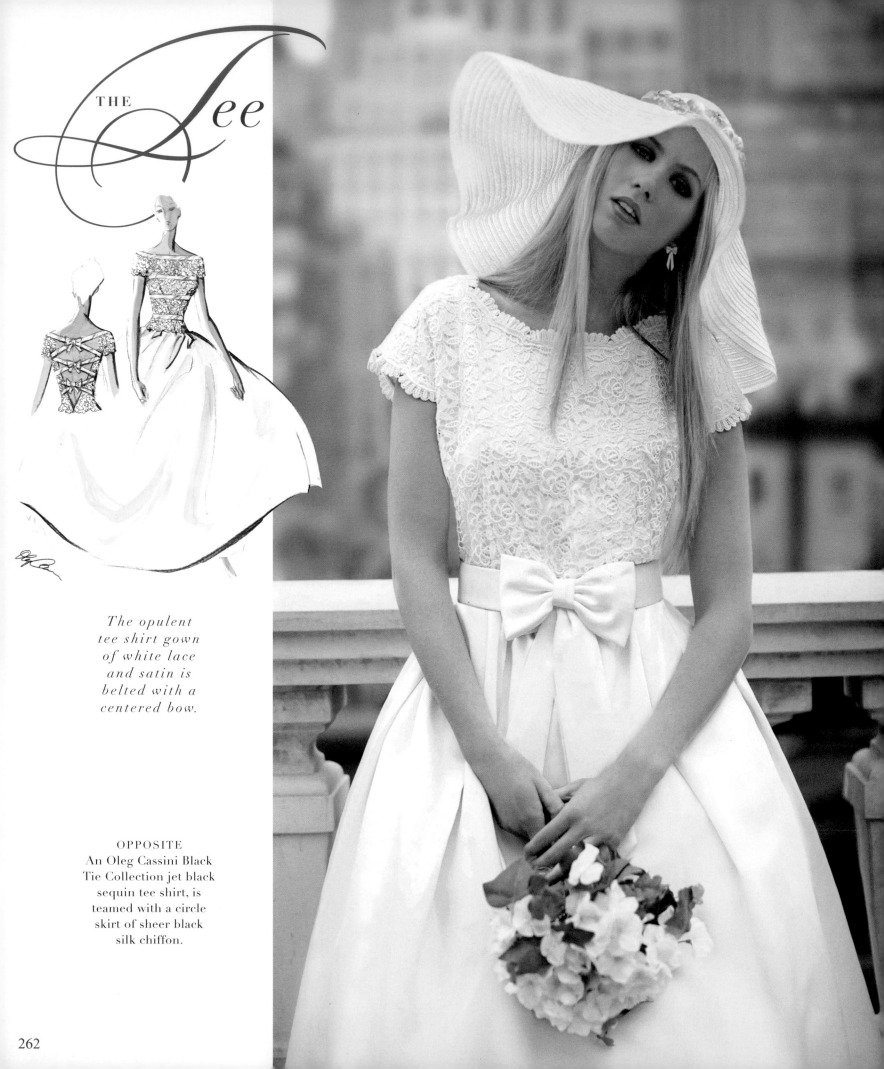

THE Tee

*The opulent
tee shirt gown
of white lace
and satin is
belted with a
centered bow.*

OPPOSITE
An Oleg Cassini Black
Tie Collection jet black
sequin tee shirt, is
teamed with a circle
skirt of sheer black
silk chiffon.

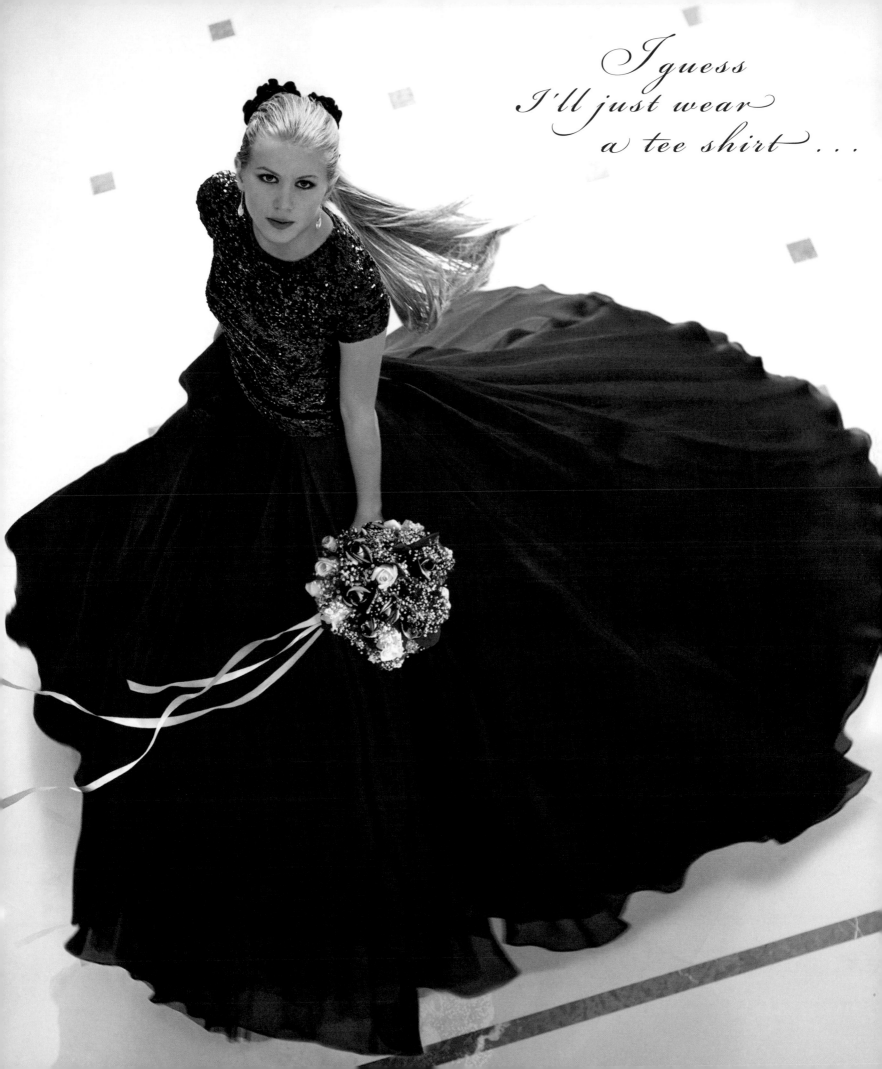

*I guess
I'll just wear
a tee shirt . . .*

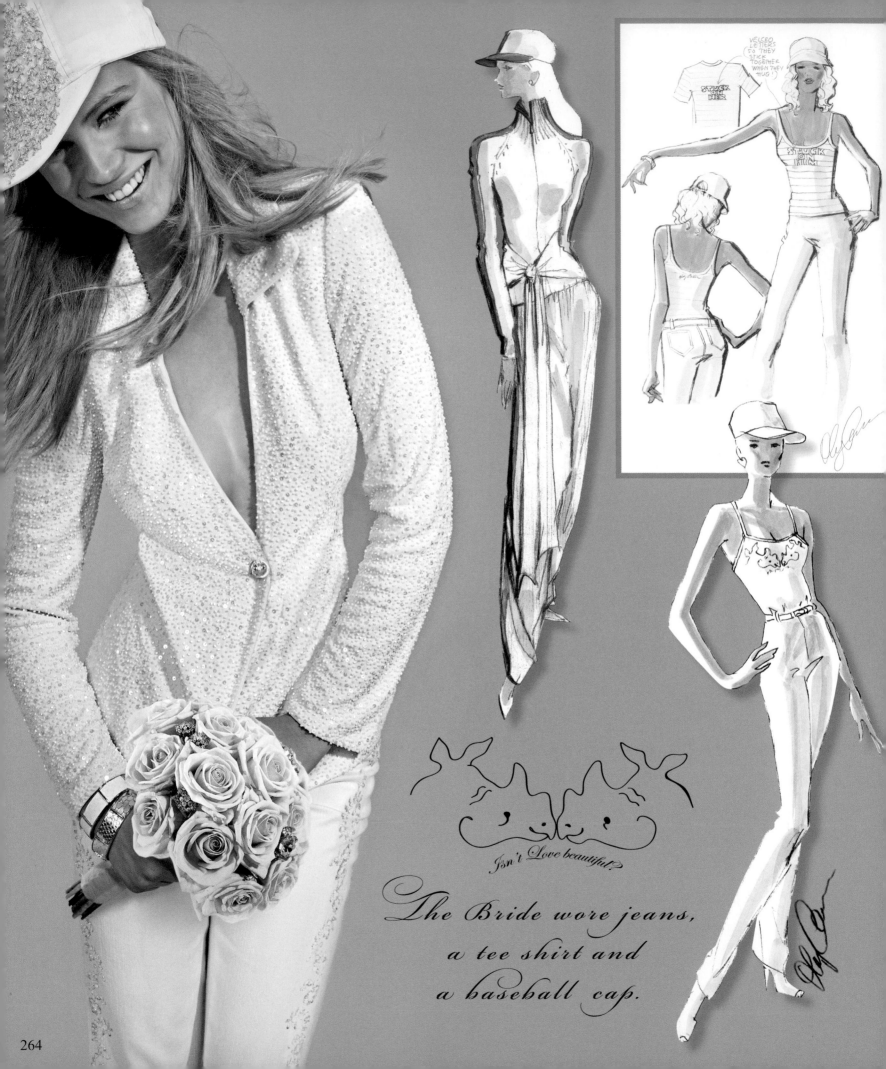

VELCRO LETTERS (SO THEY STICK TOGETHER WHEN THEY HUG!)

STUCK ON HIM

STUCK ON HER

Isn't Love beautiful?

The Bride wore jeans,
a tee shirt and
a baseball cap.

The Oleg Cassini Sport
"Warm-up" Suit

*The ease of French terry knit
fabric is embroidered with filigree
gold threads. White and gold
Oleg Cassini Sunglasses are
accessorized with gold track shoes.*

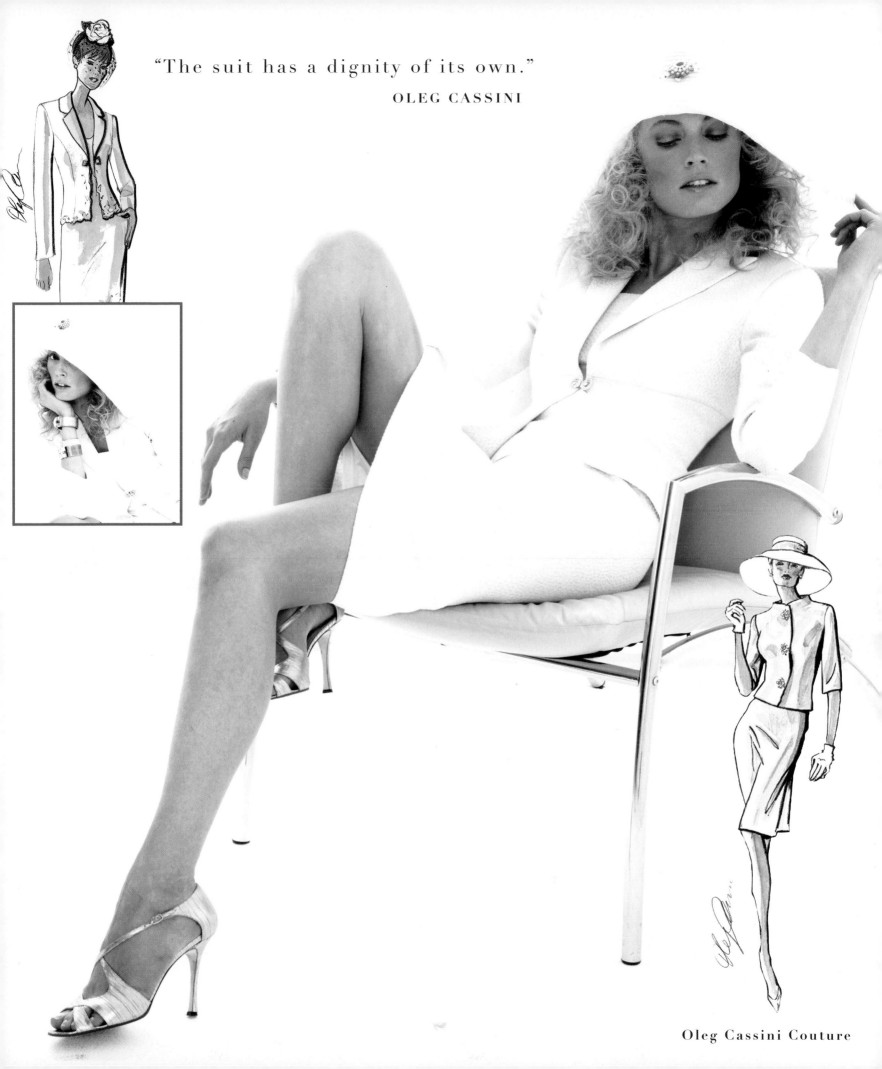

"The suit has a dignity of its own."
OLEG CASSINI

Oleg Cassini Couture

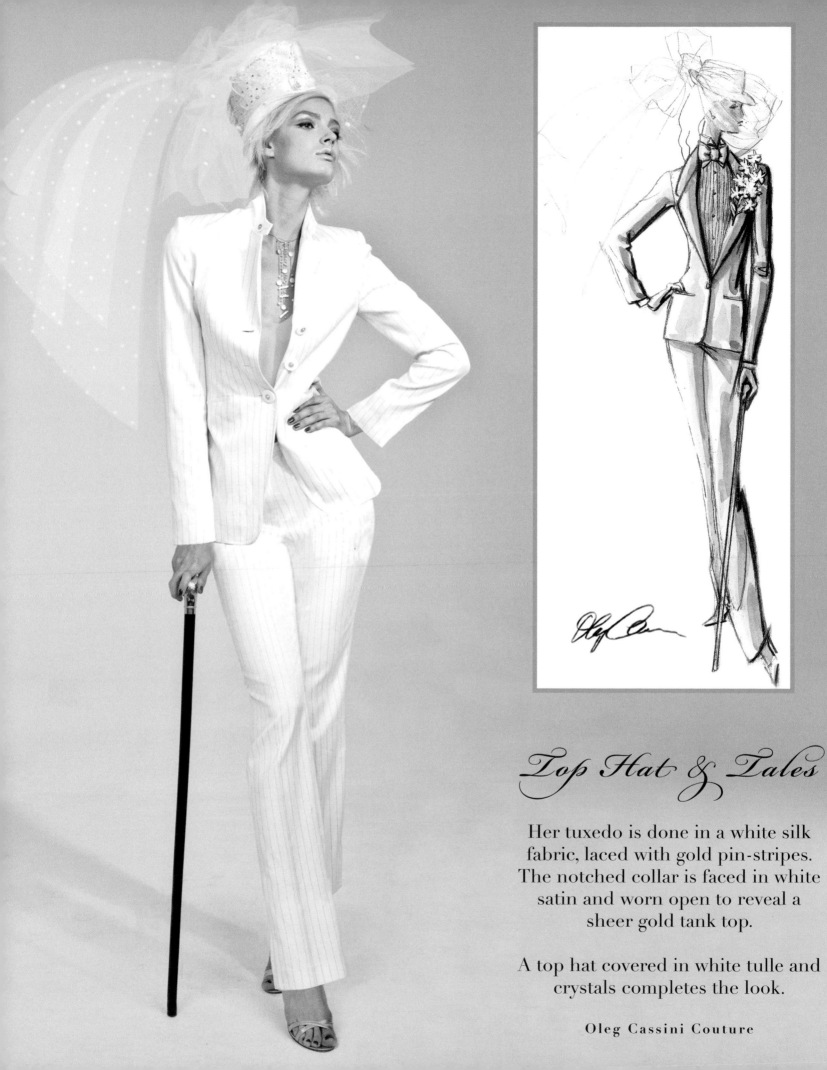

Top Hat & Tales

Her tuxedo is done in a white silk fabric, laced with gold pin-stripes. The notched collar is faced in white satin and worn open to reveal a sheer gold tank top.

A top hat covered in white tulle and crystals completes the look.

Oleg Cassini Couture

The Bold & the Beautiful

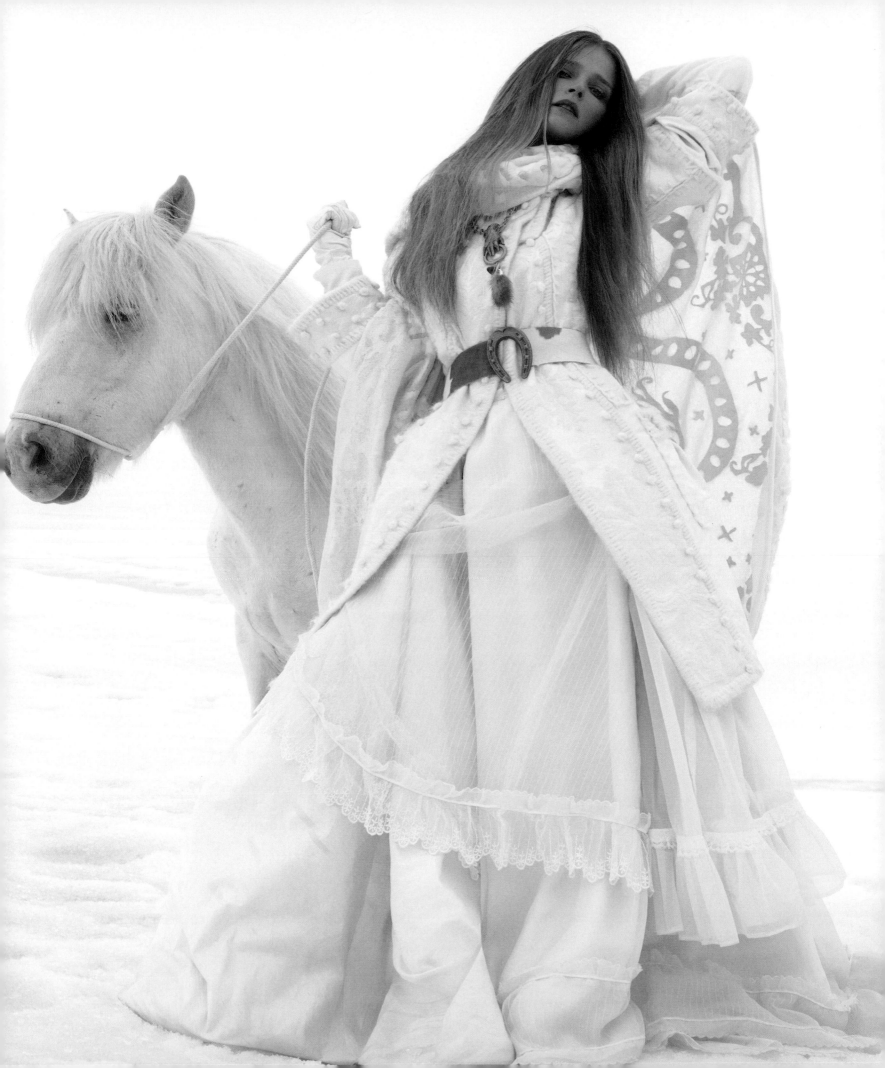

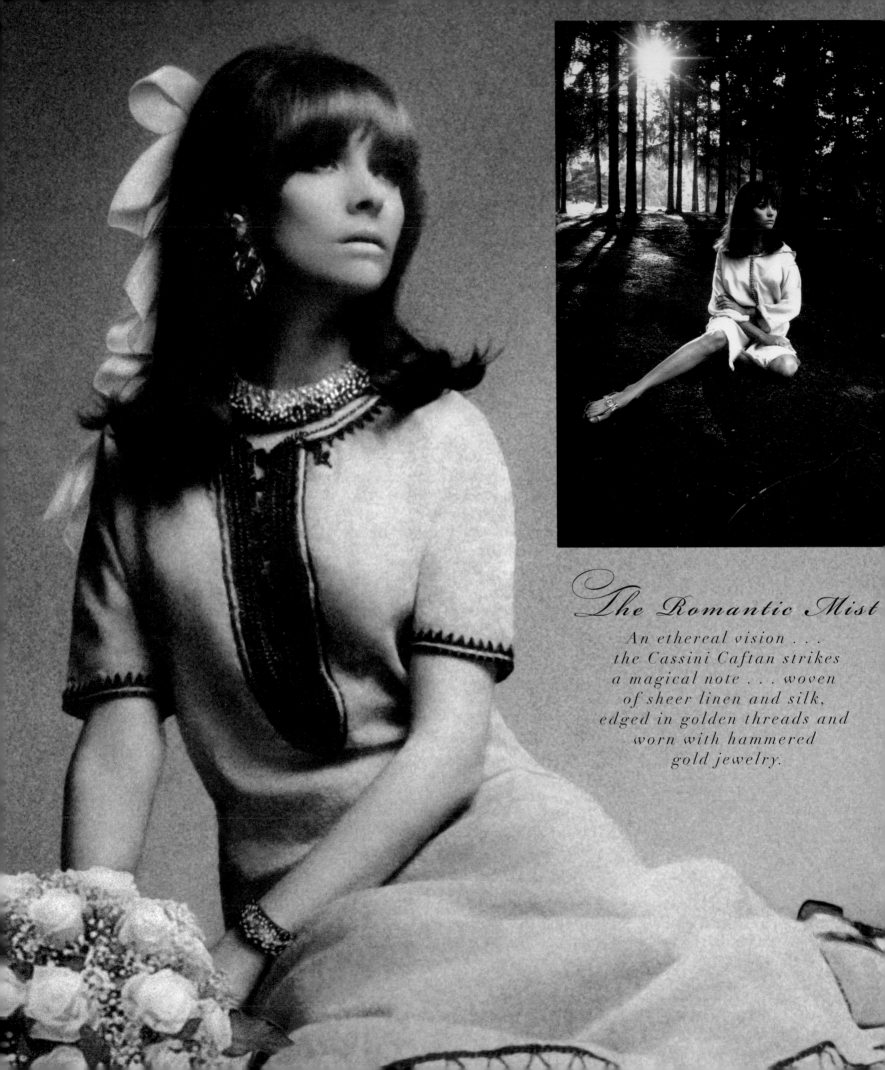

The Romantic Mist

An ethereal vision . . .
the Cassini Caftan strikes
a magical note . . . woven
of sheer linen and silk,
edged in golden threads and
worn with hammered
gold jewelry.

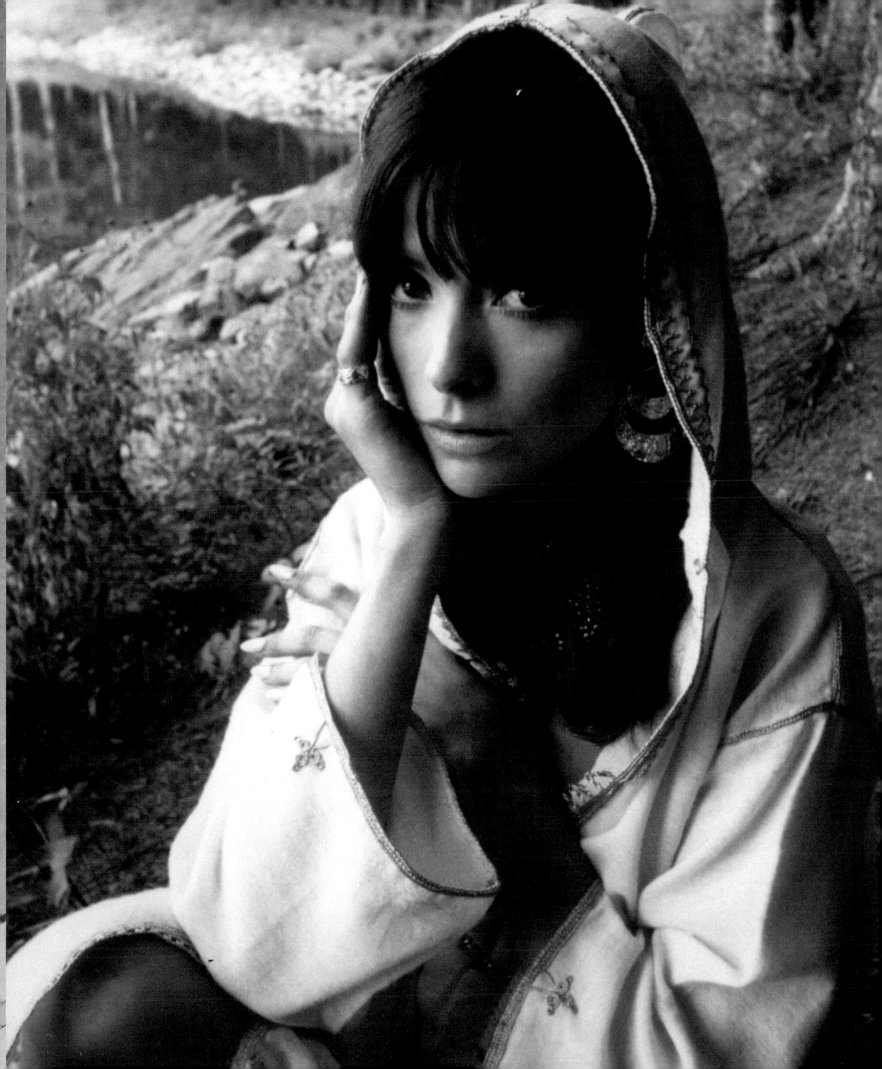

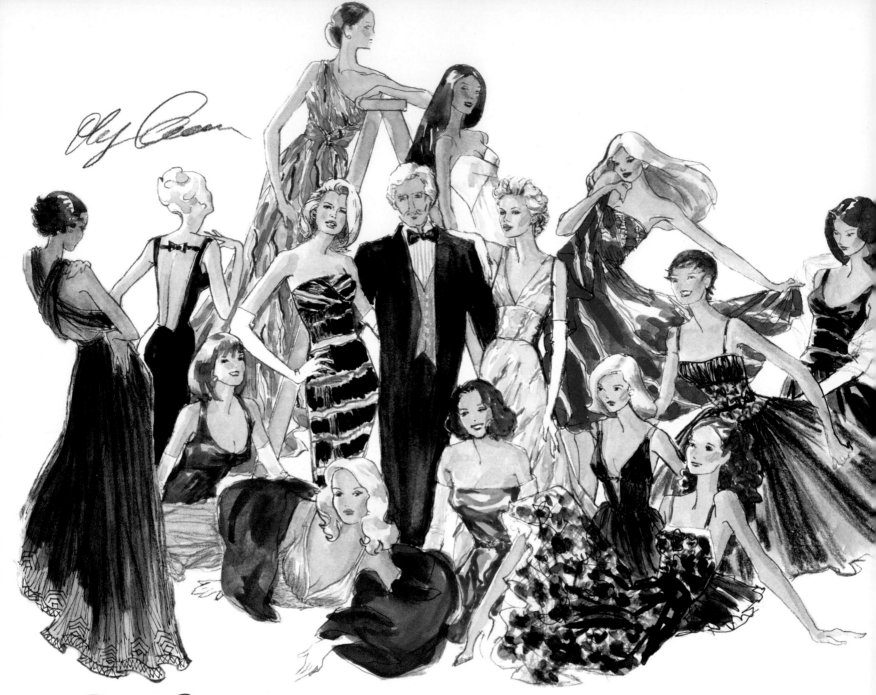

Women make their fashion selections based on:

Color—is the first thing to catch the eye;

Fabric—she will want to feel the texture;

Style/Silhouette/Label—she will look to see who the creator is and if she likes the concept;

Fit—if she likes all the preceding so far, she will then try it; and,

Price—if she is convinced on all other points.

The beauty of designing a garment with a printed fabric, is that the print itself can contain subtle shades of seventeen to twenty colors, from soft muted tones to beautiful and bold, which creates a palette of inspiration for the designer.

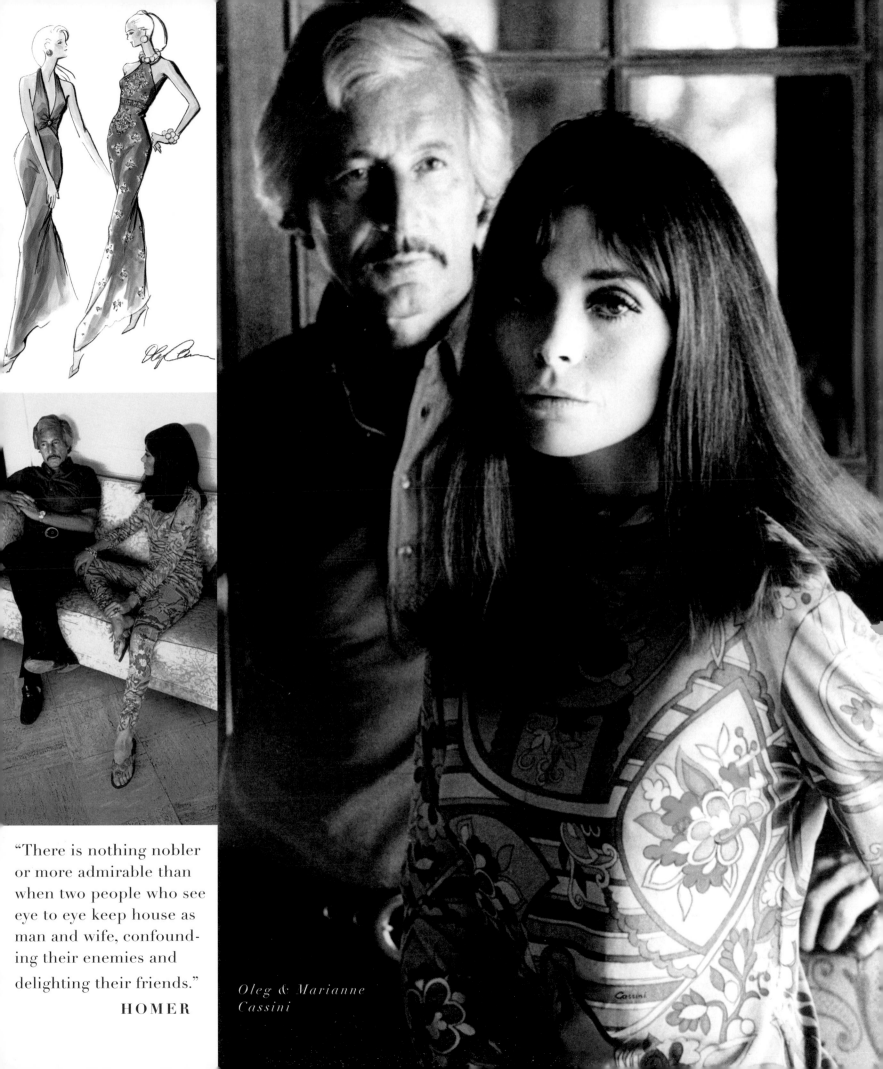

"There is nothing nobler or more admirable than when two people who see eye to eye keep house as man and wife, confounding their enemies and delighting their friends."
HOMER

Oleg & Marianne Cassini

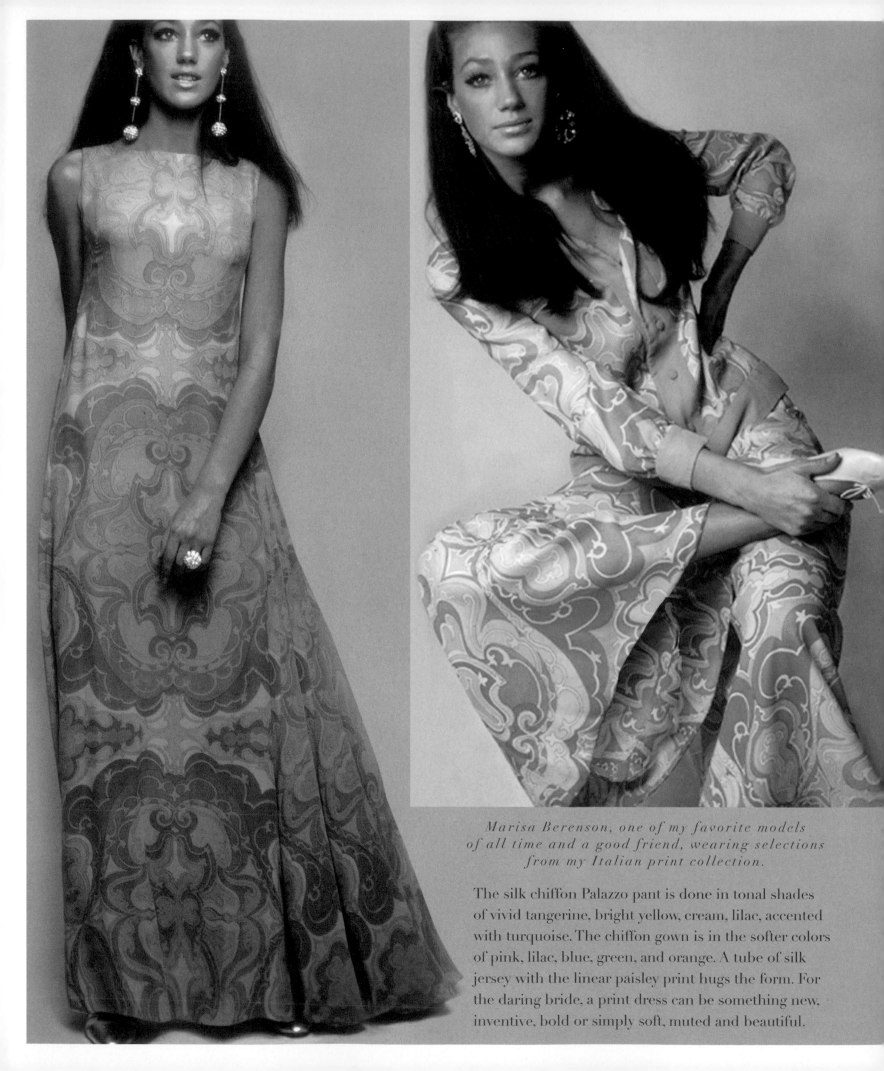

*Marisa Berenson, one of my favorite models
of all time and a good friend, wearing selections
from my Italian print collection.*

The silk chiffon Palazzo pant is done in tonal shades
of vivid tangerine, bright yellow, cream, lilac, accented
with turquoise. The chiffon gown is in the softer colors
of pink, lilac, blue, green, and orange. A tube of silk
jersey with the linear paisley print hugs the form. For
the daring bride, a print dress can be something new,
inventive, bold or simply soft, muted and beautiful.

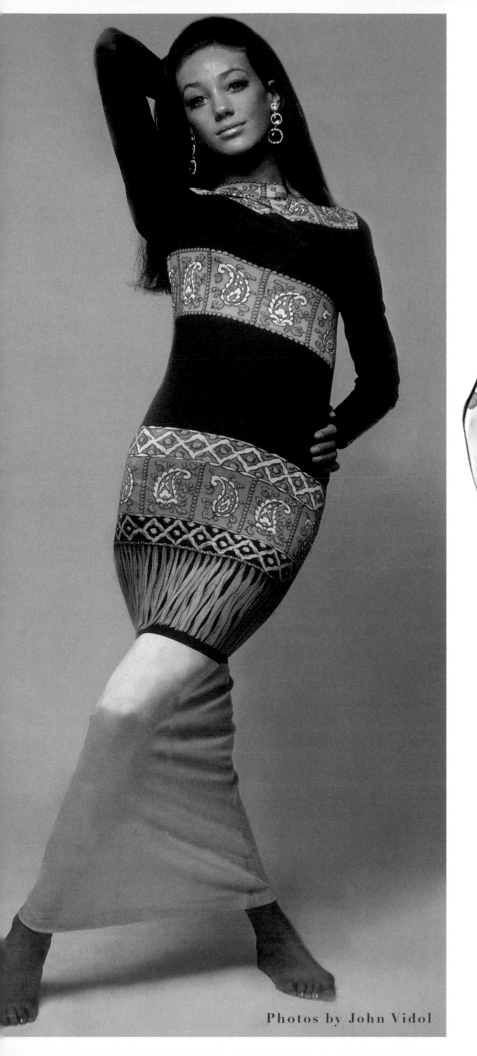

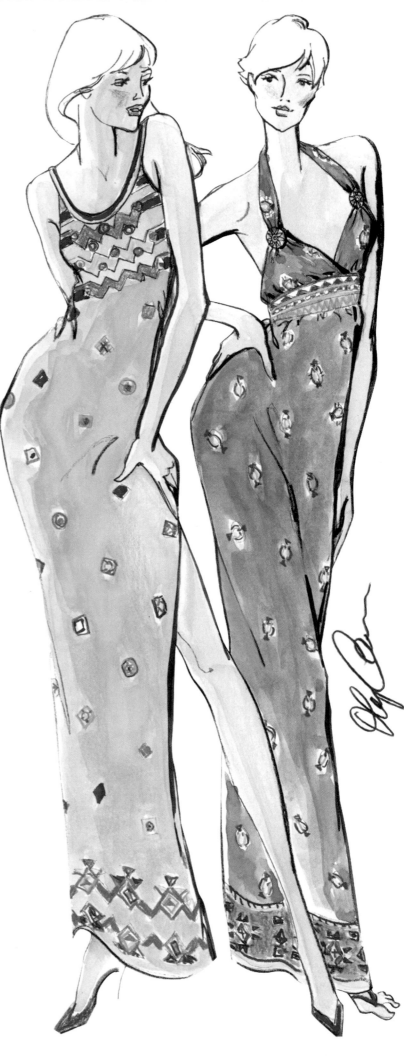

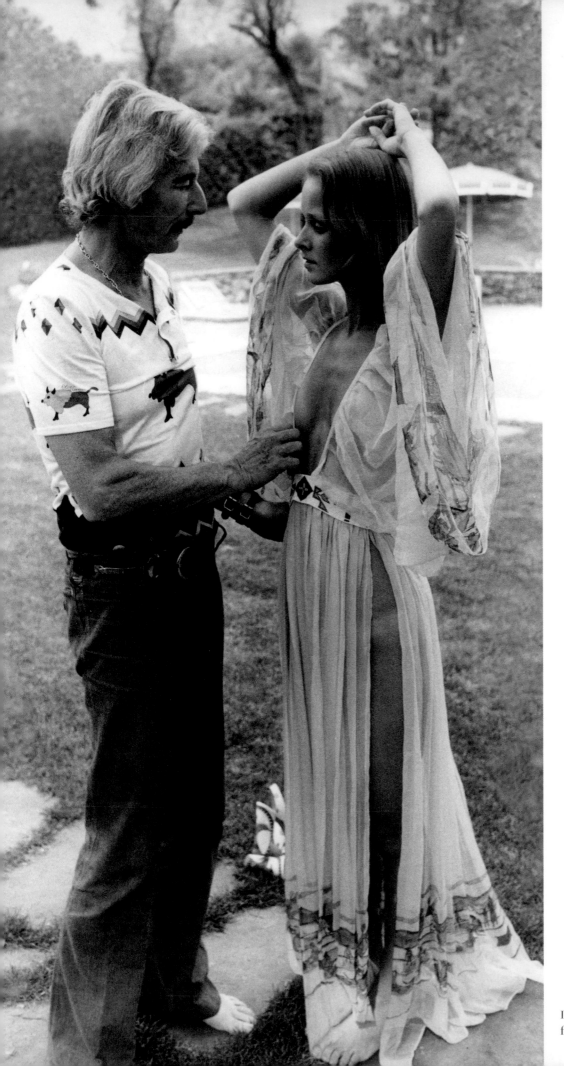

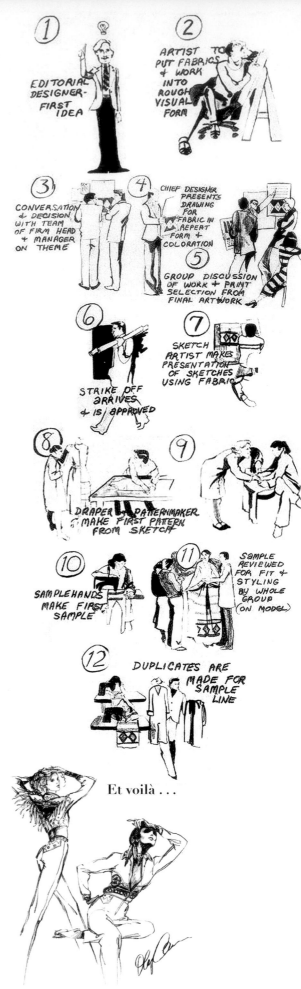

LEFT In the process of fitting a wedding dress in Milan for a fashion show finale.

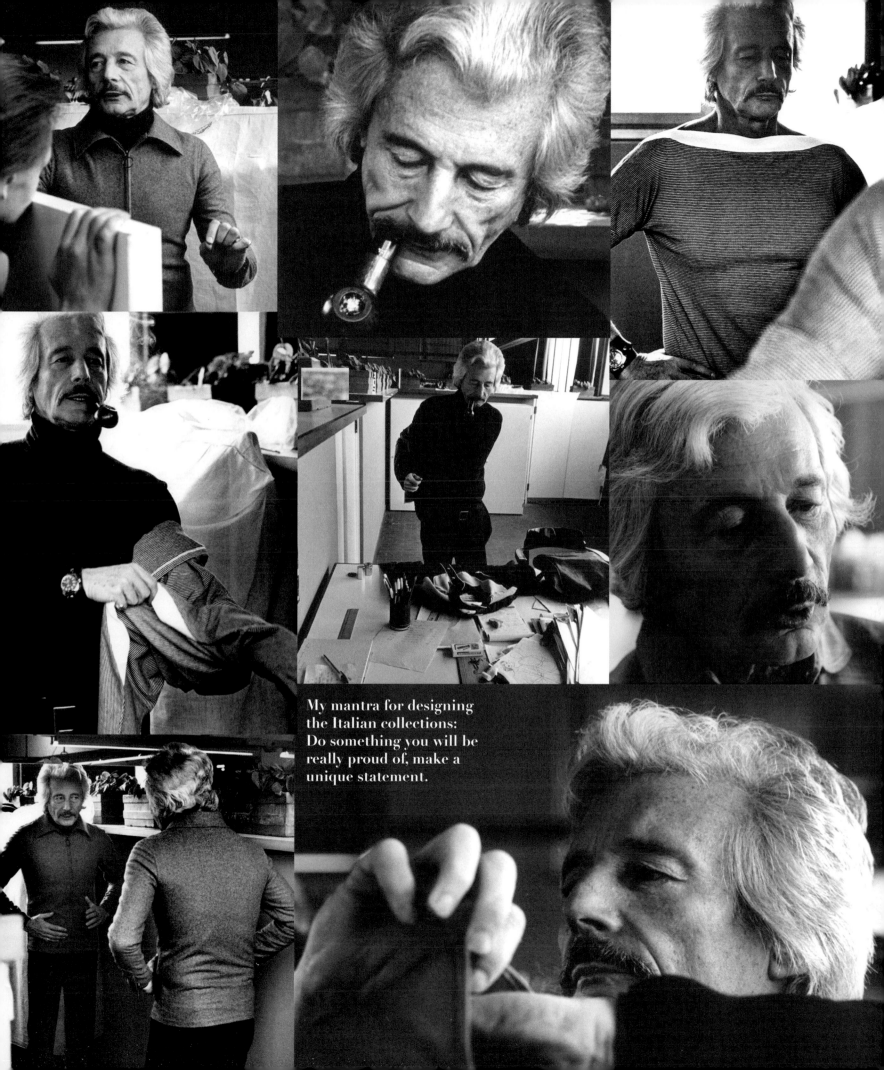

My mantra for designing the Italian collections: Do something you will be really proud of, make a unique statement.

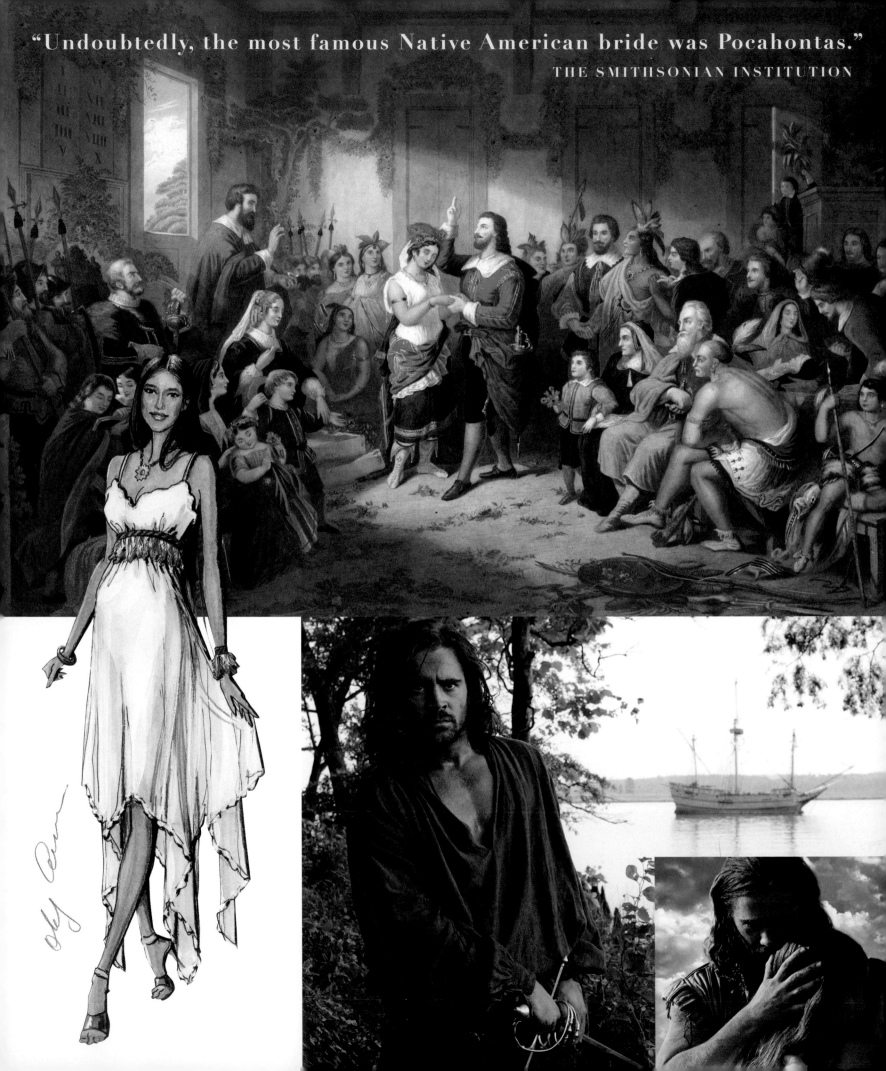

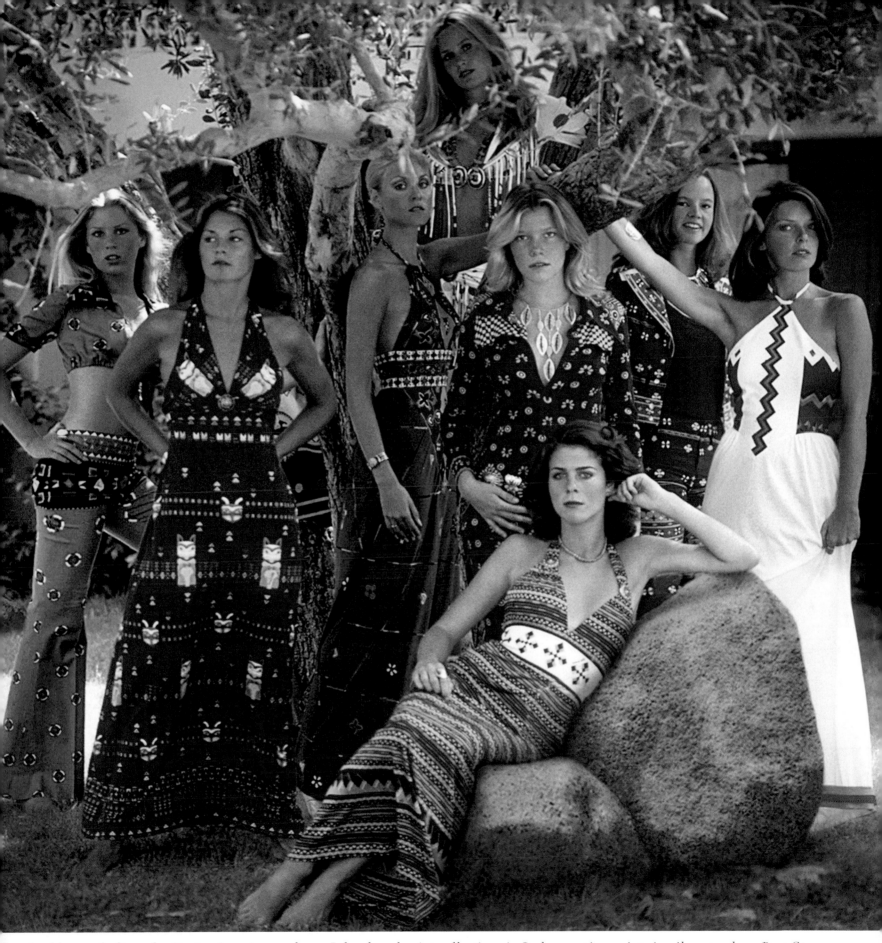

Inspired by my feelings for Native American culture, I developed print collections in Italy, creating prints in vibrant colors. Bert Stern captured the brilliant colors during a photo shoot in Palm Springs, California. One of the prettiest models, posed at center front is Rita Wilson Hanks who produced the hit film, My Big Fat Greek Wedding, *Hollywood's top grossing romantic comedy.*

Colin Farrell and Q'orianka portrayed Captain John Smith & Pocahontas, daughter of Powhatan, Chief of the Algonquins, in the film, The New World. *She wore Oleg Cassini dresses, that were themed for Pocahontas, to the premiere and awards ceremonies that followed.*

Grammy Award Winner Pink
in black leather and tulle

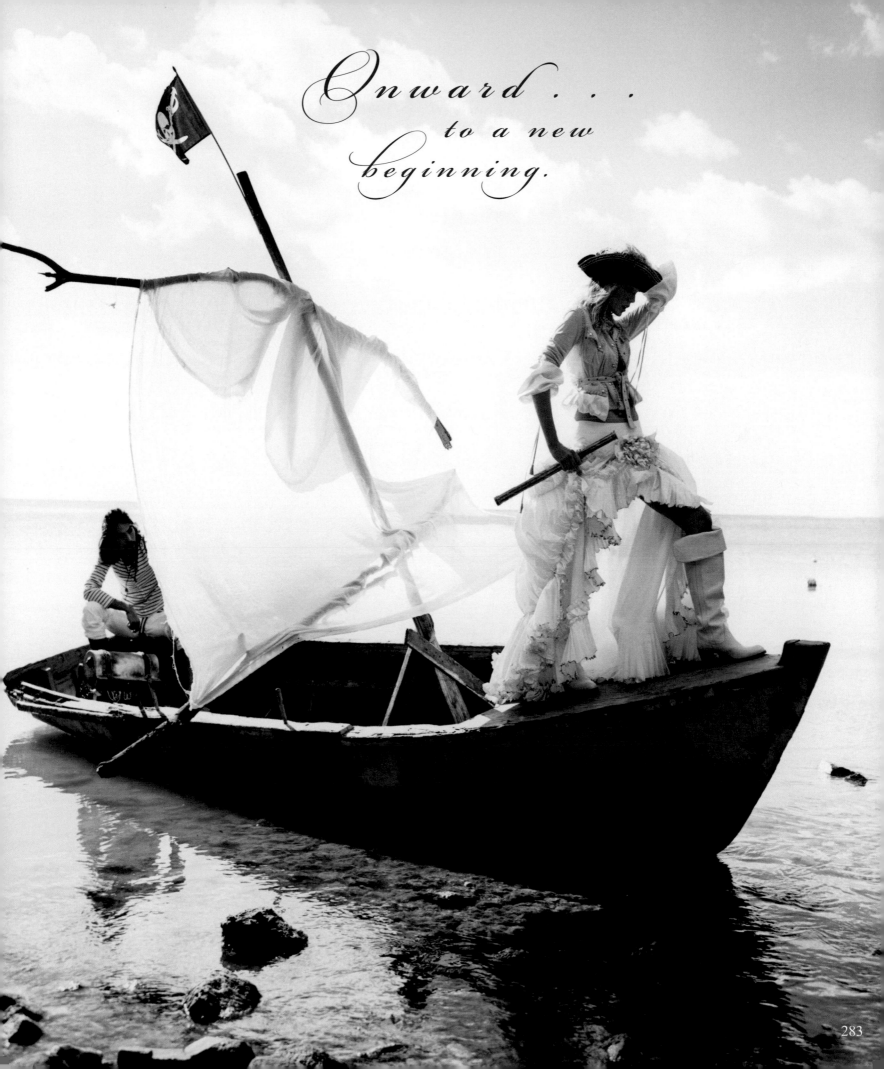

Onward . . .
to a new
beginning.

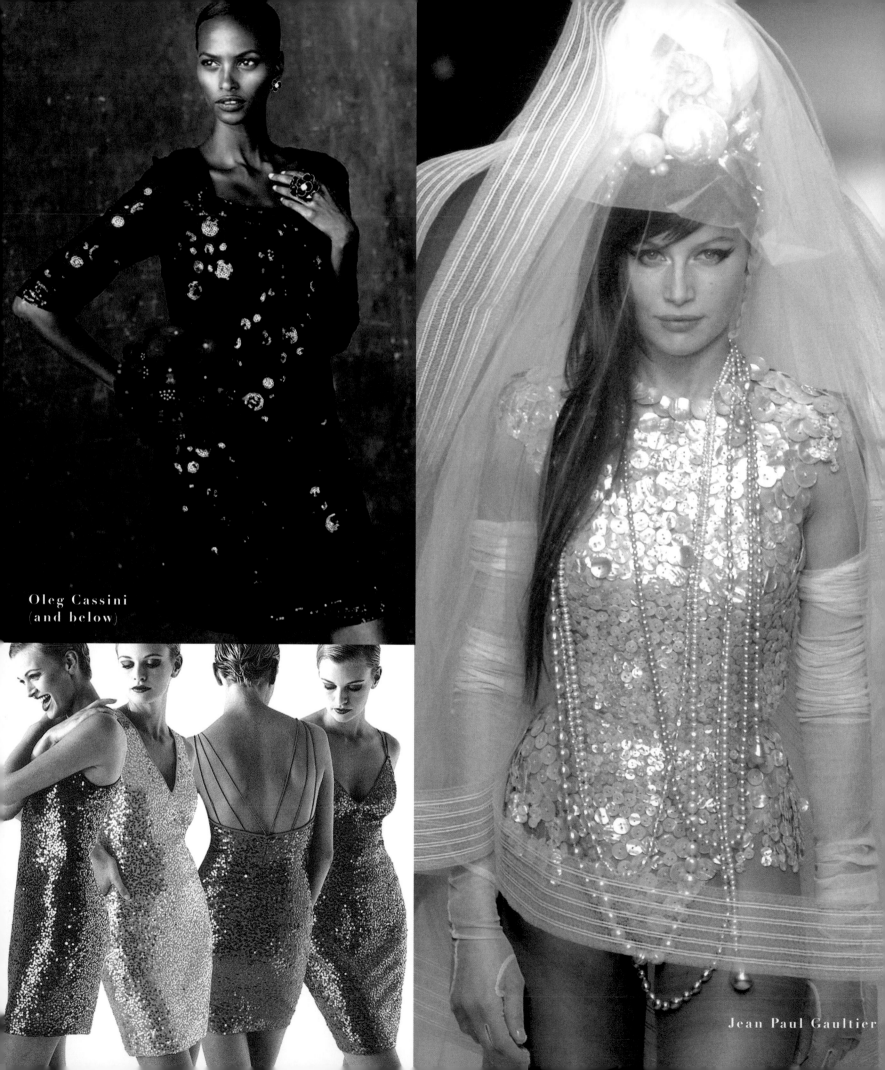

Oleg Cassini
(and below)

Jean Paul Gaultier

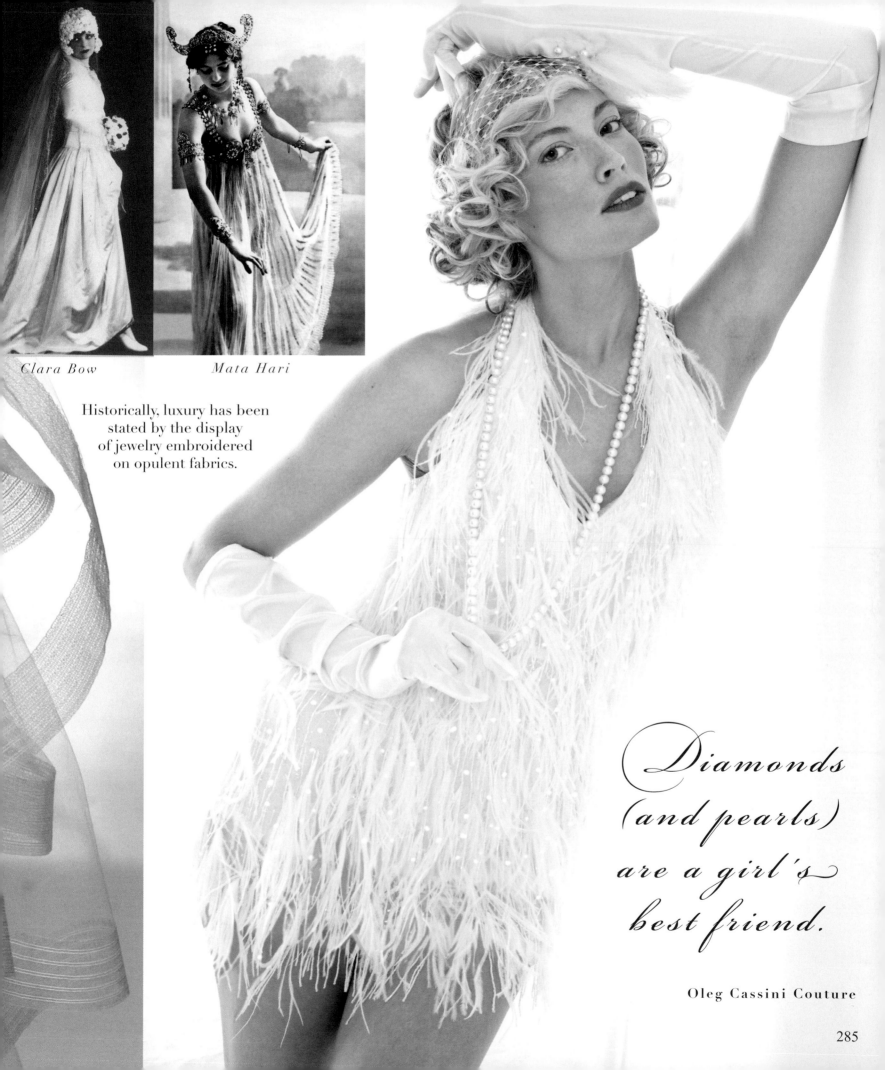

Clara Bow

Mata Hari

Historically, luxury has been
stated by the display
of jewelry embroidered
on opulent fabrics.

*Diamonds
(and pearls)
are a girl's
best friend.*

Oleg Cassini Couture

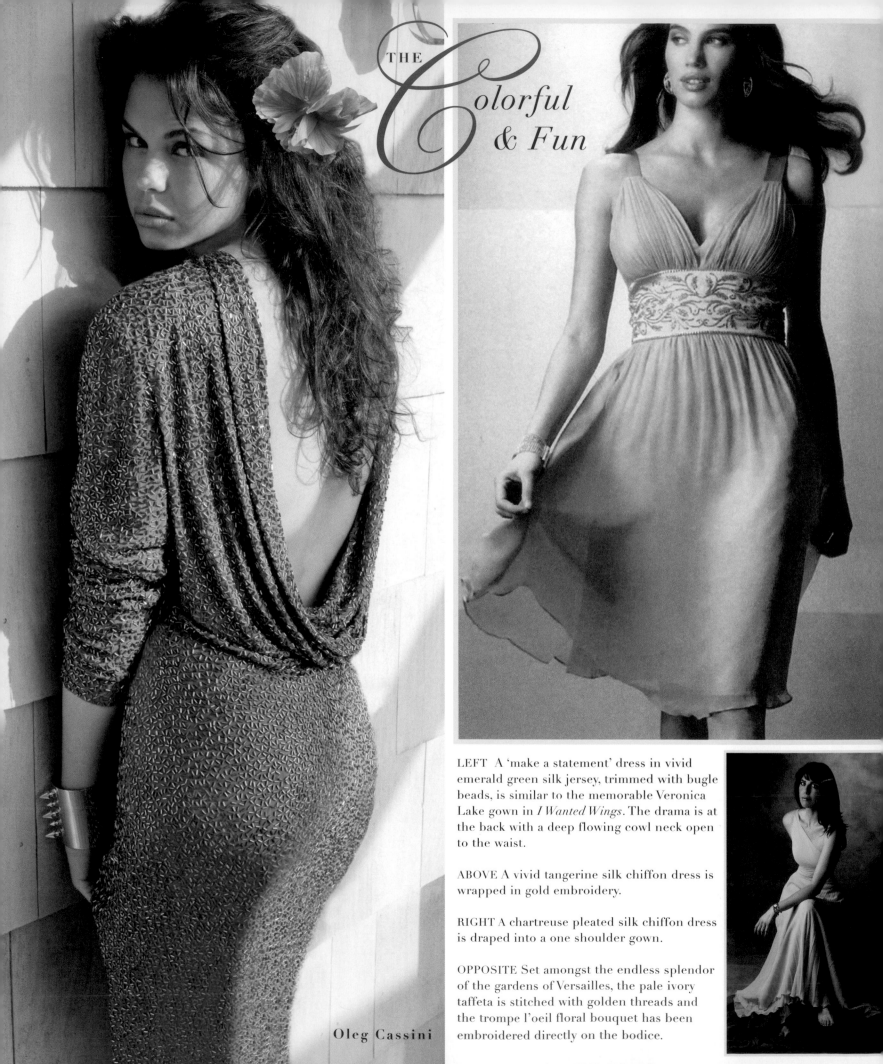

THE Colorful & Fun

LEFT A 'make a statement' dress in vivid emerald green silk jersey, trimmed with bugle beads, is similar to the memorable Veronica Lake gown in *I Wanted Wings*. The drama is at the back with a deep flowing cowl neck open to the waist.

ABOVE A vivid tangerine silk chiffon dress is wrapped in gold embroidery.

RIGHT A chartreuse pleated silk chiffon dress is draped into a one shoulder gown.

OPPOSITE Set amongst the endless splendor of the gardens of Versailles, the pale ivory taffeta is stitched with golden threads and the trompe l'oeil floral bouquet has been embroidered directly on the bodice.

Oleg Cassini

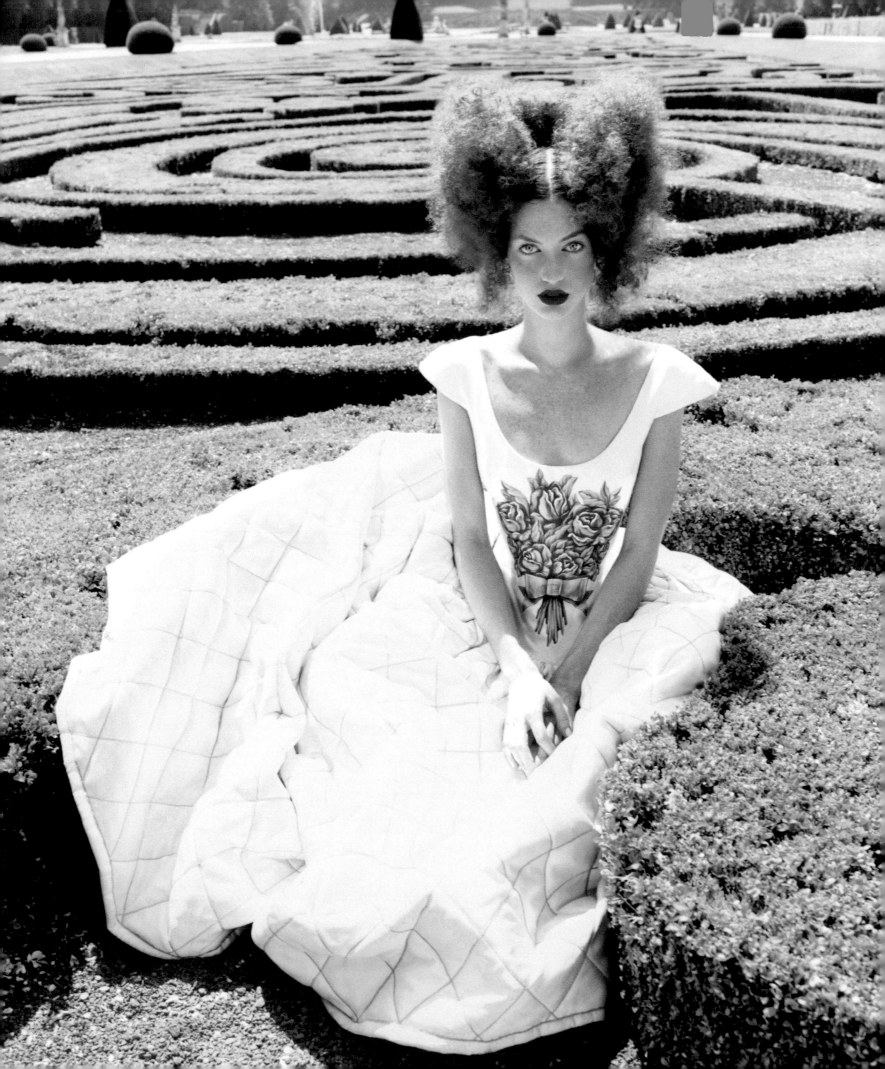

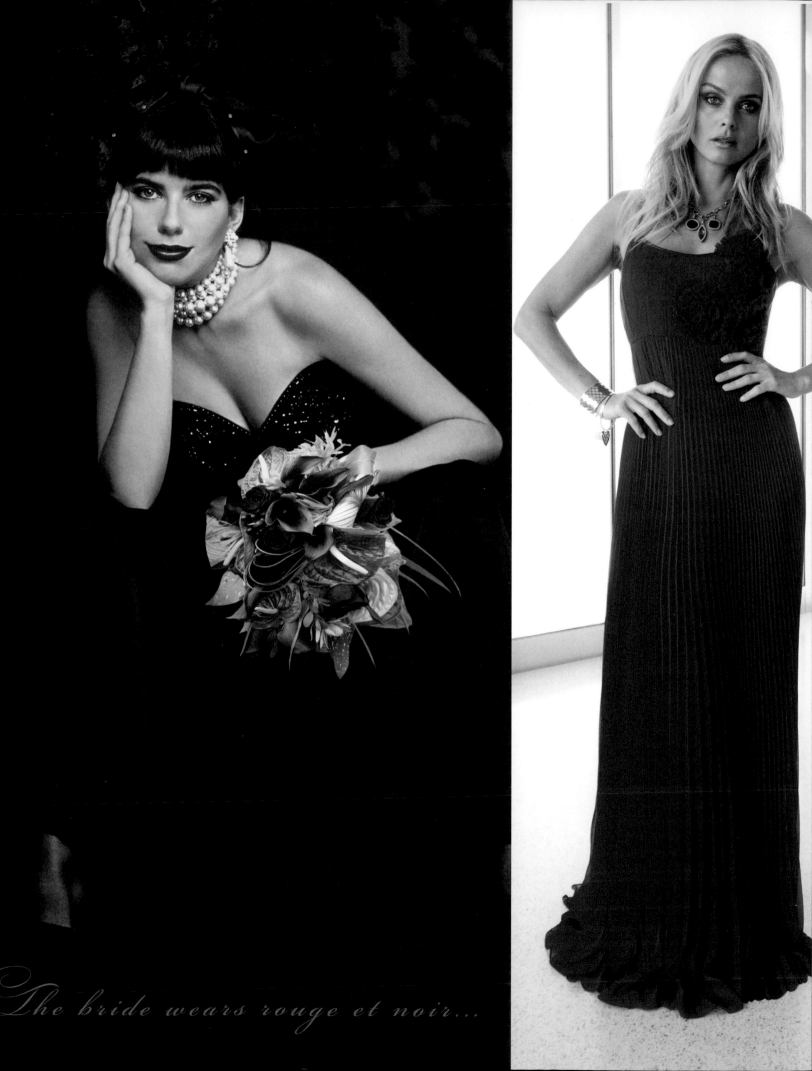

The bride wears rouge et noir...

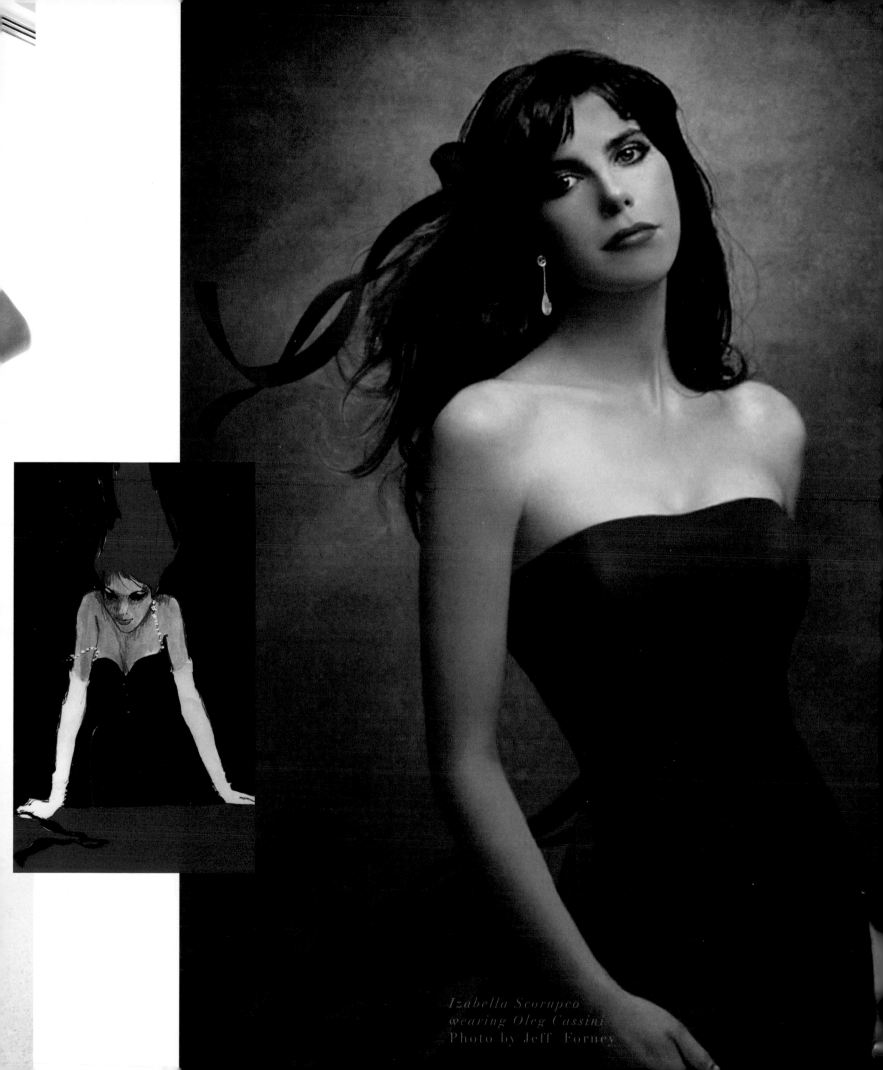

Izabella Scorupco
wearing Oleg Cassini
Photo by Jeff Forney

Jean Paul
Gaultier

*Oleg Cassini
at the
Trump Tower
(and below)*

Kenzo

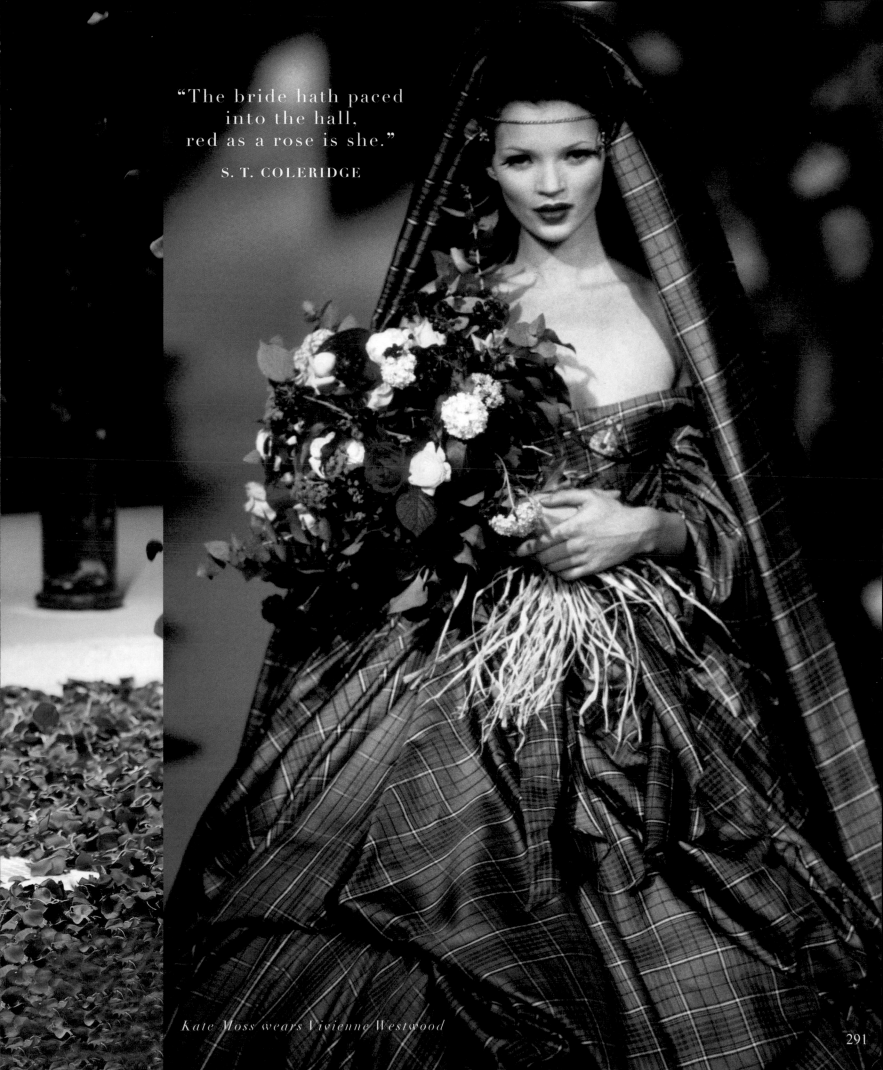

"The bride hath paced
into the hall,
red as a rose is she."

S. T. COLERIDGE

Kate Moss wears Vivienne Westwood

291

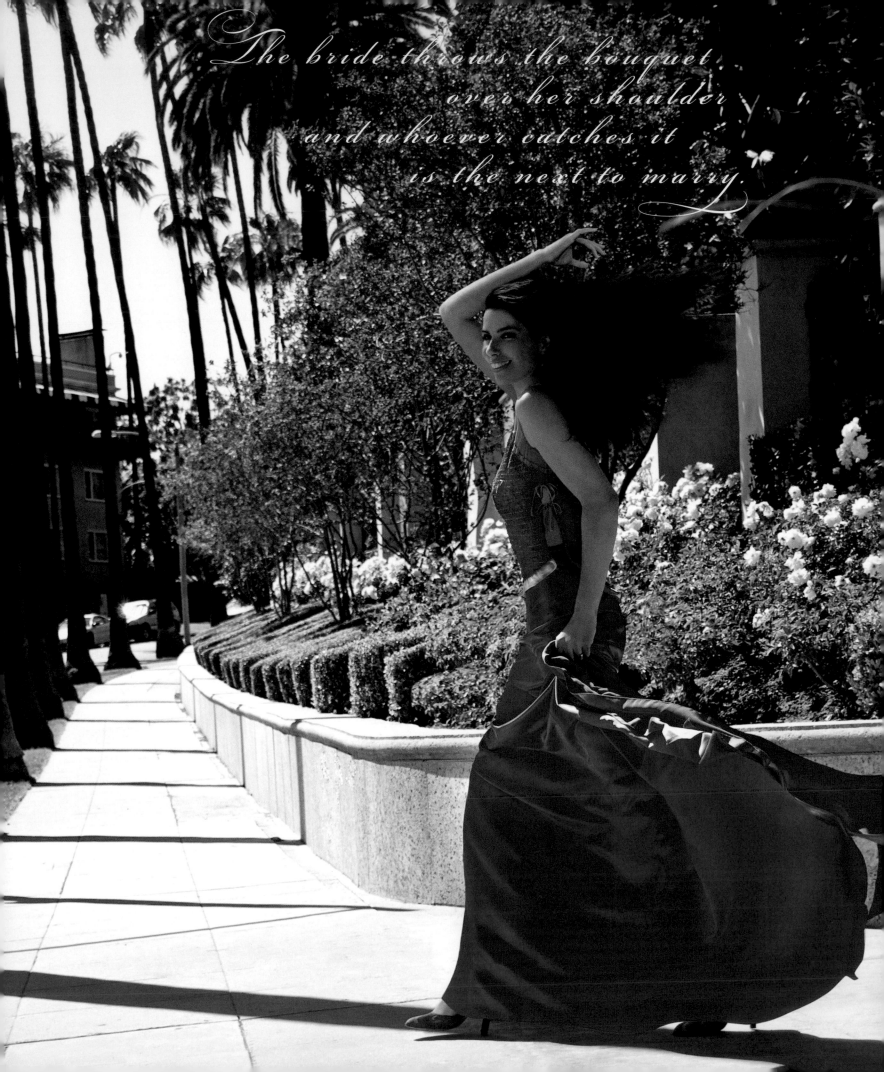

The bride throws the bouquet
over her shoulder
and whoever catches it
is the next to marry.

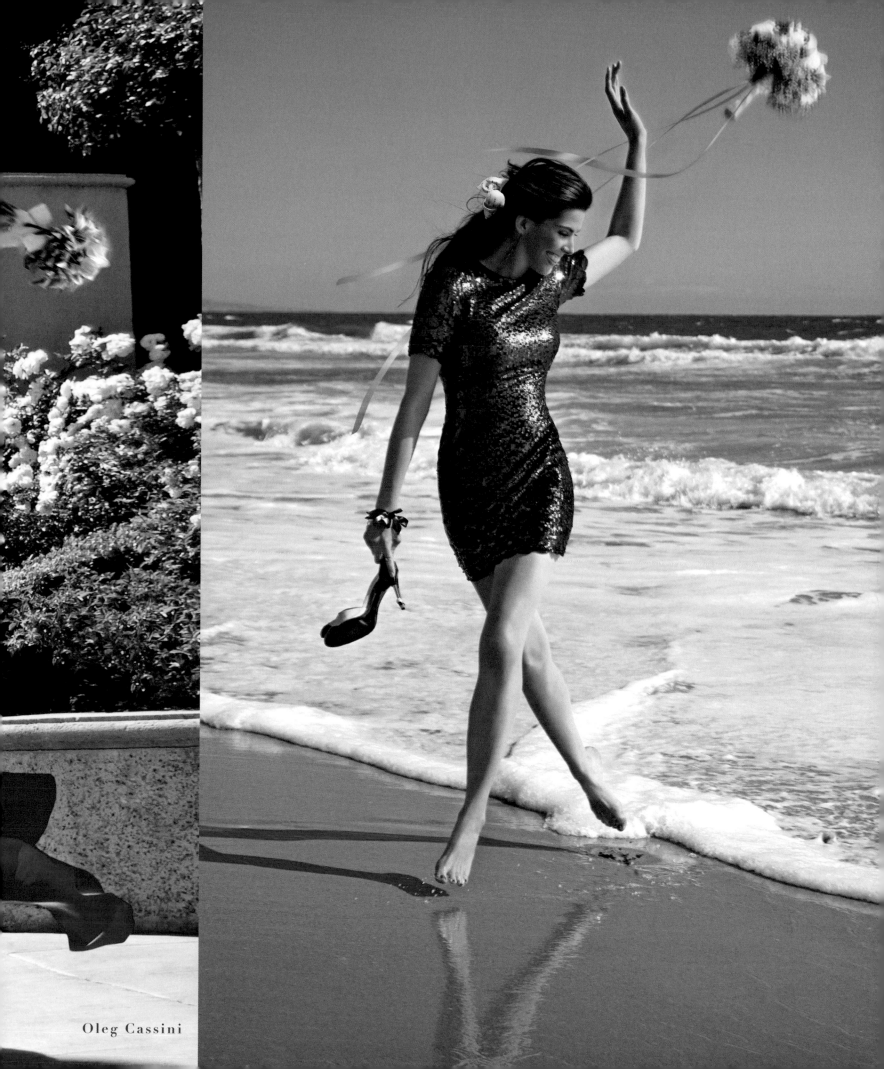

Oleg Cassini

Bride

manhattan

Fall/Winter 2010 $4.95

Your Complete Wedding Guide...
Over 760 Gowns Ideas & Resources

Great Locations *Perfect for Your Day*

Romantic, Stylish, Delicious
Your Menus, Cakes, Music, Flowers, Photography

38 Real Weddings
Romance & Inspiration

Win a Honeymoon *in St. Lucia*

manhattanbride.com

Gowns by Oleg Cassini
Photos by Rick Bard

The Mantilla

The Mantilla captures the essence of romance and is created by a circular or square piece of lace, or lace trimmed tulle, usually secured by a decorative comb.

Oleg Cassini
Collection

Alexander
McQueen

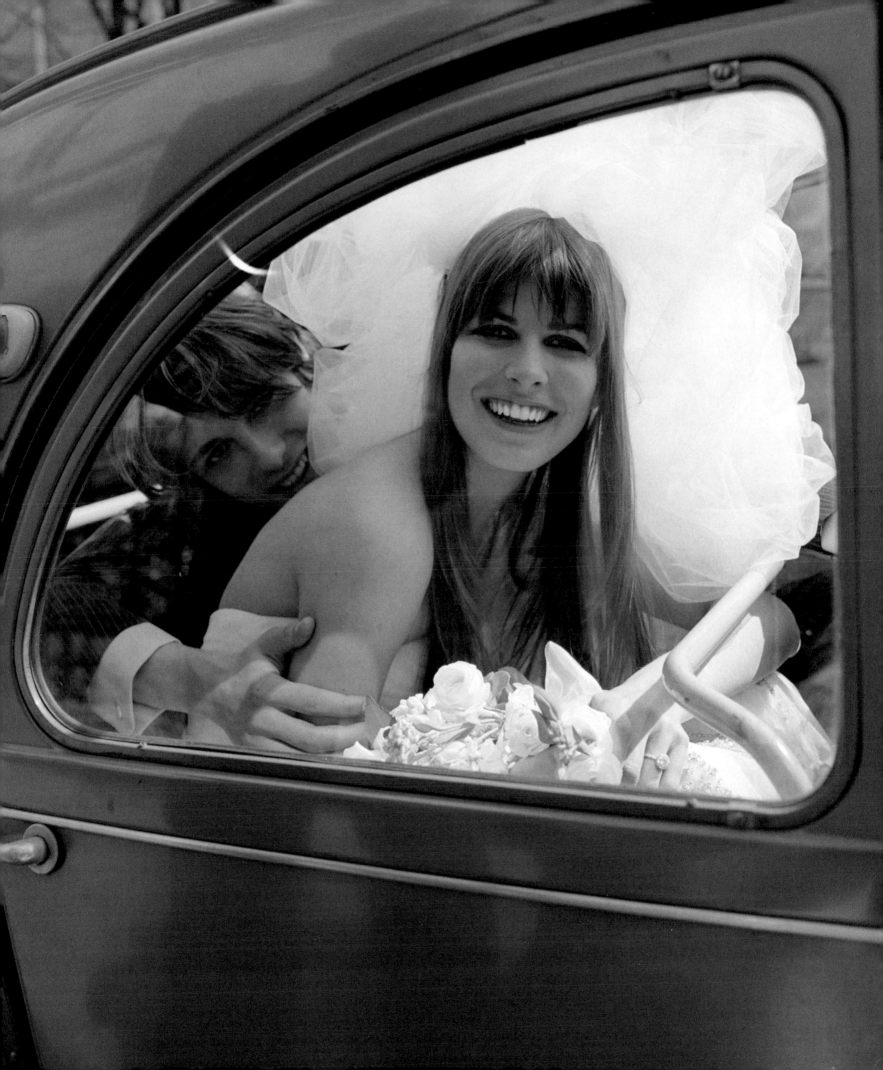

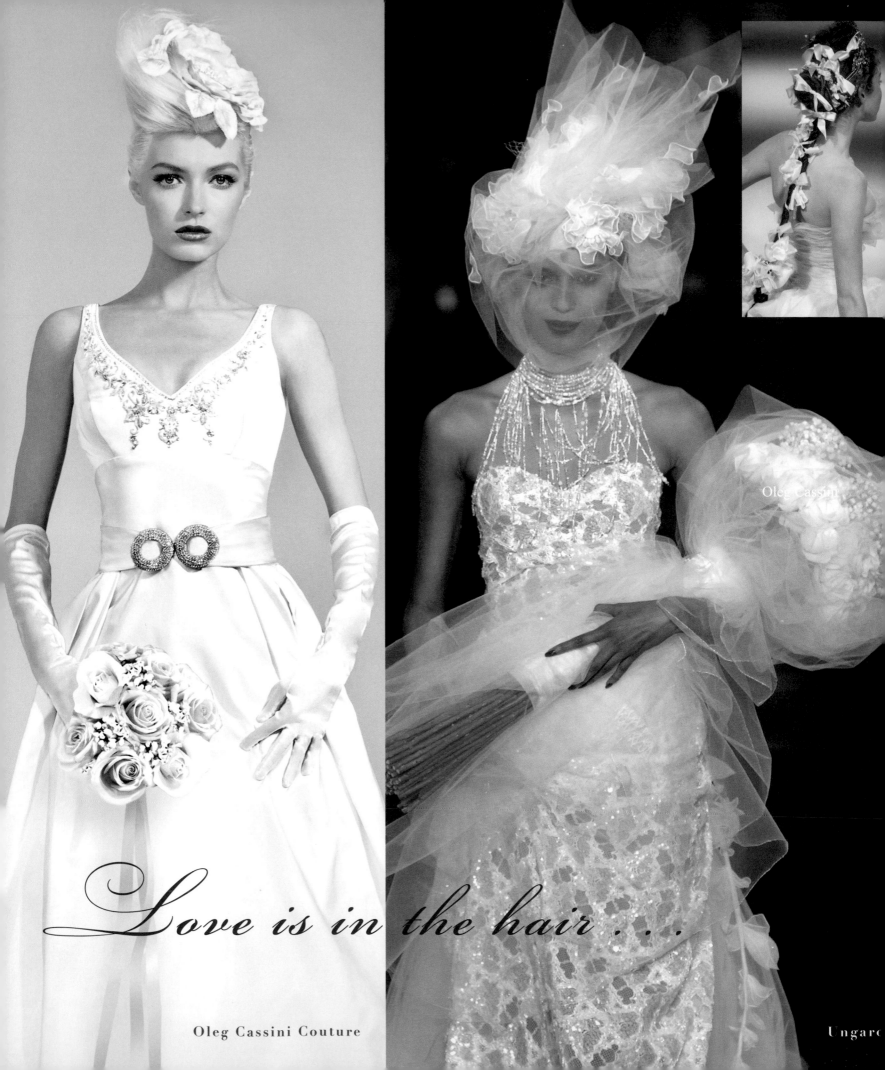

Love is in the hair . . .

Oleg Cassini Couture

Ungaro

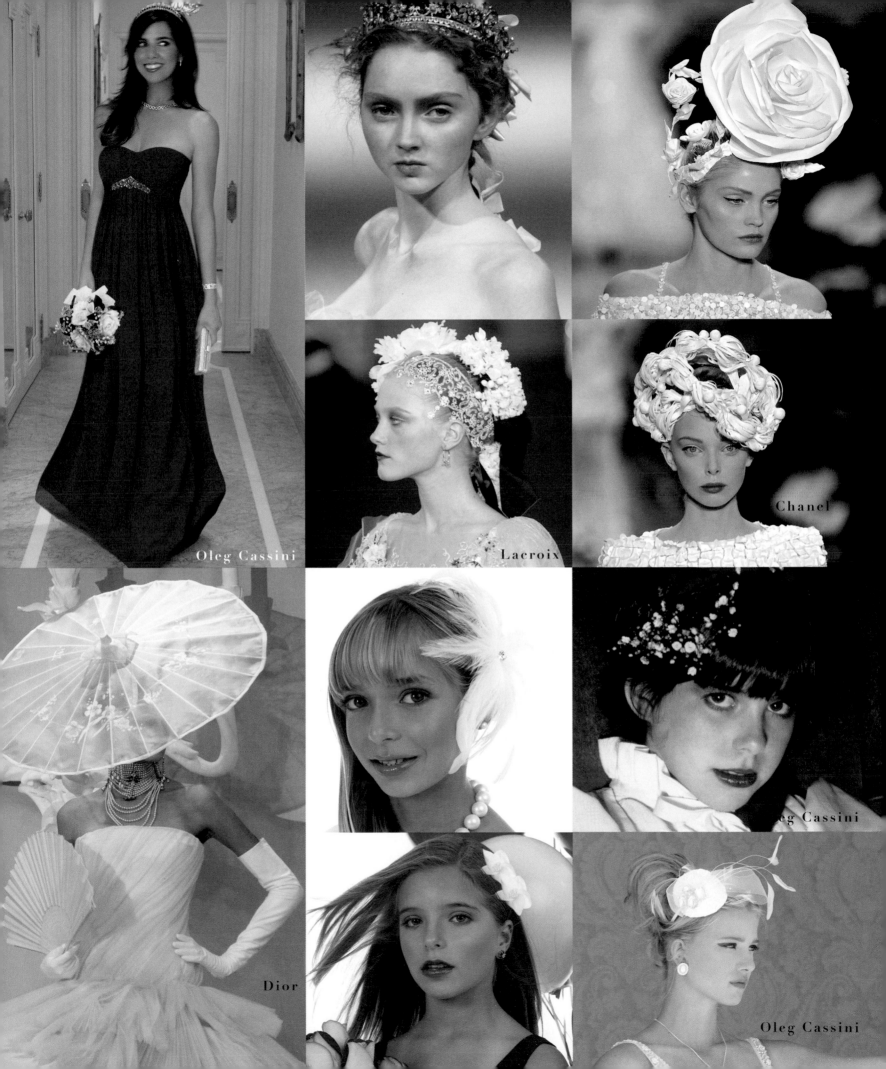

Oleg Cassini

Lacroix

Chanel

Dior

eg Cassini

Oleg Cassini

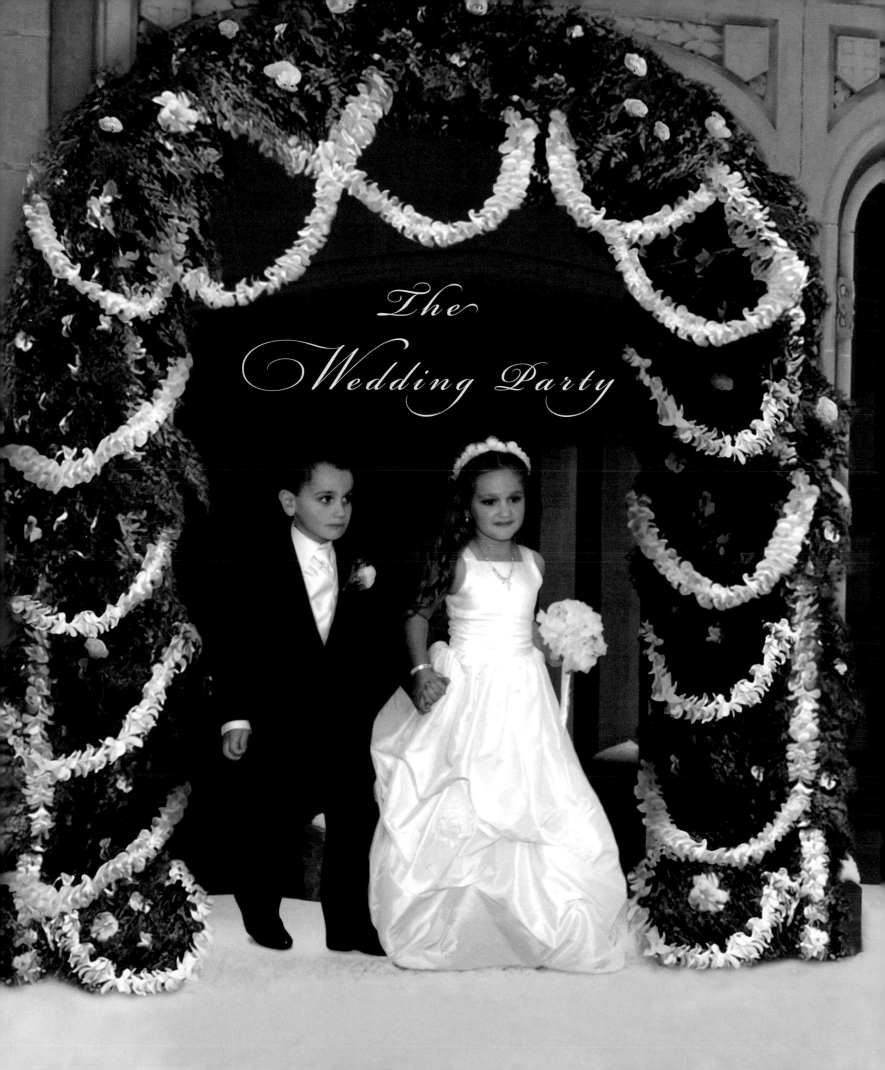

The
Wedding Party

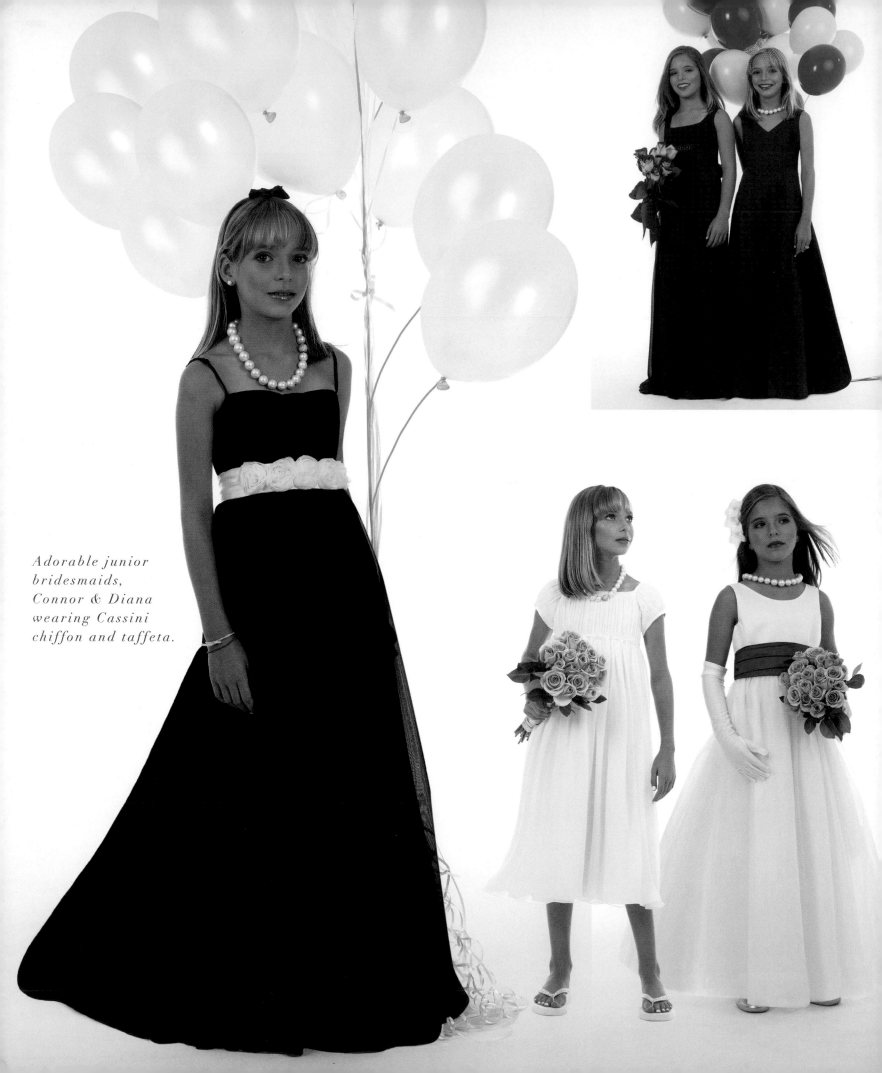

Adorable junior bridesmaids, Connor & Diana wearing Cassini chiffon and taffeta.

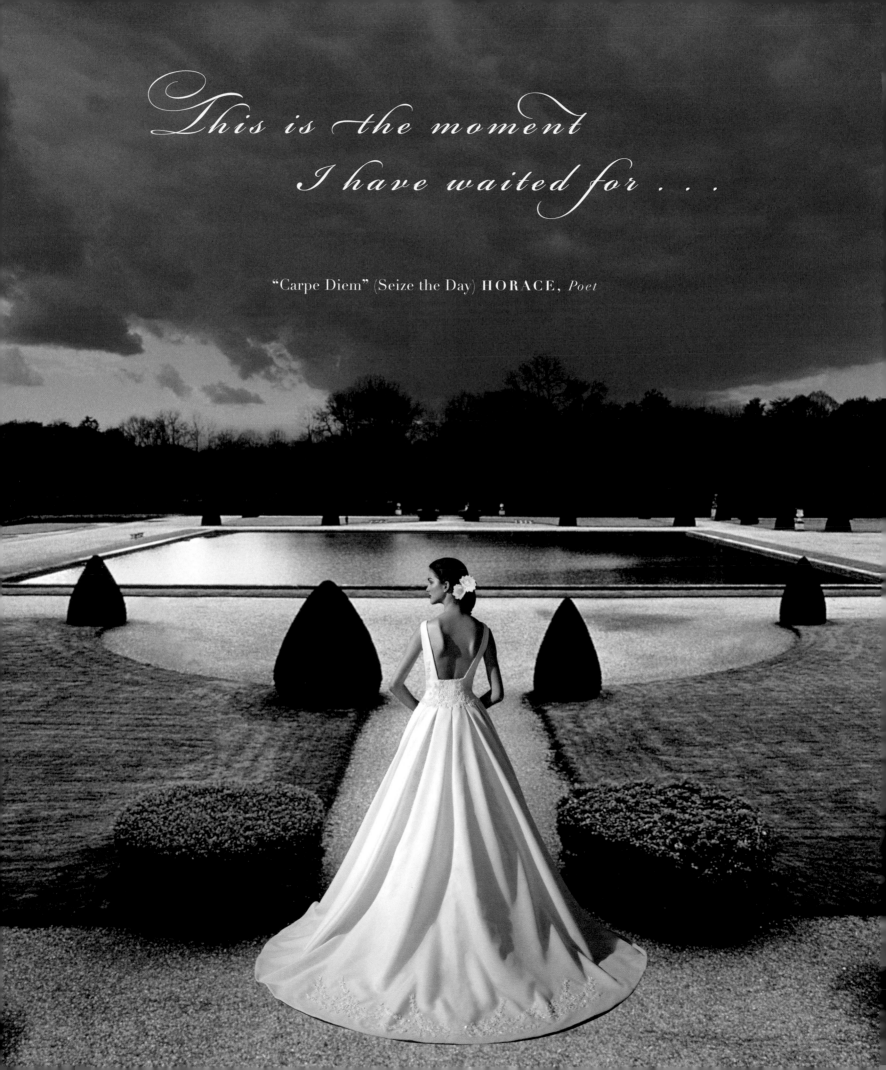

*This is the moment
I have waited for . . .*

"Carpe Diem" (Seize the Day) HORACE, *Poet*

OLEG CASSINI

the Wedding Dress

Creative Director: Peggy Nestor
Foreword: Liz Smith
Preface: Suzy Menkes
Commentary by Rosemary Feitelberg,
Alex Witchel, Sally Bedell Smith,
and Jennifer Sharp
Art Director: Reed Seifer
Photo Research: Flying Dog Productions

With Special Thanks: Charles Miers, Anthony
Petrillose, Kathleen Jayes, Maria Pia Gramaglia,
Kayleigh Jankowski, Caitlin Leffel, Catherine
Alestchenkoff, Grimaldi Forum,
Monaco, Robert Huth, and Ken Green.
Royal Collection—HM Queen Elizabeth II
The Box Hill Mansion—York, P.A.
The Hillwood Museum—Washington, D.C.

Photographic & Artist acknowledgement/credits
We thank the following contributors for their kind permission to reproduce the following photographs:

Sergio Alteri: pg. 240 (left);

Stefan Anderson: pgs. 132 (top right), 213, 242 (right), 262, 263;

Vicky Andren Private Collection: pg. 110 (top);

Arnault/Gancia Private Collection: pgs. 104 & 105;

Clive Arrowsmith: pgs. 202 & 203;

Rick Bard: pgs. 258, 294 & 295;

Del Matthew Bigtree: pgs. 150 & 151, 292, 293;

Dpa PICTURE-ALLIANCE GmbH: pgs. 85 (bottom right), 221 (bottom right);

Horst Paul Albert Bohrmann: pg. 224 & 225;

Box Hill Mansion Studios: pgs. 246 & 247 (illustration);

Bride & Co South Africa: pgs. 126 (bottom right), 188, 189 (top);
200 (top left), 299 (lower right);

Michael Bristol: pg. 300 (lower right);

Henry Brueckner: pg. 280 (painting);

Richard Burbridge: pg. 192;

William Cadge: pgs. 179, 272 (top right), 273;

Joseph Cartright: pgs. 300, 302;

CATWALKING: Pgs. 186 (top middle & left, bottom middle & left), 198 (bottom center), 230 (left & top right), 284 (right), 290 (left & right), 291, 296 (right), 298 (right & insert), 299 (bottom left, center-first & second image, right-top & middle image);

Alex Cayley: pg. 220;

Viola Chan: pgs. 190 & 191;

Fabio Coppi: pgs. 2 & 3, 143;

CORBIS: Pgs: 26 & 27 (partial), 29 (upper right), 41 (top), 44 (top), 82, 86 (all images), 87 (all images), 88, 93 (top-second image), 96 (top right, lower right insert, bottom left & right);

Bruno Dayan: pgs. 170 & 171;

Patrick Demarchelier: pgs. 134, 163, 165, 241 (right);

Adrian Dennis: pg 101 (bottom left);

Mattias Edwall: pgs. 112 & 113, 139, 185;

Carlos Eguiguren: pg. 259;

Arthur Elgort: pgs. 178, 184, 241 (left);

Sebastian Faena: pg. 239;

Robert Fairer Photography: pg. 187 (left);

Jeff Forney: pgs. 249 (Malin Akerman), 289 (Isabella Scorupco);

GETTY IMAGES: pgs. 8 (lower left), 13, 16 & 17 (Illustration), 28 (right), 30, 37 (left), 39 (top left), 45 (top), 51 (left top & bottom, right), 52 (top left & right), 53 (top right), 55 (lower right), 72, 74, 75 (bottom), 76, 78 (right), 79, 80 (top & bottom), 81 (all images), 83

(left & right), 84 (all images), 85 (top & bottom left), 89, 90 (bottom left), 91 (top left), 92 (all images), 93 (top–third image, bottom– left & right), 95 (top right), 96 (top left, top middle & right insert), 98, 99 (top left & right, bottom left), 101 (top right & bottom left), 107, 108, 109 (all images), 111 (right, bottom right insert & bottom left), 114 (partial) & 115 (illustration), 123 (all images), 135 (illustration), 136 & 137 (illustration), 145 (bottom left & right), 158 & 159 (illustration), 173 (illustration), 195 (illustration), 215 (illustration), 218 & 219 (illustration), 222 (partial) & 223, 228 (illustration), 243 (bottom left), 252 (right middle), 255, 280 (painting & image bottom right), 303 (illustration);

Marco Glaviano: pgs. 4, 172 (top right), 174 & 175;

Benno Graziani: pgs. 10 & 11;

Milton H. Greene: Cover, pg. 39 (bottom);

Pamela Hanson: pg. 176, 235, 297;

Marc Hom: pg. 282;

Matthew Hranek: pg. 221 (top right);

HILLWOOD MUSEUM & GARDENS: pgs. 24 & 25;

Horst: pgs. 113 & 114;

Jean Howard: pg. 47;

Ron Jaffe: pg. 33 (bottom–third & fourth image);

Daniel Johnson: pg. 301 (illustration);

Joshua Jordan: pgs. 116, 117, 118, 119, 120 (right), 121 (left & right), 129, 135, 187 (right), 193 (right & top insert), 198 (bottom left), 201, 208, 226, 229, 233, 237 (right), 253 (right & bottom right insert), 261;

Rugen Kory: pg. 288;

David LaChapelle: pgs. 64, 287;

Inez van Lamsweerde & Vinoodh Matadin: pg. 182;

Lord Patrick Litchfield: pg. 75 (bottom), 110 (bottom right);

Konstantin Makovski: pgs. 23 (painting), 24 & 25;

Carol McCabe Private Collection: pg.198 (bottom right);

Ericka McConnell: pg. 236;

MEENO: pgs. 2, 124, 125, 131;

Anne Menke: pg. 283;

Frank Micelotta: pg. 123;

Peter Murdock & David Boatman: pg. 23 (right);

David Needleman: pg. 248 (top left);

Dewey Nicks: pg. 268;

Morgan Norman: pg. 130 (all images);

CASSINI STUDIOS: pgs: 6 (Collage), 8 (bottom right), 9, 10, 11, 12 (top left, top right, & lower right), 21 (top right, top left & bottom left), 22, 23 (upper left), 28 (left), 29 (lower right), 31, 33 (top & bottom-second image), 34 (top left, bottom left & right), 38, 39 (right), 40 (all images), 41 (all bottom images), 42,

43, 44 (bottom left & right), 45 (bottom left & right), 46 (correspondence & image), 48, 49 (collage), 50 (left top & bottom, right), 51 (top left insert), 52 (top right insert, bottom left & right), 53 (top left, bottom left, middle & right), 54, 55 (correspondence), 56 (top & bottom), 57 (top left & right, bottom right), 58, 59 (collage), 60 & 61 (collage), 62 & 63 (collage), 78 (invitation), 90 (bottom right), 91 (top right), 110 (bottom center), 111 (top left), 122, 144, 145 (top right), 146 (left & right), 156, 157 (left & right), 162, 168 (right), 169, 183 (right), 198 (top left & right), 199 (right), 221 (left), 238, 243 (right), 256, 257, 266, 278 (left), 279 (collage), 284 (bottom left), 292 (bottom left), 299 (top left), 304;

OLEG CASSINI ILLUSTRATIONS: pgs. 8 (upper right), 12 (lower left & middle), 33 (upper left), 34 (top right), 50 (middle), 51 (middle), 52 (middle), 53 (middle & bottom right), 55 (bottom left), 57 (bottom left), 77, 110 (top left), 124 (sketch & fabric), 126 (top left), 138 (all sketches), 142 (all sketches), 145 (left), 146 (center), 148 (top right), 154, 160 (left & right), 166 (right), 168 (center), 172 (all sketches), 180 (right), 183 (left), 188 (top right), 189 (top left & center), 193 (bottom left), 196 (all sketches), 198 (top center), 199 (top left), 201 (top left), 208 (top right), 209 (left), 212 (insert), 215 (top) 217 (center), 222, 226 (right), 230 (bottom right), 231 (top left), 233 (bottom left), 234 (left top & bottom), 239 (top left), 252 (sketch & fabric), 253 (sketches), 257 (sketch), 258 (left), 259 (left), 260 (insert), 261 (top left), 262 (sketch), 264 (sketches), 267 (sketches), 269 (sketch), 274 (all sketches), 275 (top left), 277 (right), 278 (right), 280 (sketch), 289 (left & insert);

Clifton Parker for Patrick McMullan Co.: pg. 243 (top left);

Norman Parkinson: pgs. 206 & 207;

Susan Patrick: pg. 290 (center top & bottom);

Irving Penn: pg. 217;

Robin Platzer: pg. 96 (top middle right insert);

Al Pucci: pg. 45 (top);

Murray Radin: pgs. 19, 275 (right & center left);

Liz Rodbell Private Collection: pg. 110 (bottom left);

Gunter Sachs Private Collection: pgs. 102 & 103;

Susan Salinger: pgs. 16, 115, 136, 173, 219, 296 (left), 300 (top right), 303;

Francesco Scavullo: pg. 245;

Sharland: pg. 252 (right middle);

Sam Shaw: pg. 35;

Sarah Silver: pgs. 120 (left), 126 (top right), 141 (left), 195, 216, 231, 300 (bottom center);

Bert Stern: pgs. 97, 168 (left), 281;

Et maintenant...

Sølve Sundsbø: pgs. 177, 194, 227, 270 & 271;
John Swannell: pgs. 140, 141 (right), 209 (right), 244, 254;
Yoshi Takata: pg. 240 (left);
The Crosby Collection: pg. 95 (top left);
THE GETTY RESEARCH INSTITUTE: Pgs. 68 & 69;
THE IMAGE WORKS: Pgs: 20, 70, 71,73,75 (top), 94 (top & bottom), 95 (bottom right). 99 (bottom right);
THE PICTURE DESK: pgs. 32 (top), 95 (bottom left), 134 (bottom right);
THE ROYAL COLLECTION: pgs: 66 & 67;
Laurits Regner Tuxen: pgs. 26 & 27 (partial, painting);
Diego Uchitel: pgs. 120 (top insert), 128, 211, 300 (top left & bottom left);
Andrew Unangst: pgs. 147, 286 (bottom right);
Antoine Verglas: pgs. 132 (left, middle top & bottom), 133, 148 & 149, 152, 153, 164, 167 (left & right), 180, 181, 204 & 205, 232, 237 (left), 242 (left), 250, 251, 264, 265, 267, 269, 285 (right), 286 (left), 298 (left);
John Vidol: pgs. 276, 277 (left);
Merie Wallace: pg. 280 (bottom right);
Hans Wiedl: pg. 221 (bottom right);
WIRE IMAGES: pgs: 15 (all images), 100 (left & right);
Troy Word: pgs. 127, 159, 200, 212, 215, 228, 229 (top left), 246, 248 (right);

Thank you: Tom Cassidy, Kristen Kaczmarek, Catalina Maddox, Mika Dalton, Sharon Wienkoski, Melody Miller, Nancy Allan, Rick Bard, Angelina Jolin, Angela Anton, Jason Feinberg, Tina Guiomar, Kristen Gabriel, Ken Eade, Agata Gotova

Every effort has been made to trace the copyright holders and we apologize in advance for any unintentional errors or omissions, and would be pleased to insert the appropriate credit in any subsequent publication.

First published in the United States in 2010 by Rizzoli International Publications, Inc.
300 Park Avenue South New York, NY 10010
www.rizzoliusa.com

Copyright © 2010 Oleg Cassini

ISBN: 978-0-8478-3280-4
Library of Congress Control Number: 2010938706

Printed in the United States of America